Performing heritage

Research, practice and innovation in museum theatre and live interpretation

EDITED BY ANTHONY JACKSON
AND JENNY KIDD

Manchester University Press

Manchester and New York

distributed in the United States exclusively
by Palgrave Macmillan

Published by Manchester University Press
Oxford Road, Manchester M13 9NR, UK
and Room 400, 175 Fifth Avenue, New York, NY 10010, USA
www.manchesteruniversitypress.co.uk

Distributed in the United States exclusively by
Palgrave Macmillan, 175 Fifth Avenue,
New York, NY 10010, USA

Distributed in Canada exclusively by
UBC Press, University of British Columbia, 2029 West Mall,
Vancouver, BC, Canada V6T 1Z2

British Library Cataloguing-in-Publication Data is available

Library of Congress Cataloging-in-Publication Data is available

ISBN 978 0 7190 8905 3 paperback

First published by Manchester University Press in hardback 2011

This paperback edition first published 2012

Printed by Lightning Source

Contents

Acknowledgments

The editors gratefully acknowledge financial support for the Performance, Learning and Heritage research project (2005–08) received from the Arts and Humanities Research Council and the University of Manchester; the enormous hard work and unflagging enthusiasm of the PLH research team, steering group and advisory board over three and a half years; and all those who contributed to the successful international conference (Manchester, April 2008), which provided the inspiration and initial testing-ground for the essays in this book.

List of figures

List of figures

Notes on contributors

Marilena Alivizatou
Marilena Alivizatou is Teaching Fellow in Museum Studies at the Institute of Archaeology, University College London. Her PhD thesis was a multisited ethnography that traced the negotiations of intangible cultural heritage in museum and heritage theory and practice. For her research she conducted fieldwork at the National Museum of New Zealand Te Papa Tongarewa, the Vanuatu Cultural Centre, the National Museum of the American Indian, the Horniman Museum and the Musée du Quai Branly.

Norwood Andrews
Norwood Andrews studies capital punishment and other criminal justice topics. He received a PhD in History from the University of Texas at Austin in 2007. He has since been a research assistant in the Centre for the History of Medicine at Warwick University and a fellow at Southern Methodist University, USA.

Joel Chalfen
Joel Chalfen is a Lecturer in Drama and Theatre Education at Bishop Grosseteste University College, Lincoln. His PhD study was attached to the Performance, Learning and Heritage project. Joel is also founder and chair of the charity Polygon Arts, which runs projects with schools and community groups, specialising in work on global citizenship and interfaith relations.

Nicky du Plessis (Cultural Radius CC)
Nicky du Plessis is a freelance consultant and teacher specialising in cultural exchange, arts funding policies, arts management and entrepreneurship. She is guest faculty at a number of institutions and on the boards of the National Arts Council, PANSA and ArtMoves Africa.

Emma Durden (PST Project and Act Two Training)
Emma Durden is currently completing a PhD in participatory theatre for development and is a consultant to a number of organisations in the fields of development, theatre and training. She has been a guest lecturer and external examiner for a number of South African universities.

Anna Farthing
Anna's practice-based collaborative PhD research with the University of Manchester and the British Empire and Commonwealth Museum explores ways of engaging the public with difficult and sensitive histories through drama. This follows twenty years of professional practice as a writer, director and producer, working to commission across the cultural industries and occasionally in higher education.

Mark Fleishman
Mark Fleishman is Head of Drama at the University of Cape Town. He is a director of Magnet Theatre and has, since 1987, created eighteen new works for the company, performed nationally and internationally. He is also involved in a number of development projects in urban townships and rural communities using theatre as a tool for social transformation.

Alke Gröppel-Wegener
Alke Gröppel-Wegener is a trained theatre designer who works as a part-time lecturer. Her research interests lie in the creation of experiences through design and architecture. Originally from Germany she has made her home in the north west of England.

Catherine Hughes
Catherine Hughes is a museum theatre practitioner and scholar, who worked for many years at the Museum of Science, Boston. She wrote *Museum Theatre: Communicating with Visitors through Drama* (1998), founded the International Museum Theatre Alliance, and completed a major doctoral research project on museum theatre at Ohio State University. She has consulted and spoken widely on the subject of theatre in museums, and is fascinated by how spectators respond emotionally to live performance.

Anthony Jackson
Anthony Jackson is Emeritus Professor of Educational Theatre at The University of Manchester and Director of the Performance, Learning and Heritage research project (2005–08). A recipient of the Judith Kase-Cooper

Honorary Research Award from the American Alliance for Theatre & Education (2003), his publications include *Learning through Theatre* (1993) and, most recently, *Theatre, Education and the Making of Meanings* (2007).

Paul Johnson

Paul Johnson is currently Principal Lecturer and Head of Drama and Performance at the University of Wolverhampton. His research interests are in experimental performance, the links between science, philosophy and performance and theatre in museums, galleries and heritage sites.

Baz Kershaw

Baz Kershaw is Professorial Research Fellow in Performance at the University of Warwick. He was a design engineer before studying at the Universities of Manchester, Hawaii and Exeter. His work in experimental, radical and community-based theatre includes productions at the Drury Lane Arts Lab in London and, since 2000, five eco-specific events at south-west UK sites. His publications include *The Politics of Performance* (1992), *The Radical in Performance* (1999) and *Theatre Ecology: Environments and Performance Events* (2007). His current research re-processes conflux in microclimates as creative antidote to performance addiction.

Jenny Kidd

Jenny Kidd is Lecturer in Cultural Policy at City University London. Previously she was the full-time Research Associate on the Performance, Learning and Heritage project at The University of Manchester. Jenny's research interests include digital media, memory and the museum.

Royona Mitra

Royona Mitra is a Senior Lecturer in Drama at the University of Wolverhampton, UK. She has an MA in Physical Theatre from Royal Holloway and is currently undertaking a PhD there on the South-Asian dance artist Akram Khan. Royona has published in journals such as *Feminist Review* and *Women and Performance*.

Helen Rees Leahy

Helen Rees Leahy is a Senior Lecturer and Director of the Centre for Museology at the University of Manchester. Her research interests focus on practices of display, interpretation and visitors' embodied experience of the museum. Helen was a member of the Steering Group for the Performance Learning and Heritage project.

Laurajane Smith
Laurajane Smith is an Australian Research Council Future Fellow in the School of Archaeology and Anthropology, Research School of Humanities and the Arts, the Australian National University; until recently she was at the University of York (UK). She has authored *Uses of Heritage* (2006) and *Archaeological Theory and the Politics of Cultural Heritage* (2004), co-authored *Heritage, Communities and Archaeology* (2009) and co-edited *Intangible Heritage* (2009), and is editor of the *International Journal of Heritage Studies* and joint series editor of *Key Issues in Heritage Studies*.

Phil Smith
Phil Smith is a Senior Research Associate at the University of Plymouth, a core member of Wrights & Sites, and company dramaturg for TNT Theatre (Munich). Publications include *Walking, Writing and Performance* (2009) with Dee Heddon and Carl Lavery, edited by Roberta Mock, and *Mythogeography* (2010).

Richard Talbot
Richard Talbot is Joint Artistic Director of Triangle Theatre Company, whose productions include a comical tribute to pop stars Nina and Frederik, a site-specific 1940s re-enactment *Whissell & Williams* (Museum & Heritage Award, 2005*)* and Olympic-inspired interventions by *Team Knickers & Vests*. Richard is Artist in Residence at Roehampton University.

Introduction

Anthony Jackson and Jenny Kidd

The use of performance in heritage contexts has, for many years, been the subject of much comment and controversy, in popular and academic discourses alike, but the focus of relatively little sustained research. Its practice has often been *ad hoc*, and its evidence base anecdotal. This book represents and documents a recent shift not only toward a more reflective and less defensive practice, but also toward experimentation, playfulness and a willingness to embrace searching and theoretically driven approaches in performance research. Wider debates in the heritage sector around ownership, authorship, participation, materiality and, not least, pedagogy, have served to highlight the role of the performer as a particularly (or potentially) exciting one, and the chapters in this volume demonstrate some of the many ways in which this challenge is being explored and evidenced.

Visits to museums and heritage sites have in recent years become (not least in promotional rhetoric) less about the *object* and more about the *experience*: an 'encounter' with a past that is 'brought to life', peppered with 'events' and advertised through a list of 'What's On'. The increased use of performance has been seen perfectly to exemplify this trend, rendering it subject to criticisms of 'Disneyfication' and 'edutainment'. We do not wish to provide an uncritical defence of such performance here; rather we argue that debate is not usefully reduced solely to tensions between art, entertainment, education, fact and fiction. What emerges from the research recounted in this volume is a more nuanced debate, one which locates heritage performance firmly within the spectrum of activities that can be usefully (but not uncritically or without reflexivity) employed in the interpretation, and indeed in the interrogation, of 'heritage'.

We have preferred the term 'performance' for this volume rather than 'museum theatre', for both pragmatic and theoretical reasons. First, 'performance' is a more all-embracing term that includes not only theatre performances that are clearly recognisable as such, but also 'first person interpretation' (historic sites rarely advertise this as 'theatre'). Secondly, we acknowledge the

recent and rapidly expanding interest in 'performance studies' as an important theoretical construct with which to analyse and understand a wide variety of social experiences, from performances at political hustings through to the performative nature of 'simply' visiting a museum or historic site (see Kershaw 1999; Schechner 2005; Smith 2006). Visiting heritage sites, museums and galleries is increasingly recognised as in itself performative, with visitors being involved in active co-creation and exploration, and taking on any number of 'roles' within the social, historical and often political contexts the site represents. In this volume, there is reference also to the performative, even theatrical, nature of the museum or historic site itself: the architectural arrangement of spaces and scenographic and narrative design of displays which invite visitors to respond in ways not dissimilar to those of a theatre audience.

Carlson, in his seminal study of *Performance* (1996), concedes that it is 'an essentially contested concept' and covers a multitude of possible definitions, but chooses to highlight two particular notions of performance, both of which are directly relevant to performance in museum contexts. One involves the 'display of skills' (frequently to the fore in third-person interpretation – where, for example, the characteristics of a spinning jenny machine may be demonstrated by a skilled costumed operator). The other also involves display, but 'less of particular skills than of a recognised and culturally coded pattern of behaviour' (Carlson 1996: 4–5). What distinguishes performance from mere 'activity', in other words, derives from the element of consciousness, or self-consciousness, of what is being done: 'I am performing here and now.' Performance is also distinguished by a conscious recognition by observers that this is performance: 'We are aware that we are watching/participating in a performance.' As Carlson argues, 'Performance is always performance *for* someone, some audience that recognises and validates it as performance' (*ibid.* 5–6). For Schechner, the term can be stretched further. Even activities that may not be considered performance in the common usage of the term – visitors entering a museum, tour guides and the like – can be studied and understood *as* performance, enabling us to understand aspects of that activity from fresh and revealing perspectives (see for example Kirshenblatt-Gimblett 1998; Kershaw 1999; Schechner 2005; Smith 2006).

The term 'heritage' of course remains complex and contested both in the literature and in institutional practice. Although, as Robert Hewison recognises in his 1987 book, *The Heritage Industry*, it is a 'word without definition' (and a relatively new one at that), there have been various connotations informing its continued use: materiality, inheritance, preservation and tangibility. Recent conceptualisations, however, place increased emphasis on heritage as a *process*, one that reveals a multiplicity of narratives (or indeed sometimes conceals them). (See Chapter 2 in this volume by Helen Rees Leahy for further exploration of this theme.) As such, heritage inevitably

becomes a site of struggle; narratives can be contradictory, controversial and contested within and between cultures and communities. This can of course make various methods of interpretation used at museums and heritage sites problematic, but can equally be seen as a liberation from the tyranny of an ordered, two-dimensional, fixed – yet still fictitious – 'past'.

The many ways in which performance permeates and informs discussion of heritage and its possibilities is the subject of this book. The unique combination of contributors has been made possible only through the conversations, seminars and performances that constituted the Performance, Learning and Heritage (PLH) project, generously funded by the Arts and Humanities Research Council 2005–2008. Many of the chapters in this volume were first conceived and given as papers for the final project event, an international conference in Manchester in 2008. The variety of contributors at the conference – practitioners, museum directors, educators, researchers, scholars – led to an invaluable exchange of ideas and commentary which has informed the final content and approach of the chapters presented here. Voices of practitioners are emphasised just as much as those of the academy. We have opted not to divide the book according to professional practice or on disciplinary grounds, but rather along thematic lines. We hope that the ways in which those voices speak to, contradict and confirm one another will further evidence the range of ways in which reflection and research in heritage performance is becoming more nuanced and complex.

The PLH project will be briefly introduced here, and some of the findings will be elaborated over the coming chapters, but for full details of the case studies, methodology, audience responses and findings, please see the project report.[1]

The Performance, Learning and Heritage project

Performance, Learning and Heritage was an investigation lasting three and a half years, into the use and impact of performance as a medium of learning and interpretation at museums and heritage sites. The project team (including the editors of this volume) set out to observe, document and analyse a variety of performance styles, in a variety of settings, and to encompass the study of a wide range of audiences – earlier research had focused only on school groups. The research was conducted over a long term in order to gauge the lasting effectiveness and impact of museum theatre, and along the way to develop new methods of assessing practice. As part of the research, we also began the task of mapping the extent and style of performance activity across historic sites and museums – in the UK and across the globe – and facilitated the wider exchange of ideas and practices through the project's website and the international conference.

The field known generically as museum theatre has grown considerably since the early 1990s; its use is sometimes contentious and its practice worldwide almost as diverse as the sites in which it takes place – but it has been notably under-researched. Museum theatre is broadly defined as: 'the use of theatre and theatrical techniques as a means of mediating knowledge and understanding in the context of museum education' (Jackson and Rees Leahy 2005: 304). It is generally presented by professional actors and/or interpreters in museums and at historic sites and may range from performances of short plays and monologues based on historical events or on-site exhibitions, to participatory events using 'first person' interpretation or role-play; it may be designed for the specific curriculum needs of visiting schoolchildren or, more broadly, for family groups and the independent visitor.

Theories of learning have recently advanced our understanding of how, and in what forms, learning in museums takes place, but, despite evaluation of individual programmes now being standard practice among museum educators, there has been relatively little published on how theatre/performance contributes to that learning.[2] In this context, there has been a pressing need for sustained, independent and practical research into the benefits (or otherwise) of on-site, theatre-based, informal learning activities at museums and heritage sites. This need was amply confirmed by an earlier phase of the research (2001–2), and by the considerable interest the research outcomes generated in the UK, the USA, Australia and several other countries in Europe.[3]

The project therefore aimed to build on, and expand from, the limited but significant findings that emerged from the earlier research – for example, the demonstrable ways in which performance enhanced children's recall and grasp of the personal stories connected to the historical material they were studying, or how performance was able to promote 'focused looking' at the exhibits (Jackson and Rees Leahy 2005).

While based in a university drama department which has a strong profile in the field of 'applied theatre', the research approach was fundamentally interdisciplinary, crossing the disciplines of drama and performance studies and museum and heritage studies. It drew its inspiration from, and was enriched by, the closest collaboration between research team, partner museums and heritage organisations, theatre companies and individual performers. The team is immensely grateful to all those who assisted in the completion of what proved to be a complex, challenging and rewarding task.

The project is now complete in the sense that the grant and the official commitments of research team members have ended. The data amassed and the questions raised, however, have inevitably been larger and more complex than any three-year project could possibly hope to resolve fully, and the research continues.

Although 'Learning' was our principal point of enquiry in the research and major focus in the final project report, here 'Performance' and 'Heritage' become our points of entry. The theme of learning is nonetheless implicit in a number of the chapters, and many of the projects under discussion have been conceptualised with some definition or other of learning at their core. However, learning is rarely recognised here solely in terms of the acquisition of factual knowledge. Rather, as was noted in the report, it is often in more subtle, complex and challenging ways that learning is supported and 'delivered' through performance; engagement, empathy, participation, challenge, understanding and taking ownership are also means through which learning may be generated.[4] Whether we define learning along lines of personal transformation, experience, dialogue, critical engagement or the promotion of 'good citizenship', performance indeed has something to offer. (For a more deliberate and concentrated overview of learning outcomes as conceived and perceived in the project see the PLH report: Jackson and Kidd 2008).

This volume

This volume is divided into four parts. The first, 'Visitors, audiences and events', sets a number of frames for the chapters that follow. The opening contribution from Anthony Jackson is grounded in findings from the Performance, Learning and Heritage project, outlining the ways in which we are beginning to understand and document engagement (in all its various forms), and the processes that constitute, frame and facilitate performance in heritage environments. It explores how visitors *become* audiences and often participants in performance, and considers ways in which members of the public can be usefully 'unsettled' in their interactions with heritage. Helen Rees Leahy's chapter similarly reflects upon the role of the visitor, outlining the ways in which the visiting of museums and heritage sites has itself been increasingly recognised as a performative bodily practice. The chapter addresses the implications of this for the performance of heritage, but also for the role and shape of 'the museum' in the future. Chapter 3 seeks to take this argument even further positing the notion that the architecture and design strategies utilised by sites and institutions might in certain circumstances render the actor interpreter redundant. Perhaps, Alke Gröppel-Wegener argues, architecture can perform a narrative or respond to events and 'heritages' in ways that are similarly engaging and lasting in impact, yet more permanent than performance. To conclude the section, Paul Johnson sets out a framework for the analysis of heritage performance using a number of binaries: fiction–history, internal–external, and risk–safety. The chapter boldly suggests widening the range of performative activity considered appropriate within heritage contexts.

The following section brings together four chapters under the heading 'Re-visioning heritage: recovery and interpretation'. Laurajane Smith opens with a chapter outlining the many ways in which the discourse around 'heritage' needs to be problematised, arguing that the 'Authorised Heritage Discourse' represents neither a useful nor a desirable way of encouraging visitors to engage with 'the past'. Smith highlights results from research carried out at a number of contrasting heritage sites to explore the implications of *not* questioning the authority and authenticity of heritage discourse. Marilena Alivizatou is similarly interested in identity and authenticity, and in her chapter critically examines performance as a means of interpreting intangible heritages by using examples from Vanuatu, New Zealand, and France. She provides us with an overview of UNESCO's initiative to safeguard the 'intangible cultural heritage', the Convention for which came about in 2003, and of which performance is a vital 'domain'. In Chapter 7 Anna Farthing introduces her concept of 'intangible human remains': those actions, attitudes and prejudices from the past which permeate our social interactions and encounters with heritage in the present, and which must make (Farthing argues) for different recognitions of 'reality' in dramatic interpretation. Exhibiting actions rather than objects re-complicates our relationship with what is 'authentic'. Following on from this, Emma Durden and Nicky du Plessis introduce their work in the iSimangaliso Wetland Park in South Africa, where they have been enabling members of the local population to find ways of interpreting their landscape, and a range of heritages which have until now been denied them. Using storytelling techniques, these individuals are becoming 'tour guides' each with their own unique take on the environment, the history, and why it is important to remember.

Part three examines ways in which current practice pushes at the boundaries of what constitutes heritage, or which attempts to re-create heritage(s). Baz Kershaw's chapter questions notions of ephemerality in performance, and heritage, exemplifying, through his practice-based research, how the interaction between live events and mediated technical environments is being creatively and provocatively explored. Royona Mitra's chapter starts with the ephemerality of singular heritage interpretation, and outlines ways in which performance is being used to spark intercultural dialogue and the sharing of forms of intangible heritage. The juxtaposition of the *Kathak* dance form against a backdrop of material heritage grandeur makes for an illuminating cultural dialogue. The following two chapters playfully engage with the politics of 'creation' in heritage practice. In Chapter 11 Phil Smith grounds his discussion in an account of his interpretive practice at A la Ronde, a practice that questioned the boundaries between 'truth' and 'fiction' at the same time as it queried the authorised and authored traditional site narrative. Richard Talbot and Norwood Andrews' chapter examines the challenges

and opportunities to be found in the immersive performative practice of character development and historical research in-role – and of dissemination in role too.

The final section encompasses writings on 'Impact, Participation and Dialogue': inter-related moments of engagement and experience, pivotal to any learning outcome that might be sought in the performance of heritage. In Chapter 13 Catherine Hughes draws our attention to scientific perspectives on emotional engagement, a form of engagement possible although never inevitable in an encounter with heritage performance. Making links from performance studies to cognitive psychology and neuroscience, Hughes' chapter represents a significant move in the direction of understanding the nuances of 'impact'. Next, Jenny Kidd outlines different models of participatory theatre encountered in the Performance, Learning and Heritage project, contextualising them within debates about 'authenticity' and 'legitimacy' in practice that seeks to be genuinely interactive. In Chapter 15 Joel Chalfen illustrates a number of examples of participatory practice designed to promote and enable active citizenship within the framework of the Historic Sites of Conscience Coalition. Research findings from a number of sites are detailed, whilst simultaneously problematising the notion of impact measurement in the field of human rights. Finally, Mark Fleishman's chapter details the Clanwilliam Arts Project, a community-based residency project in South Africa which forms part of the larger 'Remembering in the Postcolony' initiative. Fleishman's reflections recognise contradiction, multiplicity and complexity both in the processes of remembrance and in the process of performance.

The varied chapters in this volume encourage us to reflect again on the relationships between 'our' pasts and presents, truth and fiction (and the fragility of memory), authority and authorship, subject and object, the personal and the collective. In essence they usefully re-complicate debate about the performance of heritage, positing a rich diversity of ways in which interpretation strategies might become more nuanced, polysemous, reflexive, playful and dialogic in response. The editors of this volume have, on occasion, cross-referenced between chapters, drawing comparisons and highlighting tensions. Beyond this we encourage readers to make their own links and connections, and to observe and reflect on the ways in which the debate is being framed, and the performance of heritage characterised and interrogated.

Notes

1 This can be found at the project website: www.plh.manchester.ac.uk. A summary of the PLH project is given in the Appendix.
2 Catherine Hughes' chapter in this volume represents a rare exception to the

rule – drawing on doctoral research carried out in parallel, and in dialogue, with the PLH research.

3 See project website: www.plh.manchester.ac.uk.

4 See also Jackson 2007 for further discussion of the interconnections of theatre, learning and meaning-making.

1 Visitors, audiences and events

1

Engaging the audience: negotiating performance in the museum[1]

Anthony Jackson

This chapter considers some of the characteristics of performance encounters in the setting of the museum, and a number of critical issues that arise from them. Drawing on findings from the Performance, Learning and Heritage (PLH) project, I will outline how we are learning to understand more fully the ways in which audiences will often engage with performance (in its various forms), and consider the processes that constitute, frame and facilitate performance in heritage environments.[2] In particular, I want to examine the transitions that take place, in museum contexts, as 'visitors' become 'audiences', and then to reflect on the productive opportunities and equally some of the pitfalls involved in the 'unsettlement' of audiences that challenging performance often aims to achieve. What can we learn from the transactions that take place as people make choices to engage with a performance, mentally and sometimes physically, especially where that performance situates itself outside the 'normal' safety zone of the traditional theatre auditorium, and where the subject matter is itself unsettling? The last of our case studies, *This Accursed Thing*, a specially commissioned performance at the Manchester Museum, dealing with aspects of the slave trade and its abolition, will provide the main point of reference for the chapter. But I want to begin by identifying a few of the factors that distinguish audiences at a museum performance from those at performances in conventional theatre spaces where 'seeing a play' is the primary purpose of the audience's visit.

Visitors and audiences

Audience response to any theatre performance is complex and varied, but in the museum is likely to be even more so. That response will inevitably vary, according not only to the style and content of the piece, but also, in museum settings, to each individual visitor's pre-existing attitudes and inclinations, and to what John Falk[3] has called the 'entry narratives' that visitors bring with them before *any* encounter with the museum galleries, let alone a

performance, takes place. That complex mix of rationales for attendance and embedded assumptions, about both subject matter and museum institution, that visitors carry in their heads as they arrive means that they are not, in other words, 'blank slates'. They must be understood in relation to the 'horizons of expectations' (Holub 1984; Bennett 1990) which are available to them based on their social and educational backgrounds and prior experiences – and indeed (as Bourdieu (1979) has shown) on the 'cutural capital' they have been able (or allowed) to acquire. In 'heritage performance' – as in all forms of theatre with educational claims – not only do we need to understand the power of performance in its various manifestations, but, just as importantly, we need to understand our audiences better than we do. (See also Hughes, Chapter 13 this volume, for further discussion of the varieties of visitor response.) Here, though, my focus will not be on the 'entry narratives' but rather on the quality and kinds of engagement evident in the moment of performance and in its resonance after the event.

The PLH research team became intrigued by a recurring thread in their analysis of visitors' experiences at museums, sites and heritage-trails: that is, the ways that visitors become (or sometimes resist becoming) audiences, or in many cases active participants in the performed events. There are various performative roles which visitors, consciously or sub-consciously, play as they encounter museum performance, and there are complex transitions that take place between the roles of (for example) 'visitor', 'audience', 'participant' and 'learner'. Often they will switch back and forth between those roles from moment to moment as they negotiate their relationship both with the performance and with the museum or site environment; sometimes they will play several of those roles simultaneously such that the distinctions blur or dissolve, with noticeable effects upon the kinds of response they offer, not only in discussion at the end of the visit but many months later too.

Most visitors to museums or historic sites do not go expressly to see a performance so their expectations and the choices they make differ fundamentally from those of the conventional theatre audience. Indeed, at many museums, performances are only advertised on arrival. *The Gunner's Tale* at the National Maritime Museum (NMM), Greenwich, for example (one of our first case study performances[4]), was given very little prominence in the museum's publicity brochures or website, but it was advertised once you were inside the museum – by means of posters, video screens and tannoy announcements. This single-character monologue, relating life aboard ship during the Battle of Trafalgar (the 200th anniversary of which was being commemorated at the time), took place at prearranged times and there were usually about twenty chairs positioned round the small performance area at one end of the ground-floor galleries to denote the theatre space. A sailcloth on the floor marked out the actor's performance area. It was clear where those

who chose to watch should place themselves and where the demarcation line lay that separated audience space from performance space. Once the performance began, both audience and performer remained separate, even if only a few metres apart. At other, more participatory performances, the distinctions between performance space and audience space become far more blurred and fluid as the performer (gallery character, for example, or actors in a promenade performance) converses with and often mingles with the audience.

'Tiers' of engagement

It quickly became apparent during *The Gunner's Tale* performance that there were three observable 'tiers' of audience engagement and positioning (see Kidd 2007: 63–4). The first was created by those who gathered before the performance began and chose to sit on the chairs (or on the floor if numbers dictated), displaying the behavioural characteristics of the traditional theatrical encounter. A secondary tier was created by people who stood to watch the performance, choosing to stay but wanting to keep their options open, or perhaps feeling compelled to stay by the spatial restrictions. At the very back was the third tier: usually people who were prompted to join by hearing or seeing the performance after it had begun, displaying interest but less commitment, and treating (or perhaps being forced to treat) their encounter with the whole spectacle of the performance as if it were another display in the museum to be viewed in passing.

Those in the first tier invariably stayed to the end – either because they were closely engaged in the performance or because the second tier had created a barrier between them and the exit. For those standing at the back, there were no such barriers: some would leave during the performance while others stayed. In one performance, the research team observed 'approximately 60 people standing and observing behind a seated area, and another 60 coming behind these people to investigate the activity before leaving' (*ibid.*: 64). Moreover, they were replaced in constant rotation by an almost equal number of new observers – almost as though there existed an invisible but definable audience space which had to be filled.

The tendency toward three distinct tiers of engagement was observed in a range of other performances at other museums, including (with some variations) the promenade performance of *This Accursed Thing* at the Manchester Museum. This production was commissioned by the research team in conjunction with The Manchester Museum and developed in partnership with a specialist professional theatre company (Andrew Ashmore & Associates) and the museum curators and education staff.[5] It dealt with aspects of the abolition of the Slave Trade Act, the 200th anniversary of which was being commemorated by museums across the UK in 2007. It lasted about an hour;

two professional actors played six characters; and the audience were taken through various galleries in the museum, with the four main scenes played in three different locations of the museum. Thus, the long, high-vaulted Victorian-Gothic Mammals Gallery lent itself momentarily to the decks of a slave ship, transformed minutes later into a Manchester meeting hall where the audience switched from being 'first-timers' on board ship in the early 1800s to a gathering some fifty years later at a lecture given by James Watkins, an American ex-slave and leading abolitionist. Before the performance began, a short introduction was given by the two actors out of role, and, at the end, a 10–15-minute de-briefing took place at which the audience were able to ask questions of the actors again out of role – about the performance, the research, and of course the subject matter of slavery and the slave trade.

Here, the first tier was constituted in the initial gathering of people who had booked in advance, in the clearly demarcated audience space where the performance began. The second consisted of those who had only just discovered there was a performance and joined the audience moments before the start or soon afterwards, drawn by curiosity, most of whom stayed for the rest of the performance. And finally there were those who almost literally stumbled across the performance as it progressed through the galleries, and tended to watch from afar before (usually) carrying on with their separate journeys through the Museum. Once on the move, from gallery to gallery, audiences had the opportunity to renegotiate which of the very fluid 'tiers' they wished to place themselves within. Some became fully immersed and stayed close to the action throughout ('You're in the story': (MM_I_PP3_197)); others were more tentative ('Not sure who we "were" all the time' (MM_Q, 001)); while a number were not drawn in to the action in the slightest ('I was really bored' (MM_Q, 009)).[6]

All the events we observed and analysed required different kinds of performer–audience relationship and different ways for an audience to negotiate their way through the events they witnessed and through the demands made on them by the performers and the space they commandeered. The givens of the space and of the ways the performer inhabits that space and addresses the audience will set the parameters, but the audience constantly adjusts, re-adjusts, and makes choices where it can. In part, this is to do with developing a degree of trust in the performers, judging 'what's in it for them', making a kind of cost–benefit analysis: if I engage openly, what are the risks – do I make myself vulnerable, look foolish in front of my children? The rules of the 'game' of theatre may or may not be clear to the unsuspecting visitor – and it begs the question of how much, if any, induction into the event might be needed, at least for those performances that migrate across different spaces and cross the usual boundary line between actor and audience (an issue discussed further by Jenny Kidd in Chapter 14).

The 'audience contract': the 'rules of the game'

As with *The Gunner's Tale*, at NMM, the tell-tale signs of performance – the chairs laid out in front of a space in the gallery with a notice giving the time of the next performance – may be all that is needed. But not all visitors will readily and confidently sit down to watch a performance about to happen just a few metres away from them. Many will hover until the actor is in place, the boundary lines clearly established and the style of performance indicated (narrative, direct address, comic interplay, physical theatre, promenade), before they contract in. For these performances, there does indeed seem to be a kind of unwritten contract on offer to the visitor – if you agree to participate, by implication you agree to give licence to the actors (within reason) to take you on their metaphorical (sometimes actual) journey through time and space.[7] It involves ceding a certain amount of control over what happens next and how you will be implicated. But a contract is of course a two-way thing. While it may be established in the opening minutes, it will be open to re-negotiation as the drama unfolds. In the fluid settings provided by museums and historic sites, some people will decide to opt out when the opportunity arises, or may re-position themselves – closer or further away – as they make up their minds about their level of engagement.

There are often clearly observable moments when the audience decide to commit to the contract – reinforced by comments made to the research team in questionnaire and interview responses. In *This Accursed Thing*, for example, the audience were to find themselves progressively becoming an integral part of the action and the drama – drawn in gently at first as the character of the Museum Curator, in the relatively enclosed space where the performance began, introduced the themes and the background to slavery, inviting them to look closely at artefacts related to the cotton and sugar plantations before asking them to follow him into the first large gallery space. Within minutes of their reaching the new space, the proceedings were interrupted suddenly by the voice of Thomas Clarkson, one of the leading abolitionists in the early years of the nineteenth century. His appearance on a bridge above the stairway was unexpected and required a physical movement to turn and look up at the figure above them, a re-focusing of their attention and a mental readjustment from 2007 to 1807. The comfortable gathering around their curator-guide, with its stable, single-character focus, was from now onwards going to have to be constantly re-negotiated. Clarkson strides across the bridge and descends the steps towards the gathered audience (who again have to readjust their positioning), and greets them as supporters of the abolition campaign, shaking hands and apparently recognising some from previous meetings. Soon the audience (for that is what they all are by now – and an actively participating audience at that) are all following him up the stairway to another gallery at

which his political meeting will take place. The re-positioning and degree of interaction is pushed progressively further at each stage in the performance. For many audience members the initial encounter with Clarkson was the first moment at which they felt connected with the events of the drama. Their own involvement was not forced, but Clarkson clearly expected them to join him vocally in condemning the slave trade. The agreement was easy, the vocal expression of dissent in unison less readily forthcoming: audiences varied enormously in the eagerness or reticence with which they joined in the call. Do I get involved now? Do I risk making a fool of myself? What's everyone else doing? Does this character really want me to call out, or is it just part of a play I'm watching? Am I an audience member, or a participant? No one was forced to respond but usually they did, with varying degrees of enthusiasm or reserve.

This encounter was a point of contact with a character clearly defined, precisely located in a moment of time, with a clear and urgent message to impart. This school pupil's comments are typical of many, recalling, some three weeks later, moments when the character made him suddenly feel part of the drama, part of the reality of the event:

> Yeah, the guy shook my hand, and I think it was Thomas Clarkson; he shook my hand right at the beginning.
> INTERVIEWER: Okay. And how did that make you feel?
> It made me feel like I was back then . . . It was like they were making you feel like you're a part of it. Like it's sort of real and things. (MM_S_PP2_158)

The event frames

One conditioning factor, serving to signal and facilitate the theatrical conventions in play, and strongly influencing the degree to which an audience will engage with the performance, is – to borrow from Erving Goffman (1974) – 'frame'. The quality of engagement – and indeed the extent of the learning taking place – will depend not just on the novelty of the experience (though that should not be lightly dismissed), nor just on the quality of the performance itself, nor the volume of information conveyed, but, at least as much, on the way the experience is organised and framed. As Goffman has shown us, it is the invisible frames constructed around social events that influence how we 'read' them, make sense of them, draw meaningful connections with other aspects of social life. There are a number of frames within which performance activity takes place at museums and heritage sites.[8] For the purposes of this chapter, I will refer to just three: the institutional, and the outer and inner performance frames. The *institutional frame* refers to the institutional context within which the performance event is located and within which it will be read and understood – for our purposes, the museum

or the historic site. It includes the architectural style of the building and its permutation of spaces, the style and foci of the collections, its location (urban, rural, etc.), and the ways in which the museum chooses to project and market itself. Of course, this frame itself operates within, and is largely conditioned by, the much wider social, political, intellectual and economic climate within which any cultural institution has to function. There are then the frames established by and within the performance. The *outer performance frame* is that which marks out the theatre event itself as theatre and signals where and how the audience will position itself, and the role (if any) expected of audience members – for example, via the entry point into the performance area, including the collection of tickets where applicable, the formal seating or 'promenade' setting, the marking out of the 'stage' if any, and the level of formality or informality that is established. It governs anything and everything that goes on within the space and place of performance. Within the performance, there are usually one or more *inner frames* operational only once the performance or the progress round the site has begun – devices used to signal shifts of time, place, character and relationship with the audience, including invitations to interact.

Finding the most appropriate frames for the drama proved to be a critical factor, therefore, in the process of developing *This Accursed Thing*. And it became a priority for the writer in devising the performance to attempt to place the whole sequence within a set of frames that would make the drama, its subject matter, and its way of operating within the particular challenges of the museum space as clear and unthreatening as possible while inviting interaction from the audience as it progressed. The institutional frames (for example, of the museum's involvement in the abolition commemorations and the corresponding publicity given to the performance event) would allow for a series of subtle (and sometimes not-so-subtle) re-framings of the action and the audience relationship to it, from scene to scene, gallery to gallery, character to character. Thus, enclosing the drama itself were the out-of-role induction and de-briefing sequences which introduced and closed the performance (without closing down the questions raised), and were designed to free up the drama sufficiently to allow for moments of interaction and genuine challenge within the performance, accompanied by the tacit permission given to the audience to opt in and out at any point. The introduction emphasised that the actors would be playing a variety of different roles, and that the museum galleries as a whole would provide the setting for the drama but by the same token not realistic sets. In this way, the large gallery spaces, the stairways and the connecting passages through which audiences passed whilst promenading from scene to scene could be seen as integral components of the drama – not as irritating and regrettable drawbacks of performing in a museum. Audience involvement was, then, designed to be incremental as the drama progressed

through the galleries, through history and through the intellectual and emotional challenges proffered by the narrative.

The design and crafting not only of the performance itself but of the inner frames through and within which the audience will observe and engage with that performance, require extra levels of care and attention where the performance event takes place in non-theatrical spaces and often with little advance warning. In part this is about finding ways of trying to equalise the power relations at work, reducing vulnerability and so enabling people to engage voluntarily and in their own way, without at the same time feeling patronised.

> I think it took a while for us really to know that we were allowed to really be part of the dialogue, you know? (MM_F_PP1_206) *(immediately following the performance)*

> I think you have to be given the chance to stay quiet. I think it would have been quite excruciating if people had had to come up and act a part if they had not really wanted that (MM_I_PP2_207) *(3–4 weeks later)*

Expectations matter greatly, and will often condition the responsiveness of the audience. But there is also much to be said for work that confounds expectations, where surprise is a strong part of the very enjoyment and/or educational impact, and for the 'wow factor' which by definition should not be prepared for.

> No, I don't think, you can't be prepared for anything like that. We were told by my friend that there was going to be a short play, I didn't realise we were going to be sent all over the building, which was great. . . . I thought we were [to go] somewhere and sit down, watch this play and the next thing they are acting it out in front of you, really good. (MM_I_PP3_190)

This brings us to the experience of the performance itself, and the oscillating, sometimes contradictory feelings and thoughts generated in audience members as they negotiated their way through the drama.

'Unsettlement'

The notion of 'unsettlement' was coined by the team to indicate an experience our respondents at all sites frequently articulated: that of having expectations overturned, assumptions about the subject matter challenged, of finding that they were personally being confronted with strong emotion or were expected to participate verbally or even physically. Such 'unsettlement' may often be positive: stimulating, surprising, generating a sense of dissonance that requires further thought, perhaps even a revision of closely held assumptions and beliefs.[9] It may be negative: visitors finding themselves trapped inside an event that they find exasperating, irritating, demanding more of them than

they wish to give, but from which there is no escape. So, as well as unsettling subject matter there is also the unsettlement generated in the encounter with unusual dramatic form and context: the unexpected moments of direct address, finding that you are suddenly in role, invited to interact verbally or even physically, or expected to follow the performance to other spaces in the museum.

In *This Accursed Thing*, probably the most challenging and unsettling sequence came during and immediately after a scene between a black African slave trader and his white (British) counterpart, here to do a deal over the next batch of slaves to be brought to the trading post. The audience begin as witnesses but then find themselves faced by a disconcerting confrontation. The white slave trader turns to them, sees their critical looks and challenges them to tell him what he's doing wrong. Some engage immediately, others (for whatever reasons) avoid his eyes and hope this is only a rhetorical question; for many there is a sense that to remain silent is either to offer tacit consent, to be complicit in the trade, or at the very least to accept its validity in the context of its time. Young children sometimes jumped in without hesitation to accuse the trader of unfairness; older children and many adults became increasingly frustrated at the trader's apparent ability to find a justification for his trade whatever the objection. For some, it was only in the relative safety of the final question and answer session at the very end, with the actors now out of role, that they felt empowered to express their reasoned analyses of the evils of the trade or, for others, their anger at its existence.

Of whatever kind, such unsettlement often generates strong feelings which

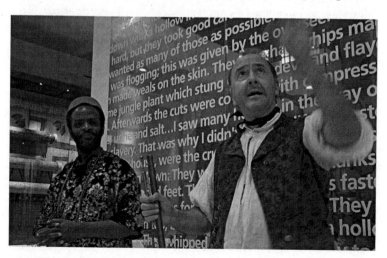

1.1 *This Accursed Thing.* The slave traders meet to negotiate a deal. Actors: Paul Etuka and Andrew Ashmore

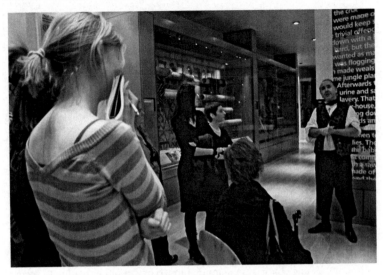

1.2 The British Slave Trader confronts his audience

remain long after the event – as the following response (some eleven months after the event), from a visitor provoked both by the subject of the slave trade and by his confrontation with a character advocating its continuance, illustrates:

> Well it wasn't, it wasn't good actually you know, the way he was saying, the way the slaves were treated and the way they were stacked. They were stacked like bloody sardines. It was horrible you know the things he was saying and people tried to make him feel guilty by saying how would you like it if your family had that done to them and he said oh that won't be done to me, we're a nice white upper-class family, you know going on like that with himself.[10]
> **INTERVIEWER:** So how did the performance make you feel?
> Well it opened my eyes about slavery, I mean I have never given it much thought because I obviously wasn't born in that time, you just get on with life don't you. But it made me ponder a bit about it. Well it must have been really tough and upsetting to have been dragged away from their families and then just brought to this other country and then treated like a piece of rubbish. (MM_I_PP3_190)

The unsettlement may be a deliberate part of the aim of the piece but it has to be handled with skill and sensitivity. The need to challenge, to unsettle, surprise, stimulate, has to be balanced against the counter-productive risks of embarrassing, confusing, de-motivating, angering and ultimately disempowering the visitor who has not yet agreed to 'buy in' to the process. That in a nutshell is the main challenge for the performer: how to unsettle *and* take your audience with you. And it begs the question again of just how, and when, the

unsettling or challenging elements are introduced, and how to ensure that the audience has had sufficient time to 'tune in' to the style, rhythm and subject matter of the performance. *This Accursed Thing* offers just one example of how this challenge was addressed and a solution found – but, not, it must be emphasised, a model of 'how to do it'.

Unsettling audience preconceptions has dramaturgical implications too. The performance itself – including single-character monologues – will often benefit from the inclusion of elements of dissonance or challenge and from the presence of 'other voices' that can provoke active engagement with the narrative. Even monologues can be multi-vocal. It may be instructive to recall what the literary critic and cultural historian, Mikhail Bakhtin, saw as the overriding quality that characterised many of the great epic Russian novels, and engaged the reader so intensively: that of 'heteroglossia', or literally 'multi-languaged discourse' (Bakhtin, 1994: 113). The voices of the characters within a Dostoyevsky novel, for example, are compelling and unsettling because they are embodied within characters who appear to have a vibrant, distinctive life within the fiction, in dialogue not only with each other but with the author. This is not just multi-vocality; this is a clash of world views, often irreconcilable, leaving the reader without recourse to the reassuring guidance of an all-seeing, authoritative, wise narrator. Consequently, the reader is allowed real space in which to negotiate his or her own meaning from the narrative. Arguably, too, it offers the reader a degree of agency often not available in other more conventionally structured novels.

One of the strongest arguments for including performance within the repertoire of interpretive strategies a museum has at its disposal is that it provides museums with a resource that helps them fill some of the inevitable gaps in their collections and the narratives they tell. It is in this recovery of distant, hidden or marginalised voices, the attempt to re-present that which is now absent, that the concept of heteroglossia – applied to drama – can offer a valuable prompt to the writer, researcher and educator in museum theatre.

Thus, a simple but effective example from our first case study. 'John',[11] who witnessed the *Greenwich Pensioner's Tale* at NMM, was able to see the events leading up to the Battle of Trafalgar and the battle itself through fresh eyes; that is, through the eyes of the pensioner who recalled his own personal experiences with the skill of a master storyteller. John was surprised and inspired by the tactics used by Nelson and by the heroism shown by those below decks as much as those in command, and also gained a better appreciation of how and why 'we won'. But where were the contrasting voices and viewpoints? The French seamen for example? It is arguable that John's empathy with the sailor also reinforced a very partial view of the battle, seen wholly from the perspective of the victors, even if through the eyes of one of the unsung heroes from the lower decks who also suffered most of the casualties.

In its own terms, it offered a lively, engaging, persuasive and enlightening perspective on the events at Trafalgar, but also, perhaps, a very narrow one. As another audience member observed, 'It might have been quite nice to have the equivalent French pensioner Joe Brown to put the French side of the battle' (NMM_F_PP1_116).

The dramatic monologue does not automatically deny the possibility of heteroglossic dialogue, just as multi-charactered drama does not guarantee heteroglossia. There are many examples of monologues that have managed to suggest 'the other' very strongly within the drama – by direct quotation or by implication. Of course you cannot do everything in 25 minutes, and many visitors expressed their appreciation of gaining real insight into that marginalised aspect of Trafalgar and of seeing it through the eyes of the ordinary seamen. But there was very little heteroglossic quality within the writing, and perhaps that made it all too easy for the pensioner's story to be drawn into a larger narrative of 'how we beat the French in 1805' and – despite, or because of, the blood, sweat and tears – of how reassuringly glorious it all was.

If heteroglossia is at work in the drama then there will be a range of voices, world views and dramatic registers evident in the dramatic dialogue or the unfolding of the story that will challenge the audience to participate because there is no one clear authorial stance that governs the meanings we take from the event, that does the work for us. Bakhtin's concept of heteroglossic tension reminds us how important it is to generate engagement, not only through empathy but through the unsettling of our preconceptions; it allows the audience space in which to enter into the drama, emotionally, intellectually, sometimes even verbally.

In *This Accursed Thing*, this quality was undoubtedly present in the variety of different voices encountered by the audience as they went from stage to stage – from their meeting with abolitionist Thomas Clarkson to the encounters with the African and British slave traders as they bartered over slaves to the meeting (sixty years on) with James Watkins, an escaped American slave now undertaking a lecture tour in England with a view to persuading Lancashire cotton workers to support the cause of the northern states in the civil war.

> I loved the way they gave a variety of voices from the slave trade . . . It was very stirring; very moving. (MM_I_PP2_71)

> It's very difficult for us to look back with our twentieth-century eyes and put ourselves in that position. Obviously that was one of the things that the play tried to expose you to, all sides of the story, and left you scope for you to fill in the gaps. (MM_I_PP2_210)

But interestingly, and tellingly, the least powerful moment (in an otherwise remarkably powerful drama) was the meeting between Watkins and a Lancashire cotton worker. Momentary differences of view were quickly

overcome as the cotton worker was persuaded of the similarity of the cause between American cotton-picking slave and Lancashire cotton-mill slave. The solidarity that was achieved between them – although historically (and remarkably) accurate – was, dramatically, all too predictable. Different voices but no real heteroglossia to unsettle the forward momentum of the argument and the narrative.

There is a tendency in much theatre that operates within institutions that have in part an educational remit (schools, prisons, museums and the like) to serve contractually demanding educational agendas in ways that explicitly demonstrate how well they fulfil the brief. Often without intending it, performers in museums can take on, or find themselves endowed with, the mantle of communicating and reinforcing the overt narrative of the museum, performances perceived as being 'authorised' by the museum and representative of a certain kind of historical truth. Bakhtin's theory of what makes for the great epic novel might, in drama, serve as a counter to this narrowing tendency.

Conclusion

The research has shown that performance in the museum often has value and resonance, that it can enhance the visitor's appreciation and critical understanding of the heritage in question. But it also suggests that we need to develop still more sophisticated ways of understanding the complex and varied ways in which the performance/audience relationship works. Moreover, how the event is framed, how the visitor is inducted into the game being played, and invited to become a willing audience-member, or indeed a participant, the extent to which he or she is allowed a degree of choice as to whether, or how far, to participate, and the opportunity he or she is given to ask questions or express opinions at the end – all these are vital issues that have to be addressed in every performance event in a museum or historic site. They become even more vital if that event deals with difficult issues, involving racial or cultural difference, and if it is intended to promote – implicitly or explicitly – learning.

For *This Accursed Thing*, the chosen structuring and framing devices were infused with the life-blood and colour of human interaction, with the embodied iterations of viewpoints, claims and counter-claims of an array of historic personages, each of whom made a claim on our attention and allegiance, only to have them denied, disrupted or sometimes reinforced by subsequent characters. Such strategies were important factors in the *relative* success of this particular project in conveying information, engaging interest, challenging preconceptions and provoking debate. I stress 'relative' because the range of responses and personal meanings articulated by audience members means that trying to reach absolute judgements is rather futile.

If anything can be extrapolated and generalised about audience response, it is not to do with assigning value or with establishing an hierarchy of performance styles or methods, let alone a model of best practice. It is rather that the research has alerted us to the complex, oscillating set of transactions that take place, in response to performance, as 'visitor' or 'pupil' shift to 'audience', to participant and to 'learner', and back again – and more often than not the simultaneity of several of those roles at any one moment. This may be where our own research (informed by recent developments in performance theory, audience-response theory, visitor studies and especially phenomenology[12]) has been most productive and where it has helped to widen the evidence base from which we may be able to understand better those encounters, and perhaps aspects of museum visiting too.

Across that spectrum of possible roles, it is also important to acknowledge that these are not passively donned at the prompt of the museum or performer. There is tacit or explicit, momentary or extended, negotiation of the roles played; and there is, moreover, often a degree of agency in the visitor's choice and performance of those roles.[13] There is ample evidence of not just participation, but a kind of negotiated agency – wary, reflective, critical, questioning, puzzled, looking for connections, enjoying the liveness of the encounter when they can, wrought from a complexity of circumstances. There will often be one particular moment where a visitor finds themselves caught up, their attention captured, and makes an impulsive choice to 'contract in' and to contribute at some level to the journey that the performance constitutes. In considering a range of performance styles and museum and historic locations, and drawing on the experience of a variety of audiences (ethnically diverse, young and old and in-between, groups and individuals), it has been instructive to discover just how willing visitors can be to become active, participating *audiences*, to be part of a *negotiation* of meaning in locations not usually associated with such dialogic processes.

If a tendency in our mediatised contemporary culture is to simplify the world around us, to make it digestible in small, bite-sized chunks, then perhaps, as the American novelist Richard Ford[14] once put it, the role of the artist is to re-complicate our perceptions of the world for us. As one of the audience said to us, after a performance of *This Accursed Thing*: 'It made what I thought was a straightforward campaign into an interesting and complicated journey' (MM_Q, 022).

Notes

1 Some sections of this chapter appeared in an article written for the journal *About Performance* 10 (2010): 'Visitors becoming audiences' (pp. 169–92); also in a

conference paper ('Cultivating audience engagement') given by Jackson and Jenny Kidd at the IDEA World Congress, Hong Kong, 2007.

2 See the Appendix for a summary of the research project; also the PLH website for further details of the project and its case studies and for access to the full report: www.plh.manchester.ac.uk.

3 Falk (2006), for example, a leading exponent of 'museum visitor studies', categorises visitors into types such as the Explorer, the Facilitator, the Hobbyist and the Spiritual Pilgrim.

4 This short play was one of a set of performances given at the Museum in 2005 that together constituted the first case study of the PLH research.

5 Copyright in the play is vested jointly in Andrew Ashmore & Associates, the PLH Project and the Museum.

6 References to interview and questionnaire data from the PLH archive. The codes used protected respondents' anonymity and enabled easy location of the transcripts.

7 See also Heathcote 1984; O'Toole 1992, for discussion of the 'contract' in educational drama.

8 There have been many discussions of framing as a means of understanding the nature and context of performance (see especially: Heathcote 1984; Bennett 1990; O'Toole 1992; Carlson 1996; Jackson 2007; Jackson and Rees Leahy 2005).

9 See Janet Wolff, *The Aesthetics of Uncertainty* (2008) for a discussion of the productive aspects of 'uncertainty' in recent and contemporary artistic expression.

10 Interestingly, while the recall of the detail of the slave trader's defence may be faulty – there was never any mention of his being upper class – the intensity of the respondent's feeling is undeniable, coloured no doubt by his own perception of racism in contemporary Britain.

11 Invented name to protect anonymity.

12 See, for example Fortier 2002; Cremona et al. 2004; McConachie and Hart 2006.

13 For more detailed discussion of the museum visitor as performer, see also Rees Leahy's and Smith's chapters in this book (Chapters 2 and 5); also Bagnall 2003; Smith 2006.

14 Author of *Independence Day*, 1996; comment made on BBC Radio 4 programme ('Start the Week'), 10 March 2002.

2

Watching me, watching you: performance and performativity in the museum

Helen Rees Leahy

A grand instance of object performance, the museum stands in an inverse relationship to the theatre. In theatre, spectators are stationary and the spectacle moves. In the museum, spectators move and the spectacle is still (until recently). Exhibition is how museums stage knowledge. They do this by the way they arrange objects . . . in space and by how they install the visitor. (Kirshenblatt-Gimblett 1998: 190)

Setting the stage

In 1971, Duncan Cameron diagnosed museums as being in 'desperate need of psychotherapy' (Cameron 1971: 11). The most serious cases, he argued, were already gripped by the 'advanced stages of schizophrenia' as they struggled to resolve a crisis of self-definition. The challenge facing the museum was how to reconcile its scholarly function of collecting, classifying and explaining objects with the expectations and interests of the contemporary publics that it purported to serve. According to Cameron, the institution was developing a split personality as it attempted to maintain its traditional role as a 'temple' for the veneration of objects while simultaneously embracing its potential as a 'forum' for debate and experimentation. As the museum became more accessible, transparent and responsive, could the dual needs of the museum's collections (as determined by its curators) and its audiences be met? Nearly forty years later, much has changed, but Cameron's critique still resonates. Although the move that he envisioned toward dialogic and reflexive practice has been taken up by many museums, there is also resistance. Even in those institutions which are ostensibly committed to social engagement, the question remains as to whether an expanded repertoire of audience-focused practice has also served to mask continuing asymmetries of inclusion and representation.

By the end of the 1980s, a number of influential texts had identified how, historically, museums had been complicit in the reproduction of

unequal social and cultural relations (Bourdieu and Darbel 1969; Crimp 1980; Duncan and Wallach 1980; Bennett 1988). Other analyses prescribed the means of compensating for past and present exclusions in terms of institutional reflexivity, expanding access and collaborative practice (Karp and Lavine 1991; Hooper-Greenhill 1992). A collection entitled *The New Museology* (Vergo 1989) identified the interrelated theoretical and practical issues at stake and, in the process, coined the term that henceforth would act as shorthand for the museum's disavowal of its role as a 'temple' and its reorientation as a 'forum'. The following year, Stephen E. Weil's essay 'Rethinking the museum: an emerging new paradigm' (1990) outlined what he saw as the communicative and social purpose of museums, which necessitated an institutional shift from object to audience. However, the extent to which the 'new museology' gained traction in museum practice, as well as in the expanding field of academic museum studies, was as much due to a convergence of practical and political contexts, as to the influence of critical theory on the operation of institution. In the UK, between 1979 and 1997 successive Conservative governments pressured the cultural sector into a more entrepreneurial and managerialist mould, in which market forces, visitor services and consumer satisfaction were explicitly linked and jointly promoted. Subsequently the cultural policies of New Labour (from 1997 onwards) tethered public funding for museums to evidence of increased access and inclusion. Rhetorically, the New Labour agenda marked a distinct break from previous Tory policies, but in practice, activities designed to expand and diversify audiences could be melded into the market-oriented museum of the 1980s and early 1990s. Internationally, as well as in the UK, new communication technologies and the related development of interactive exhibits, together with the growth of museum education, further contributed to an enlarged repertoire of visitor-friendly practice.

This is the context in which museum theatre has expanded and matured as a medium of interpretation since the late 1970s. During that time, it has simultaneously contributed to the praxis of the audience-focused museum and also attracted criticism for its perceived populism and 'Disneyfication' of the visitor's experience. The source of much of this criticism is found in the broad range and quality of work variously described as 'museum theatre', 'living history', 'costumed interpretation' or 'live interpretation'. At one end of the spectrum, performance is certainly deployed more as a marketing tool and a crowd-pleaser than as a serious educational tool. As the director of a Masters programme in museum studies, I am struck by the number of my students whose holiday jobs in museums and heritage sites have required them to dress up as 'wenches' or 'knights' to take part in loosely constructed enactments of medieval tournaments or Tudor festivals. Their experiences demonstrate that the term 'living history' is an umbrella beneath which shelters

a range of practices that divide both museum staff and their visitors into two camps: on one side, there are those who regard such activities as a legitimate and enjoyable means of enlivening a staid institution; on the other side are those who argue that playacting has no place within the authoritative frame of the museum. In the 1980s, critics of the so-called 'heritage industry' regarded the popularity of such events as symptomatic of a deplorable national fixation with the past as nostalgia rather than as history (Lowenthal 1985; Wright 1985; Hewison 1987). From this perspective, 'living history' and its allies were charged with the commodification of the past as a consumerist spectacle.

As an activity that is often outsourced from commercial companies (like much exhibition design, for example), museum personnel have also questioned the rigour of the research and scholarship on which dramatic performance is based. Inevitably, the resources and professionalism applied to museum theatre vary, but, as the case studies analysed by the Performance, Learning and Heritage (PLH) project show, the best museum theatre practitioners pride themselves on the depth and breadth of their research. Unlike the author of a museum text who may never directly encounter his or her readers, the actor in the gallery needs to mobilise his or her knowledge in response to the unpredictable expertise of, and questions from, the audience; being unprepared is not an option. The inherent transience and fluidity of performance also confronts the apparent solidity and stasis of the museum and, in turn, may encounter resistance from those entrusted with the preservation of its collections and traditions. It is not surprising, therefore, that the insertion of theatre into the space of the museum can act as an unsettling presence for both staff and visitors.

The experience of 'unsettlement' prompted by an encounter with museum theatre is one that the PLH research team identified as:

> that of having expectations overturned, assumptions about the subject-matter challenged, of finding that they were personally being confronted with strong emotion or were expected to participate verbally or even physically. Such 'unsettlement' may often be positive: stimulating, surprising, generating a sense of dissonance that requires further thought, perhaps even a revision of closely held assumptions and beliefs. It may be negative: visitors finding themselves trapped inside an event that they find exasperating, irritating, demanding more of them than they wish to give, but from which there is no escape. (Jackson and Kidd 2008: 70)

Taking its cue from Jackson and Kidd, this paper explores the notion of unsettlement provoked by museum theatre and questions its implications for audiences and institutions. Does the experience of unsettlement point to the potential of museum theatre as the kind of reflexive and dialogic practice that would be welcomed in Cameron's 'forum', but viewed as an unwelcome

interloper in his 'temple'? Is theatre a potentially unsettling activity within the museum precisely because it draws attention to the cultural production of knowledge itself, thereby fingering both conventional displays as well as drama with the charge of fabricating historical fictions (White 1978)? What is it about museum theatre that can make us feel physically, as well as intellectually, uneasy? Taking this last question first, my contention is that by disrupting people's habitual practices of museum visiting, the presence of theatre has the capacity to prompt awareness of their comportment in the museum. Put another way, museum theatre permits a different performance from the museum visitor.

Becoming an audience

One of the findings of the PLH project concerns the process by which, in the terms used by Jackson and Kidd (2008), visitors transform themselves into an 'audience' for the duration of either the whole or part of a piece of museum theatre. Jackson and Kidd view this as a transaction in which the visitor decides that he or she is willing and able (or not, as the case may be) to join fellow visitors as a member of an audience for all or part of a theatrical event. It is, they suggest, a shift from an individual to a collective experience and from one mode of spectatorship to another. Barbara Kirshenblatt-Gimblett neatly captures the traditional dichotomy between the theatre and the museum: 'In theatre, spectators are stationary and the spectacle moves. In the museum, spectators move and the spectacle is still (until recently)' (1999). The PLH research shows that moving from the space of the museum into the space of theatre involves negotiating a series of physical and metaphorical thresholds between exhibition space and the arena of the performance, which may be an area set aside for this purpose or marked by the address of the actors (as in a promenade piece). But only the most committed audience members (or those too embarrassed to leave) seem to regard this contract as binding. Others drift off physically or mentally: they walk away and/or are distracted by other sights and sounds in the museum. Even those who carry on watching the performance may not be wholly absorbed by it: they may keep one eye on the performance and another on the surrounding spectacle of the museum and its population of objects and people.

Many of us who have had an unanticipated encounter with museum theatre will recognise the questions that it triggers: is this for me or is it really just for children? Will I be bored or (worse) be required to participate? These momentary questions disrupt our sense of ourselves as museum visitors. The surprising invitation to become a theatre audience calls on us to mobilize a set of cultural competences and bodily techniques which are different from those that we usually employ inside the physical and symbolic spaces of the museum. Merleau-Ponty describes how, in an art gallery, we position

ourselves in relation to the artworks on display so as to achieve the optimum 'balance between the inner and outer horizon' (1962: 302). In other words, the practised visitor knows how and where to position him- or herself in relation to the exhibit so that 'it vouchsafes most of itself' (*ibid.*: 302). The viewing body of the visitor is thus attuned to the requirements of the object on display, and the visitor situates him- or herself in relation both to this (the ostensible focus of attentive looking) and, as importantly, the fellow spectators (Rees Leahy 2009). Kirshenblatt-Gimblett observes that all museums activate 'propriocepsis or how the body knows its own boundaries and orientation in space' (1999). This knowledge is, in turn, materialized in relation to conventions of comportment that have been continuously developed since the emergence of the public museum in the eighteenth century constituted a new public arena for walking and looking, both at the exhibits and at other visitors (Hemingway 1995). The emulation of more practised museum-goers has always been an important aspect of civic instruction performed within this arena: if visitors could be made to walk properly, they would also learn to look properly (Rees Leahy 2007). Knowing how to position ourselves in relation to both artefacts and people in the museum is evidence of what Merleau-Ponty calls 'habit acquisition' (1962: 142): it provides us with a repertoire of potential, appropriate and situated actions.

For many (although by no means all) people today, the experience of museum visiting is so familiar that we take these behavioural codes for granted. Indeed, our cultural competence is such that we have forgotten that we had to acquire the habit of walking and looking in the first place: it is only when a sensation is new or unexpected that it is worthy of comment. *L'Assommoir* (1876), Emile Zola's great novel of alcoholism and poverty in late nineteenth-century Paris, includes a passage in which a working-class wedding party visits the Louvre for the first time. Initially, the group is delighted and amazed by the highly polished wooden floor of the gallery, crossing which is like 'walking through water' (Zola, 1970: 89), as much as by the old master paintings on the walls. Self-consciously, the party navigates the physical demands of the gallery: they enjoy stepping on the polished floor, but are also fearful that they might slip and fall. They quickly give up trying to look at the ceiling paintings because this makes their necks ache. Although certain pictures take their fancy, they are more interested in the copyists working at their easels: the performance of these amateur artists is more compelling than the 'centuries of art' that passes before 'their dazed eyes' on the gallery wall (*ibid.*: 90). However, it is not long before the wedding party itself becomes a conspicuous presence in the gallery.

> people sat down on the benches to watch the procession at their ease, while the attendants shut their mouths tight so as not to make rude jokes. And the wedding

party, already weary and feeling far less awestruck, dragged their hobnailed boots and clattered their heels on the noisy floors, like the trampling of a herd running amok in the bare and solemn grandeur of the galleries. (*ibid.*: 90)

The spectators have now become the spectacle, caught in a web of glances and stares exchanged between visitors, staff, copyists and artworks. After a while, the visit begins to descend into chaos when the party loses its way in the maze of galleries and they find themselves going round in circles, unable to locate the exit. As the group becomes increasingly lost, weary and despondent, they continue to attract the attention of other visitors and of the gallery attendants who 'watched them go past and marvelled' (*ibid.*: 91). Within this play of appearances, viewers are also viewed and their conduct is calibrated as a register of cultural competence by fellow visitors and museum personnel. As Irit Rogoff reminds us 'the performance of exclusion has nothing to do with entrance or access and far more to do with perceptions of the possible' (2005: 120f.). She argues that 'entering a space inscribed with so many caveats and qualifications . . . leads to the active production of questions concerning the very rights of entry and belonging' (2005: 120f.). Lost inside the Louvre, Zola's wedding party was trapped in a performance of their own cultural exclusion.

What does the word 'performance' mean in this context? Borrowing from Judith Butler, we can see how the silent (and not so silent) messages of the museum operate through what she terms a series of 'performatives' ('forms of authoritative speech'), which make the body both legible and manageable (1993). As Elizabeth Gray Buck puts it: 'The "hey you, don't touch" or "silence please" produces a museum body that is never unwieldy, noisy, smelly, or dirty. This body, described and conditioned by nineteenth century museum guidebooks, is only an eye that roams demurely' (1997: 16). Yet our own experience also tells that our recalcitrant bodies frequently rebuke the museum's performatives; we resist or ignore these injunctions and, as Butler says, we never quite comply with the norms that would compel us to act according to its strictures. Our individual, improvisational performances do not always follow the institutional script (Rees Leahy 2009).

Gaynor Bagnall's analysis of visitors' experiences of Wigan Pier, a heritage attraction which used acting as a medium of interpretation (it has now closed), proposes a permeable relationship between performer and audience. Her interviews with visitors suggest that while they may or may not have enjoyed the dramatic reconstructions on offer at Wigan Pier, they demonstrated a flexible capacity to 'consume' the site through their own embodied performances involving the production and exchange of emotions, memories and critique (2003). Bagnall locates this dual capacity to be simultaneously audience and performer within our experience of 'a new kind of social space,

a mediascape' in which we 'form a new kind of audience that is performatively attuned to the spectacle of the performance of others' (2003: 95). Certainly, in the worlds of Facebook, YouTube and Twitter we are accustomed to performing our lives for the consumption of others, just as we, in turn, consume the de-materialised performances of both friends and strangers via such social media. But, within the museum, the encounter between ourselves and others is materialised once more, and our awareness of fellow visitors is a source of distraction which, in turn, reminds us that we too are capable of catching the gaze of others.

While Bagnall's article identifies the contemporary conditions of an entanglement of performance and audience, museums and exhibitions have always staged a similar entanglement of spectacle and spectator, as the passage in Zola's *L'Assommoir* shows. In 1857, there were frequent stories of visitors following the luminaries of the day around the Manchester Art Treasures Exhibition. Indeed, a culture of celebrity-watching in the exhibition was stimulated by the weekly publication of the names of famous visitors, including the inevitable lists of royalty (Rees Leahy 2007). The American novelist and diarist Nathaniel Hawthorne came to Manchester expressly to see the exhibition. He became a regular visitor, and his reflections on the exhibits were frequently peppered with lively comments on the origins and behaviour of other visitors. One day someone informed him that Tennyson, the Poet Laureate, was in the exhibition and Hawthorne was delighted when, after searching for the great man, he tracked him down: 'Gazing at him with all my eyes, I liked him well, and rejoiced more in him than all the other wonders of the Exhibition' (1898: 530f.). Hawthorne lacked the courage to introduce himself to his fellow writer, but discreetly continued to observe him as if Tennyson were a walking exhibit.

Rogoff has analysed a similar encounter that she and a friend experienced when they were visiting an exhibition of the work of Jackson Pollock at the Tate Gallery (2005). Rogoff is a professor of art history and visual culture and – like Hawthorne, who had set himself the project of making a close study of the Art Treasures Exhibition – felt something of a professional duty to visit the Pollock show, despite her misgivings about both the artist and the premise of the exhibition itself. Perhaps both Hawthorne and Rogoff were therefore susceptible to the distraction afforded the gallery crowd. In any event, the visit of Rogoff and her companion was considerably enlivened when they spotted the actress Julianna Margulies, who at the time was starring in the television series *ER*. Like Hawthorne in pursuit of Tennyson, Rogoff and her friend found themselves tracking the actress around the gallery, happily discussing the latest plotlines and characters in the programme while simultaneously 'viewing' the exhibition (*ibid.*). This welcome distraction from the reverential attention prescribed by the installation of Pollock's work enabled Rogoff and

her friend to realign their visit by playing the part of television fans at the same time as regarding the exhibition from a rather more oblique perspective than the curators had intended.

Rogoff uses this anecdote to explore what happens when we 'avert our gaze': that is, when we deliberately do not look at the work of art that demands our attention (2005). She argues that by resisting and disentangling ourselves from the institutional script we demonstrate a flexible capacity to view (and be viewed) in more ways than one. Similarly, the PLH research found that the decision to join the theatre audience is rarely a definitive choice between being theatre 'audience' or museum 'visitor': people 'switch back and forth between those roles from moment to moment as they negotiate a relationship both with the performance and with the museum or site environment; sometimes they will play one or more roles simultaneously such that the distinctions blur or dissolve. . .' (Jackson and Kidd 2008: 62). As Rogoff found during her visit to the Pollock exhibition, different modes of spectatorship are not mutually exclusive: they can be simultaneously folded into the lived experience of what she calls 'the cultural moment' (2005: 13). The gaze of the spectator can be fragmented and imbricated with alternative viewing positions: that is to say, it is possible to be both art viewer *and* celebrity watcher. In the same way, the mode of spectatorship required by museum theatre is invariably infused with the spectacle of the museum itself. In the terms used by the PLH researchers, 'audiences' never stop being 'visitors' too.

So far, I have proposed a rather conventional model of museum visiting which privileges a familiar combination of walking and looking. But what happens when the museum (or an artist) changes the script and disrupts this choreography of viewing? In 1938 at the Exposition Internationale du Surréalisme, Marcel Duchamp transformed the gallery into a kind of cave by covering the gallery ceiling with coal sacks and lighting the space with a single bulb. Visitors were issued with flashlights so that they could see the exhibits. Then in 1941 at the First Papers of Surrealism exhibition in New York, Duchamp wove a three-dimensional web of string across the galleries, entirely obstructing the view of some of the art on show (Kachur 2001). Such projects were devised both to tease and exasperate, and also to draw attention to the work of the spectator in deciphering, interpreting and thereby completing the creative act initiated by the artist. Subsequent artists recruited the bodies of visitors in acts of interpretation that were rather more physically demanding. In 1971, the sculptor Robert Morris mounted an exhibition at the Tate Gallery that required visitors to drag concrete blocks up slopes, balance on balls and wires, or crawl through a tunnel (Figure 2.1).

Described in the press as 'an assault course' and a 'fun fair', the exhibition attracted 2,500 visitors in just five days, at which point it was closed due to a number of injuries sustained by members of the public (Bird

2.1 Robert Morris exhibition at the Tate Gallery, 1971

1999). When the Tate reprised the exhibition in May 2009, the rough plywood which was the source of many splinters in 1971 was replaced by rubber elements and steel structures, and visitors were carefully monitored by a team of gallery attendants in order to comply with current health and safety regulations (Hoyle 2009). One can only imagine what Duchamp might say about that.

The reconstruction of Morris's exhibition thirty-eight years after it was first staged is part of a trend for resurrecting past exhibitions for contemporary audiences based on varying degrees of archaeological exactitude. Exhibitions such as *Art on the Line* at the Courtauld Gallery (2001; Figure 2.2) and *Art Treasures in Manchester 150 Years On* at Manchester Art Gallery (2007) have addressed nineteenth-century modes of display and reception, thereby drawing attention to the historical production of viewing bodies. For example, *Art on the Line* was installed in the same gallery in Somerset House that had been used by the Royal Academy for its annual exhibitions in the early nineteenth century. Once again, the walls of the gallery were hung floor to ceiling with densely packed, historically precise displays: there was not an inch to spare between the paintings' frames, let alone space for the customary museum label. Instead of walking around a line of paintings each hung at the same (accessible) height, visitors stood or sat in the middle of the room and looked up and down: horizontal looking gave way to vertical looking, aided by opera

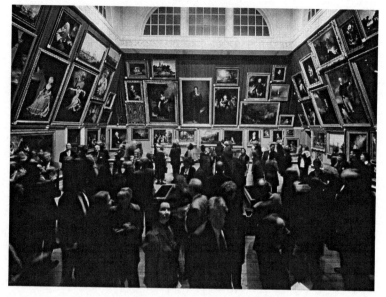

2.2 *Art on the Line* exhibition at the Courtauld Gallery, London, 2001

glasses needed to see the very highest pictures. An adjacent display in which the nineteenth-century visitors' experience was illustrated in contemporary prints also included a television monitor streaming images of their counterparts in 2001: once again, the distinction between spectacle and spectator was dissolved by the invitation to view ourselves viewing.

By deliberately staging their visitors' performances, each of these exhibitions prompts phenomenological reflexivity: that is to say, we become aware not only of our own embodied practice, but of the relation between ourselves and others within the shared space of the museum, past and present. As with museum theatre, the experience can be unsettling (and in the case of the original Morris exhibition, uncomfortable and even painful) but also revealing about taken-for-granted behaviour and our expectations of the institution. Exhibitions such as *Art on the Line* deliberately fragment the act of viewing by enjoining us both to look and also to experience ourselves looking. Again, there is a parallel with the ambivalent member of the museum theatre audience who simultaneously observes the play, other members of the audience, the museum at large and possibly him- or herself as spectator/performer. Arguably, the transition from 'visitor' to 'audience' is not quite as clearly delineated as the PLH research suggests, given that neither category can resist being destabilised (unsettled) by our consciousness of ourselves and others in the act of looking.

From reflexivity to critique?

At the start of this paper, I sketched the diversity of theatrical events staged in museums and other heritage sites today. While the primary aim of many productions may be to entertain and to affirm the dominant narratives of the museum, I want to conclude by briefly considering its possible alternative role as a medium of institutional critique. Can its disruptive presence prompt institutional self-understanding with regard to the museum's knowledge practices and the exertion of its cultural authority? Or is its capacity for critique blunted by its marginal status within the institution and the transience of its interventions? Both the work of Triangle Theatre at the Herbert Museum and Art Gallery, Coventry and the production of *This Accursed Thing* at the Manchester Musuem (PLH case studies 3 and 4 respectively) explicitly raised these questions by each presenting alternative narratives that exposed, rather than sought to fill, omissions in the museums' official texts.

This Accursed Thing was a new piece, commissioned by the PLH research team in partnership with the Manchester Museum as part both of the project and of a wider programme of work entitled 'Revealing Histories, Remembering Slavery', which involved a number of museums across Greater Manchester. The production was designed to mark the 2007 bicentenary of the abolition of the British slave trade by performing the history of slavery within the Manchester Museum itself. Significantly, the piece began and ended with an actor talking to the audience in the role of a museum curator: the subject of the performance was thus both the museum (and its past failure to acknowledge its links to the history of slavery) as well as the transatlantic slave trade itself. The objective of the project was compensatory as well as educational: in effect, it was devised to give a voice and a presence to those whom the institution had previously shut out, as well as to expose the hitherto 'hidden histories' of slavery within the museum's collections and the sources from which they came.

As a piece of promenade theatre, which required its audience to move through a sequence of different spaces in the museum, *This Accursed Thing* repeatedly stimulated an awareness of each viewer's physical position in relation to the play, other audience members and the space of the museum. The decision to 'contract in' (or not) had to be renewed each time the action moved forward from one space to the next, offering a moment to slip discreetly away. The audience had to re-settle themselves in relation to the actors and to each other in each successive space . . . Whether to stand or sit? To take up a position close to the actors or a little way back? For many people, the performance framed a new way of moving through the museum which seemed to resonate with a new way of 'seeing' the museum's history in relation to slavery. The findings of the PLH research indicate that for many

people *This Accursed Thing* was a moving and sometimes painful experience. The use of direct dialogue with the audience was particularly powerful in, for example, a scene in which a black African sells people whom he has captured to a white European trader. At the end of the scene, the white trader challenges the audience to criticise his actions; the well-prepared actor has a deft answer to all the objections that they raise. It is a piece of skilled improvisation which fuels precisely the kind of debate (and position-taking) that the performers intended.

This Accursed Thing also constituted a piece of ventriloquism that enabled the institution indirectly to speak the unspeakable for the first time in its history. This act of institutional ventriloquism is evident from the start of the performance when the actor not only appears in the guise of a member of staff, but also emerges from a fantasy office of a fictive curator. This 'office' is actually an artwork called the Bureau for the Centre for the Study of Surrealism and its Legacies which was installed by the artist Mark Dion in 2005. Initially devised as a temporary project, Dion's piece has been not yet been removed and in the intervening years, its meaning has shifted from ironic commentary on the relationship between remembering and forgetting within the institution to becoming just another artefact in the museum's collection. Within the Manchester Museum, Dion's licence to parody the curatorial process expired some time ago, and the appropriation of his installation as a stage set in 2007 reveals the museum's capacity to layer emergent museological practices. As with so many museum artefacts, the original context of Dion's work has been forgotten, and, freed from its original purpose, it can accommodate the museum's latest acquisition in the form of *This Accursed Thing*. The imbrication of these two commissions within the space of Dion's Bureau signals a new programme of institutional collecting and display: not of objects, but of practices and performances. The addition of *This Accursed Thing* to the museum's repertoire can be read as an example of Rogoff calls a strategy of 'compensatory visibility' (2002: 66): a performance of inclusiveness which actually affirms, rather than subverts, institutional power. Rogoff observes that 'we seem to have made a smooth transition from exclusion to inclusion, from xenophobia to xenophilia in one fell swoop and without unraveling ourselves or our institutional practices' (*ibid.*: 66). In the process, the object of collecting may have changed, but the museum's impulse to accumulate and interpret remains intact. The problem is that 'contrary to its own self-perception as revisionary, this infinitely expansive inclusiveness . . . is actually grounded in an unrevised notion of the museum's untroubled ability simply to add *others* without losing a bit of the self' (2002: 66). According to Rogoff, what is required is for the museum to give up something of its own, rather than attempt to represent loss on behalf of others. Institutional self-denial is a tough prescription, but Rogoff's analysis suggests that works such as *This Accursed Thing* may

be more effective in prompting reflexivity among visitors than within the institution which has the most to lose, in every sense.

Conclusion

The art critic Robert Hughes once remarked that people do not go to see the Mona Lisa, they go in order to *say that they have seen it* (Pettie 2008). Contemporary museum visiting is saturated by our desire for, and consciousness of, the experience of the experience. And, as professional observers of the museum scene, we are now more interested in the responses of viewing audiences to the object on display than in the object itself (Rogoff 2005: 118). Against this backdrop, the PLH project usefully draws our attention to the work of museum theatre for an analysis of the relations between the institution and its visitors: the visitor's flexible response to the disruptive presence of theatre within the museum illuminates taken-for-granted practices of museum visiting. Butler reminds us that 'performativity is . . . not a singular "act", for it is always a reiteration of a norm or a set of norms, and to the extent that it acquires an act-like status in the present, it conceals or dissimulates the conventions of which it is a repetition' (1993: 12). Theatrical performance therefore has the capacity to subvert the norms of museum comportment, and thus open up a more fluid and flexible space for a range of improvisational, and frequently self-conscious, embodied audience responses.

By using Rogoff's critique of compensatory strategies of contemporary museums to deflate the claims made for 'revisionist' interventions such as *This Accursed Thing*, my purpose is to deflect attention from the institution's ostensible justification for such projects and to focus on the more productive evidence of audience critique. Through the PLH research this critique has become vocalised, but it has always been evident in visitors' embodiment, from Zola's account of the performance of exclusion to Rogoff's knowingly fragmented viewing of exhibition/celebrity in the Tate Gallery, and to the visitor who is drawn into a different kind of performance by the sight and sound of an enslaved man in the middle of a twenty-first-century museum.

3

Creating heritage experiences through architecture

Alke Gröppel-Wegener

The use of space in heritage attractions, whether they are specifically created as such or adapted from an existing site, is often overlooked in its potential for creating a 'performance' for visitors to experience. Yet the design of the environment is a crucial aspect of a heritage setting because it is utilised not only by performers but also by the visitors themselves. The impressions and emotions felt by an individual when visiting a space can be read as similar to those experienced when witnessing a live performance. This chapter focuses on the design of space[1] and the potential of architecture in creating memorable heritage visits. By looking at the examples of the Jewish Museum in Berlin, the Imperial War Museum North in Salford and The Workhouse in Southwell, it examines the performative nature of architecture and poses the question whether under the right circumstances architectural strategies can take the place of a live performance and give visitors an experience that is not led by performers.

In her article 'Performing objecthood: museums, architecture and the play of artefactuality', Naomi Stead states that 'architecture has always had an audience, but it has most often been an audience unconscious of the performance' (2008: 45). Performativity, explained by Lizzie Eldrige as 'the ability to bring into being that which is named' (2005: 100), is inherent to architecture in that buildings, by being used, order the experience of the people using them – their audience. Experiencing a building begins by seeing its outside, but becomes more personal when navigating around its inside, by creating a path through it and being exposed to its features, be they visual, acoustic or utilising other senses. This live experience does not cast its audience as passive consumers but rather as active participants (see Reason 2006), potentially spectators and performers at the same time. The idea of the visitor to a designed (and architecturally constructed) space becoming the creator of a meaningful experience is close to Judith Adler's discussion of travel as performance (1989), in which she argues that travel becomes performance when it is 'undertaken and executed with a primary concern for the meanings

discovered, created, and communicated as persons move through geographical space in stylistically specific ways' (Adler 1989: 1,368). This concept can be applied to the examination of how heritage attractions create meaningful experiences for their visitors through architectural strategies.

The problem with considering experiences as the desirable outcome of a heritage visit is that they are fiendishly difficult to define and evaluate: 'The meanings created through travel performance are neither independent of its audiences and contexts of reception nor necessarily stable' (Adler 1989: 1,369). Even if the same situation is encountered by a number of people, their experiences are likely to be at some level private and individual. As Hilde Hein explains, they 'are not collectibles, but are quintessentially transient and elusive. Moreover, unlike material things, experiences are unequivocally not containable in time or space' (Hein 1998: 108). The museum experience in particular – that is, the type of experience that museums try to create and which Hein describes – is exceptionally complex as it is made up of the 'related and complementary aspects' of education and entertainment (Hooper-Greenhill 1994: 140). Here entertainment 'is used as a method of education, in the full knowledge that learning is best achieved in circumstances of enjoyment' (ibid.: 140). However, what exactly triggers the engagement of the individual is incredibly hard to verify or quantify and the implication 'that such experiences are valuable on their own account, or that the having of experience is intrinsically valuable' (Hein 1998: 112) certainly needs further investigation (as Hein suggests). This chapter is not such an investigation. Instead it is based on the premise that the most valuable visits to heritage attractions – and those where the most is learnt – result in an engaging experience. It explores the contribution of architectural strategies to the performance of visitors by looking at three examples, each of which draws on my own personal experiences in the specific space.[2]

Architecture is only one in a number of design strategies that can contribute to the creation of an experience, and museums are complex and dynamic spaces (Wakkary and Hatala 2007: unpaged). Vom Lehm, Heath and Hidmarsh describe the experiences to be had in these spaces as *multivariate*, subject to multiple influences resulting in multiple outcomes (Vom Lehm, Heath and Hidmarsh 2001).

One factor worth exploring in the context of the heritage setting is the notion of the 'real place' as introduced by Kevin Moore. Heritage settings are often 'real places'. They can be geographical locations which have a historical connection to an event of the past (Moore 1997: 135), such as battlefields, or buildings where an important personality lived or worked. In his book *Museums and Popular Culture*, Moore talks about the 'triple notion of the power of the real', which combines the power of the 'real place' with the power of the 'real thing'[3] as well as the 'real person' (ibid.: 135) – or, as

he puts it succinctly: 'real things in their real place as experienced by real people' (*ibid.*: 142). Since Moore's discussion of this notion of the real in the museum context was published the debate around these issues has moved on significantly. Terms such as 'authenticity', 'genuineness', 'reality', 'meanings' and the overall notion of 'heritage' have been questioned, re-defined and problematised. (See other chapters in this volume for further exploration.) However, his framework of identifying place, things and people as significant elements of the museum (and heritage) experience is adopted here as a useful starting point in laying out the issues that inform the creation of architectural experiences in heritage contexts.

This 'power of the real' can also be re-created (or even created from scratch) through making, building, acting and all kinds of clever design. Moore acknowledges that heritage attractions can create a powerful sense of the real 'through artifices' (Moore 1997: 140). When it comes to re-creating 'real places', one strategy to turn to is architecture.

Some museums attempt to re-create environments as time-capsules; objects are put into the context of a room as it could have existed in a particular social and historical setting, a type of 'room set' (*ibid.*: 140). According to Moore's argument about the powers of the real, these time capsules work even better when integrated into a place where they would have actually existed rather than artificially built in a museum.

A middle ground is the construction of a 'set' that transcends the limitations of a room and instead consists of something bigger, a street scene or whole building, for example. Travel performances are often founded on 'the search for direct experience of another time' (Adler 1989: 1,375), and heritage attractions often try to provide this by recreating part of the past. According to Moore these street-scenes work 'by providing a sense of a real place, through reconstruction, for the real things' (Moore 1997: 140). Kirkgate, a reconstructed Victorian Street at York Castle Museum, is one such attraction, where visitors can not only stroll along the street, but also enter a number of shops, a police station and the jail. With 30 million people having visited Kirkgate since its opening, it is not only the oldest recreated street in Britain, but also, according to the York Castle Museum website, 'one of the most popular and thought provoking attractions in the country' (York Castle Museum website 2008: unpaged). The street is considered by the museum itself as one of the main reasons people come to visit and re-visit the attraction (York Castle Museum website). The popularity of these types of exhibitions is perhaps an indicator of how much enjoyment a visit to them brings, even if it cannot tell us anything about how much guests actually learn from strolling through them. In their design and construction, they are not unlike theme parks such as Disneyland,[4] only supported by accurate historical research. As Ames points out:

In response to claims by university historians that history museums are popular-izers and vulgarizers of history not far removed from theme parks, museums claim the advantage of a history that is based on authentic objects, the 'real *things*' and their use in object-learning. (Ames 2005: 45, his emphasis)

While the objects in Kirkgate might be as much a recreation as the street set itself, they allow the visitors to put them into a seemingly authentic context. In a heritage context 'theming' should never be done for the sake of it.

If we were to accept that such 'real places' allowed 'real things' to be set in a specific context, then it might follow that the incorporation of 'real people' allows us to show how the things were used in the place. While this almost certainly will have to be faked, it is not impossible to give a sense of 'real people', through films (which might include 'real people', but within the two-dimensional constraints of a screen), walk-throughs with still or animated man-nequins (sometimes with added sound), guides or costumed interpreters who do not take on a character in the story, and performances where 'real people' come to life through first-person interpretation (Moore 1997: 143). These first-person interpretations can range from scripted theatre-style pieces to direct improvised interactions with the audience. (See other chapters in this book.)

Performance in a heritage context can turn an ordinary visit into an immer-sive experience, where the audience can not only see relevant objects, but become immersed in an environment peopled by characters transforming the context into a story.[5] Experiencing an environment by walking through it, and seeing, hearing, touching, smelling it is very different from looking at objects in display cases because it necessarily engages more senses. Again this can be linked to research conducted on travel as performance. As Martin Welton explains: 'Like theatre, the touristic imaginary is often described in ocularcentric terms, related to the practice of sightseeing . . . biased towards the visual' (2007: 48). That, however, is a very limited view, because tourism 'involves not simply looking at "other" things, people and their places, but the activity and practice of a variety of modalities in their "perception, inter-pretation, appreciation and denigration"' (Welton 2007: 48, quoting Rojek and Urry 1997: 4). The specific tourism that happens in heritage attractions can also benefit from those modalities, especially when a learning experience is part of the core mission of the attraction. In that context experiencing an environment in a multi-sensory way by walking through it is probably more effective because:

Memory is related to our level of involvement with information. Unless we are working very hard at it, we remember approximately 10 per cent of what we read, 20 per cent of what we do, 30 per cent of what we see, 70 per cent of what we say and 90 per cent of what we say and do. (Hooper-Greenhill 1994: 144; also see Beard and Wilson 2006)

Becoming part of a context/story by interacting with it can potentially be more powerful than just experiencing the environment, simply because it includes more doing. In the Canadian Museum of Civilizations visitors can sometimes take that step:

> At times visitors will be invited to don a reproduction of a period costume – to put themselves in the shoes of people in the past – and play a role in an unfolding drama. This type of involvement can provide an emotionally charged experience which . . . challenges one's culturally biased assumptions. (Moore 1997: 146; quoting MacDonald, and Alsford 1989: 146)

Moore argues that this 'do-it-yourself first-person interpretation' leads to an even 'deeper level of interpretation' and is what is behind historical re-enactments (Moore 1997: 146). The visitor is placed as an active participant through the combination of the place, objects and costumes.

However, faithful recreations that invite active audience participation have many potential downsides. As Rumble argues, some aspects of history:

> can only be enacted to a limited extent. We can't kill people on the battle-fields; we can't have dysentery and disease in medieval re-enactments. Do we debase people's understanding of the past because such events can't be fully reproduced? (Rumble 1989: 29)

Leaving this important issue aside, it is also fairly expensive to populate an environment with actors who are knowledgeable enough about a subject to be able to portray a historical figure without stepping out of character or giving false (factual) information. At the same time it can be difficult to get the visitors on board. As the Performance, Learning and Heritage project found there are 'tiers of engagement' when it comes to audiences, 'from those who immediately sign-up to being an audience, and who may volunteer to participate, to some who will resist the process of becoming involved' (Jackson and Kidd 2008: 9).

But is a faithful recreation necessary to create an educational experience? As has been discussed above, architecture has a performative quality (Eldridge 2005; Reason 2006; Stead 2008). It could therefore be argued that an immersive experience can also be arrived at through non-manned strategies, and some museums and heritage attractions have chosen this way. This does not necessarily mean painstaking recreation of every last detail; after all, some concepts cannot be illustrated figuratively. Some museums prefer not to go down the recreation route but instead use spaces to let the imagination of their visitors run wild. As Daniel Libeskind said, regarding the Imperial War Museum North, museums can 'offer substance for the imagination and the daring of the unexpected' (2001: 62f.): buildings can be more than the simple housing for a collection.

It is rather telling that Libeskind's first high-profile museum, the Jewish Museum in Berlin, became so famous before it was opened that 350,000 visitors were allowed to tour it before the exhibits were installed. As Lapp states:

> The visitors got the opportunity to see this architectural sculpture in its original state, unobstructed by exhibits and display cabinets, banners and text panels. The angled walls were white, the spaces pure, and the only exhibits were its architectural details: the window slits that provide the interior's individual characteristic, the black walls of the 'voids', the staircase into the building that is crossed by large concrete beams. (Lapp 2002: 12)

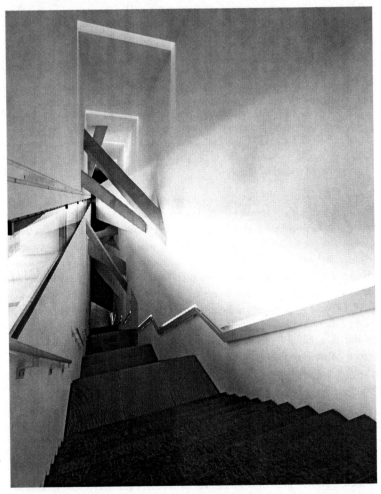

3.1 Inside the Jewish Museum, Berlin: the Sackler Staircase ©, designed by Daniel Libeskind

Now the museum is completed, large parts of the rooms have become populated by display cases, text panels and computer screens. This way of listing information may provide hard facts, but is perhaps far less successful in giving a sense of what it might have been like as a Jew in Germany during the Nazi regime than the empty, enclosed and claustrophobic spaces of the bare architecture.

The building is striking from the outside, but the architectural features visitors encounter inside are even more so. The visitors' experience is manipulated from the beginning – the Jewish Museum does not have a discernible entrance but rather needs to be entered through an underground passage from an adjacent building, instilling the idea in visitors' minds that there is no way out. Once one is inside, the usual architectural conventions are not to be found. This is not a traditional gallery; walls are at odd angles, almost appear to be slashed by narrow windows and are complemented by extremely high ceilings. Narrow corridors and a treacherous layout make it very hard to keep a sense of where you are. This is a performative building.

It is no surprise that traditional gallery exhibits were hard to integrate into this space. Lapp observes that 'it is an interesting museum, in a wonderful building' but he goes on to say that 'the opportunity for a great museum has been missed' (*ibid*.: 13):

> Where the exhibition works brilliantly . . . it becomes an integral part of the building. The showcases continue the forms of the architecture, the materials and colours of the installation are restrained (mostly glass and steel, grey and black) and the structure of the show is very clear. But there are many other parts where the display seems to have been planned for a different museum – a built-in set of stairs leading nowhere, objects or their space that are obscured by interactive gadgets, pull-out text panels, image-wheels and computer-screens.
> (*ibid*.: 13)

This non-fit was something that was redressed in Libeskind's next museum project, the Imperial War Museum North (IWMN), a building designed as a meditation on global conflict:

> The building is a constellation composed of three interlocking shards. The Earth Shard forms the generous and flexible museum space. It signifies the open, earthly realm of conflict and war. The Air Shard, with its projected images, observatory, and education spaces, serves as a dramatic entry into the museum. The Water Shard forms the platform for viewing the Canal with its restaurant, cafe, deck, and performance space. These three shards together, Earth, Air, and Water, concretise twentieth-century conflict, which has never taken place on an abstract piece of paper but has been fought on dramatic terrain by the infantry, in the skies by the air force, and on the sea by battleships.
> (Libeskind 2001: 63)

The dramatic outside of the IWMN is not just an exercise in attracting the attention of passers-by. Here a building has been created where outside and inside complement each other perfectly. Architectural strategies have been utilised to create an experience for the visitors, who do not enter into a number of rectangular rooms. It is not a neutral canvas. Rather the shape of the shards is sustained inside: the Water Shard, housing the café and restaurant, is the most traditional; here the curvature is gentle and the main features are wide windows providing views of the Manchester Ship Canal, once used to ship ammunitions. The Air Shard, by contrast, is a purely architecturally created experience, complete with a lift that runs at an odd angle (a rather bleak concrete staircase is also available), to a viewing platform that, although still located in the structure, feels very open to the elements.

The principal gallery, located in the Earth Shard, is like a massive cave in which the ceiling follows the curve that can be seen on the outside and a slightly curving floor, 'reminiscent of creating a global horizon that is at the same time always changing and shifting' (Gröppel-Wegener 2004: 11). With no right angle in sight, a timeline of twentieth- and twenty-first-century conflict runs along the gallery wall. Six silos containing separate exhibition areas are located inside the Earth Shard, each positioned near a wall and opening towards the timeline rather than the open space. That does not mean that the main space is totally bare; large objects, such as a tank and parts of an aircraft are dotted around the Earth Shard.

The problems regarding the integration of the exhibition that arose at the Jewish Museum in Berlin have been dealt with here; at the IWMN the displays 'are part and parcel of the architectural experience, and vice versa' (Glancey 2002: 10). The overall effect is performative – thoughts are provoked by experiencing the building (the curving floor, the vast expanse of the Earth Shard, the walls that seem to be floating) that are in turn reinforced by the exhibition. Described as 'disorientating yet engagingly sane' and with 'the power to disorientate and disturb visitors, encouraging them to reflect on the perils, the mechanics and above all the human cost of war' (Glancey 2002: 10), the IWMN aims to make its visitors think and reflect on conflict by the architectural strategies it employs. This is 'an architecture of uncomfortable thoughts' (Gröppel-Wegener 2004: 3).

Created environments also allow the possibility of including a performance element that is not driven by actors while intensifying the experience of simply walking through the spaces. The Jewish Museum in Berlin, for example, has an art installation by Menashe Kadishman that does just this. *Shalechet (Fallen Leaves)* is located in one of the 'voids' of the building and invites visitors to walk into a (very claustrophobic) space on metal plates that have rather eerie face-like holes in them. These metal plates are loose and the sound created by walking on them is amplified in the tight space. Walking

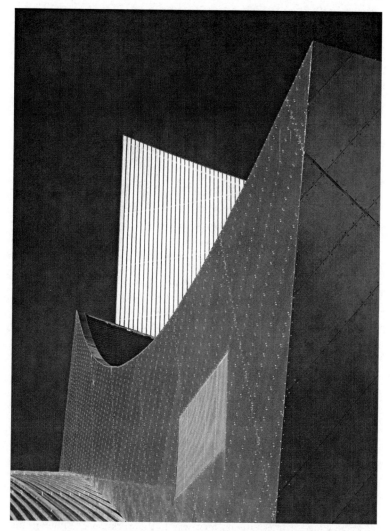

3.2 Exterior of the Imperial War Museum North (Salford, UK), designed by
Daniel Libeskind

there, on your own or with other visitors, is certainly a performance of some
sort, your own movements creating a haunting and intimate soundtrack as
you almost literally step on faces.

The Big Picture Show, the performance element at the IWMN, is more
overtly dramatic. A multi-media show that provides visitors with background
information, it is described on the website as 'a 360° audio-visual experience

and a unique way for visitors to access the Museum's world-renowned collections of photography, art and sound' (IWMN website: unpaged). It turns the gallery walls and floor into projection screens for pictures and uses an audio surround system to provide a soundtrack to aspects of war, moving music as well as playing fragments of oral history:

> The Big Picture Shows have been conceived as experiences that will inspire debate and discussion. There are three versions of the show, The War at Home, Children and War and Weapons of War, each of which feature the thoughts, voices and experiences of those involved in or affected by major conflict. (IWMN website: unpaged)

Rather than attempting to faithfully reproduce an environment in order to create an immersive experience, the Jewish Museum in Berlin as well as the Imperial War Museum North make use of architectural strategies and the ways in which spaces are experienced to provoke thoughts in their visitors and stimulate their imagination. As Libeskind states:

> A building can be experienced as an unfinished journey. It can awaken our desires, propose imaginary conclusions. It is not about form, or image, or text, but about the experience, which is not to be simulated. A building can awaken us to the fact that it has never been anything more than a huge question mark. (Libeskind 2001: 74)

However, it is not necessary to employ an award-winning architect to design a brand-new heritage attraction in order to take this route of interpretation and make the most of the performative nature of architecture. The Workhouse in Southwell took the courageous decision to go down the less-is-more route when it came to the creation of a memorable interpretive site (see Chapter 15 for further discussion of The Workhouse).

The Workhouse is a massive two-winged red-brick building set in quite extensive grounds and looks quite grand on approach, more like the residence of a large merchant family than the domicile of paupers. On the way toward the reception visitors encounter two ghosts from the past – cut-out silhouettes of grey-painted pauper girls on their way to the workhouse. Although this is the first indication that the interpretation at this National Trust property might be unusual, it starts in a fairly conventional way. In the reception area is a model of the house, which a knowledgeable guide refers to when giving visitors an overview of the organisation and workings of the workhouse. Then guests see an introductory film dominated by the Reverend Becher (or rather an actor portraying the real person) writing a letter (in about 1824) reflecting on and describing the philosophy of the workhouse based on his own concept; we see him writing, listen to his thoughts as voice-over and watch documentary style film sequences of the story of a family and how they fared

once they had joined the workhouse system. Only then are the visitors (each aided by an audio-guide) allowed to enter The Workhouse proper.

One of the first spaces visitors encounter is an out-building – the Wash House – where people undressed, presumably washed and got their uniforms. They were 'sorted' into men, women and children, and were split up for the remainder of their stay. Here the grey, ghost-like silhouettes make another appearance – painted onto the whitewashed walls, with names and ages of inmates written beside them. The Wash House has a looped audio track of an overseer reading out names and telling people to 'get a move on'. This soundtrack encourages visitors to identify with newly arrived paupers, allows them to choose the appropriate corridor – men, women or children – and lets them join the ghostly inmates on their journey.

Once the visitor is outside the Wash House, the audio-guide takes over. There are two main parts to this: each entry starts with an explanation of the room the listener is currently in (complete with a description of how this room might have looked regarding the furnishings); next there is a story that has characters progressing through the workhouse as part of an official inspection.

The first section is necessary because of a very bold decision that was made when the National Trust took over The Workhouse – to resist the temptation to attempt a reconstruction. When the Trust bought the house in the late 1970s it was bereft of any of the original furniture or photographs of how it had looked. The only matter that was certain was that it would have been bright and clean – painting and cleaning being dull, hard work and perfect tasks for the inmates. The Trust decided to restore the whitewashed rooms and let them speak for themselves. Not only is there a shortage of furniture, there is also a distinct absence of labels; information in written form is given in the reception area and two rooms at the end of the tour. During the tour itself, it is the audio-guide that provides information, while folders of photographs and other documents are on hand with the assistants should visitors want to find out more details.

What stands out is the beauty, but also hopelessness, of those bright, empty rooms which each housed thirty or more people. These spaces, furnished and peopled by the visitors' imaginations, are (in my view) far more impressive and moving than the one room – a women's dormitory – which has been filled with approximations of beds and other props to recreate living conditions.[6]

The interpretation of The Workhouse uses the existing (real) place and space to guide the visitors' imagination to experience the building and concept behind the nineteenth-century workhouse. This is not the same as just leaving it empty – the model in the reception area and introductory film set the scene while the audio-guide leads the visitors around and provides the necessary, research-informed material that allows visitors to experience the space

first factually and then in the context of a story.[7] Hein argues that 'objects have been reconstituted as sites of experience' (1998: 106). The Workhouse can be seen as not only the 'real place', but also as the object itself, the 'real thing'. As Stead states 'Museum architecture is, uniquely, both *a* museum object and *the* museum object; it is both form and contents, container and contained' (Stead 2008: 43). In this particular interpretation the building as object is used to guide the overall concept. As Stead points out:

> The programming and choreography of phenomenal experience is increasingly a part of the museum's overall strategy – plotting not only a particular path through museum space but also a particular experience and affect. (2008: 43)

The Workhouse is very successful in using this particular strategy.

The interpretation at The Workhouse, both auditory and in the treatment of the building, follows what Rumble calls for in the interpretation of the built and historic environment: 'the style and the media used must respect the monument as part of a continuing evolution of a nation, whether or not we like the ethos or custom it represents' (Rumble 1989: 25). The same could be said about both the Jewish Museum in Berlin and the IWMN: although these monuments were constructed from scratch they not only respect the history and concept behind their mission, but also find a way of utilising performative architecture. Experiencing the environment becomes an individual performance that lets the visitors become part of a story that is not led by performers. They are both excellent examples of what Stead refers to when she argues that 'a building can also be a work of theatre' and 'a generic scenographic stage for experience' (2008: 45).

Conclusions

> Today's museums are engaged in an entirely new enterprise aimed chiefly at eliciting thoughts and experiences in the public. That objective is not exclusive of assembling collectibles, but it takes collection as a means rather than an end – and by no means the only means to that end. The end is the achievement of a certain type of experience that is genuine. What is noteworthy about such experiences is that they do not depend on mediation by an authentic object. They can be triggered by a multitude of devices, not all of which are real or genuine, or material – and museums are busily constructing such devices. (Hein 1998: 108f.)

The three examples discussed above show that it is possible to design heritage attractions that engage the visitors by provoking a sense of wonder in them, even triggering an emotional experience. The powers of the real that Moore identified and Hein alluded to are utilised, but in an abstract rather than a specific sense – these places let visitors experience the essence of a concept. The

planners of the Jewish Museum in Berlin, the IWMN and The Workhouse in Southwell have focused on the architecture as a central feature and considered how each individual building is occupied and traversed. Consequently, people visiting these places discover meanings (just as Adler suggested in her discussion of travel as performance) by moving 'through geographic space in stylistically specific ways' (Adler 1989: 1,368).

Utilising architectural strategies is obviously not suitable for all subjects or all missions, but it is an option that should become part of any interpreter's toolbox. Being more aware of the performative experiences that environmental – and specifically architectural – design can inspire, can be the beginning of new, original learning experiences, that are fully grounded in the powers of the real.

Notes

1 While they are closely related there is an important distinction between the terms 'space' and 'place' that has also become an integral part of performance theory (see for example McAuley 2000; Schechner 2003; also compare Kolb 2007). For present purposes, I define 'space' as an area that can be altered (for example by architecture), while 'place' is understood in the basic sense of a specific location.

2 While I am certain that other visitors to these sites will also have had an engaging experience, there is no guarantee that they will have felt the same way as I did when in the same space.

3 Moore's conception of the 'real thing' is probably the most straightforward, as this could be taken simply as the artefact traditionally collected in museums. Edson and Dean point out that it is the visitors' main wish to see real things, 'the genuine object' (Edson and Dean 1994: 147), in museums. They argue that 'this is the particular domain in which museums hold undisputed sway, and is their source of uniqueness among all other public institutions' (Edson and Dean 1994: 147). 'Real people' are more problematic. When it comes to learning about history, contemporary witnesses can only be met directly in respect of the most recent events, beyond that, we may need to employ different media.

4 For a more detailed look at architectural strategies used in theme parks see Gröppel-Wegener 2004.

5 The creation of a 'story' does not necessarily have learning benefits. An engaging experience can be arrived at with little or no regard to the heritage settings surrounding it. At Warwick Castle, 'Ghosts Alive', according to the website a 'chilling live-action spook experience' (Warwick Castle Homepage 2008: unpaged), although incredibly enjoyable taught me nothing about medieval life or Warwick Castle. While it is located in what is called the 'Ghost Tower' in the grounds (formerly the Watergate Tower) and seems to be based on a murder case in 1628 (Warwick Castle Homepage 2008), I am convinced that this particular performance would be just as enjoyable were it located elsewhere.

6 There are two other sections of the tour that stand out: on the top floor rooms

have been left in the condition they had been in when they were purchased by the National Trust – dark with peeling paint. This is accompanied by an audio account of a woman from the Trust describing how she felt when exploring this historic site for the first time. The last room of the audio tour has been left how it was during the 1970s, when families had been temporarily housed there. This is supplemented by a recollection of a woman who had been a little girl back then describing what it had been like to live in that room with a whole family. She vividly describes the lack of privacy and how much like a prison she felt it was. This seemed to be the only room with colour in it – a bright turquoise.

7 However, I believe the audio-guide would have been more effective if the visitor had a choice between either the information on the rooms or the story. At the time I visited, both strands of narrative were included for each room in one audio-file, which led to information overload which I, as well as my companion, overcame by forwarding through the story.

4

The space of 'museum theatre': a framework for performing heritage

Paul Johnson

The term 'performing heritage' can include an array of different types of heritage and a multiplicity of performances. It can take place in historic sites, appropriated or purpose built buildings such as galleries or museums, in archives or libraries, or it can be more elusive and hidden amongst communities, either real or virtual. The heritage component can be social, cultural, political, artistic, architectural, industrial, scientific, botanic or some combination of these. The interpretation of it through performance can be radical or reactionary, open or closed, educational or artistic, participatory or pedagogic. The performances can be first or third person, scripted or improvised, on a stage or site-specific, fixed or promenade, open or closed, solo or ensemble, unique or recurring, flamboyant or subdued, devised or written, central to the interpretative strategies or peripheral to them. There have been various attempts made to understand this field of work, through practice or observations of practice, through case studies or participant studies, as well as drawing up definitions and glossaries to develop a shared language for those interested in it.

This chapter presents a framework for analysing the performance of heritage. It also offers a more general way of understanding performance work that sits in the area mapped out by the conceptual lines joining the terms performance, learning and heritage, as well as a way of understanding the broader performative elements of heritage interpretation and visiting.[1] If there is a tendency, as Jackson observes in *Theatre, Education and the Making of Meanings*, to assume a false dichotomy between '"aesthetic" and "instrumental" theatre' then a more complex theoretical framework can provide a means to move the discussion away from those simple terms (2007: 272). I will assume for the purposes of this chapter that the artistic and the educational are not separate ends of the museum theatre spectrum but rather that 'such varieties of theatre [that have an educational function], when most effective, constitute *wholly artistic forms*' (Jackson 2007: 4). There is perhaps the remnant in museum theatre of an unfounded stereotype; that is, of actors who care

only about performance, and of museum staff who care only about the collection. The reality is clearly that the two are not mutually exclusive, but in fact can and should be interdependent. If this current analysis privileges performance over learning or heritage then that is partly due to the background of the author, and partly a deliberate stance in order to recognise that the developments in performance theory and practice that have taken place in the second half of the twentieth century have not always made their way through into the performance of heritage. As there are many types of heritage, so there can be many types of performance made in response to, or to interpret, that heritage, and this framework is intended to include as wide a range of both heritage and performance work as possible. The potentially somewhat reductive term 'museum theatre' will however be used as a shorthand for a whole range of performance work, including work that would not normally be classed as theatre nor that would take place in a museum.

Although museums and heritage sites have responded to 'The New Museology' in radical and profound ways (see Chapter 2 for further exploration of this response), performances in these sites have not always responded to the 'New Performance' to the same extent. For instance, though there could be in theory a postdramatic museum theatre, which does not operate through dramatic representation but which subverts or substitutes the component parts of dramatic theatre (plot, character and dialogue), in practice this is not common in the field of performing heritage. Live art and performance art in gallery spaces seldom share similarities of either form or content with the mainstream of museum theatre. That is not to say that all museum theatre should operate as performance art, but rather that the possibility should be open for it to do so.

The New Museology has a number of characteristics that would be familiar to contemporary performance practitioners, such as the value of an object being 'not an inherent property of the object, but rather an attribute bestowed upon objects by their inclusion in the museum' (or the performance) (Stam 2005: 57). Similarly, as meaning 'is altered by museums through the recontextualization of objects in the museum setting', the meaning of objects in performance is altered through their being on stage, whether those objects are operating as props in a dramatic fiction or in some other way in some other type of performance (Stam 2005: 57). All objects visible in the performance signify, as all objects in the museum have value, even if it is merely the value acquired through their location in a museum case or on a stage.

A narrow conception of performance as solely the enactment of dramatic fiction has limited the types of performance work that have been considered as appropriate ways of performing heritage. If there are these manifold connections between the 'New Museology' and the 'New Performance' then a reconsideration of the conceptual space within which museum theatre

operates can give the opportunity for establishing a richer understanding of the possibilities inherent in the performance of heritage. Whilst this must of course include the single character monologue that so often typifies museum theatre, a far wider range of performance work can meet, sometimes comfortably, sometimes in a more challenging way, the requirements of curators, education staff, theatre artists and visitors.

To help clarify the relationships between the three terms performance, learning and heritage it is helpful to introduce a series of binary oppositions: namely between history and fiction, between risk and safety, and between external and internal (see Figure 4.1). It is suggested that the binary history/fiction occupies the space between heritage and performance, as there are a priori connections (and possible tensions) between heritage and history, and fiction and performance. The binary risk/safety is suggested between performance and learning because of the perception of performance as a potentially unpredictable or unruly activity in comparison with the respectable task of learning. The internal/external binary is proposed as a link between learning and heritage, as learning can be thought of as operating on or internal to the individual, in comparison with the shared, collective nature of heritage. The following discussion will clarify exactly what it means for these binaries to 'occupy' that space, and how that develops our understanding of the space mapped out.

Through this framework a three-dimensional 'museum theatre space' can be constructed, a space that can in theory house all possible heritage performance in a way comparable to what Richard Dawkins describes as a museum of the zoological imagination:

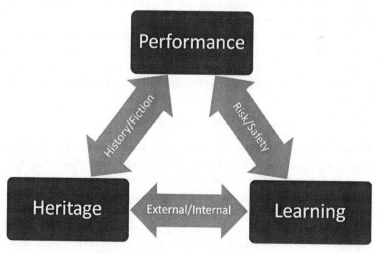

4.1 Relationships between performance, learning and heritage

Imagine a museum with galleries stretching towards the horizon in every direction, and as far as the eye can see upwards and downwards as well. Preserved in the museum is every kind of animal form that has ever existed, and every kind that could be imagined. Every animal is housed next door to those that it most resembles. Each dimension in the museum – that is, each direction along which a gallery extends – corresponds to one dimension in which the animals vary.

(Dawkins 1996: 182)

This museum is of course a theoretical construct rather than an enormous taxidermical endeavour, and the animals housed within it need not ever have existed, nor even in some ways have been able to exist at all. In a similar way the museum of performing heritage imagination is filled with every kind of museum theatre that has ever existed, and every kind that could be imagined, with each housed next door to those that it most resembles. Not all of the museum theatre contained within will be artistically or educationally effective, and perhaps little of it would warrant the effort of bringing forth into the real world. Dawkins' museum exists in a multiplicity of dimensions, as there are a multiplicity of ways in which animals can vary, but the museum of museum theatre instead varies, initially at least, on just three axes: fictional–historical, risk–safety and internal–external. The terms performance, learning and heritage are then locatable in terms of these binaries, and the range of existing and imagined museum theatre work locatable in the space mapped out by these three axes (see Figure 4.2). As heritage is positioned at the external and history ends of those binaries, it can be placed in the space between those axes. Similarly, learning can be placed between internal and safety, and performance between risk and fiction. Hence, the three dimensional museum theatre space can be seen, with performance, learning and heritage each mapped out within that space (see Figure 4.3).

Consequently museum theatre that is internal and safe might be most easily understood in terms of learning or rather will be seen to operate in that area. Similarly work that is external and concerned with history focuses on heritage, and work that is concerned with fiction and risk is performance centred.

Fiction-history

Della Pollock asks, in 'Making history go', the introduction to her edited book *Exceptional Spaces*, is 'there a space between fact and fiction from which to make history?' (1998: 16). Rather than assuming a divide between fact and fiction, instead it is worth considering a division between the demands of fiction and the demands of history when performing heritage. This is not to advance the truth claims of history over those of fiction, nor indeed the narrative claims of fiction over those of history, nor even to suggest that one is more stable or trustworthy than the other. Indeed, as Vivian Patraka

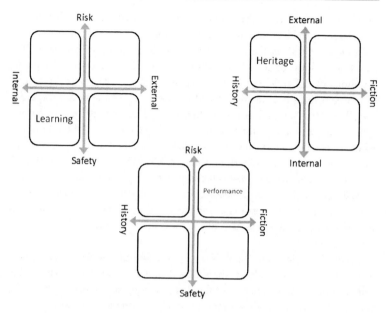

4.2 Three dimensions of museum theatre space

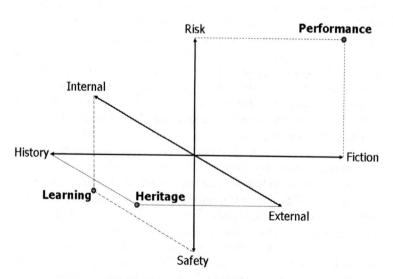

4.3 Three-dimensional museum theatre space

observes in her essay on the US Holocaust Memorial Museum, 'No historical referent is stable, transparent in its meaning, agreed upon in its usage, or even engaged with in the same way by any large group of people' (2002: 82). Rather, ideas of fiction and history become important when discussing questions of authenticity, which is a key idea in the analysis or production of museum theatre. If in the New Museology, as Stam argues, meaning is socially determined and assigned, then surely history must be written in a similar way, and indeed the museum or heritage site is one of the locations where an embodied form of that writing takes place, and so performance itself can be one of the ways of writing (Stam 2005: 57). In order to understand the process of interpretation, whether through live performance or otherwise, a useful comparison can be made here with the process of adaptation, in that any form of interpretation can in fact be seen as a form of adaptation, in this case adaptation across categories (conceptual to embodied) rather than across art forms.

Brian McFarlane in his book *Novel to Film* argues that, when considering adaptations, issues of fidelity are often a distraction. He claims that 'fidelity criticism depends on a notion of the text as having and rendering up to the (intelligent) reader a single, correct "meaning" which the . . . maker has either adhered to or in some sense violated or tampered with' (1996: 8), and it is clear how this could be applied to the process of adaption in museum theatre. McFarlane further goes on to identify three key differences in the move from novel to film: a move from a wholly symbolic language to a language that operates through an interaction of codes; action presented largely in the present tense; and a spatial and temporal orientation 'which gives . . . a physical presence denied to the novel's linearity' (1996: 29). Similarly, when moving from some conceptual understanding, whether of history or heritage, to an embodied representation, such as performance, there must almost inevitably be changes: in the language, in the tense, and in the spatial and temporal orientation that can often result in the raising of questions of authenticity.

Traditionally measures of authenticity in the performing arts focus around two areas: 'accurate replication of a score or script and fidelity to the spirit of the work' (Rubidge 1996: 219), and these two areas highlight the possible conflict when performing heritage. The desire for accuracy of replication, either (in this case) of historical or biographical evidence rather than of a script or score, or fidelity to the spirit of the performance, both offer the potential for conflict. This suggests two distinct ways of understanding the relationship between the performance work and the space in which it is created or performed: either as an *interpretation* of that space or instead as an *extension* of that space. This division is an idea to which I will return later in the chapter when discussing the risk–safety binary.

Authentic meaning, according to Gary S. Tomlinson:

is not fixed or permanent but is constructed by the interpreter, temporarily defined through a dialectic between the work's 'text', its culture and his or her own personal and cultural context. A work's meaning is therefore not solely reliant on authorial intentions, but allows for several authentic meanings to be generated from the same script or score. (Quoted in Rubidge 1996: 224)

Hence, there can be a range of approaches to performing heritage, taking a more or less historical or fictional approach, all of which may have different types of authenticity (see also Anna Farthing's chapter on re-definitions of authenticity).

In terms of the authenticity of a dramatic character, a useful comparison can be made with the function of objects in relation to narrative in biographical exhibitions. Caterina Albano, writing on this theme argues that:

> the original functionality of biographical relics is displaced in favour of their biographical significance. They act as discontinuous traces and active memories of the biographical subject that are used to produce a tangible archive that testifies to the individual and can be used to construct biographical narratives, since they endorse a myth of authenticity and an illusionary creation of reality. (2007: 20)

Similarly, for a performance there is an authenticity in the enactment, because that is the 'real' before the onlooker. That single realisation of the character is the one that is manifest before the spectator, regardless of whether or not it also has a biographic, historical or even dramatic authenticity. The form this authenticity takes might well vary, depending on whether the character or act presented is psychologically credible, or is linked to other tokens of authenticity such as objects, locations or known narratives. It is quite possible, however, that enactments lacking this scaffolding of authenticity might still be taken as authentic purely because of their presence before the spectator. The uncertainty and careful consideration of competing sources of evidence can often disappear, replaced with the particular certainty of performance.

Rubidge asks, 'what kind of authenticity is important in the performing arts? The answer to the question would seem to depend on the purposes for which the authenticity is being sought' (1996: 230). Museum theatre can have the authenticity of history, but that may well clash with the authenticity of fiction, as the demands, and consequent benefits, of these different authenticities may not always coexist.

Pearson and Shanks in *Theatre/Archaeology* argue that the 'issue of authenticity is one at the heart of [their] project of theatre/archaeology', and question what the 'real past' is now, and what an 'authentic past' would look like (2001: 113). For them the question of authenticity is intractably linked to ideas of heritage, in that 'a major complaint against heritage is that it involves an ignoral or distortion of the "real" past; heritage contaminates' (2001: 113).

Internal-external

The relationship of the second binary, between internal and external, to museum theatre is perhaps the least obvious. The foundation for this binary is that museum theatre can operate either within the individual (internal) or between individuals (external), and this difference can be explored through examining the competing views on heritage and its relationship to memory. There is not space here to enter fully into the substantial debates about the term heritage, but for the purposes of constructing this framework we can start with Patrick Cormack's definition in *Heritage in Danger* (1976). Cormack writes of heritage in terms of scenes (morning mist on the Tweed, a quiet Norfolk church, etc.) recalling 'an indivisible heritage' that is 'part of the fabric and expression of our civilisation' (1976: 14). Numerous criticisms of this position have been made, and rather than defending (or not) this view of heritage it is sufficient merely to note that this, like so many other definitions of heritage, seems to exist in some way beyond the individual, constructed as an external object, whether or not the positioning or function of that heritage is problematised.

Laurajane Smith, in *The Uses of Heritage*, states that there are 'tensions that inevitably exist between the idea of memory, which must always invoke the possibility of forgetting, and the idea of heritage as constructed in the [Authorised Heritage Discourse]' (2006: 58). She goes on to state that 'memory is an important constitutive element of identity formation, unlike professional historical narratives, it is personal and thus collective memory has a particular emotive power' (2006: 60). Hans-Georg Gadamer argues that memory needs to be rescued 'from being regarded merely as a psychological faculty and to see it as an essential element of the finite historical being of man' (1989: 16). Indeed, Gadamer sees memory as being a creative process, where the 'process of thought begins with something coming into our mind from our memory. But even this is an emanation, for the memory is not plundered and does not lose anything' (1989: 425). Memory here is internal, even if what is remembered, or the actions that come about because of the memory, are not.

For both Gadamer and Smith, memory is operating as internal to the individual, as opposed to the external operation of certain types of heritage. Museum theatre can be positioned in relation to this, and arguably 'external' museum theatre most closely engages with the reproduction or construction of heritage, and 'internal' museum theatre with learning, and a constructivist notion of learning in particular.

Museums themselves are undergoing great changes, and as Max Ross observes:

> older narratives of empire, class, race and science are seen by professionals
> as inappropriate to the requirements of a pluralistic, multicultural society.

Museums, it is argued, must rid themselves of their elitist image and outlook, and abandon monolithic visions of history, if they are to have ethical justifications for their continuing existence. (2004: 85)

Ross goes on to argue that, in line with constructivist theories of learning, the museum professional is being redefined 'as an "interpreter" rather than a "legislator" of culture', and in terms of our binary this in effect is the start of a move from an external to an internal function (2004: 85). This move requires, amongst other things 'a heightened awareness of diverse audiences and publics' rather than the 'presentation of ethnocentric, patrician or "legislated" accounts of the region's history and culture: the grand narratives of class, nation and empire' (Ross 2004: 90). Perhaps more significant is that the effect of internal museum theatre is largely determined by the spectator or participant of the work, rather than by the producer. This provides then a clear distinction between internal and merely participatory. As has been noted before, there is a real danger of 'theatre practitioners disempowering the very people they set out to liberate' through participatory work that supports those already with power, and where the outcomes are predetermined (Jackson 2007: 8). With museum theatre, as with all interpretation, those with power determine what is considered appropriate content. As with historical importance, the material which is considered valuable is only 'ascribed retroactively' by those with appropriate 'intermediating power' (Gielen 2004: 148). As museum theatre becomes more internal then the more integral to it will be the opportunity or even requirement for individual spectators or participants to determine what happens to that material, and the ways in which they respond to it.

For museums to consider themselves 'centres of learning', they need to provide 'more than displays on interesting themes; they should be able to connect these displays and themes to the life experiences of different groups of audiences' (Illeris 2006: 17). Illeris goes on to note that 'education, even when connected to the best intentions of social inclusion and personal empowerment, is also always related to some form of disciplining power' and as a way of avoiding the 'unreflected, uncontrolled chaos associated with visitors who do not know how to behave in museums and galleries' (2006: 18, 19). There is of course the danger that the museum theatre work moves so far toward the internal that it loses all connection with its location and environment, or becomes entirely unstructured. In determining the external or internal positioning of museum theatre, an important question to ask is 'whether we have to consider learning in museums and galleries as mainly an individual or a social project' (Illeris 2006: 23). Considering learning as a social project should not necessarily be thought of as somehow inferior to learning as an individual project, but this consideration highlights that

learning can be 'a social activity embedded in the surrounding social settings' rather than just for individual benefit (Illeris 2006: 23). Internal museum theatre then operates on the individual in unpredictable ways, and does not necessarily present clear learning outcomes in terms of an act of interpretation. External museum theatre may be more socially cohesive but also more prescribed. It may well interpret the collection in a clearer way, but may not result in any lasting change to the spectator or participant – work that is more internal in character may not necessarily achieve a lasting change, but it is more likely to do so.

Risk-safety

The final binary for positioning the performance of heritage is that of risk and safety. This will initially be explored in terms of interpretation rather than participation or physical and emotional comfort, though it could be expanded to include these features. Baz Kershaw writes of a scene in a community play, *The Reckoning*, which he remembered because 'of its sense of danger . . . generated by the raw conflation or overlapping of several "political" dimensions (or frames of reference) which were at play' (1996: 136). For Kershaw, the 'simultaneous occupation of various "realms of representation"' caused the sense of danger in that various spectators would perceive a variety of specific ideological meanings in the performance (1996: 137). Therefore, for Kershaw, danger is associated with multiplicity and unpredictability, as with the open against the closed text. It is this sense of risk that can be applied to positioning the performance of heritage, particularly in conjunction with an understanding of space and place.

In *The Practice of Everyday Life* Michel de Certeau argues for a distinction between space and place, claiming, 'in relation to place, space is like the word when it is spoken . . . caught in the ambiguity of an actualisation' and that 'space is a practiced place' (1988: 117). This actualisation of space is comparable to Kershaw's 'simultaneous occupation of various "realms of representation"' discussed above in that it is 'dependent upon many different conventions, situated as the act of a present . . . and modified by the transformations caused by successive contexts' (de Certeau 1988: 117). Vivian Patraka uses this 'opposition between "place" and "space" [which refer] to "two sorts of stories" or narratives about how meaning is made' (2002: 82). For Patraka 'place means a pre-scripted performance of interpretation, and space produces sites for multiple performances of interpretation that situate/produce the spectator as historical subject' (2002: 90). This can be linked with much of the debate around the construction of heritage, so that a heritage site, a place of heritage, is risk free or safe in that it lends itself to a unitary interpretation. Of course, that same place of heritage can also be a multi-vocal

space, full of risk and multiple overlapping frames of reference. As Patraka continues:

> space must be a site for multiple performances, multiple and so not delimited by place. And if space is a site for multiple performances by spectators, it is not just a question of interpreting. Interpretation itself becomes a kind of multiple performance . . . not only are there multiple performances of interpretation, but the museum design provides multiple scenarios for these performances – scenarios whose relationships to each other are not narrativised in advance. (2002: 91)

To design a museum that leaves open multiple interpretations in the museum space is an act that carries a genuine risk – there is no privileged position, and no correct reading of the totality of the experience. It leaves open multiple conflicting and contradictory readings, which each individual spectator must navigate and attempt to assimilate. Museum theatre does not in itself lead towards performance space, it can just as much be about performance place; as Patraka states, 'the *place* of performance is much more rigid, more likely to be about the spectacular or the quest for the Real. . . . But if we think of space in relation to performance, we must think of multiple performances' (2002: 92–3).

Praxis

To illustrate this framework I will now turn to four case studies from different sites in the UK. These are the live interpretations at the Royal Armouries Leeds, Yorkshire; Triangle Theatre's *A Servant's Christmas* performed at the National Trust property Charlecote House, Warwickshire; The Blists Hill Victorian Town, a part of the Ironbridge Gorge Museums, Shropshire; and finally Birmingham-based theatre company Stan's Cafe and their hometown performance of *Of All the People in All the World*.

The Royal Armouries Museum in Leeds opened in 1996, and describes its role as 'guardian of the national collection of arms and armour' and 'the display and interpretation of its outstanding objects' (Royal Armouries, Souvenir Guide). There is a daily programme of museum theatre, described as live interpretations, and a dedicated team of interpreters employed by the museum. There are three performance areas within the building, and an outside Tiltyard for falconry and equestrian demonstrations, including jousting. The most common form of performance on the indoor stage is the single-character monologue, often, but not always, connected to an object from the museum's collection. For instance, *The Vanishing Man: 1842* has a costumed Peeler, or police officer, telling the story of his pursuit of a murderer in Victorian London. This performance takes place on a stage, introduced as an 'interpretation' by a member of the gallery staff and with a clear divide

between the performer and the stationary, seated audience. Though it is an engaging performance, there is no opportunity for participation or interaction. Whilst the story told through a single character, this character impersonates many of the other characters involved in typical storytelling fashion, and uses humour effectively. At the end of the performance, after bowing for applause, the performer introduces himself and gives the historical details, including which characters were from the historical record, and which were composites of historical characters created for the demands of fiction.

The performance is typical of the 'standard model' of museum theatre, and as such can be positioned toward the centre of the museum theatre space. It is perhaps slightly closer to safety than risk, as it lends itself to a single unitary interpretation. Similarly it is perhaps closer to external than internal, as it presents a shared view of a historical period, and, while learning may well take place, it is unlikely to be learning in a constructivist sense. The whole event is probably again slightly closer to history than fiction, particularly as it is framed by a historical explanation, making clear where changes have been made, and giving the historical narrative the final word.

In contrast, Triangle Theatre makes work that presents a coherent alternative to the standard model of museum theatre. Although they have undertaken a number of pieces with school groups as resident company at the Herbert Museum and Art Gallery, Coventry, they have also produced work for general visitors at a National Trust Property, Charlecote House (see also Chapter 12 on Triangle's work at Charlecote House). Triangle describe this improvised work as using 'detailed, rigorous and ongoing historical research that explored some of the hidden histories both of the building and among visitors' (Triangle Theatre n.d.: unpaged). In the winter of 2007 Triangle undertook their second project at the house, *A Servant's Christmas*. As well as various unscripted interactions throughout the day, a scheduled 'performance' took the form of a rehearsal for an entertainment that the staff intended to perform to the Lucy family at part of the Christmas celebrations. Whilst the Victorian period for the piece is clear, the audience are certainly not passive recipients of historical information; indeed, the company state that the 'audience are participants as well as witnesses and passive observers' (Triangle Theatre n.d.: unpaged). One audience member would stand in for Lady Lucy in the rehearsal, and other spectators would become incorporated into the action in various ways. The performance is fragile and unpredictable, with the audience seeming at times uncertain how to respond, but the humour is used as a way into the work. Much remains unexplained at the end, such as many of the various objects used in the piece, and the performers remain in character throughout.

This piece is clearly positioned far toward the fiction end of the fiction-history binary despite the detailed historical research undertaken. This is not

because it is historically inaccurate, but rather because its primary authenticity is one of fiction. It is also positioned more toward risk than safety, as the multiple overlapping ways of reading the performance do not offer up an easy single interpretation. Finally it is perhaps equally positioned between internal and external, as it offers a particular external communal heritage activity (the Victorian Christmas) which will tend to act on the participants in a wide, internally varied range of ways, as experimental performance or children's theatre to name but two.

Interpreting the same historical period is Blists Hill, a late Victorian working town created on a site over a mile in length, consisting of a mixture of original buildings, buildings moved from elsewhere and rebuilt and some replicas. They are 'staffed by costumed demonstrators' who explain their work and answer questions, and visitors may change money in the bank to purchase items with pre-decimalisation token coins (Ironbridge Gorge Museum Trust 2001: 1). The environment is immersive and convincing, due partly to the sheer scale of the site. Some of the demonstrators operate primarily as costumed shop staff, and others have well developed practical demonstrations with accompanying third-person explanations, for example going into great detail about the Victorian candle-making process, and how the replica process differs from the authentic version. This then can be positioned at the history end of the fiction–history binary, as there is little opportunity for the fictionalising of the material. It is also external, the acting out of a shared Victorian heritage through learning the origin of terms such as 'not worth a light'. It is also safe, as the extent of participation, indeed, whether a building is entered at all, is at the discretion of the visitor, and in each building a clear interpretation is given.

The piece *Of All the People in All the World*, by Stan's Cafe, first performed in 2003 and performed again in Birmingham in 2008 after playing in various cities around the world, offers a chance to explore the boundary conditions for museum theatre. This is a piece 'performed' in an metalwork factory, but it is not an interpretation of the industrial heritage of Birmingham. Instead, the piece consists of 112 tonnes of rice, one grain representing each person on Earth. Each visitor is given 'their' grain of rice as they arrive, and then left to wander through the building, which is filled with piles of rice representing various individuals (including the punning Condoleezza Rice) or groups, such as the population of England, or Kiwi fruit growers in New Zealand, or more moving measures of human life and death. The piles of rice are organised in various ways, geographically, conceptually, artistically, and amongst them move actors in brown lab coats, weighing and sweeping and tidying the rice world. With this piece, the framework perhaps starts to break down: the work presents no fiction as such, but is organised in an entirely artistic way, so where does it sit on the fiction–history line? There is a clear engagement

with history in the broadest sense; for instance, one of the rooms of the Birmingham performance had huge piles of rice representing the global population in AD 1, AD 1500 and AD 1900, but this appeared to have more of an effect in terms of providing a context for the present than illuminating the past. As a piece of work, it is similarly difficult to place on the risk–safety axis, though it certainly offers multiple performances of the performance space for spectators to negotiate. Similarly, on the internal–external axis the work could perhaps be seen as internal, as the piece operates on an individual rather than as a social project; however, experiencing the work is clearly a social event.

Conclusion

This framework provides a way of thinking about the features of a range of ways through which heritage is performed. Of course, there are numerous other ways in which museum theatre can vary, such as level of participation, but often these could be better reduced to the three dimensions discussed. For instance, an understanding of levels of participation can be found through the amount of risk inherent in the work, as that indicates that the participation genuinely allows for change, rather than merely following predetermined paths (see also Chapter 14 on participatory performance). Furthermore, this framework allows for the analysis of performance work that would be recognised as theatre or as live art, as well as positioning the performative elements of heritage visiting or indeed the activities of the visitors in space as constructed by the museum or heritage site. In practice, thinking about the space of museum theatre might allow for a greater range of potential work to be considered, and for the divergent range of performance practice to find space within museum theatre. It is vital that the form of museum theatre work used is appropriate for the function it is intended to serve, and a broadening of the forms commonly used will surely lead to an increase in the artistic, educational and interpretative efficacy of live interpretation.

Note

1 The original version of this chapter was presented at the 2008 conference organised as part of the Performance, Learning and Heritage research project, and the relationship between these terms was therefore taken as a starting point.

II Re-visioning heritage: recovery and interpretation

5

The 'doing' of heritage: heritage as performance

Laurajane Smith

As the subject of international treaties, conventions and charters, and the subject of national laws and policy programmes, heritage is often defined as a thing of value – something to be cherished, managed, conserved or curated. There is, however, no such *thing* as heritage. Rather, heritage is a cultural performance that occurs at, and with, heritage sites or museum exhibitions. It is a process of remembering and forgetting, and while particular 'things' or spaces may be used as tools in that remembering, it is not the things or places that are themselves 'heritage', it is the uses that these things are put to that make them 'heritage'. Heritage is a process or a performance, in which certain cultural and social meanings and values are identified, reaffirmed or rejected, and should not be, though it often is, conflated with sites or places. This chapter challenges the idea of the authentic heritage as past material culture, and instead looks at the ways material culture is used as aids to remembering/ forgetting, and as prompts for recalling and authenticating cultural and social experiences.

Re-theorising heritage: heritage as performance

Re-theorising heritage as a performance – rather than a 'thing', place, site or monument – broadens the conceptual understanding of heritage, and shows the cultural 'work' that heritage does in any society. The idea of heritage as performance has been developed in previous work (Smith 2006), which is summarised here, and is based on the premise that all heritage is intangible, in so far that heritage is a moment or process of re/constructing cultural and social values and meanings. Heritage is a way of seeing and feeling. As such, heritage frames not only the way the past is understood, but also the meanings and significance it has for the present, and is itself institutionalised within heritage agencies and amenity societies. Heritage can thus be seen as a form of social control, or at least negotiation, over social values and meanings, as it creates a mentality or way of seeing and knowing that renders certain

social problems – particularly those that intersect with claims to identity and representations – tractable and subject to regulation.

Heritage is a form of representation. Securely embedded within both heritage literature and governmental policy is the idea that heritage is expressive of identity and, in particular, national identity. How heritage and identity are linked is never really examined, and is certainly not well understood. That the two are intertwined, however, is a naturalised assumption. The physicality of traditional ideas of heritage – as grand mansions, national monuments, or sweeping vistas – not only aids in this naturalisation of identity, but also provides the intangible notions of identity and cultural value with readily identifiable tangibility, rendering them more objective. Our attention is so focused by this way of seeing heritage, and so abstracted by issues of authenticity, that we are diverted from considering how these objects are used to underpin and legitimise certain identity claims, while de-legitimising others. If we jettison our preoccupation with the materiality of heritage, and focus instead on the intangible, we open up a wider conceptual space within which to reconsider not only the nature of heritage, but also how it is used, and the work that it does in society.

The heritage values that inform any sense of identity are used to construct ways of understanding and making the present meaningful. In particular, 'things' that are defined as heritage are part of the suite of cultural tools that help individuals and societies remember (Wertsch 2002). They become, as Raphael Samuel (1994) points out, theatres of memory or of remembering. Heritage sites and museum exhibitions are places that help to mark a particular act of remembering or commemoration as important and noteworthy, and it is at this point that heritage becomes understandable as an *act* – or, indeed, a performance. The performance of heritage visiting, or of curating and managing heritage, are acts through which social and cultural values and narratives are re/constructed, remembered (and forgotten), negotiated, embraced or rejected. Visitors to heritage sites and museums are not passive receptors of intended heritage 'messages', but rather interact with sites, exhibitions and their curators in a range of ways that is both mindful and active in the meanings constructed (Moscardo 1996; Falk and Dierking 2000; Bagnall 2003; Mason 2005; Watson 2007).

It is important to note that these performances, no matter the narratives and memories they construct or rehearse, will always be contested. All heritage is dissonant and controversial, and what may be inclusive and comfortable to one person or community will always be exclusionary and discomforting to another (Brett 1996; Tunbridge and Ashworth 1996; Lowenthal 1998b; Ashworth 2002). What is valued and treasured by one community may be devalued or valued for different reasons by another, and heritage values and narratives will therefore be contested and disputed.

However, the performance of heritage is *about* the negotiation of these conflicts. It is a constitutive social process through which we examine, legitimise and/or contest a range of cultural and social identities, values and meanings that prevail in the present, which can be affirmed and passed to the future. Thus, heritage is not the historic monument, archaeological site, or museum artefact, but rather the activities that occur at and around these places and objects. These places are given value by the act of naming them heritage and by the processes of heritage negotiations and re/creations that occur at them. They are not intrinsically valuable, but receive heritage values as they are taken up in national or sub-national performances of identity and memory-making.

This re-theorisation of heritage, however, stands in opposition to dominant ways of thinking, talking and writing about heritage, which I call the 'Authorised Heritage Discourse' (AHD). The AHD emphasises the materiality and innate value of heritage, and stresses the monumental and grand, national narratives and values, as well as the comfortable and the 'good'. It asserts the legitimacy of expertise to work as stewards of the past, protecting historical fabric for the edification of present and future generations. It, in short, defines heritage as a 'thing', which must be authenticated and preserved, unchanged for the future by heritage experts. This dominant and professional discourse is institutionalised within public policy, heritage statutes, agencies and amenity societies, and has come to frame the heritage performance at the national level. The AHD is by no means the only discourse or way of defining and understanding heritage, but it is the dominant one within European public policy and practice (see Smith 2006, 2009; Smith and Waterton 2010, for further discussion). The performative nature of heritage and the consequences of this performance for the construction and maintenance of certain social values and narratives are often obscured by the AHD, which also works to de-legitimise other competing discourses or performances of heritage.

Performing heritage: case studies

How are heritage performances played out at places of heritage, and what are the consequences of these performances? To explore these questions this section examines a number of case studies, drawing on visitor interviews at country houses, labour history museums, community festivals, and exhibitions marking the 1807 bicentenary of the abolition of Britain's slave trade. Research on these case studies was undertaken in 2003–04 and in 2007. The former research is reported in detail in Smith (2006); the section below draws on that research while also updating it with more recent research undertaken in 2007.

Country houses

One of the most highly visited and best-known sites of heritage in England is the country house or stately home. These house museums are one of the flagships, or quintessential site types, expressive of the English AHD. During 2004, 454 visitors to six such sites were interviewed, with a further 276[1] interviewed in 2007 from four houses (two of which had also participated in the 2004 research). Visitors were asked questions designed to explore the memory and identity work they were undertaking during their visits, in both 2004 and 2007. The performance that is the country house visit is ubiquitous across England – visitors will wander through the gardens and terraces, enjoy the often panoramic views and appreciate the delights of the botanical collections. They may enter the house and, with minimal textual interpretive aids, read the symbolism of the gilt and the spatial arrangements of the furnishings and artworks. Tea and souvenirs will be available in tastefully displayed shops, often located in the converted stables or servants' quarters.

The most frequent response given by those interviewed in 2004 and 2007 as to why they visited was that they were there either for recreational reasons, or for the experience of 'going to a country house', with 45% nominating either of these reasons in 2004 (Smith 2006: 139) and 84%[2] in 2007. This performance was very real and important to many visitors – a number of people interviewed had literally been to hundreds of country houses – one had been to over 300 – and others saw it as something you do in the summer months. The sense that it is something you just 'do' was important:

it's just an enjoyable day. I don't keep things in my head, so words are no good, it just is. (CH365,[3] female, housewife, husband electrical engineer, reported that she had been to over 100 houses, 2004)

because I'm English. Stately homes are important to being English. (CH79, female, 30–39, general manager, 2004)

I do feel content being here out in the gardens, although not sure exactly how. (CH373, male, 30–39, computer programmer, 2004)

Although many people noted that they simply came for recreation or because it is 'what you do', on probing it became evident that what people do at these sites is perform a sense of what it means to be English, often defined against a sense of foreign 'otherness':

A continuum – a continuing history: America does not have a heritage. (CH29, male, over 60, teacher, 2004)

English Architecture – something the USA does not have. Something that belongs to us. (CH21, female, over 60, retired RAF, 2004)

Now I know why so many Americans love it [Country Houses and royalty] – its history, heritage, belonging. (CH89, male, over 60, 2004)

Unlike USA – we are keeping history – it's not Disneyland – it's British – [it's the] set out of buildings which will always be there unlike today's buildings. (CH135, male, 18–29, radio producer, 2004)

Englishness. I am proud of our rich history and see why foreign visitors are engaged by it. (CH384, female, 40–59, teacher)

However, the performance was not just about national identity, but significantly *middle-class* English identity. For a significant number of visitors, the country house performance engendered a sense of comfort, belonging and a reaffirming sense of social deference. Marketing and research surveys have found that most visitors to country houses fall within the professional or managerial occupation categories (Markwell et al. 1997; Tinniswood 1998), and the interview work in 2004 and 2007 reproduced a similar demographic. At country houses, visitors reported that it made them feel comfortable that they would encounter people like themselves undertaking similar activities at these sites.

As well as being in touch with heritage – it's very important part of leisure time – very middle-class thing to do. . . . Particularly important to middle class – gives pleasure. But that's all right: different places appeal to different people. (CH369, female, over 60, academic, 2004)

To the vast majority it doesn't mean a thing – people would rather go shopping. It seems to be a middle-class thing [visiting country houses] due to education and how you are brought up to reflect, it reflects the direction of your education. (CH409, male, over 60, 2004)

These constructions of class and national identity were interlinked with feelings of 'comfort'. A sense of social and cultural security – of 'knowing your place' – was a significant outcome of the country house performance (Smith 2006: 138f.). This motif of comfort was very strong in the 2004 interviews, for instance:

Gives a sense of comfort – the history and stability and continuance of it. I like old houses – interested in how people lived, not what people lived – the servants and owners, the interdependence of their lives . . . [it is also] comforting to know that it is still being preserved thanks to English Heritage and the National Trust (CH286, female, over 60, 2004)

I like the house – it is warm and welcoming. I feel comfortable and at home here. (CH269, female, 30–39, computer systems operator, 2004)

Contented – wouldn't change my lot for this. (CH329, male, over 60, company director, who identified that their mother had been 'in service', 2004)

Comfortable about visiting even though it was built on slavery, but nonetheless it's part of the country's history. (CH122, male, 30–39, night shift team leader)

The cultural meaning of the country house performance is very strong and the sense of comfort drawn from this reinforces its emotional relevance and, indeed, its authenticity. As Bagnall (2003) also found with visitors to museums, this idea of 'authenticity' was based on the degree to which the emotions and experiences engendered by the visit felt 'real', and was useful or relevant in legitimising or making the visitor feel 'comfortable' about their social and cultural identity and sense of place.

The strength of the authenticity of the country house performance was illustrated in 2007, when interviews were undertaken with visitors at county houses that staged two different types of exhibitions, drawing attention to some of the less comfortable aspects of country house history. Interviews were undertaken at three houses (one of which was also included in the 2004 research) taking part in a linked exhibition on 'Work and Play'. The linked exhibitions were designed not only to look at the leisure activities of the elites, but also to point out how the labour of estate workers and domestic servants had made that leisure possible. The heritage gaze of the visitors we interviewed at these houses simply passed over much of this material. Only 19% of visitors actually actively engaged with the exhibitions, while some visitors admitted that they had failed to notice the exhibitions at all. As one woman observed 'to be honest with you I haven't even noticed it, I just look at the paintings' (WP74), while another woman noted that what she liked about the country house visit was 'just looking round and just looking at stuff and just walking round nice and quietly without people talking loud next to you in an annoying way' (WP127). When asked if the exhibition had made her think about past lives she observed 'no, I don't think we were walking round thinking about things on a deep level'.

The performance of the country house is about feeling comfortable and relaxed, and while many of those interviewed expressed an interest in finding out about the differences between the leisure and working actives of elites and servants, the interest was often vaguely expressed. Only 6% of visitors had come specifically to see the exhibition. For many of those interviewed, the exhibition was either not specifically noted or was just 'there' as part of the scenery they were wandering through and did not elicit any particular or specific interest, or, as one person put it, 'it's just taking it all in really, it's not anything specific' (WP08).

The strength of the country house performance, and its comforting affirmation of authorised heritage and history, is even more strikingly illustrated by visitor responses to one house's exhibition to mark the 1807 bicentenary. Harewood House marked the 200th anniversary of Britain's abolition of its

slave trade with an exhibition that attempted to recognise the links between the house's history and wealth and the enslavement and exploitation of Africans. Visitor responses here were particularly active in their denial of this history's relevance to the authenticity of the country house:

Interviewer: Did you find the exhibition [on 1807] interesting?

No, not really it is irrelevant, we came to see the house, the history of princess Mary, the royal family, so it's a very kind of separate issue to visit here, so we kind of passed it by. (1807(32), male, 25–34, Financial administrator, 2007)

When visitors were confronted by the exhibition, and then by an interviewer asking them what the exhibition meant in the context of the history of the house, most of the people interviewed actively distanced the relevance of the history of slavery to their sense of the country house performance – that history was dismissed as either irrelevant or overplayed. This distancing is evident, for instance, in response to the question 'is there any national significance in marking 1807?':

I don't think it should be celebrated really, I don't think it deserves that much attention. (1807(12), male, 25–34, sales manager, 2007)

It's something in the past really, we organised it and ended it and that's it, I don't think we should dwell too long on it. (1807(13), male, 45–54, civil servant, 2007)

I think it probably is an important part of our history, but totally overplayed at the moment . . . but the other thing is apologising, the Africans should be apologising to themselves, if they didn't catch the slaves we wouldn't have shipped them. (1807(81) male, 45–54, insurance broker, 2007)

It's been a little bit overplayed. Yes it's a significance of a remembrance of what went on, I just think it's over the top. (1807(82), female, 45–54, secretary, 2007)

The performances conducted at country houses were both framed within and reinforced the AHD and its master narrative about Englishness and the good and the great. However, heritage performances also operate outside of the AHD and in opposition to it.

Contesting and changing the AHD
In 2004, interviews were also undertaken at a range of social history museums dealing with mining history and/or organised labour. As with the country house performance, the performance here was also about constructing a sense of identity – although this time often a critical working-class identity that was often not expressed in terms of national identity, but rather family identity. In much the same way as at the country houses, authenticity was measured not by concerns with historical 'accuracy', but by the degree to

which the museums elicited feelings, emotions and a sense of place that spoke to people's collective memories of working lives.

The Beamish open-air museum, often criticised in the heritage literature for being inauthentic, particularly because of its use of costumed interpreters and reconstructed buildings and other structures, offers an illustrative example of the way visitors mediated ideas of authenticity. Many of the people interviewed at the colliery exhibition at this museum remarked that they knew that what was being depicted was not really 'as it was', often noting it was much dirtier in the past than the displays indicated (Smith 2006: 217). In a sense, the reconstructed environment was identified as, in some aspects at least, 'inauthentic'. However, this was often not an issue as people were using their visits to trigger memories, and to pass on family stories and knowledge about the lives of parents and grandparents to children. The museums were being used as both props and prompts in the processes not only of storytelling, but also of the passing on of certain social values underpinning those stories:

I come from a mining community. My dad was a miner, I was raised to work as a miner, basically we were fodder for the factories and mines. This place brings back memories of my family, it's nostalgia, and I was showing my wife around and telling her about my grandfather, the wood smoke and the backyards of the cottages took me right back to thinking about him. (OAM89, male, 40–59, lab technician, 2004).

I brought the grandkids, as I like them to see how things was in the past. (NCMM72, male, 40–59, vehicle inspector, 2004)

This place has great importance because mining has been the backbone and structure of society and now it's all gone and it's important for my daughter to come and see. (NCMM62, male, 40–59, retired miner, 2004)

It was our lifestyle and we like to pass it on to our grandchildren so that they will know what it was like. (NCMM9, female, over 60, from a mining family, 2004)

Some of the reminiscing that was done was explicitly used to construct and reconstruct what it meant to be working class, or from a working-class background or community. This reminiscing, however, was not being used simply to construct a nostalgic experience or to enliven a 'nice day out'. While many people claimed they had come to these sites primarily for recreation, this activity was doing other social and cultural work beyond the provision of entertainment (Smith 2006: 216f.). The reminiscing and passing on of family knowledge would often also be used to construct critical commentaries about current social values or issues, for instance:

I'm from a mining village and [I am thinking about] the major ramifications culturally and socially that the closing of the industry has had. (NCMM 83, male, 30–39, sales assistant, 2004)

That our ancestors worked damned hard – the life we have now is due to the hard manual labour that they did. The technology has moved on because of their labour. (NCMM84, female, 30–39, bank clerk, 2004)

That we must not forget – not to trust the elites, never trust the elites! (TP31 male, over 60, diplomat, self-identified as coming from a working-class background 2004)

The heritage performances undertaken at the museums were markedly different to the country house performance in a number of ways. Firstly, although both performances were re/constructing identity and a sense of place, the performances at the museums were often refocused to actively make critical commentaries about both the past and present in a way that was not done at the country house. At the country house, the performance was about cultural status and stasis. At the museum, the performance hinged around the theme of cultural change. People interviewed at the museums frequently expressed how lucky they were to be living now and how much workers in the past were owed for current standards of living and workplace reform. A strong sense of empathy with workers in the past was often engendered or expressed, and as one woman put it:

Humble. It gets to you there [punches chest] as well as up there [points to head]. Going down pit is a shock to the system, I went down a pit forty years ago and I still remember it. (NCMM77, female, 70s, teacher, husband a miner, 2004)

People were using their emotional responses to the exhibitions and their empathy not only to critically comment on the social values of the past, but also to critically engage with the present. This critical engagement was linked to the way the respondents at social history museums defined 'heritage', with 30% of respondents identifying intangible heritage – that is, memory, knowledge, skills, workplace experiences, traditions and so forth – as an important aspect of heritage (Smith 2006: 209–10). This acknowledgement of the importance of 'intangible' heritage sits outside of the AHD (Smith and Waterton 2009). Intangible heritage as a concept remains unrecognised at national policy levels in the UK, as evidenced by the reluctance of the government to sign the 2003 UNESCO *Convention for the Safeguarding of the Intangible Cultural Heritage* (Kurin 2004b; Smith and Waterton 2009). When definitions of heritage were given by respondents at the social history museums that recognised or fell within the AHD and its emphasis on material heritage, the AHD was often discounted by those same respondents as belonging to that individual's sense of heritage, for instance:

[heritage is] working-class history as opposed to seeing a stately home, where the landed gentry live [said sneeringly], country houses are interesting in themselves but there is only so much you can learn from them, and why would I pay

someone to look around their house – they can pay me 10 quid to look around mine. (NCMM5 male, 40–59, miner, 2004)

Heritage was about memory and often its 'preservation' occurred through the performance of passing on memories and family histories; a performance that was facilitated, but not determined, by the material culture exhibited at the museums. The performative nature of heritage is also illustrated by the work of the Castleford Heritage Trust (CHT) – a community-based and -run organisation in the ex-mining and deindustrialised West Yorkshire town of Castleford. Each year the CHT holds a heritage festival based loosely on the old mining galas. The festival is a performance where exhibitions about the history of the town and its industries are put on, art exhibitions are held, and poetry and music performances are undertaken. For many of the people who participate in the festival – as both performer and audience – the festival sends out a message that Castleford has a heritage that *matters* (Smith 2006: 256; Drake 2008).

Further, the festival is not simply about remembering the past and what that means for the present, but is also about creating memories that will help bind children and adults to a sense of community identity. As one audience member to the 2004 festival observed, the festival both 'creates and jogs memories'; that is, collective memories are not only being remembered, but are also created in the context of an event that marks the importance and meaning of both new and old memories. The Festival, in fact, is producing heritage, in that it is producing memories to be remembered not only at later festivals, but also in terms of what it means to be a member of the Castleford community. It is, as one person put it, 'a case of producing heritage and creating something now' (CF17, 2004).

This sense of action, of 'doing', so that new memories are created is important, as in none of these examples is heritage passive – people are engaging and doing; they are remembering and creating memories that help them make sense of their place and position in society. Sometimes this is done within the confines of the AHD, as at the country houses, and sometimes it is done in opposition to, or without reference to, it. However, in the 'doing', social and cultural values and meanings that help them make sense of present lives and experiences are being acknowledged and then affirmed, rejected or renegotiated. This sense of action and performance is again reinforced in the results of interviews undertaken at museum exhibitions marking the 1807 bicentenary. Interviews were undertaken with 1,498 people at a number of museums across England to understand the memory and identity work visitors were engaged in as they encountered exhibitions recounting the traumatic history of British involvement in African enslavement. Again, one of the things that emerges from these interviews is the degree to which visitors were highly

active in constructing the considerable range of meanings and messages they took away from exhibitions. Some actively distanced themselves from the history portrayed, some constructed quite negative messages, others wrestled with issues of guilt, and yet others took away hopeful and critical messages. Nevertheless, one exchange I had with a visitor to the new International Slavery Museum in Liverpool and her husband is enlightening about the process of heritage and meaning-making she is engaged in. The final question asked of visitors in the interviews centred on the issue of 'apology':

Interviewer: The issue of 'apology' has been raised in this exhibition/public debate over slavery. What is your opinion on this issue?

1807(223): Yeah.

Husband (interjecting): But there's no one left to apologise [to]; everyone is dead.

1807(223): No there isn't. Yes. But to me I think it's important. I think we should apologise for what we did. How we would do it I don't know. It's like [husband's name] said there's no one left to apologise for them really.

Husband: It would be no significance for anyone, if the Prime Minister or anyone, they had nothing to do with it in the first place, who're asking for an apology will get nothing out of it.

1807(223): But I think it's representative apology. Do you understand? I think it's representative apology. To show people what exactly what went on and in their way apologise for it.

The couple are having a mild argument here. He thinks an apology is pointless, she, on the other hand, wants to apologise, but does not know how it would be done or by whom. Then she talks about a 'representative apology' and I ask her what she means:

1807(223): Yeah. We walked into the room where it was dark and it was the slaves on the ship being shackled, I found that quite horrendous we had to come out of there. We belong to the National Trust so we go to a lot of properties, so Penrhyn Castle in North Wales, their wealth was built on sugar and slaves it affects everybody doesn't it. Because they've got a bit about the slave trade in Penrhyn Castle because their previous owners were involved in it. They all were involved.

My reading of this is that her 'representational apology' is an act of apology. Her act of coming to the museum is an acknowledgement of the history of British enslavement, and that by acknowledging that a lot of the heritage properties she visits, like the Welsh castle she mentions, were involved she is enacting or representing her apology – she is performing the apology. She is also performing or doing heritage, for in her response to the questions

and her discussion with her husband she is mediating the meanings of the history of enslavement she has just encountered. She is negotiating what this history means, and finally concludes that it affects everyone. In what she is saying, she is surfing the tensions between the AHD, her membership of the National Trust and the sense of empathy she encountered in the dark room she mentions. What this intersection illustrates is that the AHD is not immutable. Although no real changes were found between 2004 and 2007 in the country house performance of heritage, and what it owes to the AHD, in this exchange, for this woman at Liverpool, challenges to the AHD were occurring.

Conclusion

Heritage is a cultural process or performance that is engaged with the construction and reconstruction of cultural identity, memory, sense of place and belonging. Sometimes this performance is framed within the AHD, the existence of which also acts to obscure the nature and consequences of heritage processes and performances. Sometimes these performances occur outside the AHD and/or in opposition to it. This chapter has attempted to illustrate the range of heritage performances that may and can occur. Overall, the argument advanced is that heritage is not a thing, but a process of meaning-making and negotiation, and that the authenticity of heritage lies not in its physical fabric, but in the legitimacy given to the social and cultural values we imbue places of heritage with through the performances we construct at them.

Notes

1 Of this, 185 were interviewed as part of the 'Work and Play' research and 91 as part of the '1807 Commemorated' project. The latter project interviewed 1,498 visitors to museums marking the bicentenary of the abolition of Britain's slave trade; of these, 91 were interviewed at Harewood House. For more details about this project, see '1807 Commemorated': www.history.ac.uk/1807commemorated (accessed on 29 June 2010).

2 This figure refers to those surveyed as part of the 'Work and Play' research only; that is, n=185.

3 Interviews used in this chapter come from a number of research projects and are referenced according to the location of the interview. CH refers to 2004 interviews at a number of 'Country Houses' and is followed by the running number of the interview, in this case this was interview 365. Those identified as 'WP' refer to interviews undertaken during 2007 at country houses as part of the Work and Play study, 1807 refers to interviews undertaken as part of the research project '1807 Commemorated' (see note 2). These were carried out during 2007 with museum

visitors and '1807' is followed by a running number in brackets. The abbreviation CF refers to interviews undertaken at Castleford and includes running order of the interview and the year date of the interview; OAM, NCMM and TP refer respectively to 2004 interviews at the Beamish Open Air Museum, the National Coal Mining Museum, Wakefield, and the Tolpuddle Martyrs Museum.

6

Intangible heritage and the performance of identity

Marilena Alivizatou

In an essay entitled 'The Valery Proust Museum', Frankfurt School thinker and Marxist ideologist Theodor Adorno argued that 'Museum and mausoleum are connected by more than phonetic association' (1981 [1967]: 175). Mobilising metaphors of 'death', 'dying' and 'sepulchres', Adorno's essay has been widely quoted by museum and heritage theorists criticising the heritage industry and the nineteenth-century modernist museum (Walsh 1992; Hooper-Greenhill 2000; Witcomb 2003). More than forty years after Adorno wrote those lines, decisive moments in museum-work (Shelton 2006) informed by postcolonial thinking (Simpson 1996) and a critical reconfiguration of the museum (Vergo 1989) led to major shifts in contemporary museum theory and practice (see, for example, Corsane 2005; Macdonald and Basu 2007). At the beginning of the twenty-first century, digital technologies, interactive media, moving images and live interpretation increasingly form part of the museological lexicon, creating a melange of the static and the ephemeral, the animate and the inanimate, the material and the immaterial. Arguably, the museum is transformed from a ritualised mausoleum/temple (Duncan 1995) into an ever-changing theatre scene.

Drawing on discussions around the concept of 'intangible cultural heritage' (ICH), this chapter examines the dynamic relationship between museums and performance. Against the backdrop of late twentieth-century politics of recognition (Taylor 1992), museums from authoritative and elitist institutions are increasingly negotiated as 'contact zones' (Clifford 1997) and 'interactive theatres' (Phillips 2005) (see Joel Chalfen's chapter for more on the 'contact zone'). By using examples of performances recorded during the fieldwork for my doctoral research in the Musée du Quai Branly in Paris, the National Museum of New Zealand Te Papa Togarewa in Wellington and the Vanuatu Cultural Centre in Port Vila in the period July 2006–February 2008, the aim of this chapter is to offer a critical examination of a series of cultural performances taking place within the context of contemporary north and south museum-work. What purpose do they serve and what is their

relationship to traditional museum displays and collections? What insights does their examination offer to the reconsideration of the notions of 'identity' and 'authenticity', two contested areas of the 'heritage debates' (Walsh 1992; Samuel 1994; Lowenthal 1998b)?

In answering these questions, three different museums, one 'Western', one 'bicultural' and one 'indigenous', provide a critical framework for negotiating museum performances. The idea of 'comparative museology', as advocated by Christina Kreps (2003), is redeployed here to enable the comparison of museum-work in different settings. Cultural performances taking place in contexts as different as Paris, Wellington and Port Vila demonstrate that this is not only a local and site-specific phenomenon, but a critical aspect of contemporary heritage-work. Using ethnographic methods (Butler 2007), such as participant observation in the museum spaces and interviews with museum professionals, the practice of museum performance is analysed in relation to the concept of ICH. Taking forward the critical examination of ICH, I wish to investigate the implications of the museum-as-theatre as opposed to the museum–mausoleum: do cultural performances breathe life into the institution or are they transformed into new museum specimens and detached displays of abandoned traditions?

Debating materiality in heritage studies and museology

Recent discussions in the field of cultural heritage and museology have focused on the emergence of the concept of 'intangible cultural heritage' and its wider implications (Nas 2002; Kirshenblatt-Gimblett 2004; Kreps 2005; Alivizatou 2008a; Smith and Akagawa 2009). In her vision of the 'post-museum', for example, Hooper-Greenhill underlines the importance of ICH as the embodiment of '(the memories, songs and cultural traditions' of groups and communities as a key part of the 'post-museum' narrative (2000: 152). Rooted in Japanese and Korean heritage conceptualisations (Yim 2004), ICH gained international recognition largely through the normative and operational programmes of UNESCO and the 2003 Convention for the Safeguarding of ICH.

Since the end of the Second World War and after the successful campaign for the salvation of the Nubian monuments in Abu Simbel, UNESCO has been regarded as the guardian of the world's cultural heritage (Conil-Lacoste 1994). Initial conceptualisations of heritage as expressed in the 1972 World Heritage Convention have, however, been regarded as Eurocentric and excluding (Cleere 2001). Claiming that the World Heritage Convention is based on Western aesthetic and historical canons, several heritage theorists and practitioners have stressed the need to reconsider the notion of 'authenticity' (McBryde 1997; Munjeri 2004) and take into account indigenous, local

and tradition-based approaches that have historically been at the margins of discussions about heritage (Butler 2006; Cleere 2001). After several concerns expressed primarily by non-European member states, UNESCO adopted in 2003 the Convention for the Safeguarding of ICH, which offered a more inclusive definition of heritage, alluding to oral and performed cultural expressions, empowering practising communities and acknowledging the need to safeguard cultural diversity from the threats of globalisation (Blake 2006).

Needless to say that, since 2003, the emergence of ICH has given rise to an important mobilisation, both intellectual and operational. While heritage theorists and academics are still trying to come to terms with the institutionalisation of tradition (Nas 2002), a large majority of UNESCO Member States, from France and Belgium to Zimbabwe, Japan and Vanuatu, have enthusiastically adopted the new Convention. As a consequence, cultural traditions, like the 'Sicilian puppet theatre', Spanish medieval mystery plays, Indian *Kathakali* and African masquerades have been proclaimed 'masterpieces of the oral and intangible heritage of humanity', while practitioners of crafts and ceremonies have been proclaimed 'living human treasures' (UNESCO, www.unesco.org). However, the diplomatic and political success of ICH has met with significant scepticism (Kirshenblatt-Gimblett 2004; Brown 2005; Alivizatou 2007). Fears have been expressed that governmental involvement might freeze cultural expressions; also, that increased promotion and reinvigoration of traditional practices might lead to their decontextualisation (De Jong 2007).

A key point to consider is that UNESCO's activities have been primarily directed toward the need to safeguard living cultural heritage from the threats of globalisation. In this sense, the international organisation seems to encourage a preservationist approach toward ICH, rather than one that allows for more contemporary and changing understandings of traditional culture. Recent academic/intellectual discussions have further pointed to the need to explore the more profound and contested meanings of the emerging ICH discourse. In this sense, ICH is increasingly related to an 'alternative heritage discourse' (Butler 2006), a discourse that is not focused on the act of heritage preservation, but on alternative modes of cultural transmission often embodied in iconoclastic acts of heritage re-appropriation.

Here, it is Holtorf's conceptualisation of heritage as a 'renewable resource' that is particularly interesting (2006). More precisely, Holtorf argues that 'destruction and loss are not the opposite of heritage but part of its very substance' (2006: 101). He, thus, asks 'what is more important, the preservation of a few relics of the past, or the active continuation of a living culture?' (2006: 104). For him, acts of heritage destruction, like the almost complete demolition of the Berlin Wall following the reunification of Germany in 1989 or the catastrophic events of 9/11, 'create new heritage' (2006: 107) by inviting active ways for engaging with and responding to the past.

Similar arguments can be constructed drawing on anthropological research on New Ireland funerary effigies, known as *malanggan*. Susan Kuechler, for example, explains how, after their creation and ritual performance, *malanggan* are abandoned in the forest, burnt or sold to foreigners (2002). For her, *malanggan* 'effect remembering in an active and continuously emerging sense as they disappear from view' (2002: 7). Their literal or symbolic destruction reveals that what is valued is not the materiality of the effigies, but the images that they leave behind to be re-introduced in new ceremonies. Western notions regarding the authenticity of materials and techniques are not really relevant here, since the creation and destruction of *malanggan* is an evolving and changing tradition.

The above invites a reconsideration of cultural heritage and ICH beyond a purely preservationist framework embodied in the materiality of objects or detached performances of abandoned ceremonies. Instead, viewing heritage as the creative re-appropriation of the past, informed by the challenges of the present, allows for its full dynamism to come into play. This not only challenges mainstream understandings of the 'authentic', but stresses the need for a more creative rather than conservative approach *vis-à-vis* cultural transmission in heritage and museum-work.

Performing heritage in museums

Challenging the fundamental museological ideas of preservation and materiality, the implications of ICH for mainstream museology are viewed with interest, but also scepticism (Kurin 2004a; Alivizatou 2006). In 2004, the International Council of Museums (ICOM), the non-governmental organisation advising UNESCO on cultural heritage and museology, held its General Conference on the subject of 'Museums and Intangible Heritage'. Museum theorists and professionals from Asia, Europe, Africa, North and South America, and the Pacific held long discussions on the subject of how 'living culture' can be part of museum-work. For example, Professor Patrick Boylan argued that the engagement of museums with ICH necessitates the creation of a new category of museum professionals trained in curating not only material, but also immaterial heritage (2006). For him,

> members of the museum profession need to adopt an open, outward looking view of their own role . . . in relation to the protection and promotion of the intangible heritage, which can be at least as important as the traditional collections of physical objects that have been the main, or in many cases the only, concern of museums over the past centuries. (2006: 64)

Interestingly, what is usually described as ICH – in other words, traditional practices and ceremonies, oral histories, arts and crafts, and local knowledge

(UNESCO 2003) – has been part of museological practice in different ways. For instance, the emergence and flourishing of ecomuseums in France in the 1970s was largely directed by the need to reconnect people with environments and showcase ways of life, beliefs and traditions, rather than historic relics or works of art (Davis 1999). Similarly, the foundation of community museums in multicultural cities (James 2005) and of indigenous cultural centres in the decolonised world (Clifford 2004) prioritised local knowledge and emphasised the need to reconnect the community with its past. This meant adopting people- rather than object-oriented approaches to museum-work by enhancing knowledge and cultivating pride in origins. Not solely concerned with the preservation of the materiality of objects, engaging with ICH meant searching for new ways of expressing identity largely based on community involvement and participation. Against the idea of the museum–mausoleum as the embodiment of an elitist institution, cultural performances in ecomuseums and cultural centres from the 1970s onwards seemed to serve exactly that purpose.

Recent work on the examination of cultural performances has, however, pointed to the controversies and problematic areas regarding the practice (Jolly 1994; Stanley 1998; Hitchcock et al. 2005). Tellingly, critics have stressed the consequences of external factors on such performative acts of cultural transmission and the ensuing issues of alienation and commercialisation of tradition. Nick Stanley, for example, in his book *Being Ourselves for You* (1998), underlines the impact of tourism and development projects on the way ethnic groups present themselves to local and increasingly international audiences. He hints at the commercialisation of traditional culture in order to generate income from tourism and significantly questions the authenticity of such performances. In this sense, a ceremonial practice that is no longer performed for the community but for a tourist audience is often detached from its original context, losing its spiritual value and often related to ideas of moving 'from ritual to retail' (Luke 2002: 96).

Moreover, retracing the history of cultural performances in museum settings, one inevitably goes back to the first European and North American international exhibitions (Greenhalgh 1988). In the spirit of European imperialism, groups and individuals from the colonial peripheries were brought – often under dire conditions – to metropolitan centres to display their ways of life, traditional practices and ceremonies to the curious European eye (Mitchell 2004 [1989]). On that, Roslyn Poignant in *Professional Savages* (2004) provides a detailed account of the history of an Aboriginal group from the northern territories of Australia touring the USA and Europe. Based on archival research, she rehearses the group's journey and reveals the hardships and cruelties they suffered while on tour. Although today such performances are lamented as an inhuman aspect of colonial times, several parallels could be

drawn between past and present with respect to how cultural representation is constructed, who is the author of the narrative, who is the spectator and who the spectacle. Obviously, this raises serious questions about the purposes of contemporary cultural performances in museums; issues that are further taken up in the comparative examination of three cases of contemporary museum-work.

Performing identity by the Seine

The Musée du Quai Branly (MQB) opened its doors to the public in June 2006 in the midst of heated debate and controversy (Dupaigne 2006; Price 2007). Housed in a multicoloured construction designed by French architect Jean Nouvel a few minutes' walk away from the Eiffel Tower, the MQB is the legacy of former President Jacques Chirac, who following the tradition of his predecessors left his own mark on the Parisian skyline. It is, thus, the realisation of the presidential dream to create a museum for the 'arts and civilisations of Asia, Africa, Oceania and the Americas' (MQB, www.quaibranly.fr). Interestingly, since its inauguration, the new museum has received both praise and condemnation from the press and museum critics. In one of the fiercest commentaries, *New York Times* journalist Michael Kimmelman described the museum as a 'missed opportunity' where 'colonialism of a bygone era is replaced by a whole new French brand of condescension' (2006). At the other extreme, Jonathan Jones, art critic for *The Guardian*, expressed his admiration for its 'seductive museum displays' that free art from 'dusty cases in neglected corners', calling the new museum not only 'exhilarating', but also 'a triumph' (Jones 2006).

In debates regarding the foundation of the MQB, the largest body of condemnation has come from the anthropological community, which has by and large been critical of the 'aestheticisation' of otherwise 'ethnographic objects' (De l'Etoile 2007). In a passionate account of the foundation of the museum, US anthropologist Sally Price (2007) laments the lack of contextual information on the displays, while her colleague James Clifford (2007) describes the museum as 'ahistorical' with little or no reference to the processes that led to the accumulation of collections in Paris and to ideas of cultural exchange and transmission. I have elsewhere looked in more detail into the exhibitionary strategies of the MQB displays (Alivizatou 2008b). What is of particular relevance to this chapter, however, and has on the whole been ignored by museum critics, is not the permanent and temporary exhibitions, but the live performances and events that take place in the museum auditorium and open-air theatre.

Alan Weber, an art consultant and producer of world music and spectacles, has collaborated with MQB staff in organising a diverse programme

of performances, including a contemporary version of the Indian epic *Mahabharata*, shamanic singing from Siberia, the ceremony of the *Bwa Plank* masks from Burkina Faso and Korean hip-hop. Interestingly, the MQB has a special team concerned with the production of these cultural events, inviting artists and practitioners from Asia, Africa, Oceania and the Americas to perform in Paris. In interviews with members of the team, the importance of these live performances was highlighted as a fundamental addition to the static displays. As one interviewee observed, 'through live performance the museum reaches a deeper level well beyond the static representation of objects' (MQB A 02/07). In a similar tone, a high ranking member of staff remarked that:

> in a sense intangible heritage is really what the museum has always been about, in so far as it does not want to be just a museum of objects and invites groups from all over the world camping on this difficult crest between authentic ritual and world theatre. (MQB B 01/08)

Obviously, the presentation of traditional ceremonies in a Western museum auditorium is fraught with controversy. On the one hand, spectators predominantly belong to the French middle-class museum-visiting audience (see for example Bourdieu and Darbel 1989; Ballé and Poulot 2004) that has little prior knowledge of the cultural tradition and its performative context. On the other hand, performers are invited to present an abbreviated version of a customary practice thousands of miles away from where the practice is usually performed and in the confined, artificial environment of a museum theatre. Therefore, as the same high-ranking staff member observed, 'the museum certainly does not pretend to show authentic rituals' (MQB B 01/08). Rather as the museum's director underlined regarding ICH and the performance of heritage, 'the MQB is not so much interested in a historic heritage that is about to disappear, but rather in the transformation and re-appropriation of tradition' (MQB C 01/08). Clearly, the wide range of performances that combine elements of tradition and modernity reveal that ICH in the MQB is not conceptualised in terms of the 'purity' of cultural traditions, but rather as hybrid manifestations of a globalised cultural diversity.

Performing Maori-ness in Te Papa

Standing on the Wellington waterfront, Te Papa, as the National Museum of New Zealand is commonly known, celebrated its tenth anniversary in 2008. Founded through the 1992 'National Museum of New Zealand Te Papa Tongarewa Act of Parliament', it is probably the world's most famous 'bicultural' museum (Te Papa, www.tepapa.govt.nz). 'Biculturalism' is Te Papa's core principle, rooted in the 1840 founding document of New Zealand, the 'Treaty of Waitangi', which was signed between representatives of the British

Crown and Maori chiefs. This document, a magnified replica of which lies at the centre of the museum, represents today the equality and coexistence between indigenous Maori people and European settlers, often referred to as Pakeha.

Taking into account that only 15% of the four million New Zealanders belong to the indigenous Maori minority, the fact that the country's largest and most famous national museum is 'bicultural' is quite perplexing. Although Maori were the first inhabitants of the North and South Islands of New Zealand, the arrival of Europeans in the eighteenth and nineteenth centuries significantly reduced their population to the degree that at the beginning of the twentieth century, they were regarded as a dying race (Durie 1998). Against all odds, Maori did not die out, but rather emerged as a dynamic player in twentieth-century New Zealand politics. With the establishment of the 'Waitangi Tribunal' in 1975, calls for Maori sovereignty and self-determination based on the 'Treaty of Waitangi' became stronger and Maori *iwi* (tribes) obtained special roles and privileges. In 1984, the success of the international exhibition 'Te Maori' that toured the USA and Europe rekindled interest in Maori tradition (Thomas 1994). Wood and greenstone carvings were recognised and celebrated as a precious patrimony of New Zealand and it was generally felt that Maori could no longer remain at the margins of museum-work (Hakiwai 2005).

Against this backdrop, Te Papa was conceptualised as a 'bicultural museum', with biculturalism manifested, for example, in the museum's management, comprising a Chief Executive Officer and a *Kaihautu* (Maori director), the bilingual written interpretation in English and Maori, and the bicultural employment policies. More importantly, biculturalism was also translated as the coexistence of Maori traditional knowledge and Western epistemologies that include, for instance, Maori creation stories alongside scientific explanations of natural phenomena. It is in the spirit of the museum's biculturalism that a *marae* (traditional Maori meeting area) called *Rongamaraeroa* was constructed on Te Papa's fourth level. Unlike a traditional *marae*, this comprises a meeting house with modern, multicoloured carvings that depict Maori ancestral figures, like Maui, and early European travellers, like Abel Tasman. Although the museum has both indoor and outdoor theatres, it is *Rongamaraeroa* which is Te Papa's heart and main performative space.

While on fieldwork at Te Papa, I witnessed a wide range of performances that take place in *Rongamaraeroa*, including traditional Maori ceremonies, performances of classic music, educational workshops and singing classes. In interviews with a member of the events team, it was stressed that there are about four hundred activities, including cultural performances taking place each year, with the most popular being those of Maori and Pacific *kapa haka* (dance). In addition, each June, the *Matariki* Festival takes place at Te Papa to celebrate the beginning of the Maori New Year. It is during this festival that

large numbers of Maori visit the museum and different performances, such as dances and culinary demonstrations by different tribes, take place. For example, in 2007 there were performances of *haka* and *poi* dances, as well as hip-hop by Maori, Pakeha and Pacific bands, bringing together elements of the contemporary and the traditional.

In the autumn of 2007, the Te Papa events team, in partnership with Maori performers, organised *Taonga Mataora*, a special event that took place once a week in the museum, with dinner and a cultural performance. This is a practice largely encountered in the North Island of New Zealand, especially in the area of Rotorua (Mitai Cultural Village, www.mitai.co.nz), where Maori crafts, arts and traditions are revived and offered as a cultural tourism experience. This, clearly, hints at controversial discussions regarding the invention (Hanson 1989) and commercialisation of tradition. However, as was observed in interviews with Te Papa staff 'the performances are a bit chopped and changed, but they certainly keep the traditions alive and part of contemporary Maori identity' (Te Papa A 04/07).

Intangible cultural heritage and performance in Vanuatu

During my fieldwork in the Pacific I experienced several indigenous cultural performances. In Vanuatu, a Melanesian nation of about eighty islands, these performances have taken place at the delicate interface between the discourses of *kastom* (pre-colonial culture) preservation and development (Stanley 1998). Since the country's independence from the Franco-British Condominium in the 1980s, efforts have been made to revive traditional customary practices as a way of reconnecting local people with tradition (Bolton 2003). At the same time, the impact of tourism is felt increasingly with the development of resorts and the arrival of international visitors in search of unique cultural experiences. Clearly, the flow of tourist money into the archipelago has not left local indigenous populations unaffected.

Anthropologist Margaret Jolly, for example, conducting fieldwork in Vanuatu in the 1970s, made an extensive study of the impact of tourism on the *Nagol*, the famous land-dives[1] that take place in the island of Pentecost (1994). She observed that the traditional practice gradually became a specta-cle for tourists with performances taking place not only out of season, but also outside Pentecost. Clearly, the meaning of the practice for the local people changed, as many saw in it an opportunity to gain an income from tourism. This led to fierce debates among ni-Vanuatu about who owns the collective ritual and who has the right to perform it (Jolly 1994). It is in this context that the former Director of the Vanuatu Cultural Centre (VCC) and British anthropologist Kirk Huffman expressed his concerns about 'the prostitution of *kastom*' (VCC, www.vanuatuculture.org).

Obviously, the dynamics between *kastom* and development are a fundamental preoccupation of the staff of the VCC. Although it was founded by colonial officials in the 1950s, the work of dedicated anthropologists, like Huffman, in the 1970s soon transformed the old and uninspired museum (Bolton 2003) into the most dynamic indigenous cultural organisation in Vanuatu (Stanley 2007) and most probably in Melanesia. Today, the VCC is located in Port Vila, the capital of Vanuatu, on a hill near the national parliament. The building, designed in the style of Melanesian longhouses, was inaugurated in 1995 and is mainly occupied by the National Museum and Library. It could be argued, however, that the most cherished treasures of the VCC are not the artefacts on display or in the stores, but the audio and video recordings kept in the *Tabu* Room.

These have been collected by the VCC since the late 1970s through the 'Oral Traditions Project' and the local fieldworkers' networks (Bolton 2003). With the input of foreign anthropologists, ni-Vanuatu volunteers – selected community representatives – have been trained in ethnographic methods to record aspects of *kastom* in the different islands. As was noted in my interviews with VCC members of staff, the knowledge surrounding the production and use of objects is more important than the actual objects, which are often abandoned in the forest. As such, the recordings kept in the *Tabu* Room are more important than the objects on display. Such recordings, for example, include traditional ceremonies and festivals or different aspects of traditional knowledge, such as fishing, weaving or initiation rituals performed by local communities. They can only be accessed by community representatives and VCC staff, and some of them are used by the VCC in radio and education programmes. The central idea here is the need to protect and safeguard *kastom* from commercial exploitation and abandonment.

Against this backdrop of cultural preservation, the VCC has made significant efforts towards the regulation of the commercial exploitation of *kastom* and *kastom*-related cultural performances. For example, a national action plan was drafted by the VCC for the safeguarding of the practice of sand-drawing, proclaimed a 'masterpiece of oral and intangible heritage' by UNESCO in 2003. This states that 'nowadays only few practitioners still master sand drawing and its associated knowledge' further explaining that 'the practice has tended to become focused on the graphic aspect for advertising or tourism, to the detriment of its original meaning and function' (VCC, www. vanuatuculture.org). As such, the VCC aims to sustain and revive the practice through workshops and educational activities aimed at local communities. While in the VCC in April and May 2007, I had the opportunity to see local ni-Vanuatu children, young people and adults performing sand-drawings in the permanent interactive display. Such performances were not directed at a tourist audience, but instead were part of the VCC's *kastom* preservation

programmes. In this sense, the participation of local communities added new dimensions to the static museum displays and transformed the VCC into a space of cultural transmission.

Reconsidering identity and authenticity

With the above in mind, how are we, as museum and performance theorists and practitioners, to approach the 'authenticity' of contemporary cultural performances? Clearly, a ritual dance or ceremony that is not only performed in the context of a community, but also as a tourist or visitor attraction, has possibly lost and maybe obtained new meaning and purpose. Does this make it less authentic for the people who perform or see it? Kenneth Hudson talking about cultural performances in the museum context remarks that, 'Zulus, Fijians and Maoris no longer behave like this left to themselves and to bribe them to do so is to indulge in a romantic escapism of a patronising and not particularly pleasant kind' (1991: 464). Similarly, Kirshenblatt-Gimblett discussing the emergence of ICH as a manifestation of 'the heritage economy' (2004: 61) describes it as a 'metacultural production consistent with economic development theory' that 'can be brought into line with national ideologies of cultural uniqueness' (*ibid.*). For her, ICH is an effort to 'preserve (in the museum) what was wiped out (in the community)' (*ibid.*).

Here, cultural performances of the sort discussed thus far could be described as 'romantic escapism', 'metacultural' and possibly 'fake' in the sense that they are not part of the 'preheritage culture (cultural practices prior to their being designated heritage)' (*ibid.*), but rather a cultural construction serving specific economic or political purposes. This is where it seems to me that the idea of 'comparative museology', or 'the systematic study and comparison of museological forms and behavior in diverse cultural settings' (Kreps 2003: 4) is particularly useful. By examining contemporary museum performances in settings as different as a 'Western' museum in Paris, a 'bicultural' museum in Wellington and an 'indigenous' museum in Port Vila, it becomes evident that performance is increasingly adopted as an important component of museum-work not only in market-oriented contexts, but more pointedly in relation to postcolonial politics of recognition. Instead of considering it, therefore, as 'fake culture', it would be interesting to adopt a more inclusive approach *vis-à-vis* the idea of authenticity, and regard the hybrid, 'metacultural' performances encountered in the three museums as an expression of the complexities of contemporary identities. In this sense, the 'metacultural' heritage emerges as a highly charged aspect of contemporary culture.

The comparative examination of the three museums has, thus, revealed that ICH as performance invites a reconsideration of key museum values and practices. The adoption of performance as a museum strategy reveals

efforts to 'humanise' museology and breathe life into Adorno's museum–mausoleum. Moreover, the combination of the traditional and the contemporary in museum performances transforms the latter into a living practice open to change and reinterpretation rather than just the revival of abandoned traditions. In this sense, cultural performances in museums, apart from animating the museum, also express contemporary Native agency. Taking into account that most artefact collections were compiled at the end of the nineteenth and the beginning of the twentieth centuries, when it was thought that indigenous cultures would disappear, it becomes evident that today such performances enable native communities to reclaim their tradition and reaffirm their place in the world. Performances such as Korean and Maori hip-hop in the MQB and Te Papa, or new forms of sand-drawing in Vanuatu therefore give ICH a new meaning: as an expression of contemporary changing, hybrid identities. This, I think, is something that cultural policy-makers, including UNESCO, will increasingly be asked to reconsider.

Acknowledgements

This chapter is a revised version of a paper presented at the Performing Heritage conference held at the University of Manchester in April 2008. My thanks go to the UCL Institute of Archaeology for funding my participation at the conference. Also, I would like to thank the State Scholarships Foundation of Greece for funding my doctoral studies and the UCL Graduate School, UCL Institute of Archaeology and the University of London for funding my fieldwork in New Zealand and Vanuatu.

List of interviews

MQB A. Interview conducted by the author on 16 February 2007 at the Musée du Quai Branly in Paris.
MQB B. Interview conducted by the author on 03 January 2008 at the Musée du Quai Branly in Paris.
MQB C. Interview conducted by the author on 04 January 2008 at the Musée du Quai Branly in Paris.
Te Papa A. Interview conducted by the author on 12 April 2007 at the National Museum of New Zealand Te Papa Tongarewa in Wellington.

Note

1 This is a traditional ritual ceremony practised by young men in the island of Pentecost to celebrate the yam season. It involves young males attaching their feet to a strong rope made from vines and jumping off a high platform or tower.

7

Authenticity and metaphor: displaying intangible human remains in museum theatre

Anna Farthing

Museums traditionally exhibit objects, tangible material culture and art works. However, museums are increasingly being called upon to create exhibitions illustrating historical narratives, such as transatlantic slavery, for which appropriate objects are unavailable or inadequate. Some museums have responded by using extended text panels to extrapolate multiple meanings from the limited objects they have.[1] Others have chosen to present empty cases, drawing attention to the absence of material evidence.[2] However, in order to adequately convey the difficult and sensitive nature of the contested history of slavery and abolition, it is necessary to communicate something of the human behaviours, attitudes and beliefs of those who were involved. This has encouraged many museums to display fluid and temporal forms of representation and interpretation, through audio-visual media and museum theatre.[3] Museums are therefore commissioning and producing new forms of enacted intangible cultural heritage.

Enacting and displaying events from the history of slavery and abolition draws our attention to what I call 'intangible human remains'; those behaviours, attitudes and prejudices that were generated in a previous era under different social, ethical and economic circumstances, yet linger on, infecting the health of our contemporary social relationships like malignant spirits.

Some question the benefit of revisiting such contested histories, suggesting that instead we forget about the past and move on. The issue of apology has in particular divided opinion.[4] But philosopher Paul Ricoeur refutes the possibility of amnesty through amnesia. He proposes that the moral and ethical justification for representing and revisiting traumatic pasts is not to 'apologise', but to 'account for' (Ricoeur and Antohi 2005). His notion of 'accounting for' is an active process that he likens to a request for forgiveness. He asserts that forgiveness cannot be bestowed, it can only be set in process by embarking upon a journey toward mimesis: a mimesis in which one consents to see oneself through the eyes of another. This 'accounting for' process incorporates education, participation, representation and identification with

others. It may also therefore be regarded as a form of 'active memorialisation' (Young 1993: 4).[5]

Museums are rightly concerned with the authenticity of the objects that they display, and have developed conventions for differentiating between the real and the replica. In this chapter, however, I will suggest that when exhibiting actions rather than objects, especially in the case of damaging human behaviours, different notions of authenticity and replication should be considered. In order to 'account for' these 'intangible human remains' through mimesis in museum theatre, I suggest that subjective rather than objective conventions of authenticity need to be developed and a greater attention paid to the aesthetic effect of dramatic metaphor.

I hope that by sharing reflections upon my practice in this area, this chapter may contribute toward debate about the variety of forms through which those engaged in museum theatre interpret this and other difficult and sensitive histories.

Background and context

As part of the commemorations of the bicentenary of the British Parliamentary Abolition of the Slave Trade Act in 2007, I was commissioned by National Museums Liverpool to research, write and produce a museum theatre play to be performed at The International Slavery Museum (ISM).

The city of Liverpool provided a site-specific context to the piece, the 'host' for the transparent 'ghost' of the performance.[6] The International Slavery Museum is situated within The Merseyside Maritime Museum. The buildings are part of the historic Albert Dock, an area from which, until the 1807 abolition, ships loaded and unloaded material goods on the outward and return legs of their triangular transatlantic slavery voyages. During the nineteenth century, Liverpool became the principal port through which migrants to and from America passed, including those involved in the anti-slavery movement. After the Fugitive Slave Act of 1850, Liverpool received increasing numbers of former slaves who were no longer safe from recapture in the free northern states of America. Once in Britain, many of them published their life narratives, or toured giving lectures about their personal experiences of enslavement (Fisch 2000: 69). The arrival of two of these fugitives, the story of how they came to Liverpool, and their hopes for the future, became the centre of my drama.

My brief was to create a half-hour piece of dramatic theatre, for two freelance actors, which could be performed three times a day to audiences of about seventy people in the opening weeks of the museum. It would subsequently be offered to general visitors as part of the well-established live interpretation programme, and to visiting school groups in term time.

The Anthony Walker Education room, in which the piece was to be performed, is dedicated to the memory of a black British teenager who, while crossing a park with a white female friend in July 2005, was tragically murdered in a racist attack. His remarkably forgiving family subsequently set up a charity to promote racial harmony among young people. The room memorialises both his death and their benevolence. Activities in this room are intended to stimulate intercultural dialogue on the links between the past, present and future.

On the eve of the opening of the ISM, the director of National Museums Liverpool, Dr David Fleming OBE, set out his vision, making explicit the museum's contemporary social agenda.

> Make no mistake, this is a museum with a mission. We wish to help counter the disease of racism, and at the heart of the museum is a rage which will not be quieted while racists walk the streets of our cities, and while many people in Africa, the Caribbean, and elsewhere, continue to subsist in a state of chronic poverty. This is not a museum that could be described as a 'neutral space' – it is a place of commitment, controversy, honesty, and campaigning. (Fleming 2007)

Given this passion, it is not surprising that my brief included the instruction 'to hit every emotional button there is'.[7]

I therefore set out to create a performance that would engage the audience through empathy, link the past with the present by provoking questions about racial identity, and inspire positive agency. The points of context described impacted on my choice of which slave narrative to adapt, the way in which the story resonated with the performance space, the conventions used in the production, and its reception by the audience.

Destination Freedom

Destination Freedom (Farthing 2007) is the text that emerged from the commissioning process. The plot is based on a biographical account *Running a Thousand Miles for Freedom or, The Escape of William and Ellen Craft from Slavery* (Craft 1860). The principal narrative concerns the flight of a young married couple from enslavement in Georgia to freedom in Philadelphia and their onward journey to Liverpool. Owned by different masters, William and Ellen could not live together. Ellen was fair-skinned, the offspring of her African-American mother Maria, and her mother's owner Colonel James Smith. As she was frequently mistaken for a member of Smith's family, at the age of eleven she was given away as a wedding gift. Determined not to be separated from each other or any children they might have, in December 1848 the Crafts planned a daring escape. Their journey of a thousand miles and eight days was undertaken using public transport, during which time Ellen

assumed the disguise of an invalid white slave-owner, Mr William Johnson, and her husband William assumed the role of his slave.

Slave narratives, often transcribed by abolitionist amanuenses, were a popular publishing phenomenon on both sides of the Atlantic in the mid-nineteenth century (Fisch 2000: 52). But the Crafts declined to entrust any ghost-writer with the telling of their tale. Instead, they presented their narrative live at public meetings until, in 1860, William gained sufficient literacy skills to set it down himself, almost twelve years after the events described.

This published narrative provided in effect a palimpsest suggesting the form in which they had performed their story. Whereas other slave narratives are linear and organised, William's is choppy and episodic, alternating between direct address to the reader, reminiscence, anecdotes and quotations from religious texts, combining vernacular speech, literary writing and poetic metaphor. To me, the text resembled a patchwork of theatrical transcription, like a stage-manager's promptbook.

Additional evidence gleaned from letters between their bookers on the abolitionist circuit (Taylor 1974: 400) and from newspaper accounts in which they corrected comparisons between their experiences and those of fictional characters in *Uncle Tom's Cabin* (Meer 2005: 179) suggested that there might have been some tension between them about 'performing' their story, arising from their increasing celebrity, their attitude towards selling their story, their differing literacy abilities, and their reception among the predominantly white middle-class campaigners in England.

These tensions were woven into the dramatisation both as a meta-narrative and subtext. By using multiple frames the characters were able to comment upon their own and each other's behaviour, and simultaneously draw attention to the performative, constructed and fictitious nature of both biography and historical re-enactment.

The outer theatrical frame of *Destination Freedom* was set up during an orientation speech, delivered by a member of museum staff, in which the audience was asked to imagine themselves at an anti-slavery meeting in 1850, and to prepare to welcome the guest speakers, William and Ellen Craft, who had recently arrived in Liverpool having fled the Fugitive Slave Law. The contemporary audience was in this way enrolled in the action as an historical audience at an imagined event, without being required to perform.

Zariah Bailey as William and Nevean Riley-Mohammed as Ellen then shook hands with as many people as possible as they made their way to the front. This physical touch confirmed the enrolment of the audience into a shared double consciousness of imagined time as well as space, 1850 and 2007, an abolitionist meeting and the Anthony Walker room, and created an atmosphere of intimate presence. Touch was also thus established as a metaphorical symbol for further development later on.

The Crafts then addressed the audience at the 'abolitionist meeting' and began to relate the extraordinary events of their journey. However, their narration was ruptured at this point by dialogue between the characters debating the dignity of presenting their private story in public at all. Ellen reminds William that 'ladies do not speak in public', nor does she want to commodify their story by repeated telling. She would rather hold their history coded in the patterns of their treasured quilt, made of material fragments from their absent relatives, to be decoded privately to their future family. William insists that until they can get work they must tell their story as 'it is the most valuable thing we have'. At this point I deliberately wanted to juxtapose the preservation and interpretation of personal narrative through material evidence (the quilt) and oral transmission (the story), and draw attention to the unreliability of both forms of museological translation through exhibition.

During the flashback scenes representing their journey William and Ellen have very different experiences, and this was advantageous to the plotting, given the expositional nature of museum theatre, where contextual information often has to be delivered alongside dramatic action. Ellen struggles to maintain not only her disguise as a white male planter, but also the role, which at the time was contradictory to her class, race, gender, politics and marital status. William has to maintain the lowest status role in order to remain unnoticed. In public he is unable to initiate either speech or action. Only in private can he discuss the self-determination of their futures.

Through William's action we were able to relate some of the generic experiences of the enslaved, sleeping on 'cotton bags' on the deck of the ship, riding the train in 'the negro car' and eating 'corn hash from a rusty plate outside the kitchen door' at the hotel. His encounters with other people, black and white, enslaved and free, provided a strong contrast to hers. While disguised as Mr Johnson, Ellen sits at the 'Captain's right hand' at breakfast, and rides in 'one of the best carriages'. While travelling she reluctantly participates in conversations with slaveholders, slave-dealers and transport authority figures who defend the institution of slavery and condemn the anti-slavery movement. By alternating between their parallel experiences, a cross-section of society could be represented, enabling us to fill in the generic environment surrounding their particular narrative without having to hold up the action for explanation.

Adopting a well-established theatrical convention, we used a ladder, a trunk and a coat stand to visually and spatially represent parts of ships, trains, horse-drawn carriages and hotel windows. But we also created imaginary divisions in the height and width of the playing space, imaginary force fields that separated their physical experiences. Between leaving Georgia and arriving in Philadelphia they did not touch, thereby emphasising those physical, emotional and psychological barriers created by artificial racial divides. When they were reunited in a hotel room, under the quilt, the audience, many of

them unused to the restrained conventions of British theatre-going, frequently erupted in cheering.

In the final scene we returned to the outer frame of the anti-slavery meeting, where William and Ellen spoke to the audience of their aspirations: 'If we are to be blessed with children, we hope they will be free and equal here.' This appeal from the past to the present utilised the dramatic irony of the audience knowing more about inter-racial relationships in Britain than the characters. It was intended to remind the audience of Anthony Walker, and other victims of race hate crimes, and to encourage them to think about their own opportunities for positive action.

After the performance, the actors came out of role and took questions about the Crafts' biographical details. However, they also answered questions with questions, asking the audience whether they thought the children of the Crafts could yet be free and equal, and if not what needed to be done today. This stimulation of debate led to the sharing of many personal experiences from those of all ethnicities. One apparently white British elderly lady revealed that she was a direct descendent of the Crafts, and shared her own family history of race relations.

Destination Freedom the play consists of a series of short scenes, each with its own form of address, either direct to the audience, re-enactment, or commentary between the characters. The scenes are interspersed with percussive underscore and snatches of song. Creating a performance with so many layers and frames certainly challenged the actors, especially as they had to sustain several conventions and switch deftly between them, without the assistance of scenic devices such as lighting, sound or projections.

The broader relationships between drama and history, and the manipulation of aesthetic effects, will be addressed more fully in the reflective analysis that follows.

Displaying intangible human remains

Human remains should be displayed only if the museum believes that it makes a material contribution to a particular interpretation; and that contribution could not be made equally effectively in another way. Displays should always be accompanied by sufficient explanatory material. (DCMS 2005: 20)

The Guidance for the Care of Human Remains in Museums was drawn up in the climate of ethical and philosophical debate surrounding the 2004 Human Tissue Bill. The guidelines further recommend that human remains should be cared for and displayed with respect for their spiritual and cultural value and meaning to ancestors.

The history of slavery is often described in language that reveals a living legacy of unresolved issues: terms such as hot, emotive, controversial or

sensitive.[8] I would suggest that this is because examining this history brings out for scrutiny those 'intangible human remains' that are embedded in our living intangible cultural heritage.

The DCMS defines 'human remains' as the body parts of 'once living people'. UNESCO defines intangible cultural heritage as follows:

> The 'intangible cultural heritage' means the practices, representations, expressions, knowledge, skills – as well as the instruments, objects, artefacts and cultural spaces associated therewith – that communities, groups and, in some cases, individuals recognize as part of their cultural heritage. This intangible cultural heritage, transmitted from generation to generation, is constantly recreated by communities and groups in response to their environment, their interaction with nature and their history, and provides them with a sense of identity and continuity, thus promoting respect for cultural diversity and human creativity. (UNESCO 2003: 3)

The 'intangible human remains ' to which I am referring are not confined to cultural practices, but include the attitudes, beliefs and prejudices that were created, supported and maintained by 'once living people' for specific economic or nationalistic ends in the past, but which are 'constantly recreated'. While UNESCO conceives intangible cultural heritage in the positive, I would suggest that some aspects of embedded living culture are less so.

The history of slavery and abolition acknowledges that certain interpersonal behaviours were developed along with the economic and social systems. These include, but are not limited to, racism, identity formation and othering, abuses of power, justification of inequality, fear, violence, guilt, denial, resistance and retribution. Any authentic representation of slavery therefore should take the above into account. Yet there are ethical considerations associated with embodying and enacting such damaging human behaviours.

The past is not always a foreign country. The making of meaning in museum settings can be painful, especially where the legacies of the past are felt to be too familiar. The research undertaken by the actors in *Destination Freedom* brought up many issues relating to their current lived experience of racial intolerance and abuse. Audiences also shared stories of their lived experiences of damaged race relations in discussions after the performances.

Cultural practices and beliefs have been described as 'memes', combining the ideas of genetic evolution and mutation with mimesis, the processes of imitation and replication. However, 'from the point of view of the "selfish memes" all that matters is replication, regardless of the effect on either us or our genes' (Blackmore 2010). The 'memes' of intangible culture are not always benign. Like the evils unleashed from Pandora's box that are impossible to put back, or rogue genes that slowly destroy the host, they can infect and disease the living culture. Therefore, to reproduce through simple

mimesis the beliefs and prejudices of the period of transatlantic slavery, without establishing a critical perspective or a distancing framework, could merely provide a haven in which racist and prejudicial attitudes and behaviours could flourish.

Living history has traditionally been judged using criteria that assume that the 'quality of representation is directly related to the degree of accuracy obtained' (Magelssen 2007: xiv), but without acknowledging that 'accuracy and authenticity are socially constructed relationships' (*ibid.*: xiii). Living history sites such as Colonial Williamsburg prefer to avoid representing historically documented brutality and violence, rather than adopt less naturalistic forms. In so doing they risk being criticised for whitewashing the history of slavery.

In dramatised museum theatre, there is greater potential to frame and represent damaging human behaviours in non-naturalistic ways. Metaphoric representation, using a range of distancing devices that require the observer to engage in the act of connecting the metaphor with the meaning, can and I believe should be more widely employed. Unless we in museum theatre are able to expand our concept of authenticity, to value not only objective veracity but subjective verisimilitude, we risk negating those methods that have been developed by dramatists over thousands of years as ways of approaching subjects that invoke pity and terror. The tragedies of the most difficult and sensitive histories are not best served by selective replication.

Museum theatre: interpretation and aesthetics, meaning effects and presence effects

The 'new museology' characterises all museum visitors as informal learners, and recognises that museums are multi-modal, knowledge-rich places for the making of meaning (Falk and Dierking 2000; Hein 2001; Hooper-Greenhill 2004). They are also increasingly rich with stimuli for aesthetic experience. Performance, whether received live as museum theatre or as audio-visual media, is a form of heritage interpretation. It should therefore seek to provoke rather than instruct (Tilden 2007: 59). Museum theatre is as much a product of the creative Muses as of their mother Mnemosyne, goddess of memory. It has great capacity to represent historical narratives through the mediating aesthetic devices of metaphor, metonym and mnemonic.

In imagining a new epistemology for the humanities that is more closely connected to the arts, Gumbrecht reconsiders the aesthetic impact of cultural phenomena and cultural events. He claims that we conceive of aesthetic experience as an oscillation (and sometimes as an interference) between 'presence effects' and 'meaning effects' (Gumbrecht 2004: 2). He suggests that it is through 'presence effects' that aesthetic experience is made tangible; the often

involuntary response of our senses and our bodies generating a form of knowing or 're-cognition' that meaning alone cannot convey. (Perhaps it was this oscillating combination of feeling and knowing that prompted the audience to applaud when the characters were again able to touch.)

Constructivist learning in the museum also relies upon recognition in order to build knowledge in the learner. Those creating constructivist exhibits are advised to incorporate elements of the familiar in order to facilitate this kind of connective learning (Hein 2001: 164). However, should museums that deal with difficult and sensitive histories be striving to make damaging human behaviours seem familiar, or seem strange? In order to hold certain behaviours up to scrutiny, they need to be presented in forms that enable critical distance as well as close recognition. Accurate replication in re-enactment may put us too much at our ease. It may be more suitable when enacting difficult and sensitive histories to create a sense of unease. Brecht's famous 'Verfremdungseffekt' can be translated both as 'making strange' and 'making artistic'.

Dramatists have traditionally used dramatic irony, situations in which the audience knows more than the characters, to promote a sense of double consciousness. As irony taps into knowledge gained outside of the action of the drama, it is well suited to the philosophies of constructivist learning. Irony can be used to connect a domestic narrative to epic events and highlight what classical dramatists would regard as universal human traits. However, dramatic irony performs very different functions depending on whether a tragic or comic form is adopted for the dramatic structure.

In 2007 I observed that many museums adopted a classical tragic narrative structure for their exhibits concerning the bicentenary of abolition, depicting mercantile greed as a form of hubris, assigning the roles of heroes to individual abolitionists, and portraying the enslaved victims as a numerous, nameless chorus. These portrayals generated an Aristotelian sense of 'pity and terror', but they also led some visitors to absorb (and later express in interviews) a nihilistic vision of 'man's inevitable inhumanity to man'.[9] Classical tragic form, at least as traditionally conceived, portrays the human traits that conspired to create transatlantic slavery as inevitable and unchangeable. This risks contributing to a sense of powerlessness in the viewer. In order to empower agency, we need to represent the potential for change.

One way of dispelling fear and neurosis is through the use of comedy and satire. However, these performance forms are severely under-represented in museums. In his 1986 play *The Colored Museum*, George C. Wolfe represents the Middle Passage through the satire of a flight attendant preparing the audience for a long voyage across the Atlantic. The audience is enrolled as passengers. 'Welcome aboard Celebrity Slaveship . . . once we reach the required altitude the captain will turn off the "fasten your shackle" sign.' The

comedic irony dispels fear, therefore encouraging, or giving courage to, the audience in order that they may be able to engage with the subjects that cause pity and terror.

Portraying tragic histories within a comic narrative structure can present possibilities for hope, reversal and change. Comic irony can render anti-social behaviours ridiculous or absurd. A knowing fool can puncture established power relations and enable people to imagine alternative ways of being by adopting familiar roles and playing out alternative situations, or, vice versa, familiar situations and alternative roles[10] (Welsford 1935; Fava 2007). In *Destination Freedom* we used comic recognition as a means of engaging the audience with the characters of William and Ellen in their domestic situation, while encouraging critical distance from the epic situation of enslavement. We also used comic recognition to engage the audience with Ellen's situation of being trapped on a train with someone who talks incessantly, while providing critical distance from the slave-owning woman's racist monologue through ridicule; this character was played by Zariah, as William, impersonating the role in drag.

However, the use of comedy for tragic themes is an expert and risky business, requiring confident and sensitive handling. I am not suggesting anyone adopts the 'horrible histories' approach to slavery, creating childish cartoons that focus on bodily functions in order to raise a laugh. What I am proposing is the use of comedic form in dramatic structure, to promote recognition, laughing 'with' rather than 'at' characters that we wish to make familiar, and using satire to hold up to scrutiny those whose behaviours we wish to condemn.[11] Comedies do not have to follow the classical structure of forced narrative closure and happy endings. Deploying irony within a comedic narrative can help us to envisage what alternative realities would look like, while remaining aware of the journey to be travelled between the alternative vision and our lived reality.

Gumbrecht highlights the co-presence of actor and audience in space, the potential for physical touch in such close proximity, and the performance of role type and situation rather than character as factors likely to generate 'presence effects'. However, where I disagree with Gumbrecht is in his supposition that 'there is nothing edifying, no message, and nothing that we can learn from' these tangible aesthetic 'moments of intensity' (Gumbrecht 2004: 97–9). Cognitive science and brain research have advanced our understanding of how the brain works and how we learn through simulated or imagined experience (Neelands 1992; Baldwin 2004; McConachie and Hart 2006; see also Hughes' discussion of this research in Chapter 13). The stimulation of the amygdala that leads to an emotional response affects not only our understanding but also our ability to remember. Our cognitive responses may be difficult to verify, but they are our authentic experiences.

Conclusion: historical drama as museum theatre: a personal viewpoint

Museum curators and historical dramatists both work in the field of interpretive arts. Both create narratives from evidence in order to communicate with the public. Both use objects as symbols, metaphors and metonyms, although the objects may be valued and read in different ways according to whether they are real or replica, displayed out of reach, or used as a 'prop' by an actor in role.

Destination Freedom began with a script, adapted from a slave narrative. In material terms, these tangible documents are the objects, the authentic definite articles. But *Destination Freedom* the drama was an indefinite subjective experience that the audience and the actors shared in time and space: subjectively and I hope aesthetically authentic, but nonetheless intangible.

Drama is dependent upon collaborative modes of production and collective forms of reception (Pfister 1977: 11). Drama requires the participation both of producers and receivers, actors and observers, even when, as is often the case in museum theatre, these roles are blurred. I would argue that these empirical experiences of participation are in their own way authentic, creating knowledge from the shared experience of aesthetic sensation rather than the application of individual logic.

Drama and history are both about what people do, with each other and to each other, and why. But whereas historical narratives are relayed in the past tense, the enactment of dramatic narrative takes place in the present tense. Historical enquiry asks 'What happened, and why?' At the heart of dramatic enquiry is the question 'Who wants what from whom, and what are they wiling to do in order to get it?' Therefore, whereas history is concerned with the event and its aftermath, and studies the evidence that remains, drama is concerned with the event and what motivates the action. As motivation is very difficult to prove, historical drama will always be reliant on a larger dose of speculation and conjecture than evidence-based history.

Museum theatre is obviously reliant on historical research, but it is also reliant on dramatic structure to be affective and therefore effective. While the most accurate and authentic re-enactment of an event is performative, and may even be regarded as a form of archeology, it does not make a drama. Whether a drama is regarded as authentic – by which I mean recognized as true, real, honest or meaningful – will depend upon the personal response of the receiver, not the quantity of evidence provided by the research. This subjective form of authenticity provides the dramatic medium with its power, and with power comes responsibility.

Earlier, I outlined certain contexts of location, time, space and narrative, and the way that I attempted to respond to the brief, taking these contexts into account when choosing to dramatise the narrative of William and Ellen

Craft. I cannot be sure exactly which elements created most resonance for each member of the audience. But I hope that by indicating some of the intentions that I had for the production, and the reasons for them, I may encourage others working in the field to discuss form, as well as content, when planning museum theatre with curatorial staff.

Museums dedicated to the narratives of tragic events can provide spaces and opportunities for participating in forms of active memorialisation. Museum theatre, accompanied by appropriate attendant rituals such as discussion or other dialogic responses, can be a part of active memorialisation if it is conceived of as a metaphoric interpretive art form, akin to the creation of a painting or sculpture. However, as Bertolt Brecht (1965) was aware, complex seeing must be practised, and while dramatised museum theatre is viewed through the same lens and assessed by the same criteria of authenticity as re-enactment and living history, it may be inhibited from fully developing its interpretive metaphorical power.

Notes

1 The British Empire and Commonwealth Museum's 'Breaking The Chains' exhibition (Bristol, 2007) used objects to illustrate the text narrative rather than vice versa. Richard Benjamin, director of The International Slavery Museum, has also acknowledged the difficulties of reducing text panels: www.history. ac.uk/1807commemorated/interviews/benjamin.html (accessed on 15 June 2010).

2 The New York Historical Society's 'Slavery in New York 1620–1827' exhibition used empty display cases to highlight the absence of material culture from the enslaved: www.slaveryinnewyork.org/about_exhibit.htm (accessed on 15 June 2010).

3 My own work in this area includes projects for English Heritage, Royal Naval Museum, Epping Forest District Museum, International Slavery Museum, British Empire and Commonwealth Museum, National Maritime Museum, Plymouth Museum, Creative Partnerships Cumbria and Bristol Museums. Drama has also been employed to interpret the history of slavery by Manchester Museum, Gloucester Records Office, The National Archives and many more.

4 Public opinions about 'apology' have been documented by the 1807 Commemorated research project – www.history.ac.uk/1807commemorated/ audiences/audience.html (accessed 7 October 2008) – and were expressed during the debate hosted by The British Empire and Commonwealth Museum on 10 May 2006: www.empiremuseum.co.uk/aboutus/relationalnews.htm (accessed 7 October 2008).

5 Young argues that conventional memorials may relieve viewers of their memory-burden. He suggests that creative educational activities, owing to their fluid and temporal nature, provide forms of active memorialisation that promote greater understanding and heighten awareness of the links between past, present and future.

6 Mike Pearson (1997) coined the terms 'host and ghost'.

7 Carol White, discussion of the commission brief for the museum theatre piece (*Destination Freedom*) for the International Slavery Museum, Liverpool. Personal interview with author, Liverpool, 19 July 2006.

8 Britain and the Slave Trade is a major case study in the report published by the Historical Association, *T.E.A.C.H. Teaching Emotive and Controversial History 3–19* (Historical Association 2007: 37).

9 Documented in the findings of the 1807 Commemorated research project. See note 4.

10 Chaplin's film *The Great Dictator* uses humour to subvert Hitler's seemingly irrepressible rise to power.

11 At the Anne Frank Museum in Amsterdam, young people are encouraged to draw comic representations of those who support prejudices. One cartoon that I saw depicted a group of children ridiculing a Ku Klux Klan costume, thereby puncturing its power.

8

Interpreting Msinsi: culture, tourism and storytelling in the iSimangaliso Wetland Park

Nicky du Plessis and Emma Durden

South Africa is a society in multiple and simultaneous transitions, and perceptions and new articulations of cultural heritage are evolving rapidly. This chapter is an analysis of a cultural tourism pilot project conducted in the iSimangaliso Wetland Park, a UNESCO World Heritage site on the east coast of South Africa. The Cultural Walks Project was an attempt to provide fundamental material and storytelling techniques for emerging tour guides of the iSimangaliso Wetland Park, who are beginning to interpret local traditions and practices to develop unique cultural tourism products.[1]

The title of this chapter is drawn from the Zulu tradition of planting a coral tree (*Erythrina caffra*), known as *msinsi* in Zulu, to invoke protection and symbolise a safe homestead. Based on this tradition, there is a common Zulu saying, 'msinsi wokuzimilela', which translates as 'where I was born and bred'. In areas where people were forcibly removed due to apartheid legislation, sometimes all that is left to indicate a former human settlement is the *msinsi* tree, with its distinctive coral-coloured flowers.

A cultural interpretation of the environment must make reference to cultural practices that shape, and have been shaped by, the landscape. Understanding what signifies 'home' (symbolised by the *msinsi*), and how the elements which constitute 'home' change over time and through various circumstances, was the core of the Cultural Walks Project. The project methodology was rooted in basic performance-based techniques of narration and the construction of stories. This aimed to reflect the dynamic nature of cultural practice and allow for contemporary interpretations.

This chapter describes the processes of the project, and raises some theoretical questions that inform the teaching of performance and the interpretation of heritage or *msinsi wokuzimilela* – the place where we were born and bred.

The iSimangaliso Wetland Park and a brief history of human habitation

The iSimangaliso Wetland Park was proclaimed as a National Park by government decree in November 2000. The Park is located in KwaZulu-Natal (KZN) and stretches from Maphelane in the south, to Kosi Bay in the north, on the Mozambique border. It was the first site in South Africa to be inscribed on the World Heritage List by UNESCO in 1999, and is recognised for its exceptional ecosystems and biodiversity.

There is a long history of settlement of people in the iSimangaliso area. Earliest evidence of human inhabitants comes from Stone and Iron Age sites, with evidence of the use of tools by the ancestors of modern Nguni peoples, which includes the isiZulu and isiThonga speakers who are now resident in the area. More recent colonial history notes the presence of Portuguese explorers in 1554, before the British colonised the area in the 1800s. During the apartheid government rule in South Africa from 1948 to 1994, land policy resulted in the forced removal of black people from areas which were of commercial or social significance for the ruling minority. From the 1950s to the early 1980s, fourteen communities or groups of people were forcibly removed from the iSimangaliso Wetland Park area. The reasons for these removals varied as the land was targeted for different uses by the apartheid state, including commercial forestry, missile testing and conservation (Walker 2005). The current democratically elected government has instituted land restitution policies since 1994 to address these removals.

This study focuses on two specific groups: the Bhangazi claimants, who lost their land on the eastern shores of Lake St Lucia; and the people from KwaMvutshane at Kosi Bay. The Bhangazi Land Claim was settled in 1999. As the site was considered vital for biodiversity conservation, the land was not returned to former inhabitants and monetary compensation was provided to those families. The Bhangazi community has a range of different access rights to their ancestral lands and receives a share of park gate revenue. A cultural heritage site, equity shareholding, jobs and procurement opportunities in tourism and development programmes on the Eastern Shores are current and proposed benefits. KwaMvutshane, is an *isigodi* (administrative unit under the traditional authority system) on the boundary of the iSimangaliso Wetland Park. Due to its location near the Kosi Bay estuary mouth, a community-run tourism facility has been established with assistance from a local non-governmental organisation. Some of the people living at KwaMvutshane are also part of the as yet unsettled land claim which has been lodged on the Coastal Forest Reserve section of iSimangaliso.

The iSimangaliso Wetland Park Authority is a body legally mandated to integrate the delivery of development and community empowerment alongside the conservation and protection of the Park's natural and cultural resources.

This represents a new model for protected area development and management, recognising that it is impossible to conserve the natural environment without putting the needs of people who live in and rely on that environment at the centre of the conservation strategy. Carefully managed tourism development is thus seen as the main strategy to generate benefits for local communities, particularly land claimants (iSimangaliso Wetland Park Authority 2007). A number of skills-transfer programmes have therefore been implemented as part of the development strategy of the Authority, so that income-generation opportunities in the tourism sector can be taken up by local communities. The Cultural Walks Project described here is one of those initiatives.

The Cultural Walks Pilot Project: a brief description of activities implemented

The Cultural Walks Project focused on two specific geographical areas of the iSimangaliso Park: the Eastern Shores and Kosi Bay. The project had three key aims: the collection and compilation of stories; the mapping of walks in the area; and the teaching of stories and presentation skills to newly trained tour guides.

The first step involved the collection of stories of the residents of the park areas, particularly those who were forcibly removed from their homes and land. The team worked with the Authority to identify families that still had living members who had experienced the removals first hand, as well as others who had close links with those families. A total of eight group interviews were held with community members in the areas of Kosi Bay, at KwaMvutshane in the north, and in St Lucia (near the Eastern Shores) in the south. Further interviews were held with key individuals, including local community leaders and renowned traditional healers. The information was collated into five distinct themes investigating forced removals and subsequent social changes; childhood and rites of passage; how people lived in relation to the land, flora and fauna; festival occasions in the community; and belief systems and traditions of healing.

Interviews were also held with Ezemvelo KZN Wildlife (the local conservation authority), to compare some of the information that was given regarding the usage of plants and animals in the area, and the history of co-operation and conflict between the people and the different conservation authorities over time. Various research papers, books and other sources that documented the human and cultural history of the area were also referred to. While these were attempts to triangulate the information, the process often raised more questions than it answered, as is discussed in the following section.

The second step in the project concerned identifying accessible two-hour walks, one at the estuary at Kosi Bay and the other at Mission Rocks on the Eastern Shores, which would offer opportunities to present the cultural

material in the physical landscape. A line map of each walk was plotted with points of interest and specific natural features noted. As there are no building remains of the lives of people who lived in the Bhangazi area and a few ruins at the Kosi site, the walks needed to focus on what could still be seen now: primarily flora and fauna. However, these walks were not designed as nature walks, but specifically shaped to demonstrate how cultural beliefs and practices are reflected in people's interactions with the physical environment and the interplay between the two.

The third step was the development of a training manual and programme for the group of twenty-five unemployed people from the area who were selected by the iSimangaliso Wetland Park Authority for the pilot project. Most of the learners had previously undergone an introductory training course in tour-guiding, and some had experience with respect to interpreting the natural environment. The ability to perform or previous performance training was not a selection criterion. The training took place over two weeks, with a week spent in each area. It was considered important that all learners worked in both areas, rather than remaining only in the area of their origin. This allowed for reinforcement of the learning processes as the content was similar, but also provided opportunities for stories to be shared between these communities.

Data collection, content creation and contested histories

Instead of preparing scripts of information for the trainee guides to rote learn and present in a linear manner predetermined by the trainers, the information was presented as a mosaic of stories and facts that were categorised by the five themes described, and cross-referenced between themes. These facts or elements of stories could then be told in various combinations in response to a variety of contextual stimuli, including the needs and interests of the tourist clients, the personality or particular experiences of the tour guide, and the collective experience of the environment on the particular occasion of the walk. The intention was to empower the learners to use the content material not as fixed lists of facts to be recited, but as starting points from which they could fashion a narrative animated by their own style. It was important to encourage stories of contemporary cultural practice and not only nostalgic views of historical cultural traditions of the past. In this way, the current and personal experiences of the tour-guides were drawn into the creation of the narrative, and the fundamental notion that cultural practice is dynamic and not statically enshrined in the past was reinforced.

At the core of this is the *bricolage* concept of French philosopher Lévi-Strauss (1966) adopted by arts and cultural studies. *Bricolage* refers to the artful construction of work or a narrative that draws on what is at hand, and

often refers to practices that develop as alternatives to the mainstream. It allows for improvisational strategies and relies on an intimate knowledge of resources and possibilities, rather than the rigidity of a strictly theory-based construct. It finds expression in self-correcting structures that are attuned to feedback through careful observation and listening. Although a generalised and broad concept, *bricolage* does offer a theoretical framework for this project, and some justification of the methodologies used. In particular, it helps begin to address the issues of contested histories and hidden voices, and provides a space for previously disempowered people to take ownership of a narrative.

At its most basic, history can be defined as the telling of stories from the past. However, questions of who tells these stories about whom must be addressed in order to have a more holistic understanding of what has gone before. In postcolonial countries such as South Africa, the 'who' and the 'why' of storytelling shapes perceptions of both the country and its people. The Cultural Walks Project was an attempt to begin to collect and create stories from previously unheard voices of those who had been dispossessed of their land around the iSimangaliso Wetland Park. Bronwyn James of the iSimangaliso Wetland Park Authority comments:

> The important issues for us were that the previous interpretations of the land-scape were predominantly concerned with the natural history, that historical interpretations were colonial and served white interests, the stories of the land claimants were not known, many of the youth did not know the stories of their forefathers, and there needed to be a process of inter-generational transmission (which we could support through documentation and training). Our interest lay with pulling out the hidden silent voices of the people who used to inhabit the land. (James, interview, 2008)

The process of soliciting stories as a source of hitherto unrecorded data and cultural information is complex. Storytellers often embellish the details, change the facts, and suit the story to their own purposes. The Zulu oral tradition is particularly context dependent, and stories are adjusted to appeal to the audience and the function of the storytelling event (Groenewald 2003). The multiplicity of motivations behind the memories and stories must be acknowledged, and we found that memory is often clouded by forgetting and desire. A frequently noted response, from initial research respondents, to the question regarding what they would want tourists to know about the area was 'They should know how we lived. How good it was then' (interview A, 2006). This nostalgia may have meant that some of the stories gathered in the initial data collection were painted over with a wistful brush.

From a traditionally Western academic perspective, the veracity of these informal stories can be seen to be questionable, merely anecdotal. And yet the majority of the formal records must be understood as coming from a different

(colonial) perspective, which has its own shortcomings. This project tried to make use of local knowledge, allowing for different appreciations of intangible heritage to emerge alongside the mainstream discourse, and also according status to people who are knowledgeable in ways outside of formal academia (see Chapters 5, 6 and 7 for more on intangible heritages).

The Cultural Walks Project data collection process was limited in various respects: the team was not trained as oral history research specialists (they were all from a storytelling or performance background); the transcriber (an isiZulu speaker) could not always identify a direct translation for some of the concepts explored in the conversations with the older people from the northern areas, who spoke a mixture of isiZulu and isiThonga; collection of oral history is extremely time-consuming; and there was insufficient triangulation of information with other community members due to time and budget restrictions.

However, this project was not an academic research exercise. The ultimate goal was to provide a learning process of storytelling so that young guides could create an attractive cultural product for the tourist market. A filter on material gathered was provided to some extent by this aim, as well as the first filter of the five themes of material. Historical relativism, unavoidable contradictions and the influence of market forces within the tourism sector all had to be navigated as skilfully as possible to avoid making the process overwhelming for the learners.

These learners were mostly young people with little or no tertiary education. The primary aim was to give them the confidence to work with a range of resource material that they could continually build on. This could be done through interaction with each other and members of their community, through continued interaction with the iSimangaliso Wetland Park Authority, and through developing their own creativity. The secondary aim was to develop a sense of the market needs and what would be attractive to tourists: thus creating a unique selling proposition for the cultural experience of a guided walk.

Bricolage of the material was implicitly taught via various storytelling and performance skills. This included using a range of forms of oral expression, both traditional and modern, and basic training in the use of the voice. Creating a structure for stories was important to provide an understanding of how information can be paced, including finding a resolution for each sub-narrative, while holding the overall rhythm of the entire presentation. Transitions between stories and points of interest on the walk needed attention, as did monitoring of responses and reactions from the audience. The learner guides were videoed, and peer critique and feedback was a central feature of the learning process.

In order to boost the confidence of the learners (who speak English as

their second or third language), the emphasis was on identifying dramatic features for each walk. These had to be appropriate to the information on hand, or useful reactions to stimuli from the physical landscape, in order to create engaging experiences that might not rely on the formal construction of language as the sole means of communication. This would allow for more interaction with the visitors both in presenting and receiving information, and enable each guide to work to their own personal communication strengths, rather than having to conform to a master script of information and a generic delivery style.

Hence a variety of performance techniques were incorporated in the training, including song, dance, stories, games and role-play. Learners were encouraged to draw on material or techniques that they felt comfortable with, and their personal efficacy in realigning the material to suit their own strengths was reinforced. The learners were always drawn back to the question of how they could make the guided walk a personal and exciting interactive experience for the client. A number of the trainees brought their own experiences to the training. In this way, other stories were shared, and the trainee guides added to the research and the resultant training materials that have since been developed.

Frames of reference and building performance

Current theory in the realm of drama and performance places great emphasis on reader reception, where the audience is actively engaged in the decoding of meaning through performance (Kernodle et al. 1985). Performances are subjective and require frames or conventions within which they can be more readily understood by audiences. These conventions function in the same way that rules apply to sports, and tradition applies to rituals. The purpose of these rules or conventions is to govern an activity that is outside of everyday life, part of a 'special world' (Schechner 2003: 13). Theatrical communication can be clearer and more meaningful if the audience has a prior knowledge of the conventions used. These conventions encourage audiences to measure a viewed performance against a standard that they recognise; what Schechner terms an 'objective standard' (2003: 45).

The performance demanded by the Western Aristotelian theatrical tradition requires a linear narrative structure, with a climax and resolution not only to each story within the presentation, but also to the whole presentation. The traditions of Zulu praise poetry are more circular, where there is seldom one point to be made but a collection of opinions and references, and tradition allows considerable time for these to be presented to the audience.

There is a potential for a clash between the expectations of an audience familiar with the linear Western tradition, and the Zulu circular presentational

style, incorporating poetry and dance. One of the questions raised by this pilot project is whether audiences from Western countries who are unused to the conventions of Zulu oral traditions are able to draw sufficient meaning from the guided walk stories and performance elements. While Zulu oral tradition has had a functional role in the rites of passage, the rituals and the education of Zulu communities, it has expanded and become democratised and more accessible since the early 2000s (Groenewald 2003). This may mean that the forms are recognised by other South African visitors to the site, but for those that are entirely unfamiliar with Zulu custom, it may still be too foreign to access.

Not only performance conventions, but also the content of the discussion of the walks may also leave visitors unclear about the presented information, or unable to access it. Observations about African cultures by early European missionaries and anthropologists showed little understanding of the local way of life (Mabweazara 2008). Similarly, the frames of reference and the life experiences of contemporary foreign visitors and the local tour guides are significantly different enough for there to be little commonality. This lack of common reference points highlighted a need for the guides to incorporate narration into their performative moments, to facilitate tourists' understandings of new concepts or unfamiliar performance elements that may be used.

The learner guides had to try to find ways to help foreigners understand the universality behind specific cultural traditions. However, they had very little exposure to cultural practices beyond their own, apart from television viewing (mostly American sitcoms and action movies). It was difficult for them to get the necessary distance to select or highlight features which might be interesting for tourists. It takes time and experimental practice to be able to successfully identify and incorporate personal anecdotes and occurrences that might be both interesting and accessible to these visitors.

An anecdote offered by one of the older learners on the course explored how as a young boy he and other pupils used sticks in the sand as their 'exercise books' for learning mathematics at school in the Kosi Bay area. If compared to the well-resourced schools of the majority of the Western world, or indeed to the current situation in South African schools, this becomes an interesting and accessible anecdote. The learner sat down in the sand with a found stick and demonstrated. Using found objects or articles in this way may make the reference more readily accessible to the visitor.

Many learners on the pilot project are also distanced from some of the traditions that they are describing on the walks. In most cases, they are not currently living in the area which they are interpreting for the visitor or may in fact never have lived there. They are repeating stories that they have heard from parents or grandparents; the narratives are often unclear, and could be reconstructed to have more meaning for both the teller and the audience.

Simultaneously, these guides need to grapple with pre-existing expectations of Africa and assumptions that tourists may often bring to the experience.

Seeing Africa as 'other' and contemporising cultural tourism

The *Collins English Dictionary* (2003) defines the exotic as being from another country, and as 'having a strange or bizarre allure'. The nineteenth-century construct of exoticism resulted from increased travel and exploration outside of Europe, and the expansion of colonialism. Even today, much of the cultural tourism in South Africa is positioned around concepts of the strange and unusual, either in terms of animals, or with respect to the traditions of pre-industrial societies.

Cultural villages as a tourist attraction perpetuate the idea that the life of 'the African' is *other*: a pastoral and primal life untouched by modern conveniences. Frequently they make no attempt to portray how daily life for indigenous people has changed dramatically over the twentieth century, and instead rely on a narrow band of representations, which ultimately have become clichéd. One of the most visited centres in KwaZulu Natal is the re-created Zulu village 'Shakaland'. Their website promotes the experience for the visitor as follows:

> Feel the pulsating rhythm of mysterious and magical Africa as you re-live the excitement and romance of the days of Shaka, King of the Zulus, in this authentic re-creation of the Great Kraal . . . Experience the sight of assegai-wielding warriors, share the fascinating secrets of the Sangomas and witness traditional customs such as tribal dancing, spear making and the beer-drinking ceremonies. (Shakaland 2008)

This exotic image is vastly different from the contemporary experience of most Zulu people living in twenty-first-century KZN, and reiterates the otherness of the African experience in the minds of foreign tourists. The nostalgia or need for exoticism associated with popular views of Africa and its indigenous people has long exerted an influence over whose stories and which stories are remembered, told or newly created. The dynamism of cultural practice is frequently and conveniently forgotten in the service of regional and even ethnic nationalism, where one language or cultural grouping might be seeking to entrench their superiority. An overview of South African tourism-related publications shows that the Shaka myth and the Zulu kingdom have become the most dominant images in the publicity around KZN, and in the eyes of the visitor.

Each of the learner guides was asked during their two-week training course to approach a group of tourists and ask them what kind of cultural or heritage information they might be interested in. Almost all mentioned King Shaka,

and traditional Zulu dance. Perhaps hoping that visitors might be interested in a more contemporary and arguably more relevant picture of 'the life of the Zulu' may be unrealistic. However, there does seem to be a growing emphasis on environmentally responsible tourism that provides authentic experiences and respectful interactions with local people, which suggests that the market might be attracted by offerings such as those developed by the Cultural Walks Project.

One of the briefs of the pilot project was to explore culture not only as a historical concept, but also as contemporary experience. The guided walks were therefore built to offer both a view of the past and an understanding of the present beliefs and practices of those living in the area. The core methodology of *bricolage* of stories and the personalising of universal content should enable the guides to respond creatively over the years in order to update material. Once further phases of the project are completed, it would be interesting to research the experiences of the tourists and see which is the more prevailing and dominant image: the magical Zulu kingdom of the past, or the rather more prosaic Zululand of the present.

Explanations and inclusion: an example of performance

A traditional ritual that continues to be practised today in the area is the annual Marula Festival, a harvest festival that takes place in summer at the time of the ripening of the marula fruit (*Scelerocarya birrea*), a dietary mainstay in much of rural South Africa. Thanksgiving rituals of this festival require that members of each community bring five litres of traditionally brewed beer to offer to the chief, who then ceremoniously drinks and gives thanks for the bounty of the tree. It is an opportunity for the community to celebrate together and for ancestors to be honoured.

One of the learners on the first guided walk, Enoch Tembe, based a small performance in his tour around this festival. Enoch identified a marula tree and explained briefly the importance of the festival. He then said to the group, 'I now invite you all to the Festival and to greet the chief.' He chose a man to be the chief and seated him with his back against the trunk of the tree, legs slightly apart with his arms resting on his knees, in a fashion showing rank and authority. He enrolled two others to be the chief's men, who were positioned either side of the chief. Two women were asked to mime bringing pots of beer on their heads to this gathering, and while they did this he encouraged everyone to clap. Enoch sang a rhythmic song that set an atmosphere and his enthusiasm made everyone feel at ease enough to participate, even if just a little. He explained that an *imbongi* (praise singer) would loudly call the praises of the king, and he gave an example of this himself.

When the 'beer-carrying women' approached the 'chief', Enoch instructed

everyone to greet the chief appropriately, saying 'Bayete! Bayete! Bayete!' (the royal salute) in unison. By this point, the 'chief' needed no encouragement to solemnly accept the 'beer', and Enoch explained how the pot would be swilled and then passed around for everyone to have a sip. Everyone in the group had a chance to participate in this mime, and enjoyed declaring that the beer was indeed of high quality. Enoch then showed the 'chief' how he should ritually pour a little of beer on the ground for the ancestors, and everyone applauded, saying 'Bayete!' once more. Enoch finished the role play with the same song, and encouraged everyone to clap along, even if they didn't know the words. He then thanked everyone for coming and asked if they enjoyed the Festival, before moving on with his tour.

This role-play included enrolment of the audience, as well as Enoch himself moving in and out of role as the guide and as the praise singer. The performative elements of song, dance, mime and poetry were all present, creating a small experience that was inclusive and interactive. Actions and roles were simple and un-threatening, enabling people to participate without loss of dignity and without anxiety about performance. Enoch was sufficiently confident and experienced in both singing and praise-singing to be able to spark the imaginations of the people present and make the role-play effective. He also managed the process well by formally concluding the role-play and enabling the next phase of the tour to begin.

In this instance, the audience was made up of trainee guides, familiar with at least the concept of the Marula Festival, if not the details. This may have eased the participation. However the careful framing of the performance and the simple facilitation of the audience involvement would arguably make this a moment in which those unfamiliar with the context (such as foreign tourists) could as easily participate.

Evaluating the training and its long-term effects

The training was considered successful[2] in meeting its aims of increasing the skill level of the guides. Videoed presentations of the learners guiding the walks in both the first and final weeks of the project showed a marked improvement in presentation and storytelling skills in the group, and feedback from the trainee guides was very positive.

An evaluation of the course by the participants on the final day of training suggested that they had enjoyed the format of the course, particularly the high level of participation and interactivity that gave them a chance to talk and be heard, to share information and ideas. Participants commented that they had liked the focus on personal stories, and that they thought the dramatic techniques and the emphasis on entertainment were very useful. The key for the learners was to entertain visitors, and to make the experience

both understandable and memorable. They recognised the need to combine traditional stories and performance elements within a frame that would be accessible to the audience.

A year after the conclusion of the pilot project, follow-up research was conducted to ascertain the effects of the training one year on. This included telephone interviews with two of the iSimangaliso Wetland Park Authority project managers, and a survey of eleven of the sixteen trained guides.[3] Seven of the surveyed trained guides (64%) have done some kind of guiding work since the training, and four (36%) are employed as guides at the time of writing. For people living in an area with a high rate of unemployment, this is a significantly high figure and attests to the fact that the training has assisted in income generation. The surveyed guides reiterated that the most useful elements from the training were the emphasis on entertainment and ways of telling stories. The working guides said that they regularly received positive verbal feedback from tourists on the way that they presented the tours.

This suggests that the selected training methodology of building performance and storytelling skills was a useful strategy for this project. Some learners have since created their own walks and itineraries in surrounding areas, which justifies the use of the *bricolage* training methodology, rather than training the guides in scripted walks that would limit their ability to work in diverse sites.

The iSimangaliso Wetland Park Authority project manager suggests that this process has challenged the more established guides in the area, who have requested training on the cultural history of the area, to improve their own tours. She also commented that what she believed was most valuable was the performance methodology, and that some of the trainees who later enrolled in a formally recognised qualification programme in tourism were adapting and using these methods in their new course. The iSimangaliso Wetland Park Authority believes that there is an increasing need for this kind of methodology that allows for the individual creative interpretation of material, and the authors have been asked to develop the methodology further for this purpose.

Conclusion

Within the context of a changing South Africa, The iSimangaliso Wetland Park Authority development programmes have been attempting to answer some of the questions raised about culture and heritage through various interventions with arts practitioners and tour guides since 2002. The authors have been two of a range of facilitators and trainers who have worked in the Park, contributing to the building of appropriate cultural tourism processes and products, while building skills and resources.

The Cultural Walks Project was an attempt to provide an alternative to conventional tour-guiding and guide training, so that guides would be able to

create and offer a fresh and attractive tourism product. While the collection of stories may have had some limitations and the framing of stories is often a politically charged event, using interpretive and creative strategies such as drama and storytelling can help to overcome some of these issues and offer a dynamic view of culture, incorporating important inherited stories of the local communities, as well as contemporary experience.

In cultural studies the term *bricolage* is used to mean the processes by which people acquire objects from across social divisions to create new cultural identities. In this instance, the guides have used the process of *bricolage* to take the stories and songs and traditions of the past and bring them into the present to create a better understanding of the Zulu experience. The act of using the method of *bricolage* and training the guides in storytelling and drama techniques has given them the tools to be able to create their own walks. Using the source material gathered through the research process, as well as adding their own experiences and family histories, they are able to offer tourists a glimpse of what life was like for those who lived in the Park in the past, as well as to understand the process of change since the mid twentieth century, and the contemporary experience of people who live in the surrounding areas.

This means that tourists may leave with a more informed view of an area that is not only recognised for its natural beauty and biodiversity, but that also has a rich cultural history and present. To walk away from the iSimangaliso Wetland Park with not only memories of landscape and animals, but with an additional understanding of *msinsi wokuzimilela*, the place where the families of the tour guides themselves were born and bred, may be the unique selling point that brings tourists back to the area and allows these young tour guides to make their mark on heritage tours in South Africa.

Primary sources

Interview A: Conducted by Cultural Radius Research team with Mr E Mfeka and family at St Lucia, 17 July 2006.

Interview conducted with Coral Bijoux, iSimangaliso Wetland Park Authority staff, August 2008.

Interview with Coral Bijoux, iSimangaliso Wetland Park Authority staff, February 2009.

Interview conducted with Bronwyn James, iSimangaliso Wetland Park Authority staff, August 2008.

Interviews conducted with the following workshop participants by telephone, September 2008:

• Siphesihle Mkhwanazi
• Gibson Mkhize

- Bongumusa Tembe
- Bhekani Gina
- NompumeleloDlamini
- Bongani Mthembu
- Wayne Ngubane
- Mandla Ngubane
- Christopher Mntambo
- Enoch Tembe
- Khayelihle Sithole

Draft Integrated Management Plan iSimangaliso Wetland Park Authority, August 2008

Notes

1 The authors were contracted by the iSimangaliso Wetland Park Authority to undertake this work in 2006/7.

2 The limitations of the data collection have been noted. A further limitation of this kind of rural development, which brings people together for training in rural areas, is that it is expensive and time-consuming. Ideally, the learning experience should be reinforced frequently over time, allowing the guides to be mentored closely in their own data collection and presentation skills. iSimangaliso Wetland Park Authority is aware of this and is attempting to provide additional and ongoing training.

3 The remaining project participants could not be contacted, as their phone numbers had changed without notice, and no one knew how to get hold of them. This is a common feature of development work in rural South Africa, and does mitigate against the ongoing sustainability of such programmes.

III Re-creating heritage(s)

9

Nostalgia for the future of the past: technological environments and the ecologies of heritage performance

Baz Kershaw

Introduction

Is it redundant to note that the knottiest research problem in museum and heritage theatre is the life of the past and how best to access it in particular spaces and places at specific times? After all, this problem has haunted historians for centuries. But . . . times change, and the onset of postmodernity, hyper-globalisation and turbo-capitalism in the final decades of the twentieth century radically altered the qualities of the past (Harvey 1990: 39–65; Luttwak 1998: 31–53; Murray 2006: 33–8; cf. Thrift 2005: 121–7). Fredric Jameson in 1982 famously saw this as a new Western cultural malaise: 'the disappearance of a sense of history . . . in which our entire contemporary social system has little by little begun to lose a capacity to retain its own past' (Jameson in Foster 1985: 125). From the perspective of the early twenty-first century, Jameson's 'little by little' now seems almost quaint in its caution. As the present speeds ever faster away from a sustainable history, humans everywhere already face a looming future in which global warming promises an uninhabitable planet. What price history, let alone theatre, in this desperate scenario?

I frame the historians' ancient problem so bleakly to indicate why iconoclastic methods may be required for re-imagining the future of the past in heritage and museum theatre. Hence this chapter responds to our new global dilemmas by undertaking a scientifically oriented *thought experiment*. The *Stanford Encyclopedia of Philosophy* defines thought experiments as 'devices of the imagination used to investigate the nature of things', and adds: 'the creation of quantum mechanics and relativity are almost unthinkable without . . . thought experiments' (Stanford Encyclopedia 2008, thought experiments; accessed 13 September 2009). 'Devices of the imagination' could equally refer to the historically anomalous practice of staging theatrical events in museums and at heritage sites: 'anomalous', because those sites are devoted to combating the ephemeral. So in a century rushing headlong

toward a wholesale 'disappearance of history', with signs of human nostalgia for the future emerging everywhere (Kershaw 2007b: 142–9), in what ways might that apparently out-of-place art be a *hopeful* part of the wider 'nature of things'?

Linking the performance practices explored in this book to questions of human–animal survival beyond the next generation or two might seem somewhat melodramatic. Especially when this potentially catastrophic prospect, as eminent ecological theorists and historians have suggested, most likely hinges on the interdependence of escalating human intra-species violence – think global terrorism – and our increasing degradation of the Earth's biosphere (Bateson 2000: 496–501; McNeill 2001: 341–9; cf. Kershaw 2007a). These future-threatening forces, interlocking culture and nature in a deathly dance, may seem remote to the historical concerns of museum and heritage theatre. But my oblique analytical strategy of using thought experiments will show that is a profound illusion. Because, as the early theorists of quantum physics well knew, the factors which couple 'culture' and 'nature' inextricably together are paradoxical in their transparent complexities (Atkins 2003: 201–36).

Consequently, this chapter attempts to critically show how (a) a key concept and (b) a novel research methodology in performance studies, plus (c) two ancient occult arts, may have crucial relevance to event-and-environment interactions in museum/heritage theatre. So, using paradoxical methods to clarify the combined complexity of concept, methodology and arts, it first aims to *expose the flaws* of the theology of 'liveness' and the doctrine of ephemerality in theatre/performance studies; that is, the widespread belief that once an event is past it is gone for good (Phelan 1999: 146/167). Second, it explores how the creative innovation called 'practice as research' can *dislocate the knowledge* that underpins the present as a way of resuscitating the past (Kershaw 2009a: 3–13; 2009b: 1–16; 2009c: 104–25). Third and more riskily, it enquires whether the practices of museum/heritage theatre should *embrace the dangers* of time travel and necromancy. These extraquizzical strategies entail that we pursue our thought experiment through a style of symptomatic analysis that I call a 'paradoxology of performance' (Kershaw 2006: 30–53; 2007a: 98–131). This deploys paradoxical methods – searching for hope in desperation, say – to investigate theatre practices especially invested with some common paradoxical qualities of performance. So tactically it accepts at face value Eugène Ionesco's characteristic *aperçu*: only the ephemeral is of lasting value (Ionesco 1960: 121).

Using these iconoclastic, deconstructive, revisionist and para-consistent methods, this writing details some virtuous ecological dynamics of performances staged by museum and heritage theatre. It proposes that such performances always involve site-specific entanglements with environmental vectors

which can constitute an 'ecological positioning' of audiences and spectators, though that quality is often hard to detect. Offering a case study of performance documentation from one of my own practice-as-research projects, it enquires how *past live events* might generate radical potential for sustainable futures through such eco-investment. Hence it considers how the creative subjectivity of audiences/spectators might function in accord with established ecological principles – such as species diversity being an indication of systemic health (Allaby 2006) – to generate a little 'eco-sanity' from current global human MAD-ness (Kershaw 2007b: 11–15; cf. Parrington 1997 on 'mutually assured destruction'). This will entail showing how the ecologies of museum and heritage theatre must incorporate particular forms of *reflexivity*, in the cybernetic sense of an organism or system stochastically testing its own foundational assumptions and processes through feedback (Lash and Urry 1994: 31–59; Bateson 2000: 405–15). I argue that such reflexivity is key to *sustainability in the effects* of live events. To frame all this in an overarching query I ask: how might theatre ecologies function to create exponentially enhanced human access to the past and thereby justify radical nostalgia for a future that is anything but rosy?

On memory and mnemonics

In his majestic study of memory Paul Ricoeur recommends a positive line on even the frailest of fragments from the past. Historians, for example, should 'approach the description of mnemonic phenomena from the standpoint of the *capacities* [of the past], of which they are the 'happy' realisation' (Ricoeur 2004: 21, his emphasis). Now the tension between such mnemonically transmitted 'capacities' and the destructive decay of time was fundamental to the site of this chapter's case study, the Bristol-based nineteenth-century heritage ship the *SS Great Britain* (*SSGB*). This huge object is a historic world-record breaker. It was, for instance, the first steam-powered propeller-driven ocean-going liner, as well as by far and away the largest iron-hulled ship ever built. But by the turn of the third millennium this amazing artefact was very actively adding to its earlier world records by playing host to the highest number of known types of rust to be found together anywhere on Earth. This colourful, highly visible rot was eating up most of the magnificent 106-metre hull so that, unless it could somehow be stabilised, within 20–30 years it would become little more than fragments at the bottom of the specially constructed 1839 Bristol dry dock in which it was built (Corlett 1990/1975: 19–20; Watkinson et al. 2006).

 That fact is the ironic kick-start to my case study's thought experiment, which focuses on a single scene from *The Iron Ship*, a site-specific spectacular that was staged on the *SSGB* in May 2000. My experiment aims to identify

a source of mnemonic endurance arising *accidentally* from the potential of Ricoeur's historical 'capacities' as they become *happily realised* in ephemeral phenomena that are especially fragile in time. It asks: could it be that the homology between the disappearance of *The Iron Ship* as ephemeral show and the fate awaiting the rabidly rusting hull might somehow reveal a common creative root to the vessel's survival? In other words: if an evanescent performance could somehow contribute to revitalising and strengthening the ship's endurance through its designs on spectators, then perhaps some related sort of physical survival by other means might emerge for the doomed wonder. That potential physical survival suggests a constitutive paradox of ephemerality was generative in our performance-as-research project on the ship. Namely: Nothing ensures the future of things like the passing of time. But also it is important to my analysis of a scene from the production *as* performance research to sound a cautionary personal note here. Because, even as its instigator, at the outset I was only very vaguely aware of how the tightening temporal homology between show and ship – their likely disappearance – could make that paradox resonate throughout its site. And so a further paradox – coined by playwright Sacha Guitry – was key to the project's evolution: the little I know, I owe to my ignorance.

So *how could* a ship-bound heritage spectacle turn the trick of *proving* endurance in the mnemonic capacities of over 1,000 tonnes of rotting iron? After all, dominant approaches to ephemerality in performance theory generally have drawn a strict line between events past and present: once gone – or disappeared – there is no retrieving their most crucial qualities, most tellingly defined metonymically as the 'live' or 'liveness' (Phelan 1993: 148; Taylor 2003: 75; cf. Auslander 2008 and Schneider 2009). However, from Ricoeur's perspective this view of the 'live' treats museum and heritage site materials as subject to a 'pathological deficiency' (Ricoeur 2004: 21). This affliction tends to collapse mnemonic phenomena into a unitary state defined by the *unreliability* of remembering – we cannot trust what we make of them – and, paradoxically, this implies that memory works uniformly on all parts of the past as traces in the present. But historical 'common sense', of course, indicates otherwise. Everything is not equally ephemeral. Some things are remembered, and sometimes their records retained as a prompt to continuing testimony, more fully than others. My tag for such variations in the productive articulation of mnemonic events and memory processes is 'degrees of ephemerality'.

The Iron Ship: case study part 1

The *SS Great Britain* was launched in 1843 at Bristol docks and it quickly became a marvel of the age of Industrial Revolution and Empire. The biggest, fastest and (for some) most luxurious ocean liner ever built, it was also

the first ship to keep to tight intercontinental timetables: the Concorde of its day. Between 1852 and 1875 it made 32 voyages between Liverpool and Melbourne carrying 15,000 passengers, ancestors to 20–25% of Australia's 2009 population of 22 million. In 1970 it was rescued from oblivion as a hulk scuppered in the Falkland Islands and returned to the dry dock where it was built (Corlett 1990: 161–76). By 2000 it had been reconstructed to become a moderately successful heritage site that told a monological story of engineering innovation and maritime conquest, but its major part in the history of colonialism and environmental degradation was almost completely ignored. As leading heritage industry critics have noted, such sites are memorials to forgetting even in the moment of remembrance (Lowenthal 1998b: 156–62).

The Iron Ship was an environment-specific extravaganza with over fifty student performers and twenty professional support staff. The show prom-enaded its spectators (130–160 a night) on and around the whole location of the ship. The opening act, staged in a large dockside shed, was a jocular surrealist vaudeville featuring a mixed bag of historical and mythical figures, including Isambard Kingdom Brunel (engineer–designer of the ship) and Mrs Brunel, Queen Victoria and a factory-worker chorus, Punch and Judy, Britannia and Neptune. Following that, audiences were led down into the dry dock where, beneath the ship's massive stern, they met the last mermaid alive and two spectres of her doomed species (Figure 9.1). The spectres ranted against the ship's creation of toxic seas before the trio sang a lament for their

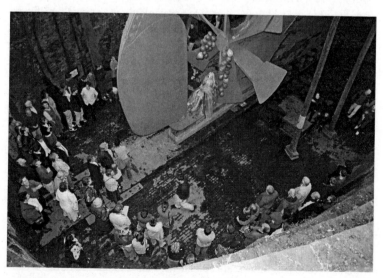

9.1 The Last Mermaid Alive viewed from the dock edge. Performer: Jane Parkins

dead sisters. By the fourth performance, despite mixed reviews, popular demand produced two audiences for this scene, one in the dock bottom, the second on the dockside above (Kershaw 2002).

This is the setting for my thought experiment, which draws on quantum physics for its analytical modes, so its language is slightly technical but not, I hope, entirely unfamiliar. My approach chimes with writings about 'quantum theatre' in performance/theatre studies, complementing the new synergies they create between the sciences and arts (George 1989: 171–9; Heuvel 1993: 19–20; Phelan 1993: 2–3, 112–29; Demastes 1994: 242–54; Gargano 1998: 151–8; Armstrong 1999: 277–88; Pitches 2000; Stephenson 2006: 73–93). Focusing on the binary division of the audience for the mermaid scene, it aims to describe a dislocation of the established knowledge of the site through treating the 'last mermaid alive' as a particulate, quasi-atomic *singularity*. In quantum theorising Stephen Hawking and Roger Penrose have become the most influential champions of singularities, but intense debate continues to trouble their development of general relativity's concept of an infinite density of matter that could be a point of origin for an expanding universe. (Hawking and Penrose 1996: 27–36; Schiller 1997–2007: 616–17; Wikipedia – gravitational singularity: accessed on 28 July 2009). 'Singularity' is defined more stably in mathematics as 'a point at which a complex function is undefined because it is neither differentiable nor single-valued while the function is defined in every neighbourhood of the point' (Encarta Dictionary – singularity: accessed on 28 July 09; cf. SOED 2003: 2,846). From this I posit the 'last mermaid alive' as a *singular performative event* because it begs crucially imponderable questions – for example: how can mythical figures ever die for good? Where do humans stop and other animals start? – so that we have to query its particular functions *through* its neighbourhood, its specific inflections *in the vicinity of* its environment, in order to make any kind of sense of what on Earth she was *doing there*.

That is why 'technological environments' is in this chapter's subtitle, as there exist two video recordings of the mermaid scene – the first shot by Harlech TV, the second by a student documentation team – which are crucial to my thought experimental task of using 'singularity' to identify dislocated knowledge. A comparison of the videos allows me to demonstrate with a degree of testable 'objectivity' how a bifurcation, then a proliferation, of 'neighbourhood functions' could be produced by the singularity of the last mermaid alive. Used as a standard tool for reducing bias in an interpretation of my 'own' performance-as-research project, the evidence of the digital recordings is re-presented here by short strips of screen-grabs, both covering intervals of almost identical length.[1] Acknowledging these as profoundly imperfect video-substitutes, my commentary aims to specify how the energies of the scene worked to position its spectators as part of a performance

ecology whose ephemeral mnemonic capacities potentially impacted very diversely – and therefore possibly more enduringly – *in* the present passing of time.

In testing the conundrum of *ephemeral endurance*, my experiment indicates that such capacities can *expose the flaws* of the doctrine of ephemerality in performance studies by identifying thematically relevant paradoxes in the performative functions generated by the last mermaid alive *in* her audiences. These paradoxes suggest how the scene could create degrees of ephemerality, i.e. how it animated the general capacity of mnemonic phenomena to trigger memory in a relatively unpredictable, contradictory and *disordered* manner. It is this performance process which had the facility to dis-locate any knowledge that might be invested in the rotting hull of the *SS Great Britain* through the dominant engineering and maritime interpretations of its 'heritage site'. In pursuit of a convincing account of that hypothesised process, the rest of this section first presents some probable effects of the scene as revealed by the video clips, then concludes with a brief speculative analysis of how they functioned ecologically in accord with key principles of quantum physics. Hence, I suggest that the last mermaid's singularity had powers – like those conventionally assigned to the black holes of space – to affect a quantum shift in the spectators' perceptions of the ship and its site.

The agit-prop rant against the Earth's toxic rape by man's industrial prowess performed by the duo of mermaid spectres lasted for a full two minutes. Hybrid creatures of culture–nature, they preached passionately of a mythical destruction that connected obviously to current global warming. In her Brechtian-style response, the last mermaid alive overtly *acted the part* of looking wistful, puzzled and fearful before singing her lament with the tuneful sweetness of a melodramatically doomed heroine:

> Who would be a mermaid fair
> Singing alone, combing her hair
> Under the sea on a golden throne
> With a comb of pearl, I will smooth my hair
> But at night I would wander away and away
> On a shipwreck and in and out of the rocks.

There was a risky conventionality in this simple pantomime-like clash of styles and themes, with populist sentimentality about endangered species struggling against a deliberately heavy-handed ecological 'message', sometimes prompting uneasy glances among the dock-bottom spectators. But the relative objectivity of the video record (if not the screen grabs!) provides a retrospective advantage for analysis, opening up more complex views on how the scene was working through performative conundrums.

The HTV publicity feature of the last mermaid's lament (Figure 9.2) was produced before the show opened – so with no audience present, and minus the two spectres – and the editing presents the scene in three takes. The initial two show the singing mermaid from the dock bottom, first in long-shot then in close-up, while the third is filmed from above on the dockside edge, from where the camera gradually pulls focus on her before lifting its lens to show the gold-lettered name on the ship's stern. This presages the main ocular options that would be open to the half-audience on the dockside, focusing on the ship's impressive scale as visual spectacle, reinforcing its historic grandeur and diminishing the mermaid's presence, implicitly underlining her fate. The student-made clip (Figure 9.3), filmed during the third public performance, is in a single-take shot from the bottom of the dock. The hand-held camera pans past the two ranting spectre–mermaids to focus from below on the last mermaid alive in close-up as she starts her song. Then it continues the pan to show one of the spectres also singing and near to the audience, before panning back and zooming in for a final close-up of the last mermaid as her song ends. It emphasises the crowded confinement of space below the stern and the hugeness of the rudder and propeller with the last mermaid caught between them. These camera angles and moves suggest the immense weight and power of the vessel, by contrast highlighting

the relative puniness and vulnerabil-
ity of the breathing bodies of per-
formers that are both mythical and
humanly real.

Taken together, these documen-
tary video traces refract two sharply
contrasting sets of spectator reception
options, and they indicate how dif-
ferent patterns of perceptual/embod-
ied energy exchange potentially were
instigated by the mermaid's singu-
larity. More specifically, their filmic
techniques expose how the particular
mnemonic phenomena of perform-
ance might stimulate perceptions of
highly contradictory historical quali-
ties deriving from the scene's place-
ment on the site. The contradictions
were generated, potentially, by the
spectators' spatial positioning, which
created relational interactions with
the last mermaid that *functioned* (in
most main senses of the word, includ-
ing the mathematical one) in criti-
cally disparate ways. Such criticality
in turn produced site-particular para-
doxes that resonate strongly with an
inherent and more general paradox
of creative performance: that less is
more.

Key to the potential paradoxical
effects created by the scene was the
fact that an invisible plane separated
the two groups of spectators, an *imag-
inary water level* created by the dock's
architecture and the painted black
(upper) and orange (lower) division
of the rotting hull: an unavoidable
reminder of the amazing engineering/
maritime achievement that the site
celebrated so enthusiastically (Figure
9.4).

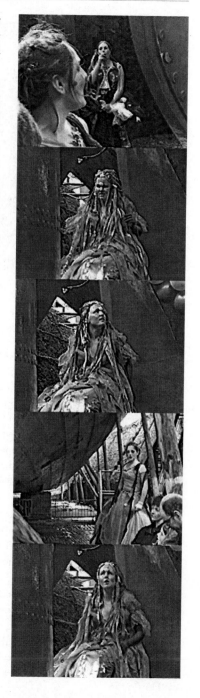

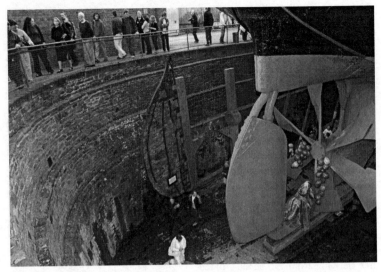

9.4 Spectators arriving above and below the dry-dock waterline of the ship

Here is the crux of my analysis, as knowledge of that achievement would be rendered strictly *beside the point* by any new sense that the spectators gained of the ship's stupendous historical energies and effects. For the singularity of the 'last mermaid alive' literally dis-places such knowledge because if what she *represents* is unfathomable, then her potential significance must lie in the *relational functions* of the whole event's environment. And these crucially hinged on the binary embodied positioning of the spectators on the site. From this perspective in my thought experiment those bodies – politically, environmentally and otherwise – speak volumes.

This claim can be translated into more conventional terms. Politically, for example, the dockside spectators may be spatially aligned with the Victorian vision of industrial progress and Empire as they look down on the mermaids, while just above their heads GREAT BRITAIN glitters in gold. Below them the dry-dock spectators are positioned implicitly as 'closer' to the sturdy artisans and sailors who built and sailed the ship. In raising their eyes they have, so to speak, a 'bottom-up' view of industrialisation, colonialism and Empire. But also, paradoxically, the two groups are a single audience able to attend to the whole of the performance event, and this generates the first of my promised less-is-more sub-paradoxes as this flow of the scene's energy exchange constitutes *bodies divided in being together*.

Environmentally, the scene worked to a yet more contradictory logic.

The dockside spectators literally are *in* their natural element, above the mermaids' imagined watery grave, entirely safe on their privileged perch. But the dock-bottom spectators are metaphorically *out* of their element, 'under water' though still magically 'surviving' as the performativity of the mermaid's singularity 'rescues' them from human respiratory limitations. This energy-exchange aspect produces a second sub-paradox as it ensures their *bodies are well underwater.*

So the combined dramaturgical and scenographic effects of the scene potentially were awash with contrasting and contesting political and environmental histories that serve to dis-locate, but not to dispel, the site's 'established knowledge'. Yet the complexities of this performance ecology, energised by a simple confounding of metaphor and actuality, were triggered by the straightforward creative stratagem of mixing myth (mermaids), history (ship and dock) and current reality (embodied performers/spectators). A practice that I suspect is not especially uncommon in the productions of museum and heritage theatre

It is important to note that it is irrelevant to my analysis whether or not the spectators consciously interpreted the scene in terms of these thematics. Though a reception study confirmed audiences had engaged such complexities of meaning, its *energetics* – circulating through the dynamic interaction of living bodies and material site – were more critical to how the scene functioned ecologically, given the singularity of the last mermaid alive (Kershaw 2008: 28–36; cf. Lyotard 1976: 110; Knowles 2004: 3–4, 20–3). Rather, as I argue next, these quantum-like factors of the event produced an environment whose energy systems constituted the subjective positioning of spectators as 'grounds' for such signifying possibilities.

General conditions of performance ecology

At least three conditions would be crucial to generating a performance ecology capable of delivering the effects just described. Firstly, some confounding of the nature/culture binaries of Enlightenment-inspired modernism. Performance causes culture and nature to embrace each other, as it were, through the singularity of the last mermaid alive. This was refracted most obviously in the manifest, tangible fact of a merging of, on the one hand, the iron-hull as massive *cultural artefact* and, on the other hand, the *natural process* of chemical reactions spectacularly progressing to their catastrophic conclusion: a disastrous surfeit of rust. But also that merger was operating in the intangible interactions between the bodies and subjectivities of performers and spectators in the present *and* in the physical and historical evolution of the site in past and future. Because the performance-in-environment brought these functions (and many more) simultaneously (and literally) into

play, creating an ecological system in which no factor could be considered irrelevant because they were all complexly interconnected. The performance-environment interactions thus manifest a more or less viable ecology – as judged by established ecological principles, such as species diversity equating with eco-health – becoming sustainable, or not.

The second generative condition for the events signifying possibilities was the processes of a performance system that adapts to its environment in ways that imply *radical performative absences* (Kershaw 1999: 137–40). In this respect the crucial factors of the scene were the obviously enormous historic powers of over 1,000 tonnes of rotting iron, plus the myriad organisms that were essential to their creation, including the two groups of spectators now gathered around the stern of the doomed wonder. I suggest that whether audience members were above or below the ship's water line a principal function of the mermaid scene would be to actively render its historic powers *ghostly* in relation to both past and future. That is to say: firstly, the past of those powers was made more transparently apparent because the shrouding of history by heritage in the site's interpretations had been displaced; and, secondly, what those powers would become in the future, given the ship's rust-ridden state, was clearly as spectral as, say, dead mermaids singing. So then it may seem weirdly fair to claim, echoing Ricoeur, that the binary haunting by performance of this extraordinary mnemonic object had *subtractive capacities* that could produce a palpable kind of *doubled absence*: absence as *known but displaced qualities* (i.e. colonial powers from the past) *and* as *known potential limits* (i.e. a rusting away to future oblivion). So what might the *presence* of *The Iron Ship*'s singing mermaids have *added* to this absence?

The third condition of possibility for the event's effects can be described as an animation of the acute and paradoxical mnemonic capacities of performance in process. To identify that potential in practice requires that we focus on the specific vectors of human performance aesthetics that produce palpably observable types of presence. For example, in scale the mermaids' presence was strictly minimalist, a *miniaturised* spectacle when set against the massiveness of the ship. But the *doubled absence* spawned by their exact placing in that massively spectacular environment had the potential to create an extreme excess of effect, a paradoxical riot of reception and interpretation that was homologous to the far-reaching dynamics of the global political and environmental pasts which congregated at the site. In the language of my thought experimental parallel: the singularity of the last mermaid alive (e.g. non-differentiated as between real and not-real; immeasurably multi-valued) *in performance* worked as a foil that could diversely animate the many historical functions circulating in *every aspect* of the ship's complex heritage neighbourhood. Those would include any memories or imaginings of past and future that the spectators might associate with, say, the attempted

nineteenth-century colonial genocide of Australian Aborigines or the twenty-first-century ecological auto-genocide via population overload MADness. There, precisely, was the potential for a radical dis-location of established knowledge by performance-as-research as represented by *The Iron Ship* and its last mermaid alive, producing complexities perhaps best expressed as testing paradoxes. For example: ecological auto-genocide favours humanity with a global wholesale deal. Hence performative promiscuity – which is integral to a quantum perspective on an expanding universe – can become highly productive of paradoxes birthed by the commonplace Beckettian rule of creative performance: less is more.

To briefly recap. Three general factors of evolving events are important to sustainable human performance ecologies: firstly, an evocation and confounding of conventional nature–culture binaries of thought/action; secondly, the creation of radical absences in environments; thirdly, the animation of paradoxical mnemonic capacities by performative singularities. The interdependence of these factors can be generalised as follows: the excess generated by effective performance – of energy exchange, interaction, signification and so on – tends to dislocate normative epistemologies and ontologies, establishing creative environments in which contradiction and paradox may fundamentally challenge the modernist nature–culture divide, thus producing potential for the evolution of novel performance ecologies that reposition spectators unavoidably as participants rather than (or as well as) observers. This is a crucial process for the emergence of eco-sanity, because it potentially entails radical experiential revision of existing spectator subjectivities. In face of an environmental calamity for humanity, such re-visioning may be crucial to the survival of hope for homo sapiens. So perhaps the hybrid animal–human mermaids do this: they temporarily heal the culture/nature divide via nostalgia for the future.

On necromancy, time travel and the twin paradox

But are there yet more fundamental qualities of performance that might best produce such effects in museum and heritage theatre? For answers we must tease out some principles implicit in my thought experiment, which so far has only hypothesised the validity of homological correspondences between the singularities of quantum theory and theatrical performance processes. Now as singularities are unobservable they may constitute an exceptional conceptual lacuna in quantum theory's account of 'natural laws' (Schiller 1997–2007: 616–17), so an equivalent 'gap' in performance theory might refract matching 'cultural laws'. This could seem portentous, but given the adage that 'art lies in concealing art' perhaps the best opening gambit would be to consider what the manifest *physics of theatre* appears to obscure.

'The physical theatre . . . is not surprisingly among the most haunted of human cultural structures', Marvin Carlson persuasively argues (2003: 2). If so, perhaps the performances of museum and heritage theatre may be doubly ghostly in haunting such quintessential places of the past displayed. *The Iron Ship*'s spectres of deceased mermaids exemplify this mirrors-within-mirrors quality, being simultaneously mythical, spectral and physical. The 'what happened to us could happen to you' implication of their predicament is thus a clue to a vector of theatre often dissimulated or disguised by its producers and champions, perhaps from fear of seeming overtly 'political' or didactic. Hence the theatre's dealings with the past are frequently cautionary (warning about tragic error, bad faith, etc.) and therefore fundamentally predictive. This is the ghost in the machine of theatre, the guilty open secret of addictive encounters with death. In short, some key qualities of *necromancy* attach to this widespread method in theatre. Might this indicate why museum and heritage performance is especially valuable in creating nostalgia for the future?

The *Shorter Oxford English Dictionary* defines necromantic practices as: 'The pretended art of revealing future events by means of communication with the dead.' (SOED 2003: 1,316) But my thought experiment's finale playfully aims to re-fashion theatrical necromancy as a 'real' art that can out-predict prediction by also delivering highly effective *time travel*. For sure, such a stab at improving the future of the past risks a riddling by ridicule. Because time travel is just science fiction, isn't it? Meddling with the dead can still land you in prison, can't it? However, even eminent theatre historian Joseph Roach implies that striking a performative 'bargain with the dead' may be historically efficacious when he asserts: 'the necrophilic impulse . . . uses the word *effigy* as a verb' (1998: 29; see also 1996: 36–7). It follows that the qualities of necromancy could be part of most performance, as its creativity, often literally, bodies forth absent – or at least, invisible – pasts through transposing what is dead, but not entirely gone for good, into the present.

Our next experimental step tightens this focus on spectres and necromancy by drawing on performance theory to extend a remarkable claim in quantum physics: namely, that time travel is theoretically possible, but only as *one-way* traffic. The step involves applying the paradoxology of performance to a classic paradox of special relativity to augment its mind-bending capacity for presenting the universe as a fundamentally paradoxical affair. One crucial methodological principle here is that a valid integrative dynamics of theory and practice should provide straightforward empirical examples that make the intuitions a paradoxology deals in easily accessible. Hence I next recommend to readers a simple practical performance exercise that shows this paradoxology does more than just grasp at straws in the wind. All it requires is for you to make a fist (with either hand) *now*, then please perform that most

peaceable of Buddhist conundrums: what happens to your fist when you open your hand?

My open-handed proposition is that the diversity of interpretations presented by the spectral qualities of performance in some sense replicates for spectators the processes that generate species diversity in successful ecosystems. But to turn the difficult trick of making this proposed homology between cultural and natural processes convincing, we need to join the paradoxes of relativity theory – especially as they relate to time travel and necromancy – to the paradoxes of performance itself.

So this experiment next takes an essential leap into the quantum world of light-as-both-wave-and-particle. Here is a version of the famous 'twin paradox' of relativity as described in a standard teaching text for budding physicists:

> [An] adventurous twin jumps on a relativistic rocket that leaves Earth and travels for many years. Far from Earth, he jumps on another relativistic rocket going the other way and returns to Earth . . . At his arrival, he notes that his twin brother on Earth is much older than himself. . . . This result has . . . been confirmed in many experiments [thus proving], in a surprising fashion, the well-known observation that those who travel a lot remain younger. The price of the retained youth is, however, that everything around one changes very much more quickly than if one is at rest with the environment. The twin paradox can also be seen as a confirmation of the possibility of time travel to the future. With the help of a fast rocket that comes back to its starting point, we can arrive at local times that we would never have reached within our lifetime by staying home. Alas, we can *never* return to the past. (Schiller 1997–2007: 306)

This illustrates how a chief quality of special relativity – time intervals varying between observers – can come about, as the asymmetric aging of the twins is a product of the same interval simultaneously being different time-lengths. However, just as relativity reigns in quantum space-time – lights in the sky *are* utterly different for a person on Earth and one flying past in a rocket – so too might it rule in fundamental matters of everyday perception and its epistemologies, even to the point of extending the conclusions that have been drawn by scientists from the twin paradox (Atkins 2003: 292–6). From this perspective, there may be more to theoretical time travel than the unidirectional beams that meet the eye of the scientific relativist, in which case such travel could include *two-way* streets.

So a paradoxology that deals in the quotidian qualities of performance can elucidate further theoretical potential in the twin paradox. This begins by noting that special relativity theorises the paradox's one-way-only outcome through rigorous application of advanced mathematical *reasoning*, which produces concepts such as 'singularities'. Next we must subject that reasoning to philosophical query via our paradoxology of performance, one

technique of which is to put related paradoxes in dialogue with each other, so to speak. So consider the *performative* outcome of the first twin's journey (i.e. the stay-at-home twin's advanced aging) from the perspective of a paradox coined by Spanish scholar Miguel de Unamuno: 'The supreme triumph of *reason* . . . is to cast doubt upon its own validity' (Unamuno 1913/1954: 104; emphasis added). At the very least, Unamuno's paradox suggests a reasonable doubt might be cast on special relativity's claim that time travel to the past is impossible. What follows from that might seem more like splitting hairs than atoms, but the philosophical movement called 'dialetheism' (two-way truth) provides justification for this doubly doubting move – in which reflexive reason queries itself through reflexivity – by offering routes via classical logic to the validation of paradox as a source of 'over-riding' truths. Debates about such routes, like those at crossroads without signposts, have been very much alive and kicking in philosophy (Orlin 2003: 21–36). So here I adopt relatively moderate views on dialetheism that are 'quite common in the current literature (*pro* and *contra*) [which] straightforwardly speak of inconsistent objects, states of affairs, and entire inconsistent worlds' (Stanford Encyclopedia 2008 – dialetheism: accessed on 13 September 2009).

From this perspective, the twin paradox is more accommodating of the possibility of *two-way* time-travel, perhaps opening the door to radical adaptations of necromancy as a method in museum and heritage theatre. Because dialetheism would support the paraconsistent conclusion that, as the spaceship-travelling twin does not age like the stay-at-home-twin, from the perspective of the latter their meeting constitutes a live encounter *with* the dead-and-gone past. In effect, past life, and therefore past *live events*, can be re-visited, even though we cannot change it, or them. Hence this thought experiment adds to the natural laws of quantum theory a new qualification based on key principles of performance art. In asserting that a human body simultaneously can be both real and not real, or spectral and physical, or mythical and factual (i.e. in the ways explored by *The Iron Ship*), such paradoxical 'laws' of performance open a doubling-back route to treating 'necromancy' as a verb, thus strongly implying that theatre can resuscitate live events of the past. So the performance of necromancy can surely parlay, in Joseph Roach's words, 'what can be known as history into what can be experienced, however phantasmally, as memory' (1998: 29). And, of course, live theatrical performance events trigger a myriad memory functions as they play through degrees of ephemerality.

Of course, such tricky theorising may prove hard to substantiate empirically. But the inconsistent world produced by a paradoxology that uses binaries to *logically* yoke together apparently incompatible possibilities could be less strange than it seems at first glance. Indeed, the theoretical result of my paraconsistent argument about the possibility of two-way time travel can

be checked against an everyday fact. Because when we see the Sun of Earth's solar system, whose beams always bask humans in the present, it is always already eight minutes in the past.

The Iron Ship: case study part 2

So I contend that my thought experiment's coupling of quantum science and performance art validly renders ephemerality open to qualification by degrees, making it potentially always subject – like the twins of the paradox – to asymmetrical times. Hence the mermaid scene of *The Iron Ship* achieved an analogical merger of metaphorical event (mermaids) and material site (ship) that expanded its degrees of ephemerality by polymorphously energising the *mnemonic capacities* of heritage and history for refreshed recycling by performers and spectators. Crucial to *that* was the show's engagement of performance ecologies, which animated homologies between the decay of bodies and other materials: as between mermaids and ship, spectators and site, organic and inorganic environment, human and non-human ecologies combined. Decay as the fount of all things lovely? Free radicals as chemical rejuvenators of aging agents? (Kershaw 2007b: 276–7; Wikipedia – free radicals: accessed on 13 September 2009). A simple scenic effect, playing *through* the ship's invisible binary waterline reflection of modernist epistemologies at the root of global warming, was utterly crucial to its ecological resonance. And this eco-vector of the scene can be tested against its most paradoxical moment.

The anti-pollution rant of the spectre–mermaids was ironically interrupted by tinkling 'magical' music as used for traditional pantomime transformation scenes, and a gentle rain of falling blue 'jellyfish' (in the form of plastic miniparachutes) floated down to the audience as if from out of the sky (Figure 9.5). Launched by out-of-sight performers on the aft deck of the ship, the jellyfish implied that the SS *Great Britain* was sunk at the bottom of a dying sea in an ecologically devastated world. Many spectators smiled or laughed in this moment of lightly disguised pessimism, an ambivalent reaction to a performance ecology that was positive even in desperation. So the whole scene worked to increase a widening diversity of response, a diversity working analogically to the ecological principle of new adaptations that ensure species survival, perhaps making its effects more sustainable: that is to say, more mnemonically durable.

Finally, from this perspective it is worth noting the nature of the material economy of the mermaid scene. All that it added to the site – beyond the energy and talent of the performers, and the focused attention of spectators – was three costumes made from recycled/recyclable materials, a lighting effect powered by an old car battery, reusable balloons, and reclaimed bits of blue

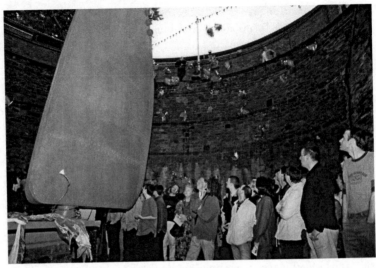

9.5 Blue 'jellyfish' falling from out of the sky/sea (preview performance)

plastic for the jellyfish. This matching of physical and metaphorical resources was carried through in its smallest detail: the 'weights' that caused the 'jellyfish' to gently fall so they could be caught by spectators were small packets of energy-giving sweets. Ironic sources, perhaps, for sustaining optimism in a jolly hopeless world? A paradox of Voltaire's suggests why such irony could be crucial to eco-sanity in the twenty-first century: the superfluous, a very necessary thing.

Conclusion

That claim may seem tenuous, but it might still gain support from some physicists at the paradoxical cutting edges of quantum research. A 2002 landmark paper on the relativist twin paradox drew the conclusion that:

> Clearly, the 'paradoxes' of spacetime offer invaluable opportunities for diverse styles of presentation and interpretation, just as a work of music or drama lends itself to varied treatment. In this vein Smorodinskii and Ugarov cited Shakespeare to proffer the pithy conclusion 'This was sometime a paradox, but now the time gives it proof '. (Sheldon 2002: 97, citing Shakespeare, 1963/1623: III i 114; Smorodinskii and Ugarov 1972: 340)

The paradox that Shakespeare assigns to Hamlet is about the relationships between honesty, beauty and time: for Hamlet in Elsinor the effects of the last – time – are causing the second to destroy the first. He is in a double

bind, for if he speaks honestly of his love that will destroy its beauty, in the form of Ophelia. So the best expression of his love is to deny it, and thus time logically and inevitably delivers a tragic result. My thought experiment suggests that such results of the past can be revisited, not in order to change them but to savour them afresh. A prospect quintessentially made possible by theatricalised performance in the present.

However fragile such links between scientific and artistic research may be, in the twenty-first century performance ecologies need all the reinforcements they can get in the global struggle for sustainable futures. From this perspective, even the slimmest boost that museum and heritage theatre might gain from countering postmodern scepticism, capitalist cynicism and globalized oppression is invaluable. Its practitioners might lack the mathematically precise tools of quantum physicists, but the paradoxes of performance can calibrate their equivalents, particularly through new angles on creativity opened by a growing diversity in theatrical and performative styles of presentation/ reception. Performance provides fertile prospects for growth of new degrees of ephemerality in museum/heritage theatre. So *however* spectator memories may persist or decay over time, performance can foster the sustainable durability of live events from the past.

But how fares the *SS Great Britain* now in the wake of *The Iron Ship*? The fate of the vessel since 2000 forms a hugely ironic object lesson in relation to degrees of ephemerality. In 2004 the UK National Lottery gave £8million for a rescue attempt that installed large horizontal sheets of glass between the dockside and the hull, then covered them in water to give the effect of a transparent 'sea' (Figure 9.6).

Beneath this, two huge air-conditioners were installed to control the dock-bottom humidity. Engineering virtuosity has saved the hull through a highly imaginative expert restoration. The ship has enjoyed a major interpretation makeover, with many manikins acting out the past in frozen poses. In a first-class cabin the male ship's doctor performs a mildly gruesome operation, while in the steerage galley two smeary-faced women are having an eternal 'cat-fight'. The genuine artefacts have been moved into a dockside museum to make an interesting display. But still the engineering and maritime interpretations predominate, but now – through the pervasive commodifying gloss of the Lottery restoration – joined by contemporary capitalist ideologies, revitalising the Victorian values of the ship's original makers (SS Great Britain website: accessed 13 September 2009). So, paradoxically, the degrees of ephemerality of its historical integrity have narrowed, while those of its heritage prospects for the future have widened exponentially. So change in such degrees at any particular place may not ever operate in a unidirectional manner: just like time travel in a quantum world-view modified by a paradoxology of performance, it is a two-way street. Thus live events that aim

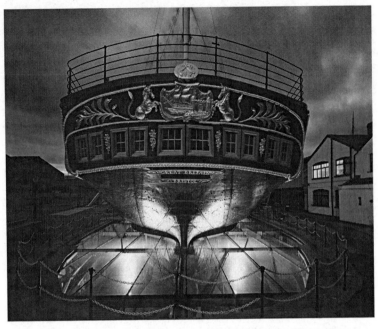

9.6 The stern of the ship 'floating' in its glass sea: note the propeller bottom centre

to be radically rejuvenating can end up facing diametrically opposite effects to the ones they aimed to produce; in the case of the *SS Great Britain*, thanks to a brilliant curator who, it seems, may have learned some invaluable heritage lessons from his experience of *The Iron Ship*.

In my quest for a quasi-quantum account of the prospects for museum and heritage theatre, I have concentrated on the advantage for performance analysis of trace materials from the past produced by new digital technologies. But these technologies can become part of further live performances, creating new types of sensorium for museum and heritage-site theatre, potentially making its necromantic, time-travelling practices productive of fresh hope among the living. This can be a recycling process that conserves one kind of resource – mnemonic phenomena/systems – to then release new forms of creative energy to the future, producing performance ecologies that could be touched by eco-sanity. Such claims could well sound a note of *ironic idealism*. But I make them because in this third millennium human animals may have little option but to find antidotes to *pathological* hope in order to survive alongside the Earth's other creatures. For this reason alone, I recommend that museum and heritage theatre might usefully commit to creating increasingly more nostalgia for the future of the past.

Acknowledgements

SS Great Britain Project staff; John Marshall, co-director; Dr Jean Rath, researcher; Bim Mason, director Circomedia; Bristol University Drama Department production staff; Drama Department and Circomedia students 1999–2000, especially Komal Tolani, Cathy Cartwright, Jane Parkins and Victoria Sutcliffe for the directing/performing of the mermaid scene. Funding: Bristol University Alumni Association; Arts and Humanities Research Board.

Note

1 The video clips may be viewed via the PLH website: www.plh.manchester.ac.uk/book.

10

Performing cultural heritage in
Weaving Paths by Sonia Sabri
Dance Company[1]

Royona Mitra

This study examines the concept of 'performing heritage' through an intercultural lens, analysing an encounter between a South Asian dance company and a British heritage site. My case study for this is Sonia Sabri Dance Company's residency and performance of *Weaving Paths* at Bantock House, an Edwardian manor house in Wolverhampton, UK in May 2007. The site under consideration is a British heritage site, confronting its own history through the re-contextualised use of *Kathak*, a storytelling dance tradition from north India.[2] Shifting the 'performing heritage' debate from a temporal and historical plane to a cultural and spatial one, I shall analyse the significance of the dialogue between a South Asian dance company and a British heritage site and the creative potential that resides within such an exchange, fuelled by the concept of an 'interpretive agent'.[3]

Custodians of the past

The embodiment of national and cultural heritage within a museum is a largely Western concept. It suggests permanence and is institutionalised through the discipline of museology. The emergence of museums in the late eighteenth century as a storehouse of collective cultural memory in time became a catalyst for the construction of nationalist identity. Sharon J. Macdonald suggests that historically museums have been 'established as sites for the bringing together of significant "culture objects"' and were gradually 'appropriated as "national" expressions of identity' (2003: 3). Alessandra Lopez y Royo (2002) examines the phenomenon of building museums in colonies and suggests that these museums became instruments of colonial power. She further observes that, following independence, young nations continued to rely on the powerful rhetoric of these museums as intrinsic to the nation-building process. Harbouring nationalist fervour, museums therefore became 'self appointed custodians of the past' (2002: 2) in both colonial and postcolonial, Western and non-Western contexts.

As a sentinel of Wolverhampton's Edwardian history, Bantock House is one such 'custodian of the past', permanent in its stature within a contemporary multicultural milieu. The presence of a South Asian company working within this British site thus opens up multitudinous interventionist opportunities. The former's diasporic identity was suitably placed to interrogate the latter's colonial power-dynamics of the past while embodying the post-colonial reality of present-day migration and assimilation within contemporary Britain. Through *Weaving Paths*, Bantock House's relatively static Edwardian past thus confronted the fluid and dynamically charged present of South Asian cultural identity construction in the West Midlands today.

Museums as community centres

Thus far I have discussed museums as static and permanent fixtures that embody national history and cultural memory. Diana Taylor (2003) would classify this process of documented and factual history exhibited through visible and tangible evidence as the 'archive'. However, in recent years British museums have grown to question their one-dimensional archival characteristic in order to negotiate their relationship with the changing demographics of Britain's population as 'Diasporic communities have challenged the lack of multivocality in museum displays' (Lopez y Royo 2002: 2). Gradually museums have become transient spaces where historicised pasts meet present-day concerns through community representations. South Asian dance forms in Britain have thus acquired visibility through this route. It is in this context that the Bantock House dialogue with the Sonia Sabri Dance Company needs evaluation. However, unlike most 'museum theatre' that relies on 'dramatic re-enactments of the past', attempting accurate representations of the 'living history' embodied within museums and heritage sites (Jackson 2000: 199–200), *Weaving Paths'* artistic intentions were unique. Instead of seeking factual fidelity or historic accuracy, it focused on the interactions between the different cultural layers that characterise Wolverhampton's past and present, and the framing of these exchanges within the iconic Edwardian environment of Bantock House.

The initial juxtaposition of the cultural past of this British heritage site and the cultural present of this South Asian dance company carried the potential to bring about an exciting encounter, even exchange.[4] This performance encounter could consequently give rise to a third and new semantic, born of cultural and disciplinary exchange. Jacqueline Lo and Helen Gilbert theorise the nature of such exchange as 'syncretic theatre', which 'integrates performance elements of different cultures into a form that aims to retain cultural integrity of the specific materials used while forging new texts and theatre

practices' (2002: 36). While this nature of syncretism within the arts can be viewed as idealistic, I intend to demonstrate that within the Bantock House project certain points of cultural encounter did demonstrate the potential for 'syncretic theatre', while others needed greater aesthetic scrutiny. To substantiate my position, I shall also analyse the variable conditions that governed the specificity of these creative processes.

The partnership

The project was initiated and managed by three collaborators: Bantock House, the venue for the residency and one of the three British heritage sites managed by Wolverhampton Arts and Museum Services; Sonia Sabri Dance Company, who were invited to be the artists-in-residence at the premises; and Black Country Touring, an organisation that makes links between community artists and venues within the Midlands.

Bantock House, the Western heritage site in question, is a Grade II listed Georgian building with Edwardian interiors in the heart of Wolverhampton in the West Midlands, and was built between 1734 and 1788. Nestled within Bantock Park, it became home to the Bantock family in around 1867. In the century that followed, the house underwent significant renovations to attain its current Edwardian grandeur. In 1948, it was officially inaugurated as Bantock House Museum and became the custodian of Edwardian history, wealth and family life.

Sonia Sabri Dance Company is a Birmingham-based contemporary South Asian dance company and was formed in 2002, 'with the desire to present the North Indian classical dance style of Kathak in a new light, without diluting its essential purity and integrity' (Sonia Sabri Dance Company 2008). Led by Sonia Sabri, a second-generation British-Indian and a *Kathak* exponent, the company embraces a multicultural philosophy. It maintains two parallel repertoires. On the one hand, its classical repertoire raises the profile of *Kathak* amongst British audiences by taking it beyond proscenium-arch theatres to new spaces and audiences. On the other hand its contemporary repertoire presents *Kathak* as a:

> living artform which can be reinvented and developed, like a language, to say new things and engage with new issues ... current inventions and ideas are introduced by dialogue, rather than fusion with other disciplines. (*ibid.*)

It is this philosophy of change embedded in the company's contemporary repertoire that harbours interventionist potential. The emphasis on dialogue over fusion suggests that the company is interested in exploring the *possibilities* of cultural/disciplinary encounter as opposed to set repertoire-led

choreographic practice. The focus is therefore on the process of the encounter itself, rather than on the end product. This vision aligns Sonia Sabri Dance Company with contemporary Western performance-making notions of devising with its emphasis on play, experimentation, improvisation and a spirit of collaboration.

The catalyst for this project was Black Country Touring (BCT), an organisation that 'programmes professional dance and theatre by working in partnership with community promoters across the Black Country, and develops professionally-led community arts projects' (BCT 2008). Through their dedicated South Asian arts programme entitled *reSonAte*, BCT links South Asian arts companies with venues in the Midlands and creates new audiences for South Asian arts beyond its own community contexts. The roots of *Weaving Paths* were sown in a mutual desire between BCT and Wolverhampton Arts and Museum Services to work on a dance project with a regional company that could potentially generate new audiences: new audiences for Bantock House beyond its regular visitors and new audiences for South Asian dance beyond its community following.

Weaving Paths

In May 2007, the Sonia Sabri Dance Company took up a three-week residency in Bantock House. Four spaces of the house were selected as areas where the company would situate their experimentations; these were the Drawing Room, the Grand Staircase, the Billiard Room and the Dutch Garden. The project's aim was to create work on site, in response to these key spaces. The artists observed, scrutinised and imbibed the qualities evident in the house's architecture, decor and artefacts and responded creatively and corporeally to the emotions that the environment evoked in them. Sonia Sabri describes the first phase of the creative process:

> musicians and dancers spent much time on absorbing the information in the room, literally (through texts around the room), geometrically, [through] spatial design, from objects in the room and also the aura of the room – any emotional or spiritual impact it embodied. From this we did a series of tasks stimulated by the distilled information. At times it would be a particular part of the room that would lead the creation of a phrase i.e. in the drawing room the two large windows area became the focus and especially because they were of different shapes and size and overlooked different parts of the surrounding area; one suggested hope and the other entrapment (one flat and the other a bay window). (Sabri 2009)

As the house was open to the public throughout the residency the visitors could experience the development of the pieces in situ. This would entice

them to return over the weekends to witness the scheduled performance which was advertised as 'a work in progress'.

In its evaluative report on *Weaving Paths*, BCT asserts that the project further aimed to bring about a 'marriage of east and west, using Kathak (classical north-Indian) dance contrasted by western instruments in response to the house' (BCT 2008). This statement is initially troubling in its use of simplistic cultural categories of 'East' and 'West' and a reminder of the naïveté that haunts so many multicultural community arts projects. However, further scrutiny into the process and performance of *Weaving Paths* reveals that perhaps the metaphor of 'marriage' in the realistic sense is in fact rather appropriate. Cultures, like individuals, cannot be essentialised into categories like 'East' and 'West'. Therefore their dialogue can indeed come to represent the ambivalent highs and lows of a marriage, where exchanges are coloured by hope, integrity and expectations, while remaining fraught with misunderstandings and imbalanced power relations all along.

Publicity material on Sabri's company website leading up to and during the project re-emphasised an essentialism of the 'Eastern' and 'Western' partners in the dialogue:

Weaving Paths (through time. . .)
A union of two halves . . . Intricately formed . . . Here . . . of a time before
Come and see dance as you've never seen it before.
Come and see the House as you've never seen it before. (Sonia Sabri Dance
Company 2008)

Such marketing risked re-inscribing Indian dance in 'Orientalist' terms, ignoring years of struggle by many contemporary practitioners to deconstruct such problematic representations. The second half was more suitably complex in its message, suggesting an innate layering and interplay of time, space, history and fiction within *Weaving Paths*. It invited the audience to experience the House, a familiar British heritage site, in a new light through the lens of *Kathak*, a South Asian storytelling tradition unfamiliar to this environment, yet strangely empowered to reconstruct its history.

South Asian dance in British museums and the 'interpretative agent'

The interventionist power harboured by a South Asian dance company in a British heritage site needs theorising through an overview of the relationship between the nationalist project of India, the role of classical dance within this, and the consequent patterns of migration from the subcontinent to Britain, where tradition-bound arts came to be heralded as the 'homeland's' heritage within the 'host culture' (Meduri 1988, 2008; Chatterjea 2004;

O'Shea 2007, amongst others). The reconstruction of South Asian dance traditions as part of the anti-colonial and nationalist project ironically aligned these dance traditions with colonial and 'Orientalist' perceptions of Indian arts. The invention of tradition was played out upon the dancer's body, constructing it as the bearer of national and cultural heritage. Diana Taylor (2003) would classify this intangible but powerful nature of cultural memory as the 'repertoire', institutionalised through repetition and written into and onto the bodies of the dancers. Taylor argues that cultural memory, carried through 'repertoire', has been historically undervalued as a valid form of documentation. She argues that this is because performing bodies are ephemeral and their idiom cannot be documented and validated by written language. Taylor advocates the need to move beyond this logocentric understanding of the past, to make space for the 'repertoire'-led cultural memory as a significant resource of our past. The infiltration of colonial sensibility into the anti-colonial movement characterised the Indian nation-building process, and the cultural memory embedded in the 'repertoire' of the dancing body was an intrinsic part of this. In recent years, while it is true that several South Asian dance artists have attempted to deconstruct such 'Orientalist' representations of South Asian dance, it is also noteworthy that a great deal of South Asian dance practices within British community contexts have often reinforced these stereotypes in their attempt to preserve tradition away from the 'homeland'.[5] Consequently, 'the dance that dominated aimed for authenticity, purity and classicism' to echo 'the central thrust of dance in India itself' and thus herald 'a kind of radical conservatism' (Khan 1997: 27). This has been further intensified by the recent policy of British museums to promote South Asian community arts framed within the contexts of displays as part of their education and outreach programmes. Consequently, both South Asian dance and dancers have been constructed as mere exhibited artefacts. This practice:

> conjures up images of exotic displays and objectification of the dance and the dancers. It immediately brings to mind the passion with which, in the past twenty to thirty years, South Asian dancers have regularly denounced perceptions of their work as exotic and immutable, declaring loudly that 'South Asian dance is not a museum piece'. (Lopez y Royo 2002: 1)

Yet, within Britain, South Asian dance has gained visibility largely through this trend. As the 'new museology' has transformed British museums from historic centres to cultural centres that promote public art, new opportunities have opened up for diasporic South Asian artists to gain more visibility and artistic presence in mainstream British community spaces.

But, as Lopez y Royo suggests, this visibility has come at a price. Fulfilling the museum's criteria for educational programmes, South Asian dancers have

been brought into museums in largely stereotyped capacities. Sometimes they have been invited to conduct participatory storytelling workshops drawing on the narrative conventions of Indian classical dance and the 'exotic' hand–gesture-based vocabulary. At other times they have been asked to move through the Indian collections at museums and respond to artefacts through dance, while, at the most intellectual level, they have been asked to contribute to discussions on South Asian dance forms and their histories. South Asian dancers involved in such projects acknowledge the strategic importance of raising visibility of their own work, but simultaneously consider such practice as low brow, with little artistic merit attached: 'additional, but in no way equivalent to performance in a theatre venue' (Lopez y Royo 2002: 7). Moreover, the rhetoric of display infused in viewing South Asian dance in a museum enhances the iconography of the South Asian dancer as exotic and mystical, belonging to the past. This renders the artist passive and lends her very little agency.[6] This is not helped by the fact that historically dancers have been perceived in dualistic, Cartesian terms with a mind–body split. They have been constructed to possess bodies that are mechanical vehicles for demonstrating skill, incapable of intellect. This Cartesian split is further amplified in the reconstruction of the Indian classical dancer as her body becomes the surface on which nationalist identity and cultural heritage is constructed. As a result, and I generalise here, the South Asian dancer has largely come to demonstrate dexterity and skill.

To rectify this Cartesian perception of the South Asian dancer as a mechanical demonstrator, and the 'Orientalist' perception of the dancer as an exotic spectacle, Lopez y Royo puts forward a model to empower South Asian dancers working within heritage sites with agency. Emphasising the artist's creativity, intellect and interpretative ability, she conceptualises them as agents who can foster a radical form of expression, 'in which the dancers' bodies are more conspicuously seen to be agents of interpretation, rather than complementary exhibits' (2002: 8). Lopez y Royo identifies the dancers as individuals, possessing intellect and harbouring potential for change. Ian Burkitt (1999) argues that embodiment shifts bodies from being empty vessels of societal constructs to becoming 'productive' (capable of transformation through acts), 'communicative' (activating power through generating/ deconstructing meaning), 'powerful' (by using the ability to transform ideology) and 'thinking' (by exercising agency). This is particularly relevant to diasporic South Asian dance artists in the UK who experience a gap between the classical dance tradition they have inherited and their current diasporic realities. Nikos Papastergiadis (2005) considers the potential agency residing in such diasporic cosmopolitan migrants and its impact on a 'host country'. He argues that migrants in metropolitan spaces become agents of cultural and social changes, empowered to transform the host country at many different

dimensions. Lopez y Royo, Burkitt and Papastergiadis collectively consolidate my notion of an 'interpretative agent'.

As 'interpretive agents' South Asian dance artists working in museums or heritage sites can enter into dialogues with the sites with a desire to embrace challenge and attain growth. Sabri acknowledges the need for this artistic and aesthetic shift in her own practice as she describes her past experiences with site-specific dance projects and re-evaluates it against the creative process of *Weaving Paths*:

> Previous site specific work [involved] visiting the space once or twice and then returning to a studio space to create a work which would then be transposed to the original site. [In this model] it always felt that the whole objective of such a dialogue was missed and no relationship was ever formed with the space. Although it did provide stimulus, it did not reflect the 'heart' of the site. What excited me about this project was that we had to create work in the actual environment with all its spatial and practical constraints as well as the opportunity to create and perform amongst the visitors to the house. (Sabri 2009)

Thus Sabri suggests that instead of coming in with a set repertoire and simply performing these predetermined patterns in predetermined spaces, an 'interpretive agent' can intervene in a visitor's regular perception of a site by reconfiguring the space, disrupting flow and fragmenting the ways in which their bodies are expected to interact with that site space. Equally potent is the influence the site can have on changing the artists' familiar models of practice and making them confront new ways of creating art. In such an encounter the potential for change is a dynamic reality and a desirable outcome for both the artist and the site. The heritage site and its artefacts challenge the artist's creativity constantly into re-evaluating their own practice, idiosyncrasies and even identity. Equally, the artist's presence in the site has the potential to reveal the 'discontinuities, gaps, lacunae, ambiguities and uncertainties' (Kershaw 1999: 161) in the hitherto uninterrupted display of its history.

I argue that *Weaving Paths* constituted a partial intervention into existing models of practice and offered an alternative space for South Asian dance within British heritage sites by embodying the concept of an 'interpretative agent'. I deliberately use the word 'partial' as I believe its productivity and agency was not sustained throughout the project. However, in its moments of success, the multiple readings it offered were powerful. At one level it enabled strategic commentary on the integration of South Asian migrant culture into the mainstream demographics of the West Midlands today. At another level it potentially destabilised the power relations that have historically governed the tendency of Britain to speak for its ex-colonies. Instead, in this exciting instance, a South Asian performance tradition reconstituted the history of a British heritage site as its artists transformed themselves from exhibits to 'agents of interpretation'.

A potential 'interpretative agent'

Weaving Paths wanted to evoke within the house's display of the Edwardian past a sense of its dynamic present, and it wanted this present to rupture the hitherto uninterrupted perception of this past. The experimental nature of this creative process tested Sonia Sabri's skill as a choreographer, forcing her to step outside her comfort zones into unknown territories and processes. To demonstrate Sabri's potential transformation into an 'interpretative agent', I shall discuss the project in two sections: first the creative process that spawned the pieces in the Drawing Room, The Grand Staircase and the Billiard Room and, second, the performance piece in the Dutch Garden. While the pieces generated in the first three spaces brought Sabri close to becoming an agent of interpretation, I will argue that the performance in the Dutch Garden reversed this process, converting Sabri and her artists into objects on display.

Devising: an interventionist tool in the Drawing Room, Grand Staircase and Billiard Room

The creative process embraced within the Drawing Room, the Grand Staircase and the Billiard Room shared the same collaborative principle of devising. This required Sabri to surrender her familiar stylistic approaches to *Kathak* choreography in favour of a more risk-ridden journey. Through adopting an open-ended approach to creating work with *Kathak* Sabri was keen 'to prove the versatility of the art form' by taking 'it out of the predictability of the Indian dance context, not only choreographically but also in terms of how it is shared and viewed' (Sabri 2009). Sabri wanted to reinvent and recontextualise the language of *Kathak* in an unfamiliar environment to testify that '*Kathak* can say anything in any context as it is not culturally or time bound and neither is the vocabulary limited' (*ibid.*). The process of devising enabled this to a large extent through its emphasis on collaboration, its focus on individual contribution and its breakdown of the conventional hierarchy between director/choreographer and performer. While it is a familiar strategy within Western performance-making, with its focus on 'innovation, invention, imagination, risk . . . eclecticism' (Oddey 1996: 2), it is alien to the dance rhetoric of *Kathak*, which is governed by the *guru-shishya* system. Thus Sabri had little control over her performers' individual and subjective responses to the spaces and therefore could not predetermine their gestures and configurations. This made spontaneity and unpredictability an essential part of the creative process. With little indication of a final product but full acceptance of the process, Sabri and her company played and experimented until patterns of movements or fragments of narratives began to emerge repeatedly and created organic structures.

Using devising within the *Weaving Paths* project enabled Sabri and her performers to focus on the process of encounter and exchange between the House and their aesthetic. It also challenged the company's comfort zones of staging familiar *Kathak* routines in designated spaces of the house. Instead, all members of the company had a stake in the creative process and an ownership over the material they created. The artists closely observed, touched and smelt the artefacts in the spaces and imbibed the traces of narratives living in them. Sabri allowed her dancers to respond as individuals to these stimulants and this generated a rich array of everyday physicality imbued with subjectivity. Out of the dancers' own experiences of the spaces emerged narratives, gestures and imagery that were either strangely evocative of the House's past or a commentary on it from the perspective of the present. The storytelling feature of *Kathak* was put to the test as its abstract and stylised vocabulary weaved in and out of contemporary everyday gestures with sophisticated ease. Codified technique was made accessible via intelligent sign-posting of pedestrian movement. Together, they created a semiotic nexus that communicated beyond cultural specificity, through which the audience experienced the reconstituted history of Bantock House. Recognising the potency of the exchange between the artists-in-residence and the house itself, Helen Streathum, the Curator Manager of the House exclaimed, 'The House will never be the same again' (in Basra 2007).

Streathum's emotional response indicates the extent to which Sabri and her company had become agents of interpretation. They had encouraged rupture of the house's exhibited past by engaging in a multidimensional dialogue with the present. Simultaneously, I would argue that the house had necessitated a re-evaluation of the company's aesthetic and philosophy and had forced the artists to re-invent themselves to achieve mutual growth. Baz Kershaw advocates the power of art to reveal and disclose the omissions and ambiguities in the writing of history. He claims that since the writing of history depends upon the perspective from which it is being presented, its strategic omissions and silencing of voices undermine authenticity. On this basis he doubts whether, 'there is . . . much difference, if any, between the writing of history and fiction' (1999: 161). The historical fiction created by *Weaving Paths* thus imagined these gaps and filled them with alternative pictures of Edwardian Britain translated by twenty-first-century multicultural Wolverhampton.

The Grand Staircase

The creative journey at the Grand Staircase started with a prolonged scrutiny of the space itself and its energies. Sabri urged the performers to find the space in the room they were most drawn to, and these spaces automatically shaped and defined the physicality that was adopted by each performer. The

large window looking out to the garden became a space for one performer's childlike waiting game. The performer continued to run up and down the stairs, to the window and back, to get a glimpse of what he was waiting for. The huge red fireplace with its stark wooden bench embodied a darkness that influenced the physicality of the woman who was drawn to it. She became a solitary figure, disturbed by something or someone and sought solace next to the fire. The painting of the young girl by the stairs with her vacant soul-less eyes drew one of the other performers and through the course of the performance, perhaps through subconscious associations, the painting came alive in her through the narrative that unfolded. Using play and improvisations, the performers discovered a latent darkness in the hallway of the Grand Staircase from which emerged a disturbing narrative. It hinted at a turbulent transition between innocence of childhood and the experience of adolescence. The piece subconsciously became a commentary on the girl in the painting and perhaps attempted to provide the reason for her soul-less gaze. There is no historical evidence to suggest what had happened to her to have been depicted with such darkness in the painting, but the piece touched on familiar grounds of innocence and sexual awakening to evoke the following response in an audience member as cited in the *Weaving Paths* report: 'The piece in the stairs was very powerful, especially with the haunting picture of the girl in the background' (BCT 2008).

Devising thus became an interventionist tool for the company, as without it neither the house nor the company's philosophy would have experienced rupture and, ultimately, growth. However, as I have already indicated, this growth and the company's ability to sustain agency through interpretation was challenged.

Display: Dutch Garden

Written into the project's clause was the participation of Shikidim, a regional community group of belly dancers. In the final week of the residency at Bantock House, once the first three spaces had been encountered and pieces had been created in response to them, the company worked with Shikidim to create a piece to be performed in the Dutch Garden. The inclusion of Shikidim and their distinct repertoire required a re-evaluation of the project's vision to accommodate the aesthetic differences between them and Sabri's company. Additionally, the Shikidim dancers came prepared with a set repertoire that they wanted integrated into the piece in the garden (Sabri 2009). This destabilised the collaborative spirit that had now become part of the creative process. Working under pressure and to a deadline for the final showing, Sabri succumbed to the security of her comfort zone and took on a 'dictatorial approach' (*ibid.*) as a *guru* and imparted a set repertoire to the ensemble while attempting to encourage some level of creativity through improvisation and

set tasks. The skill with which the ensemble demonstrated Sabri's repertoires and carried out the tasks was inevitably varied. Sabri elaborates:

> The style of the dance [by Shikidim] proved tricky to fit in with the style of the work that was created inside the house. For this particular vocabulary to work well with depth and meaning perhaps required much more time and working with [Sabri's] dancers who felt the need to progress. (*ibid.*)

The piece in the Dutch Garden lacked alignment with the rest of the project and required collaborative ownership. Some of the Shikidim bodies rendering Sabri's repertoires looked awkward, demonstrating discomfort with the physicality.

Most disturbingly, this grand finale of *Weaving Paths* became a display of an essentialised and 'Orientalised' East. The piece was set amidst the garden's natural beauty and failed to become an intervention in the space as each of the pieces had achieved in the other three locations. The Dutch Garden piece transformed the artists from 'interpretative agents' to Cartesian vehicles of skill on display. The power they had acquired and exercised through their residency and the interpretative agency they had demonstrated in their work through the rest of the house was called into question.

Recognising the gaps between the Dutch Garden sequence and the rest of the project, BCT's evaluative report on *Weaving Paths* identified time management as the key issue that contributed to the differences between Shikidim's expectations and Sabri's intentions (BCT 2008). It failed, however, to acknowledge the extent of the artistic lacunae that existed between Sabri's vision of aesthetic intervention and Shikidim's expectations from participating in the project. However, Sabri herself admits this and claims that her 'artistic vision remained consistent up until [she] came to work with Shikidim' (Sabri 2009).

Conclusion

The discussion above has attempted to demonstrate the moments when *Weaving Paths* was at its artistic high, working with intellectual and creative integrity towards fulfilling the project's brief while overcoming challenge and achieving growth. Equally, it has revealed the moments when the project was unable to sustain its interventionist vision. Despite this inherent incongruity it is vital to acknowledge that the projects did partially succeed in creating an alternative space for South Asian dancers in British heritage sites as 'interpretative agents'. In its endeavour to respond to the British heritage of the site through the South Asian heritage of *Kathak*, the encounter operated beyond the planes of history and tradition and instead created fiction through an interpretation, extension and embodiment of the space itself.

And while the 'place', the building itself, embodied a fixed Edwardian past, the elasticity of 'space' filling the house, as an extension of the artists' fluid identities and learnt traditions, was charged by the dynamism of the present. Spatial configurations within the architecture, artefacts and furniture lent the physical interactions dynamic presence, context and depth. It is this very dynamism that the artists intuitively responded to, to create fiction through the eyes of archived history around them. It is also this very dynamism that lent the reception of *Weaving Paths* innumerable frames of reference. It made experiencing the piece unpredictable and volatile for the audience, as cultural registers, temporal planes and disciplinary dialogues overlapped and interwove into a multidimensional experience through Sabri's intelligent artistic choices. Sabri embraced the house as a multivocal space begging for articulation, instead of a risk-free fixed place that offered little aesthetic and artistic opportunities. The artists created works that were not fixed in meaning, but that left room for multiple readings of the works, reliant on cultural modes of reception and encouraging stimulation of multiple registers for the audience. At this juncture I reiterate my initial argument that framed *Weaving Paths* as a partial model of *syncretic theatre*. As per Lo and Gilbert's definition of this genre, sections within *Weaving Paths* did create a third and new semantic, which forged new texts. The new performance lexis demonstrated integrity to its source cultural traditions while pushing their application and re-configuring them for their present and multilayered context. Reliant on visuality and viscerality, this new semantic required its audience to leave behind their familiar registers and their security of known performance aesthetics. Thus, by foraying into the unknown, *Weaving Paths* re-constructed the history of Bantock House through the medium of South Asian culture and identity, and embodied the concept of 'interpretative agents'; it thereby became an important project in the history of South Asian dance in British heritage sites.

Notes

1 Since this chapter was written, the company name has changed to 'Sonia Sabri Company'.
2 Migration from South Asia to Britain has introduced many of its classical dance forms in the host nation. Those that have received most visibility in Britain are *Bharatanatyam* and *Kathak*. *Kathak* is itself a hybrid art form, born of cultural and religious assimilation between indigenous Hindu storytelling tradition and characteristics of Persian dance brought to India by Muslim dynasties and fostered by the Mughal Empire (Massey 1999; Chakravorty 2007).
3 The term 'interpretative agent' has been derived from Alessandra Lopez y Royo's concept of 'agents of interpretation' (2002) and is elaborated on later in the chapter.
4 It is worth nothing here that the Sonia Sabri Dance Company comprises both

diasporic British Asians and non-Asians, lending it a hybridised and layered constituency.

5 A great deal of literature from within Diaspora Studies theorises the diasporic tendency toward reification of culture that results in an existence within a time warp between the 'homeland' and the 'host culture'.

6 Historically most forms of South Asian dance have been nurtured and practised by women both in South Asia and abroad. This feminisation of the forms has continued within diasporic contexts where the upholding of traditions from the homeland is seen to be the duty of female migrants. While more men are now successfully entering the field, South Asian dance continues to be seen as a largely female art form.

11

A la Ronde: eccentricity, interpretation and the end of the world

Phil Smith

The Royal Albert Memorial Museum (RAMM) in Exeter, Devon (UK) was closed in 2007 for refurbishment. At the time of writing (2009), I am waiting with some trepidation to see what this means for its Natural History Collection, in which a moose stood hoof deep in ornamental chippings and a bison was presented on a bath mat, examples of what Barbara Kirshenblatt-Gimblett calls the 'tourist surreal – the foreignness of what is presented to its context of presentation' (Kirshenblatt-Gimblett 1998: 152).

Photographs in a corner of the Natural History Room hinted at the Collection's moves and dismantlings over the previous century; dramatic 'nature red in tooth and claw' tableaux of warring animals gradually broken up into discrete pieces, educational and ecological agendas draining reflexivity from its displays, a rational aesthetic (plus children's drawing desks and treasure box games) replacing the mix of grotesque and terror sublime. The collection had lost much of its brazen performativity, but not all. It still retained something of the nature of 'a museum of a museum'. What remained in the absurdity of groupings and in the incongruity of backdrops forefronted an ambiguous ideological manoeuvre: partly what Kirshenblatt-Gimblett has identified as a Brechtian estrangement characteristic of museum displays (Kirshenblatt-Gimblett 1998: 157) and partly an immersion in a dreamy otherness. Made redundant by mass travel and changes in zoological science the exhibits had taken on a different function: 'long after their scientific usefulness has expired, they become almost cultural landmarks' (Thomson 2002: 75).

In the sole illustration of things to come in RAMM's brochure 'Our Renaissance', there is some hint of what to expect from refurbishment: in a brightly lit room, the image of a simulated dinosaur plays across a suspended screen, around a doorway there is a grid of discrete rocks, and in the centre a single 'interactive' specimen is displayed on a stand. The airbrushed 'artist's impression' conveys a translucency, a cool, digital reduction to a smooth, monocular narrative of scientific abstraction.

Such a flattening of space and discourse, while generating its own

vulnerabilities, supports Tim Edensor's argument that there is a 'necessity to supplement . . . expert memories . . . and to imagine beyond these limits backwards and forwards . . . not merely . . . through the fabrication of sub-altern accounts which rely on similar principles of 'historical truth' [but] that we "make things up in the interstices of the factual and the fabulous"' (Edensor 2005: 164).

In 2000 I wrote and directed a performance piece, *Cancelled Menagerie*, in the Natural History Room of RAMM, seeking to work in the kinds of inter-stitial spaces that Edensor identifies, drawing attention to the performative absurdities of the displays as a kind of visual-poetic performance language, invoking some of the melancholies of the site. A performer drew attention to a large crack in the museum wall below the sign: 'Geology At Work'. Three of the performers lay head to foot beside part of the skeleton of a mature river crocodile, modelling a maximum length unlikely to be reached again due to interdictions upon natural habitat. 'After' the performance, audience members were stalked through surrounding streets by 'hunter-collectors'.

Six years later I received an invitation from the National Trust to create a performance for Father's Day, 2007, at their A la Ronde property near Exmouth, Devon (UK). I was surprised to find a comparable politics of space and narrative to those at RAMM, and the same necessity to 'make things up'.

Where the Natural History Room was a shadowy, often hushed and eerie place, a few steps from a bustling street, A la Ronde is a four-storey, late eighteenth-century house, set in its own grounds, with panoramic views of the Exe estuary. The house was originally built to serve two wealthy cousins, Jane and Mary Parminter, as home and private museum for their Grand Tour mementoes (many of which remain in the house).

On first acquaintance, A la Ronde is intriguing: sixteen-sided on the exterior, built around an eight-sided inner room that reaches up to the roof, topped by a gallery of intricate sea-shell designs. The outer rooms were originally designated so the bedrooms caught the first light of day, after which the cousins would move clockwise from room to room following the sun. This daily circumambulation of the house was amplified in a 'constitutional' walk around the borders of their land, echoing the doubleness of the house's architecture.

'Eccentric' is the favoured description on tourism websites. The National Trust's handbook and website for A la Ronde eschew the word, but quote accounts of the house as 'curious looking' and having 'a magical strange-ness'. Deploying low-level paranoia as a routine part of my research for such a performance, I wondered who might benefit from such tamed otherness. However, I had no evidence that there were other significant meanings.

I was frustrated in my search for primary materials. The Parminter family records were destroyed, along with much else, by the bombing of the Devon

Records Office during the Second World War. However, working from secondary sources like older guidebooks, a transcription of Jane Parminter's fragmentary Grand Tour diary, and local histories, I began to gather various narratives that suggested an added purpose for A la Ronde: it was a symbolic machine for expediting the end of the world, partly by racial means.

One story regularly told about A la Ronde is that the Parminter cousins had ordered the oaks in their grounds to be left untouched until such time as the wood could be used to make ships for the return of the Jewish Diaspora to Israel; a key requirement, for some Christians, for the coming of the Kingdom of God.

This apocalyptic motive is consistent with the cousins' commissioning of an adjunct to A la Ronde: a complex of buildings built in 1810, including an oddly shaped, low-roofed chapel which the cousins named 'Point-In-View'. This name is sometimes interpreted as a reference to Langstone Rock, a sandstone point at the mouth of the River Exe visible from the door of the chapel. However, the chapel's motto – 'Some point in view, we all pursue' – makes little sense in relation to Langstone Rock. The text of elder cousin Jane's memorial in the chapel suggests an eschatological meaning, anticipating Mary's joining Jane in glory at the sound of 'the last trump', implying that this was expected during Mary's lifetime; a 'point' *already* 'in view'.

Part of the devout machinery for bringing on this 'last trump' is the chapel complex itself, including diminutive dwellings and a schoolroom. Consistent with the tale of the oak trees, first choice of accommodation at the complex was offered to converted Jewesses, with places at the school reserved for the Christian re-education of their children. This narrative took on a more sinister hue when I began to interrogate the origins and possible significance of the design of the house itself.

Neither the architect nor the significance of the design of A la Ronde is known. The case for the cousins as pioneer women architects has been taken up, particularly by some feminist historians, while the case *against* the women seems to rest wholly on their gender. There is no primary evidence either way, although the cousins' descendant, Reverend Oswald Reichel, a church historian and writer on canon law, born a year before Mary's death, attributes the house's design to Jane. As to the nature of the design itself, the best we can do is 'family tradition' (Reichel, again, is probably the source), repeated (sometimes guardedly) in guidebooks and pamphlets: that the eight-sided domed core of the building is a reference to the eight-sided basilica of the cathedral of St Vitale at Ravenna, visited by the cousins on their Grand Tour. Indeed, there are similarities. The shell gallery at A la Ronde echoes the sumptuous mosaics at the cathedral and both domes have ambulatories (one at St Vitale is reserved for women, echoing a similar restriction on residency at A la Ronde imposed by the cousins).

It was not difficult to find religio-ideological connections between St Vitale and A la Ronde. The key shared narrative is the conversion of the Jews. St Vitale's construction was instituted by, and its décor prominently celebrates, the Emperor Justinian, author of a set of notoriously draconian laws against Jews, including a sentence of execution for any Jew denying the authenticity of the resurrection of Christ or (perhaps significant to this narrative) the Last Judgement. It was possible that A la Ronde was at least referencing, at worst condoning or joining in, a celebration of the forced conversion of the Jews.

I had not 'made this up' in the sense of manufacturing a fiction, but rather (and perhaps closer to Edensor's meaning) I was stitching things together: making metaphorical connections, drawing together symbolic similarities. To not address these supplements to the official 'memories' at the A la Ronde site would have been to capitulate to the same combination of fragmentation of materials and cool withdrawal to a modest overview (an overview, all the same) that seemed about to encroach on the performativity at RAMM. At the same time I had no wish to launch a conspiracy fiction, nor to disguise the speculative, paranoid and playful qualities of my enquiry.

My method of enquiry drew on the practice of 'mythogeography' as developed by site-specific artists Wrights & Sites, initially in response to monocular heritage sites. 'Mythogeography' is an experimental approach to site as a place of performance, a space of multiple layers, including ambience and psychogeographical effects, geological, archaeological and historiographical data, myths, rumours and lies, unrealised architectures and collectively expressed desires, autobiographical associations, incongruities and accidental hybrids.

'Mythogeography' has not developed in a vacuum, but as part of a growing and changing practice of disrupted and exploratory walking, drawing from the situationists, Fluxus, various land artists and psychogeographers. It borrows and invents techniques of collection, trespass, observation, kinds of mapping that upset functional walking, means of heightening or changing perception, performativity, embodiment and subversions of official tour-guide discourse. 'Mythogeography' offers a model which aspires to subject each layer of meaning to a rigorous historiographical, or alternative and appropriate, interrogation, connecting those diverse layers and exploiting the gaps between them, while avoiding a scientific withdrawal, a collapse into a monocular satire or a capitulation to safe and policed forms of eccentricity.

Informed by this practice, my performance walk at A la Ronde (Figure 11.1) – *A Father's Day Foray* – was multilayered, a double-walking, echoing the daily trajectory of the Parminter cousins, both intimate and boundary-testing. Dressed in a cream suit, I greeted my audience from behind dark glasses, affecting the questionable aplomb of a Jonathan Meades-like commentator, saddling audience members with my suitcases. I began by setting a number of stories in motion, rippling outwards from the site – including my own 'Grand

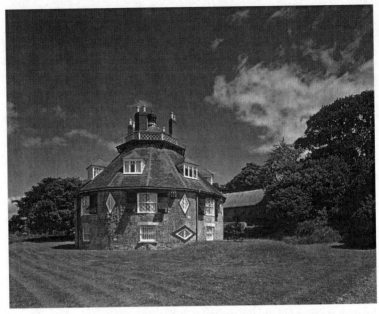

11.1 A la Ronde, Exmouth (UK), The National Trust

Tour' of walking performances in Europe and a sixteen-day walk looking for oak trees – and linked the wartime loss of all primary materials on the house to the absence of Devonian souls in Mormon heaven (the Mormon Church conducts services of post-mortem conversion based on online county records). The narrative of Jewish conversion, its bloody precedent in Ravenna and the notion of the A la Ronde/Point-In-View complex as some sort of apocalyptic machine sat within these layers, some well evidenced and clearly sincere, others speculative, comic, mischievous or fantastical.

This multilayered mythogeographical account contested some of the established narratives of the A la Ronde site, including the privileging of the *cultural* prism of the Grand Tour as the dominant influence at the site, and the, at least partly consumer-imported, narrative of gentility. Performance and journey sought to add to, rather than to resolve, any instability: in lieu of a millenarian 'milk and honey' chocolates were offered, the audience were invited to step onto an empty plinth to model whatever they thought was missing, and I disrupted historical narratives to break into autobiographical reminiscence. Absences were highlighted rather than abolished; apparently evocative broken statue feet were revealed as the disappointing trace of an inappropriate 1960s addition, recently stolen. The performance was super-empirical, factoid piled upon factoid, but, by deploying the primacy of 'and

and and' advocated by Gilles Deleuze and Félix Guattari (2004: 109), the emphasis was shifted from the materials themselves to the connections, or gaps, between them.

The journey was labyrinthine. Following the route of the cousins' 'constitutionals' meant picking a way along paths that, while maintained, were not part of most tourists' itinerary, or subject to the usual '"rules": expectations and conventions of behaviour' of the site (Wilkie 2002a: 244). A usually inaccessible 'back stage' to the house's garden was opened for the performance. The audience braved traffic on a narrow road to the little-known Point-In-View complex; the connection between chapel and house coming as a surprise to most. Both performance and walk were self-reflexive, setting in entangled doubt not only the veracity of the established narratives but also my own tales of A la Ronde. Lumbered with suitcases, the audience were invited to question the validity of our eccentric visit, the significance of the Parminters' Grand Tour, and the meaning of the contemporary site's 'rules' of touristic ambulation. However, the aim was not fragmentation, but to raise the possibility of an alternative, empirically well-founded historical narrative and make a principled resistance to official relativism.

Cancelled Menagerie and *A Father's Day Foray* are part of a series of performance-based walks and 'mis-guided tours' that I have played a role in creating since 1998, often for marginalised and disdained sites, sometimes made independently, very often with others (including Wrights & Sites, scenographer Anoushka Athique, visual artist Tony Weaver, singer Nicola Singh and performance artist Katie Etheridge). Often collaborative, invariably a *bricolage*, these walks and tours are an accumulation and disruption of influences, sometimes from the work of other artists (Mike Pearson, Kinga Araya and Simon Whitehead, for example), sometimes from the detailed responses of academics and artists (Fiona Wilkie, Dee Heddon (Heddon 2008: 102–11) and Emma Bush of Propeller, for example). Given a decentred intention and a 'community' of interest, it is perhaps not surprising that variations on both common dynamic patterns and shared aesthetics of space characterise these works.

This making geographical of the work, in concept and embodiment, drew on site-specific performance, theories of space and, perhaps most significantly, their complement: the spatialisation of theory. The museum and the heritage site have been key, and unexpectedly fruitful, loci for these entanglements; the relationship between performance, theory and museum has been more associative, more compromised and more reciprocal than expected.

It has been necessary to 're-read' heritage loci in the context of more general changes in social space: the weakening and shrinking of civil society and public space, the dominance of visuality and of relations driven by image rather than commodity, new economies of display and taxonomies of gaze

(virtual and mobile, cinematic and transported). In this 're-reading' the new-found fluidity of site-specific theatre (repeatedly 'newly found' by artists and critics since the late 1960s), freed – not always comfortably – from black boxes and fourth walls, encountered museums and heritage sites experiencing a similar liquifaction. Fiona Wilkie's 2000–01 survey of site-specific perform-ance in Britain found 'Museums and Grounds' was one of the six key generic sites for this work (Wilkie 2002b: 144).

Performance empathises with the struggle of these sites to engage with sliding planes: of the presentness of super-valued visitors to whom they must market the past, and of the insubstantiality of that past (upon which they rely for the validation of their fabrics and artefacts) as it loses its value (aura, presence) in a 'contemporary social system . . . (which has) begun to lose its capacity to retain its own past . . . begun to live in a perpetual present and in a perpetual change that obliterates traditions' (Jameson 1997: 205). Fredric Jameson characterises the museum's dilemma; its necessary renewal repeats the conditions of its crisis: 'a vision of futurity . . . where the museum speaks of itself and not of the collection it aspires to represent' (Message 2006: 74). This is not unlike performance's own problems with liveness within a visual economy whose predilection is for digitised, exchangeable records of performance. There is an irony in the orbital dance of these sites and performances about each other.

The authority, orderliness, experimentation and near-monopoly on a multiplicity of experience that accrued to museums in the nineteenth century came when they sprang collection and display from the hands of entertainers. But the cultural currency of these values has declined. Multiple saturations by mass media, and more recently mass transportation, and the spectacu-larisation of everyday life have eroded the impact of the museum artefact, flattening the auratic presence of rocks, vases, arrowheads, coins and skins. Such reduced traces are attractive 'properties' for a performance seeking to escape from the spectacular aura of reanimated, mass-produced drama. Unfortunately, museums and heritage sites, forced to address a market demand for 'to order' experiences and competing with the fluid imagery of adventure tourism, documentary television and cgi, are largely passing this 'modest' performance by. The museum misses the terrain of theatricality in an under-confident, often brusque shift 'from Flemish tapestries and Churchill porcelain to the human stories . . . people want to hear about people from people' (Pearson 2008).

Beaten to the regenerating rigours of the freakshow by contemporary visual art, any return to theatricality has been wary and mostly disappointed in advance. For (the aforementioned irony) theatre has suffered as much as, though differently from the heritage site, at the hands of a Spectacle that has jilted collection and favours displays without pasts. ('The Spectacle' is a

change in social relations from ones mediated by commodities to ones mediated by images, famously articulated by Guy Debord in *The Society of the Spectacle*.)

The dominant discourse in contemporary theatricality to which heritage and museum institutions now turn is a 'late' mimetics. Originally a radical nineteenth-century embrace of the realist, scientifically serious, commodification of appearance (the idea that appearance has both use and exchange value in itself), this mimetics has been reanimated, devoid of psychology and seriousness, to satisfy the Spectacle's visual flatness (screens). When performed in a museum or heritage site, this behaviourist theatre competes directly over scarce expressive surface space with the very artefacts and historic fabrics that its performance is supposedly illuminating. Realism, even when conscientiously done, tends to *mask* the site, not only in the sense of obscuring it, but also in making it subservient to the immediate conditions of its re-presentation.

I played a culpable role in just such a masking in 1992 when I worked as a writer on a project for Theatr Clwyd Outreach: *Gwyr Y Goron / All The King's Men* at Chirk Castle, a play about events in Wales during the 'English' Civil War. Unfamiliar with questions of site-specificity or the spatiality of non-theatre-designated contexts, I wrote a series of studio-sized scenes for studio-sized spaces in the Castle, naturalistic in characterisation, imagistic in texture and structure. The parts of the Castle were used like substitute theatres, effectively functionalised to serve the performance. Material traces of the Castle surfaced through the blizzard of image and character at moments of contradiction, when seventeenth-century costume rubbed up against modern signage and explanatory texts for visitors. Rather than engage with these disjunctures, the performance feigned ignorance of them, anxious to forefront its production of its own inconsistent consistency over that of the Castle's. In its own terms the script of *Gwyr Y Goron / All The King's Men* is hyper-fabricated – historiographical research fragmented and rearranged to serve the image-pattern of a play – but rather than set that inconsistency in orbit about the inconsistencies of the Castle the play (its dramatic virtues and vices apart) masked the site in order to sustain its own 'logic'. In doing so it followed the dominant mode of theatrical interpretation of heritage sites, combining an anxiety about the potent deceptiveness of un-interpreted 'site itself' with a fear of not engaging the audience with its own means of production.

The work I make today offers no resolution to these problems. It is not a model for a better kind of interpretation. It is part of the same decline, operating by the weaving of shared losses, attempting to leave open and make visible the poignancy of the flattened artefact, and using the Spectacle's foregrounding of its relations as a new narrative content. It draws from elements of (longstanding) surreality in the museum and heritage site; accidental

and sedimentary juxtapositions of fragments celebrated by Robert Smithson: 'mixing the time states of "1984" and One Million B.C. . . . the "cave-man" and the "space-man" . . . under one roof . . . all "nature" . . . stuffed and interchangeable' (Smithson 1966a: 15), these juxtapositions not seen as aberrant, but as 'vital to the production of the museum . . . bring[ing] together specimens and artifacts never found in the same place at the same time and show[ing] relationships that cannot otherwise be seen' (Kirshenblatt-Gimblett 1998: 3). Smithson widens the gaps in these attempts on totality: 'the blanks and void regions or settings that we never look at' (Smithson 1996b: 44) foregrounding an intensifying tendency: – 'from Flemish tapestries' towards the diaphanous and the elusive in the very idea of the museum itself.

In contrast to the impositions upon Chirk Castle in 1992, in a 2008 'Twalk' performance at the Royal William Victualling Yard, as part of the Hidden City Festival in Plymouth (UK), I allowed the Yard to impose on me. I invited the audience to feel the chipped bone in my arm where I had fallen on its granite steps (making myself a relic of the Yard), gathered the audience around me so I could change into tropical naval shorts (as issued at the Yard in 1939 to my father's half-brother on his way, incongruously, to Scapa Flow and his death aboard the Royal Oak), carried beef for the cattle slaughtered in the Yard and consumed rum, beer and biscuits for the supplies once produced there. By portraying, as with my cream-suited 'guide' at A la Ronde, an unravelling, uncertain (and increasingly tipsy) performing self I could evoke a similar unpicking of the Yard's totality, articulating its sliding planes: its almost immediate redundancy upon opening in 1835, its unrealised re-designation as a death camp ('made up' by me from the evidence of a German invasion map from the Second World War and the huge Yard's escape unscathed from Plymouth's bombing) and the spectral revenant of its architect's anti-revolutionary grid in its recent 're-development'. Avoiding an 'organic' portrayal of either self or site, a text of accidents, misrepresentations, banalities, disappearances, failures, losses and removals set the grander narratives of an epic site (and my marginal part in them) in motion about both each other and the transparent theatricality of their representation.

Challenged by the self-reflexive 'being there' of the spectacularised mass audience, museums and heritage institutions have begun to realise the potential of the elusive, the absent and the everyday in both their sites and their audiences. Exhibitions of personal ephemera (spectral traces from the deluge of commodities), once ironical or hyper-empirical, are now part of a generalised democratisation. Trails, games, fictive investigations and treasure hunts are *de rigeur*. The use of ghosts as promotional tools is an acknowledgement, in a predominantly materialist and secular society, of the elusive and hyperalienated condition of artefacts and properties in a visual economy. But this is not all about surrender to the Spectacle. For this thinness – fragile, depthless

and anti-psychological – is exactly what mythogeographical performance aspires to: pretexts, possibilities and Deleuzian 'experiments' rather than authentic subtexts (none of which precludes the success of the 'experiments'). In Alfred Hitchcock's *Vertigo* an apparently deluded character points to rings on a huge tree stump, saying: 'I was born here and died here'. In *The Delirious Museum* Calum Storrie creates a turbulent version of these temporal ripples in a spaghetti-like map that joins places with concepts and artists. Robert Smithson uses an Ad Reinhardt poster *A Portend of the Artist as a Yhung Mandala* (1955) as a disrupted map of 'an Art World . . . whose circumference is everywhere but whose center is nowhere' (Smithson 1996c: 88). In these models a multiplicity of differences is presented *as if* in the same naïve plane.

This is a potential model for a new kind of interpretation, where the point is not what lurks beneath or before or organises from above, but is the story of levels themselves, sliding about each other like the geometrical characters of Edwin A. Abbott's *Flatland*. The intention of such a model is not dramatic suspense, but sympathy, its style not only agitated and paranoid, but also depressive and reparative. The 'passages and intersections' (disruptions or information freeways) between these levels are opportunities for re-weaving social meaning from its fading traces; and it is in this sense – a sense of performative light-footedness – that an ambulatory performance has something to offer museums and trusts. Bruce Brown has described how a pre-Columbian culture in Peru, without recourse to writing, used woven and knotted strands, transported along 'superhighways . . . dead straight through the empire' as aide-mémoires (Brown 2000: 48). To contemporary culture's 'ability to externalise knowledge through the fragmentation, freezing, packaging and distribution of our memories' (Brown 2000: 51), Brown counterposes a trajectory model of assemblage and dissemination that first agitates and then repairs the fragmentations of memory. Brown is not alone. Countering the dominance of high paranoid style in critical theory, Eve Kosofsky Sedwick proposes a 'depressive position . . . from which it is possible in turn to use one's own resources to assemble or "repair" the murderous part-objects into something like a whole – though, I would emphasize, *not necessarily like any pre-existing whole*' (Sedgwick 2003: 128).

In this spatialised model of thinking and making, dislocated fragments of narrative thread are re-paired (in unexpected and shocking juxtapositions), deploying tactics from situationist praxis such as détournement or Brechtian disruptions, an 'uncovering of . . . conditions. . . brought about by processes being interrupted' (Benjamin 1973: 18). This repair is not a return to '*any pre-existing whole*', but a re-combining of what is already disparate, if often apparently homogenous (ideological), into threads of narrative in trajectory across Nazca-like theoretical 'planes'. Fiona Wilkie emphasises the porous

quality of such weaving, 'I like the fact that weaving always leaves gaps, no matter how tight or loose it tries to be' (Wilkie 2001), using the Penelope myth to describe part of the weaving process as 'an unpicking of stable categories of memory' (Wilkie 2007: 11).

Referencing Francis Yates' description of an 'art of memory', an esoteric use of a built environment as a visual mnemonic, John Rajchman proposes a contemporary architectural equivalent to the use of planes or levels; what he calls a 'noniconic diagrammaticity', a 'freer space in which many unexpected things can happen at once, without overarching story . . . a kind of "nonmonumentalizable" time given diagrammatically through passages and intersections rather than iconically through symbols of the myths of holistic communities or already-given peoples' (Rajchman 1999: 153–4). In other words, interpretation is not simply a performed exegesis of the given, expert 'meaning' of a site, but rather the open, explicit, performative *making* of that meaning.

'Mythogeography' operates as an 'art of memory' for Rajchman's postmodern space of 'passages and intersections'. Unable to use such a volatile landscape as an esoteric filing system, the mythogeographer must weave multiple, fluid narrative lines that can respond to the instability of the postmodern plane. For all postmodern sites, however functional, are, by definition, anomalous; most rewardingly articulate when regarded as mysterious, and all as worthy of subjective, associative interpretation as such official oddities as Ferdinand Cheval's Palais Idéal at Hauterives, Bory Var at Székesfehérvár (a castle built in a suburban street during Professor Bory's summer holidays; Figure 11.2) or The Winchester Mystery House at San Jose, where Sarah Winchester, haunted by the angry spirits of Native American and Civil War victims of the products of her family's Rifle Company, kept a team of builders busy for fifty-four years, making daily adjustments to her mansion (guided through a ouija board): 'a mind twisting labyrinth . . . windows in the floor, a set of stairs run up to a blank ceiling and doors (that) open onto sheer drops . . . a cupboard door opens onto a space a half-inch deep . . . the entire place is a massive ghost trap . . . custom made to baffle and frustrate spirits' (Simmons 2003: 50). The role of the mythogeographical interpreter is to 'hunt' such ghosts of meaning that heritage sites seek to thwart, calling up their diaphanous histories and re-animating whatever contradictions we can still take responsibility for.

When silenced histories are re-voiced in heritage properties where narratives of gentility constitute a 'safe haven [for] a troubled history that glorifies colonial adventure and a repudiated anthropology of primitivism' (Kirshenblatt-Gimblett 1998: 136), such histories are more insistent and less resistible when they are part of a general rather than a limited destabilisation of meanings. Troublingly, though, for institutions of both conscience

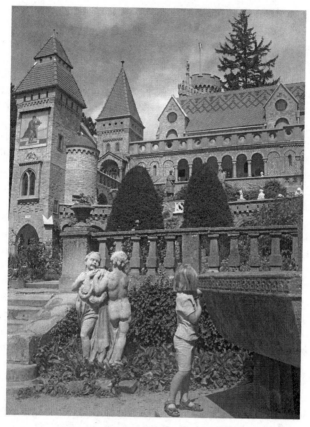

11.2 Bory Var, Székesfehérvár (Hungary)

and conservation, it is the dematerialisation of artefacts, buildings and historiographies which is required for this general effect – a performance effect – without the comfort of the mimetic conservation of appearance. What institution would support such a trajectory toward a 'Delirious Museum . . . aspir(ing) to the condition of the city', setting institutions in a '"semilattice" of interconnections and overlaps' (Storrie 2006: 2)? Yet such a self-reflexive de-materialisation has already been at least partly accommodated in official relativism: 'information presented should be layered, using expert views *woven* alongside more personal ones' (emphasis added) (National Trust 2004: 2).

A Father's Day Foray was perceived at A la Ronde not as a subversion, but as *adding* elements not present to the existing interpretation: 'the walk around the meadow with reference to the house, itself being (a) "grand tour",

drawing on the shapes, symbols, flora and designs of the property, together with your unique style' (Carr-Griffin 2008). I was invited back to create a new performance at the property for 2008. The National Trust's regional curator welcomed the additionality, and explained that the Trust would value a new, even controversial, well-founded interpretation as 'a major addition' even when it constituted 'a subject foreign to most people' (Pearson 2008). There is an enthusiasm for varied viewpoints, accelerating a long-term drift away from authoritative objects towards diverse interpretations (the collection of artefacts replaced by the collection of narratives), made available to the more discerning visitors in information sheets. But, as also at RAMM, the enthusiasm does not extend as far as a fundamental re-telling of these sites as disturbed and disturbing; except as 'commercially' (Pearson 2008) haunted houses, a drained gothic.

The 'and and and' of the institution is a hierarchical one, even in a democratised postmodern form in which hierarchy is now laid on its side, seductively appearing as if a fragmentation across a plane rather than an ordered cross-section. Organisations of conservation, still reproducing bounded identities (national or local) are necessarily cautious and normalising, but in new ways: as 'nuanced cultural institutions with practices that are interdisciplinary, multipurpose, collaborative and cross-cultural . . . within complex processes of decolonization and the multiculturalism that is privileged in many cases by the dominant state' (Message 2006: 201). What suffers in such a 'machine' is historiography's encounter with historical extremes; an encounter which is subjected to a disempowering (and paradoxical) homogenisation and fragmentation within an equalised diversity of accounts.

Rather than a professional or institutional strategy, what I am proposing here is something more like an orrery of ideas and practices, a praxis for a 'guerilla' interpretation, as open to use by a museum visitor as an artist or a heritage professional, a toolkit of aide-mémoires, as much a work of imagination as dramaturgy, a re-gearing to overlapping 'fields' (including 'power-geometry': how 'different social groups, and different individuals, are placed in very distinct ways in relation to . . . flows and interconnections' (Massey 1994: 149)), even the idealisation of specific environments as an art of perception.

As eschatology has disappeared at A la Ronde (assuming it was ever there) and is unlikely to return soon as anything more than an additional viewpoint, will there be a similar vanishing at the refurbished RAMM? Or will there be space to engage with extreme elements of its Victorian assemblage, such as the big game hunting and racist fiction of C.V.A. Peel, collector of many of the museum's animal specimens including the iconic 'Gerald the Giraffe'? Will accounts of the murderous fantasies of Peel's colonialist 'utopia' *The Ideal Island* be inscribed in the new exhibits? Or, like the violent drama of animal

tableaux, and antisemitic eschatology at A la Ronde, will they be muted or silenced?'

Discussion with RAMM has been comforting and worrying. On the one hand, there is a willingness to engage with the history of collection: 'A gallery is [to be] devoted to the early collectors like Peel' (Parsons 2008). On the other hand, the intense details and excesses in Peel's story may languish as 'research material [that] is available and informs our choices in storylines, object choices and approach' with public access on a character like Peel limited to 'a hundred or so words' (Parsons 2008). The decision to re-distribute the Natural History Collection 'to display natural history material alongside other collections' could generate heady juxtapositions, but it could also signal the museum's escape from itself, de-narrating and homogenising its artefacts in fragmentation.

In the face of official relativism, Keith S. Thompson proposes that 'museums and their collections should always serve big ideas . . . [N]ow there are as many visions as there are treasures' (Thomson 2002: 103–4). The model of mythogeographical critical practice and performance strategy, however, sets that multiplicity of visions in motion relative to each other, subjecting their relations to a spatialised criticism, resisting both one 'big idea' and multiplicitous relativism, aiming to generate a flattened aesthetic space in which to entertain the possibility of virulent and extreme narratives, even in the histories of collection and display.

12

Triangle's immersive museum theatre: performativity, historical interpretation and research in role

Richard Talbot and Norwood Andrews

Introduction by Richard Talbot

Since 1988 Triangle Theatre Company, based in Coventry, England, and led by Artistic Director Carran Waterfield, has incorporated historical research as a significant aspect of all of its studio productions. A curiosity about personal stories, family histories, and national historical events and figures has led to research-oriented performances in which the processes of uncovering, unpicking and piecing together narratives and identities are still active in the 'finished' (unfinishable) work. Triangle's interpretations veil and unveil characters through the technique of slippage in which voices and perspectives of different personae shift across the apparent body. In these shifts the voice of the actor also occasionally leaks out. Such work exploits the dynamics of gossip, interruption, intimacy and betrayal in order to unsettle the authoritative historical or protagonist voice.

In its recent experiments with site-specific 'immersive museum theatre', the company has been playing with the notion of 'character' and the actor's co-presence as historical researcher. One feature of this work is an ongoing negotiation between document-*based* and character-*driven* historical enquiry. This mode of performance-as-research interrogates documentary evidence as a foundation for enquiry and is self-reflexive about the function of intuition and speculation.

In this chapter we will discuss Triangle's work on two projects: a series of improvised performances in 2008 at Charlecote Park in Warwickshire, a property now managed by The National Trust, and the very early phase of devising *The Last Women*, a production which has since been scripted, recast and rehearsed and which opened at The Belgrade Theatre B2 studio space in April 2009.

At the 'Performing Heritage' Conference, at Manchester University in April 2008, we delivered a partially improvised live performance-presentation which sought to revive the interactive methods of these two projects, and to suggest how apparently different contexts shared some features consistent with Triangle's

emerging methodology of historical performance. In the following 'discussion', which is shared across numerous personae and voices, we will attempt to articulate some of the ways in which performance practices and historical research practices may become mutually informative and integrated in and as the event of performance.

What follows is a partial transcript and further iteration of the conference presentation, which seeks to sustain the exchange and contradiction between the two figures on stage in Manchester: Richard Talbot, the actor in-role, 'as' the nineteenth-century architect of Charlecote, Charles Samuel Smith, and Dr Norwood Andrews, the academic, performing himself: the historian and advisor on *The Last Women* project. In the live performance, the voices of some characters, scholarly texts, and other actors on the projects were fragmented or displaced, appearing in video clips or as texts which the audience were invited to read out.

As I write this, distancing myself from the actor in-role, I see that I am emerging as an additional voice in this process of reflection; that is, as someone writing up the performance. I am aware that a proliferation of characters and contexts is an inevitability which undermines the inclination to refine or clarify events and inform the reader. The conversation which is presented here, then, examines this slippage and juxtaposition of actor/curator/researcher/academic and other research characters. This slippage can be understood as a performative ambiguity in which the reader is brought into a shared and productive uncertainty as to the framing of the speaker's proximity to past events, including their presence in the conference piece.

In this transcript, the stage directions and various voices are not provided to suggest a reproduction of the performance-paper or of the same scene imagined for staging in the future. Rather, these clips are a collage of multiple perspectives, including that of the 'non-actor', Dr Andrews. Norwood Andrews presented a self-contained paper in the latter part of the performance; nevertheless, his presence at the back of the stage throughout the first part was a form of mute commentary. This presence is approximated here through the use of asides linked by thematic association and accumulating toward Norwood Andrews' concluding contribution.

One 'candle' (an electric light with a pointed bulb) on a chair. Charles Samuel Smith is dressed in a top hat. 'Pat-a-pan' (Christmas folk music) is playing from a mobile phone on the floor. A figure (Richard Talbot [RT]) is dancing in the dark, barely lit. The audience is guided one by one to chairs assembled around a blind suspended below a swag of net curtain. The tough calico blind has a small architectural plan painted on it in black ink and blue watercolour. When the audience is seated, a candle is held up to the architect's ground plan. Throughout Dr Andrews [NA] is sitting in the gloom behind the screen. He too is barely visible.

Charles Samuel Smith/RT:
I am – I am being – Charles Samuel Smith. I am Charles Samuel Smith. I
built this. This is Charlecote Park in Warwickshire.
I indicate the floor plan. . .

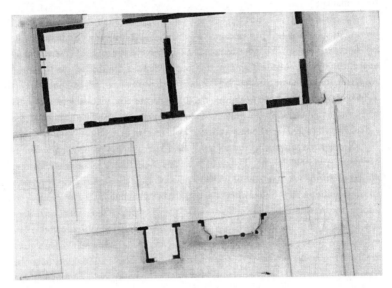

12.1 Floor plan, Charlecote Park

Mullioned windows replaced with 18th century sashes, two storey canted
bay windows, ogee-roofed turrets, brick and stone piers, strap-work on
balustrades, obelisk finials. . . (Jones 2007: 45)

Queen Elizabeth stayed here for two nights in the late 1560s. They built
the portico in her honour in 1573. The footprint of the 'original' building
is therefore a typical Elizabethan 'E' shape. I was – I am – responsible for
re-edifying the building and adding an extension *(I indicate)* – *here*, and for
creating a canted bay, and for literally raising the roof in the Great Hall.

Charlecote Park is The Tudor home of the Lucy family for more than 700
years; the mellow stonework and ornate chimneys of Charlecote sum up
the very essence of Tudor England. There are strong associations with
both Queen Elizabeth I and Shakespeare, who knew the house well. (The
National Trust, 2009)

Shakespeare, it is alleged, was caught poaching deer on the estate as a
youth. He was brought before an impromptu court convened by the
landowner, Sir Thomas Lucy, then tried and punished for this misde-

meanour. However, according to one Victorian critic, Nicolas Rowe, Shakespeare took his revenge in *The Merry Wives of Windsor* in a scene in which Justice Shallow mentions the 'lousie', in other words, the flea-bitten and hopeless local JP, the master of Charlecote, Sir Thomas Lucy:

> A parliamentary member, a justice of the peace
> At home a poor Scare crow in London an asse
> If lowsie be lucy as some volke miss call it
> Then lucy be lowsy whatever befall it. (Attributed to Shakespeare by Rowe) (*The Dramatic Works of William Shakspeare*, 1823, quoted in Wainwright 1989: 210)

This tenuous connection with Shakespeare brings tourists here in 1769 for a conference and Shakespeare 'jubilee' presided over by the actor David Garrick.

Sir Walter Scott also paid Charlecote a visit in 1828:

> While we were surveying the antlered old hall with its painted glass and family pictures, Mr Lucy came to welcome us in person, and to show the house, with the collection of paintings, which seems valuable and to which he had made many valuable additions . . . This visit gave me great pleasure; it really brought Justice Shallow freshly before my eyes. (Sir Walter Scott, letters, quoted in Wainwright 1989: 218)

In the great hall Mr Lucy becomes Justice Shallow in an unwitting re-enactment prompted by an earlier description of a visit to the property by Washington Irving.

> I was courteously received by a worthy old housekeeper who, with the civility and communicativeness of her order, showed me the interior of the house . . . there is a wide hospitable fireplace, . . . formerly the rally-ing place of winter festivity . . . I had hoped to find . . . the redoubted Sir Thomas sat enthroned in awful state [before] the recreant Shakespeare. (Washington Irving, quoted in Wainwright 1989: 213)

The Shakespeare mythology exceeds the verisimilitude of this site. It was/has been/is almost entirely 'modernised' by George Lucy in the late eighteenth century and I have largely re-constructed it as a 'mock-Tudor' house for the nineteenth century.

A slippage occurs shifting the perspective from Charles Samuel Smith to that of the actor, although the physicality and tone of voice of Smith is weirdly sustained.

RT:
The site has a theatrical connection (based on real and apocryphal events) and a theatricality as it becomes something like the stage set for the legend in

which the contemporary Lucys and their household appear as guides. In this mode they are able to re-dress the humiliation of Sir Thomas and performatively reinstate his judicial status through a re-incorporation of Shakespeare. This time the poet appears not as an outlaw, but as the hero of the scene at Charlecote. This lineage of legal, ritual performances, and the subsequent mythologising re-interpretation, inspired interactions in 2008 which aimed to interrogate the claims of the various historical and contemporary players.

A small video image appears on the domestic blind. The image is positioned just above the floor plan drawing and the projector lens has been distorted by a lantern glass, creating a kaleidoscopic effect, distorting and dividing the image into segments with different hues. The image is further distorted by scratches and film jitter. A scullery maid, a footman, a butler and the architect can be seen moving through the building and grounds. It is projected without commentary.

RT *(continuing)*:
Triangle's performances at The National Trust are pitched into a curatorial environment of intensive preservation. However the historic building and the artefacts it contains can be understood as a materiality that is decaying and also reconstructed through preservation and, to some extent, 'improvised'. Although they are intangible, the improvised performances by visitors, the 'unmatrixed' (Kirby 1995: 45) performances of volunteer guides, and the presence of professional actors restore or re-enact the performances by a 'visitor' like Walter Scott or a 'guide' like the housekeeper – not through impersonation, but through a dialogic kaleidoscope or matrix of viewpoints and knowledges. This interpretation strategy draws as much on the predicament of the visitor as on the knowledge of the interpreter, and is stimulated by unproductive, excessive and playful speculation as much as by 'fact'.

NA: *(as if from the dark at the back of the room)*
On the day of my visit, the 'house staff' spent some time in the rooms of the service wing which are open to the public (principally the scullery and the kitchen), peeling potatoes, and making crude sculptures out of potato. Generally they seemed easily distracted from their chores. They persuaded most of the visitors to join in country dancing, and offered a farcical staging of a Shakespearean comedic scene in a section of the garden.

Miss Nicholls, the scullery maid, typically displayed a downcast expression and manner which reflected her life of drudgery, but she serenaded the visitors with an unexpectedly pure and heartfelt rendition of 'Sigh No More, Ladies' (*Much Ado About Nothing* Act II, Scene 3).

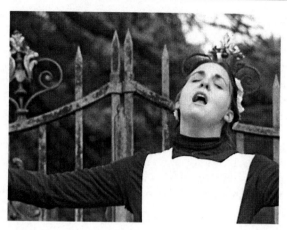

12.2 Miss Nicholls

Miss Nicholls:
Some people believed me stories more than others; some I had to slip a wink; others I left with the cruel un-satisfaction of an un-finished story as I had things to do; others I was with for far too long; some trapped me and others I trapped. Sometimes I forgot who I was and had to remember meself. Knowing where I came from 'elped. I saw some of their eyes glaze over like cows when I was talking – this was not a good sign so I just left 'em and decided to walk off and get on so they could watch me from afar. I do cut a finer figure from a way off more than I do up close, like. I keep forgetting that.

RT:
At Charlecote, the visitor's sense of trespass may be strongest in the study, which is used by the current resident, Sir Edmund Fairfax-Lucy, as well as his forbears. On the desk there are artefacts in the process of repair. This lord seems to be an active participant in his own conservation. From here he can observe visitors and they may spy him. This is a museum with a living resident. It is a space in which the volunteer guides are 'squatting'. Like jesters in an empty 'seat' or throne, this might be an opportunity to play. However, the tendency is towards a dutiful respect: inside the public areas of the house volunteers take up positions at doorways and at desks, and in each room framed by doorways, thresholds, corridors and stairways they lurk and wait to deliver their 'material'.
 (*slipping again into a perspective shared with Charles Samuel Smith*)
 In the cramped study, I mutter over the shoulders of a small group of visitors as they look for signs of real life: an aristocrat at his desk. They

are pressed up against a rope barrier and 'real life' appears behind them and surprises them with a whisper.

In the Great Hall we hug the walls and rush to corners, working on the edges of the rooms and in-between spaces: leaning against a pillar, whispering from the shadows, or eavesdropping on visitor conversations. Alternatively, working against my own habits and expectation, I pace along corridors with apparent purpose – looking for someone.

In the intimacy of the bedrooms we mutter about Victorian pornography. Along the corridor or on the staircase we shield the public from 'ugly' paintings. We use the bay windows as stages, walled on three sides. We create a massed dance in the hall, just like Washington Irving supposed.

(slipping again)
It is by playing dialogically with speculation, and the unknown, that new knowledge unfolds.

(and again)
During my time in Charlecote I am asked a question by a visitor about the different shapes of the ceilings in the library and dining room respectively – one is barrel-edged, the other square-edged. A specific question about an apparent line of darker paint where the barrel ceiling meets the walls is not answered by a guide but redirected via the actor (who could not answer) to other visitors, and then onto the guide (who could not answer) and on to other guides and visitors until everybody spending time in the library or dining room participated in an enquiry that offered numerous explanations from the improbable to the technical. For the most part the educational method in the National Trust is to return to the available facts and methods of manufacture. Here the enquiry and outcome was based on how the ceiling made the visitor feel as they took up space 'squatting' in this residence. As the light changes, the optical illusions created by the ceiling design shift and there is a shift in our collective conjectures. The ceiling and fabric become a sculptural and affective artefact in their own right rather than simply a design whim of a wealthy former resident.

The ceiling in the library creates an optical illusion. The pendant stucco moulds are all the same length but appear to be more squat when viewed at a distance. As you move they also appear to move. In addition they are differently formed. In the plaster work there is an apparent 's-shape', a 'comma' and a 'question mark'. They are arranged in a pattern – perhaps this could be a code? Each one is decorated with beads or diamonds, forms like sugared fruit, or sweet corn or decora-

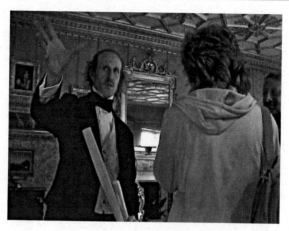

12.3 Charles Samuel Smith

tions from a Christmas cake. You must be careful not to spill your soup down your front when you look up to admire them. The ceiling is so delicious you could eat it. You could snap the pendants off. They are like meringues. Each one is surrounded with a quatrefoil and the coffers are filled with exuberant arabesque and serpentine forms. (*Extract from Charles Samuel Smith's monologue.*)

RT:
We breed misunderstandings and distractions, all the time drawing more people into a sense of bewilderment. We start some business with a piece of rubbish, like a cart or a plank. We struggle with the paraphernalia of the site, the railings, the fences, ropes and barricades, bay windows, narrow corridors. We talk at tangents to a more serious history of the house, we invent fantastic plans, such as installing plastic double-glazing or building improbable extensions made of iron grid work.

NA:
Bold, insubordinate Miss Hunt induced one visiting family to dance around a maypole, and then persuaded the children to put on pieces of her uniform and take on some of her tasks.

RT:
All costumes are in processes of ongoing repair: the scullery maid's pinafore became stained by mud and potato juice; the housekeeper's skirts became 'daggy' after trailing in the mud; and dry mud was ingrained in the knees of the butler's woollen breeches every time he proposed to Miss Hunt, the

housemaid. The pocket of Miss Hunt's original nineteenth-century apron strains under the pressure of her notebook and pencil. Hunt's restorative needlework around the pocket is her mark on the history and personality of the apron. These many ways of being worn out become the thread of subsequent narratives shared with visitors. Perhaps this is why each persona has been self-contained, carrying all other artefacts in the pockets of a costume that becomes a portable museum.

NA:
Miss Hunt told me that she and I were to be married and instructed me on preparations for the event. Mr Parsons, the butler, asserted his authority over the household staff but was plainly unable to establish control (rumours of a drinking problem were spread about by the house staff). The butler and the maids were constantly trying out ways of using space and engaging visitors. While their uniformed presence implicitly invoked a familiar type of living-history display, with costumed interpreters acting out traditional work routines and offering earnest explanations, their actual choices about performance defied these expectations and (consequently, in my view) elicited both bemusement on the part of visitors and a heightened level of curiosity.

RT:
Coming as it were from the edges of conventional performance at an historic property (e.g. the guided tour or talk), these responses or 'entrées' divert expectation. They have a stab at what visitors may be thinking and they challenge the tendency of audiences to start acting or directing when they encounter 'costumed characters'. We seek to playfully undermine the format of the conventional visit. Visitors are gently degraded or mocked. Alternatively, volunteer guides may be dubbed 'upper servants', or even as stalkers of the former aristocracy. This 'institutional critique' is intended to expose some frustrations visitors may feel with the constraints and ideology of the institution.

An audience member who encounters a character *on the stage* is put in what performance scholar Nicholas Ridout has called a 'predicament' (Ridout 2006: 32). Ridout's predicament arises from a disorientation. The audience asks who am I here and now? What am I supposed to say and do? A person who encounters a re-enactor on site is already immersed in a performative space, but also an improvisational everyday space in which the script requires contemporary and anachronistic behaviour. We are not encouraging the audience to pretend. We notice and comment when they stand on ballet toes or rock from side to side like Harlequin or a Pantomime Dame in anticipation of their 'role'.

Charles Samuel Smith/RT:
'What are you supposed to be?' asks a 70-year-old red riding hood in orthopaedic sandals. Visitors sometimes seek to address me as an actor. To me the question sounds ridiculous, if not rude. It may be posed in good faith, the speaker standing straight as a pin on tidy feet, assuming the stance of a ballerina or harlequin. But in the heat of the late afternoon this game can twist into cruelty and feed my alienation and glee. I once came across an Italian architect (so he claimed) who was elaborately but unfashionably dressed up, in a Fellini sort of way. He asked if I was teasing him with my pretence at being an architect, and perhaps he was right. He asked if I was honestly interested in architecture, but rather than wait for an explanation he began sucking on a long monologue about beauty. His partner, 'Sophia Loren', was standing beside him pushing an empty wheelchair. Her face was deeply fake-tanned and as her eyebrows lifted they pushed dark waves of wrinkles back to her hairline. Who is the wheelchair for? I wondered. I am anachronistic myself and when I come across anachronistic fashions or frail bodies there is a slight recognition that invites a deathly playfulness, but it is important to play seriously.

RT:
Sometimes this predicament may inspire aggression. The instance of the heckle has been theorised by stand-up comedian and academic Kevin McCarron as a moment in which authoritative texts are challenged by improvisation (McCarron 2008). The heckle is a spontaneous demand on the comedian to make a witty unplanned riposte, and to prove themselves over the heckler. Likewise in the heritage house, joking or confrontational responses demand a counter-response that is markedly unplanned.

Fionn Gill/Ellis, The Groundsman:
Exploring ideas on the spot, ... and then developing those into a 'mini-scene' – you have a start, a twist and an exit [learning] how to 'warm-up' your potential audience ... learning how to do this alongside another performer ... [this is an] almost scientific side of comedy and improvisation.

RT:
The unstable amalgam of period character and contemporary commentator is constantly mutating. Characters betray confidences and factual details borrowed and stolen from visitors. They learnt to give the household staff more reality by executing the steady labour of cleaning or serving. Initially, actors tend to find planned scenarios and detailed research

blocked or confounded by visitors who have other priorities: some visitors cast themselves into the role of visiting gentry, or as activists demanding social change. Some simply ask for directions to the café. Making self-conscious external changes to character is problematic: a sudden change of accent can throw the hierarchy established with other actors. However, the audience is changing day by day, and the way that their individual stories weave into the work of the staff assists (or threatens) character by extending the whole network of conversations and events.

Miss Hunt:
Met a 'Lord and Lady' who used to live in Sheffield but now live in Gloucester. Their house was four inches from being flooded. I explained about the cellars here and the Avon flooding. This encounter seemed to cross the boundary of time. The couple were talking in a very modern sense about something personal that had just happened to them. I was talking in a Victorian context and yet we understood each other perfectly and they did not think I was being patronising. There was no 'Oh well I suppose they used to. . .' It worked perfectly in the present tense.

RT:
Thus interpretation is not 'first person' which is used to mean that the performer identifies with the character and is restricted to the time era allocated to the performance. Nor is it 'third-person' interpretation, which speaks from a fixed sense of 'now' about what 'they' would have done then. In this work we are trying to find a way for the actor and the guest to be both too late (third person) and too early (first person), not yet present, but rather present imperfect, becoming, any minute now.

The lighting is less gloomy now. The figure behind the screen is clearly visible. He is wearing a smart jacket and tie and carries a clipboard, from which he reads a prepared essay. He is not improvising, it seems:

NA:
I am a historian, part-time projectionist, present-day acquaintance of Charles Samuel Smith, and newcomer to immersive museum theatre. I became immersed myself, as a participant–observer, in the theatrical space of two of Triangle's projects.

One of these is the Charlecote Park project which you have just experienced in its incarnation as text. The other is a work titled *The Last Women*, which was performed in April 2009 and had been developed over the preceding months. Triangle's Artistic Director, Carran Waterfield, devised and

directed this project. I occupied a vantage point within its development, with a view of Carran's methods. This experience has informed my own study of the same historical episodes which the theatrical work explored. Triangle's projects differ from each other in important ways. Separately, *The Last Women* and the work at Charlecote Park reflect methods, objects of concern, and other particularities that distinguish Carran and Richard as individual artists.

RT:

Factors which influence these particularities include the very different context of performance and public engagement imperatives. At the stage of research and development, artists working on *The Last Women* made weekly improvisations for a small invited audience. At Charlecote Park public engagement is in the form of day-long improvisations. 'Development' in both cases may be measured by the ways in which an exchange of information between audience and actor becomes more detailed or evocative and less general or stereotypical as the actor's understanding of the historical context deepens.

NA:

Still, in both works the historian recognises a shared concern with the fluid qualities of identity, and the relationship between the construction of identity and the experience of improvised performance. Both works speak to the ways in which scholars are seeking to understand historical episodes in terms of their performative essence.

Each of Triangle's productions has found resonance in past experience, whether intimate (as in Carran's own family history) or communal (as in the Coventry blitz). Carran sets conventional narrative aside and instead renders experiences, and relationships among characters, by arranging a sequence of images, spoken words and actions, which can include symbolic objects, references to myth, repetitive movements taken from ritual practices, and sense-memories and remembered moments from a particular individual's life, together with musical accompaniment. These arrangements can convey the mind of a character, or the heart and soul of a community, more acutely, and with a stranger and more intense emotional impact, than a linear story.

The Last Women used historical accounts of several women, from different times and places, as searchlights to illuminate some of the darker aspects of women's shared experiences and female identity. The historical women included Mary (Queen of Scots), Ruth Ellis (the last woman hanged in Britain, for murder, in 1955), and the two last women hanged in Coventry (Mary Ann Higgins, in 1831, and Mary Ball, in 1849). 'Mostly

these women are connected through the theme of execution', Carran observed (in the text of a museum exhibit which preceded the staging). 'I have wondered what it might have been like for those women to contemplate their impending deaths in that short time between sentencing and the final act. It is thinking the unthinkable and imagining the unimaginable that has become the artistic challenge for this work' ('The Hour of Death', exhibited at the Herbert Art Gallery and Museum, 4–18 March 2009). Throughout the work, historical sources were invoked, but never in the most simple or direct ways.

As with Carran's previous productions, *The Last Women* drew upon both improvised and scripted performance in its separate phases. Devising the work was an intensive process in which a cast of performers explored Carran's chosen themes, and the most resonant means of displaying them, through improvisational exercises. This work informed Carran's writing, and a newly assembled cast rehearsed and performed the scripted play.

During the devising process, Carran constructed and directed the episodes of improvisation so as to elicit instances of uncertainty, uncalculated actions, and unanticipated outcomes, in ways similar to Richard's work at Charlecote. Each actor was assigned different roles to play at different times. At the end of each week, Carran and the cast held events open to the public in which they interacted with visitors while in character, and also enacted a performance drawn from recent improvisational exercises. Upon arriving at these events, visitors would be greeted by several ladies who were preparing to hold a club meeting modelled on the Women's Institute.

Pictured here is Miss Nanna Smith, wearing her signature blue dress with white lace (as well as a mysterious neck brace). Among the ladies,

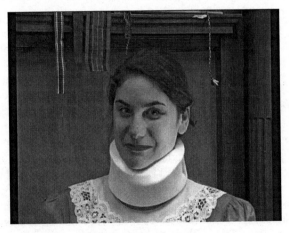

12.4 Miss Nanna Smith

Miss Smith most clearly displayed a commitment to home, hearth and the domestic realm. She had a mannered but charming way of speaking and acting which was highly distinctive. (The actor who played this character is Nina Smith.)

Each week the performance carried out by the actors would take them away from the ladies, and the club meeting would morph into something else entirely. But as the actors assumed different characters and enacted different scenarios, occasionally the unexpected would occur. At the end of one weekly performance, Nina Smith and another cast member, Emily Ayres, acted out a scenario of cross-examination, in which Nina took on the persona of one of the historical women (Mary Ball, who was tried and convicted for the poisoning of her husband). Questioned by Emily's prosecuting attorney on the details of her case, Mary Ball stood uncomfortably, threw out lame excuses, claimed not to remember what she had done. Then, pressed to the limit, at the climax of the interrogation, Miss Nanna Smith suddenly answered the attorney, in her distinctive voice: 'Could you please take the chair?' The actors then reversed roles, with Nina's character asking leading questions and Emily's character standing uncomfortably.

Other choices made by the actors in the scene reflected prior planning, but the switch, or slip, when Mary Ball is asked a question and Miss Smith responds, suggests an accident, or a spontaneous decision on Nina's part rather than a calculated one.

Carran's devising process seeks to elicit such sudden acts of displacement. She expects that the truth will come out sometimes by accident, in the heat of the moment. In this particular case, she later indicated to me that Nina's action was not especially productive, for purposes of the devising process. But the historian–witness pursuing his own simultaneous inquiry into the life story of Mary Ball may apply a different standard to particular instances of improvised performance. Such occurrences may contain clues – or at least raise possibilities – about Mary Ball's case which would not occur to the historian himself. Could a spousal poisoning have reflected a displacement of domestic energies or a homemaker's impulses, under the pressure of domestic abuse or other possible circumstances? What forces were tightening around Mary's neck, long before the hangman fastened the noose?

As a day visitor at Charlecote Park, I observed Mr Parsons the butler, and Miss Hunt and Miss Nichols as maids, 'squatting' in the performative space. What is particularly important, in the historian's judgement, is their commitment to 'serious play', genuinely spontaneous interaction, and productive, non-predetermined dialogue. The actors at Charlecote were frequently switching or perhaps slipping between period character and contemporary commentator as they chose angles of approach and

engagement. Like the improvisatory exercises assigned by Carran, their performance allowed the opening of unexpected possibilities and the potential creation of new knowledge.

In evolving their own views, historians have recently come to appreciate some of these same possibilities. Richard Schechner's primer on performance studies analyses the full spectrum of human activity in terms of performed routines. This analysis draws a basic distinction between ritual and play, as the two composing elements (Schechner 2005: 22–44; Kershaw 2006: 30–53). But for historians trying to see into the past, the most visible patterns have often been ritual practices – actions taken by authorities in their official capacity, or by members of organisations with their own codes and standards, or by communities with their formal and informal traditions. For a past generation of historians, the order and sequence of parades, or the deliberate conduct of food riots, offered clues about social life that could not be found in statute books. Structuralist anthropology portrayed culture as composed of rules, and systems of rules.

More recently, Peter Burke has detected a distinct trend – what he calls a 'performative turn' – in the work of other historians. 'The main point to emphasise', in Burke's view, 'is the fact that the same people behave in different ways, whether consciously or unconsciously, according to the occasion, situation or, as linguists often say, the "domain" in which they find themselves – public or private, religious or secular, formal or informal' (Burke 2005: 44). This shared assumption privileges fluidity over fixity, and the exercise of individual agency through visible improvisation as opposed to the enactment of scripts.

Historians are therefore seeking out instances of agency-wielding subjects rejecting assigned roles and breaking the surface of fixed routines. Thomas Laqueur's influential reinterpretation of public executions as communal carnival, rather than ritual affirmation of state power, vividly portrayed unruly subjects with purposes of their own (Laqueur 1989). In a more recent study of the execution of a seventeenth-century French provincial judge convicted of murder, James Farr decodes the judge's unusual performance (theatrical public conduct and urgent private appeals for distinctive treatment) as calculated to maintain family honour (Farr 2003: 1–22). In studying British Jacobins, James Epstein and David Karr focus on 'the excessiveness of their behaviour', citing heated rhetoric which deliberately transgressed restrictions on political expression: 'By toasting and countertoasting, exchanging words and slogans, refusing to back down, they [the Jacobins] were testing limits, exploring expressive boundaries, playing at the edge of the permissible – and perhaps suggesting other worlds' (Epstein and Karr 2007: 520).

RT:

This often happens during encounters in the brewery when the boundary between real and fake drunkenness seems uncertain. A person is found asleep, or mumbling, or spilling beer on the floor. Who appears to be slacking – the performer or character or both?

NA:

The observer–participant in both Carran's and Richard's separate works will recognise the premises of these historical inquiries. Given the protean character of identity, any given individual possesses the capacity for separate personae and the scope for play. Individuals oriented toward these possibilities will typically engage in switching and sometimes betray this in instances of slippage. The instances in which they do so may primarily be interactive, and (more specifically) dialogical – instances in which the mutual recognition of shared thoughts and perceptions, and the momentum of continued play, overwhelms one set of intentions and draws out other truths.

Ultimately, however, the observer of *The Last Women* as a whole may be impressed by the limits, as well as the possibilities, of improvisation as a means of relating history to performance. While Carran's methods of devising may mirror (as well as inform) the effort to construct historical meaning, the enactment of the written script was more closely akin to the expression of polished assertions and conclusions. On the stage of the Belgrade Theatre, *The Last Women* presented scenes which contained familiar elements – switchings of personae embodied by individual characters, the invocation of historical figures only partially embodied, deliberately contrived juxtapositions – but in a precisely arranged interweaving. Instead of finding moments of discovery in improvised performance, Carran and the new cast presented moments of expression made resonant by careful calculation and elegant design. The relationship between individual actor and scripted routine may still be more complicated than historians are prepared to realise. For this historian, part-time projectionist and immersed participant–observer, the experience of Triangle's work continues to demand reflection.

The historian keeps watching, from within the margins of the performance, and asks that the lights above the stage be dimmed once again.

IV Impact, participation and dialogue

13

Mirror neurons and simulation: the role of the spectator in museum theatre

Catherine Hughes

As an actor in a museum, I once played the captain of a whale-watching boat, and I put the audience into the role of whale watchers about to go on a tour. The performance was set up on a stage inside an exhibition on cetaceans, including whales, dolphins and porpoises. I began by singing an old sea shanty, which often took visitors milling about by surprise. A song at the beginning of any performance has a wonderful way of jump-starting interest and creating an audience.

In my museum theatre career, I played many different characters. Most were female, though some were male; many were real while some were fictitious; a few were dead but most were alive; and all were earth-bound save one extraterrestrial. I have spoken the King's English, Irish Gaelic, Brazilian Portuguese and gibberish.

It was a joy to inhabit such a wide range of characters and I was fully committed to creating each to be as detailed and believable as possible. And yet, in all those years, did I ever really fool anyone into thinking I was the character I was playing? Did anyone really think I was a plump little Parisian man with a very bad French accent? I hope not. It was never my intention to fool anyone. I never sought to have them lose their grip on the reality that they were watching a performance by an actor, but I really enjoyed the challenge of playing someone or something that was far from who I am as a person. So what was the spectator thinking as he or she watched one of my performances, and anyone else's for that matter? Over the years I became less interested in what I was trying to do with my performances than in how the spectator was responding, and it is the spectator that is the focus of this chapter. I utilise the theoretical lens of reader-response and transactional theory to explore the role of the spectator, while also attempting to provide a focus for critical thinking as well as direction for future research.

Key questions centre around what the audience contributes to a theatrical performance and how they do this in different performance formats. I will refer to research into spectator response to performances in two museum

sites, and tease out some of the theoretical connections to other domains of knowledge such as cognitive psychology and neuroscience that might enhance best practices. In 2006, spectators who attended five different performances at two museum sites, The Kentucky Historical Society and the Museum of Science, Boston, were asked to articulate their expectations and responses to a performance. The primary focus was to investigate the nature of response to theatre that is also intended as pedagogy and takes place in a museum, and how spectators made meaning of this event. This empirical study (Hughes 2008) found that expectations did not dictate participants' responses, and that spectators' abilities contributed to the meaning created from these performances.

In order to clarify what I mean by 'spectators' abilities', and to highlight the kinds of contributions the spectator can make to the theatre event, I begin by drawing on a museum performance given at the Museum of Science, Boston, some years ago. For a play about Nicola Tesla, we created a fictitious character that could have been male or female. For several reasons, it made more sense to use a male character to tell Tesla's story. Tesla had some notorious issues with women, which would have made it slightly illogical to use a female character. A Museum of Science staff member, acting as producer, found this problematic since I, a female, was going to be playing the part first, before a series of different actors took on the role. I rallied to play a man. It heightened the theatricality, calling into focus the doubleness of performance. I wore a man's suit and fedora, but merely pulled back my hair and used no make up. I was asking the audience to accept my portrayal as a man, whilst also recognising I was female. I was widening the imaginary jump that the spectator needs to make. This choice was made, not to make them work harder, but in part because it would be fun and, more to the point, because it would work better at engaging people. This might sound contradictory. In fact, these ideas were espoused by Brecht (1965) to encourage distance between the audience and performance, so that the spectator would always be aware of the performance as theatre.

As an actor and director, I had resisted Brecht's notion of distance, which I interpreted as disdain for the value of empathy. This seemed the opposite of what I was trying to do, as I was attempting to bring about an immediate, visceral experience, not keep audiences at arm's length. Eventually, I came to recognise and appreciate the fruitfulness of this tension between distance and contact. The audience must be aware of the theatrical frame while also actively believing in the fiction we create within it. We want them to see double, as it were. Here is one place where the contributions of the spectator become visible. Without their ability to see double, the museum theatre creator's work to fine-tune this tension would be futile. The performance creators need the spectator to work with them. It is a delicate balancing act: too much frame

visible and there is the risk of losing engagement; too little framing and the line can blur between realities (see also Jackson's discussion of framing in Chapter 1).

The following is an example of when too little framing led to confusion for me as a spectator. I saw a museum theatre performance many years ago in which the performer began with no clear indication that he was starting a show. We had followed an announcement over the public address system and were assembled on benches, which were all facing in one direction, indicating something would happen in front of us, but there were no obvious indicators, such as set or costuming or signage. Approximately twelve people were seated. The performer, a young man, walked in front and started talking in a very ordinary manner, telling us about his father's experience being shot down during a recent war. His voice remained conversational throughout. It was a compelling story, but highly personal and I became increasingly confused about the tone of the performance. Was this an actor performing a script, or was this a young man sharing his family's narrative, or an actor who happens to have this family story? I discerned no theatrical shape to the story, nor could I connect what he was telling us with the institution's mission or an educational focus. He finished without flourish and offered to answer questions, and we as spectators stuttered out applause. Eventually I asked him whether this was his story, and he chuckled, shook his head in the negative and said, 'I'm an actor', as if that was explanation enough. I was annoyed with his cavalier manner, to say the least. It felt duplicitous and conjured up feelings of inadequacy and ignorance in me.

I am not suggesting that performances must be clear to the spectator at all times. A bit of dissonance or uncertainty can sometimes jar the spectator to see something in a new way. I realise some theatre practitioners want to mask the theatrical frame and thus provoke questions about what is real. I am not implying this is not appropriate for museum theatre. However, I suggest there is a delicate line between purposeful ambiguity and perplexity. Clarity of frame, without changing much of the actor's performance, would have avoided incomprehension. Sharing the rules of the stage with the audience and clearly making visible the frame enables the spectator's informed participation, for without the spectator actors lose their *raison d'être*. By joining forces, the museum theatre creator and spectator can create art together.

The spectator's part in any performance may be improvised and unpredictable, but it is no less vital than that of the actors. The following quotation attributed to the late actor/director Orson Welles encapsulates this idea:

I want to give the audience a hint of a scene. No more than that. Give them too much and they won't contribute anything themselves. Give them just a

suggestion and you get them working with you. That's what gives the theater meaning: when it becomes a social act. (Welles, no date)

I believe it is the art of theatre to know how much is just enough, to give the audience just a hint. We want to provide the spark to light the fuse of our audience's imagination. In the past I argued instinctively, with precious little theory to back this intuition, that theatre audiences are active, rather than passive. It was part of my subsequent research to discover how it is that they work with us as performers to create the performance. On a very basic level, we all recognise they are absolutely necessary. There are few museum theatre performers who have not had the experience of performing for a crowd, and a chaperone suddenly stands up in the audience and announces they have to leave to make the bus or coach. The spectators all jump up and trot off, leaving an empty space where before there had been an audience. At these times, the exhibition hall would be absolutely still. Did anyone keep going? No, I think not. A presentation is not a one-way street. A quotation attributed to the actor Kenneth Haigh states:

> You need three things in the theater – the play, the actors and the audience, –
> and each must give something. (Haigh, no date)

Understanding what the audience gives beyond their presence is not easy. Here I will step back and use an analogy to the process of watching theatre – reading a text. Marvin Carlson (1989) suggested that reader-response and literary reception theory have much to offer in the way of potential strategies for analysis of contemporary and historical theatre experience. I have used reader-response and the related transactional theory in particular as a theoretical lens through which to consider the spectator. Reader-response and transactional theory hold that the text is meaningless until it is read by the reader. In the act of reading, the reader transforms marks on a page into ideas, images and emotion, rather than the meaning being directly fixed into the text by the author. Similarly, actors performing a scene without an audience are meaningless beyond the intentions of the creators. The meaning is created from the performance by the spectators, who bring with them a lifetime of experience and prior understanding.

Reader-response considers that readers bring themselves to the reading experience. The theorist Wolfgang Iser put it this way: 'The significance of the work . . . does not lie in the meaning sealed within the text, but in the fact that the meaning brings out what had been previously sealed within us' (1978: 157).

This is a key aspect to the transactional process of reading that we can translate to the performance experience. 'The reader is active', and the text serves as a 'stimulus that activates elements of the reader's past experience – both with literature and with life' (Rosenblatt 1978: 11). Transposed to

performance, the spectator is active, and the performance serves as a stimulus that activates elements of the spectator's past experience – both of performance and of life. A segment of the audience in museum theatre may have little to no experience of past performances. Generally these spectators have not gone to the museum to see a performance, or they might be part of a school group. But regardless of their past experience of performance, it is their life experience that bears on the meaning made of the performance. I saw this clearly in my research. In a play about the Second World War, those old enough to have lived at that time responded to the performance very differently from those who had not been directly touched by it, but all respondents were living in a time of present war in Iraq, which resonated as a comparison to the play for both young and old.

The mother of transactional theory, Louise Rosenblatt, characterised all acts of reading as transactions (1938, 1978). Borrowing her characterisation, I have proposed that we regard acts of theatre as transactions. The reading transaction is between text and reader, while the theatre transaction is between performance (which includes performer and text) and spectator. Rosenblatt (1978) focused on what the reader did in a transaction, rather than on what was being read. She theorised that the difference between kinds of transactions lies not in the text itself, whether a newspaper or a novel, but in the way the reader performs differently with each text. How the reader performs the reading transaction is shaped by stances that the reader takes toward the text. Rosenblatt offered a continuum between two stances that the reader might take toward texts. At one pole is an efferent stance, from which the reader focuses his or her attention on information that is to be gleaned from what is read. At the other is an aesthetic stance, from which the reader focuses his or her attention on what is perceived and experienced from the text through the senses and feelings or for the pleasure of the experience. In most reading transactions, varying combinations of these stances inform what the reader selects for their attention.

Rosenblatt cautioned that to realise a work of art, the reader (or spectator) must take an aesthetic stance (*ibid.*), but it is also true that a poem can be read efferently, as students are often asked to do, and a newspaper article can be read aesthetically. The difference is in how the reader performs. While Rosenblatt envisioned a continuum between these two stances, I propose instead an axis that shows all theatrical transactions as containing different proportions of each stance (Figure 13.1). For instance, one spectator's stance might be more efferent/less aesthetic, while another's could be equally efferent and aesthetic.

Rosenblatt's focus on how the reader performs with different kinds of text touches on a long-standing discussion in museum theatre. Staying with the reading analogy, the question has been whether museum theatre is a

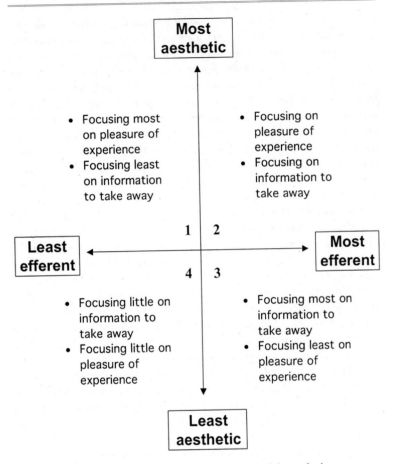

13.1 Theatrical transactions: the efferent and the aesthetic

newspaper or a novel, a poem or a textbook. This argument has generally stretched between two perceived poles – education and art – and forced a binary between them. Consequently, museum theatre has been viewed as art by some, and as education by others. But are education and art poles apart? The implication from transactional theory is that we must stop focusing on the end product, and instead look to what the spectator is doing. Are they making it art or education? To begin with, how are they orienting themselves to the performance?

One aspect of transactional theory is how stance influences what is selected for the reader's attention. In my study, spectators were asked whether they anticipated gaining information, or anticipated losing themselves to the enjoy-

ment of the performance. Those surveyed were split fairly evenly, with 45% expecting to learn and 49% expecting to enjoy, while 6% expected both to learn and to enjoy. This indicated that the spectators in my sample were not of one mind in their expectations for a museum theatre performance (Hughes 2008).

Though spectators might position themselves in a particular stance prior to performance I found this did not determine their experience. In reacting to a performance, some spectators readjusted and the data showed that for some 'gaining information' took precedence initially, but they could shift to a more aesthetic stance, and some who began by 'experiencing it through their senses and emotions', also professed to have gained information. Both shifts are exemplified in the following visitors' comments: 'It was more informative than what I expected,' (participant,[1] survey, 18 August 2006) and 'Didn't expect much but it was very good' (participant 12, survey, 5 August 2006).

Spectators at these performances did not find a notice in the newspaper for a museum theatre performance, call to reserve tickets, see a poster advertising the show, or read a programme describing who was in it and the plot. The most they might have seen was a listing in a daily events sheet after they purchased a museum entry ticket. There was little information to influence expectations. Even something as basic as whether the performance was a tragedy or comedy was not known before the performance. Nor was their reading of the performance shaped by seeing the same play performed elsewhere, *intertextually* (Carlson 1989), as it could be for a theatre-goer attending a play by Chekhov or Shakespeare (Tulloch 2005). The lack of these influences allowed for an openness on the part of the spectator.

I believe this openness led to a high percentage (68%) of the participants in this study expressing surprise at the performance. These participants were surprised by the museum's use of theatre: 'Totally unexpected way of relaying the story' (participant 133, survey, 1 October 2006); at the combination of art and science: 'I had no idea what the show was going to [be] about and how it was going to relate to science' (participant 94, survey, 29 August 2006); at their own enjoyment: 'Better than I thought it would be' (participant 16, survey, 5 August 2006); and, finally, at their own learning: 'I learned things I didn't know about the *Titanic*' (participant 132, survey, 1 October 2006).

I also found creativity in spectators' responses. They were not merely reconstituting the author's intent; they were filling in the gaps left by good writers. This was obvious from the variation in interpretations of the different performances. Here is an example from the play about the battle of Iwo Jima at the Kentucky Historical Society (Hughes 2008). Many participants compared public response to the Second World War with public response to the Iraq conflict, but older participants talked about the need for patriotism and respect for the military, while some younger participants focused on details of

soldiers and marines as people. These details included the notion of soldiers' relationships to family and friends left at home.

Iser asserts that in any process of communicative interaction between people indeterminate gaps form and are modified 'by the imbalance inherent in two-sided interactions, as well as that between text and reader' (Iser 1978: 167). In a conversation between two people, these gaps can be discussed and balance can be restored, but this is not the case between reader and text, nor between spectator and performance, unless in purposefully participatory drama interactions. In reading, 'balance can only be attained if the gaps are filled' (*ibid.*) by the reader's imagination. Consequently, the gaps of a text are places in which the reader participates most actively, and is a co-producer of meaning. Iser proposed that these gaps mark a genuine work of literary art and, in most cases, the genius of the writer. In these instances, the writer trusts the reader enough to avoid out-and-out didacticism and, by doing so, allows for more varied interpretation of the work.

Filling the gaps is similar in theatre, if a bit more complicated by an additional layer of meaning-making between dramatic text and theatre artists, such as the director, designer and actor. This initial process of meaning-making might fill some gaps, but open others. The trick is to avoid filling in all possible gaps at this phase, allowing the co-production of meaning to take place with spectators during performance. This is the *less is more* ethos implied by Orson Welles' comment, and theatre artists who have succeeded have done *more with less*.

Again, the play about Iwo Jima provides an example (Hughes 2008). The location of the battle was suggested by a life-size blown up image of the famous photograph of marines raising an American flag on the beach of Iwo Jima. There was little else to the performance area. The script moved back and forth in time and place with no change in scenery, with the actor in character as a marine telling the story of the battle. At one point, he danced with an invisible girl friend that he had left back home. At another point, he was in the thick of battle, with sounds of gunfire and explosions. Here was one participant's comment about this performance:

> He did a lot with a little, relatively simple but put the message across very well, appealed to the imagination, what film and television don't do, radio used to do this, just bare necessities, it's very effective, we don't have to have everything realistic. (participant 55, interviewed 13 December 2006)

This spectator realised his role in the joint venture of the performance process and appreciated the performance creators' restraint in allowing gaps to be filled. So the spectators bring themselves to any performance – their prior experience and understanding from life and performance – which they use to find significance and create meaning, as well as bringing an openness and

creativity. They are contributing their imagination to build a new reality, and are not confused by the presentation of an actor playing a character outside a proscenium. So long as the performance has been adequately framed, they can see double.

Support for the notion that spectators can see double comes to us from cognitive science. The theory of conceptual blending (Fauconnier and Turner 2002) suggests that people often blend cognitive categories or concepts and then un-blend them to get a sense of what they are doing. Cognitive concepts include the colour 'blue', or the notion of 'fast', or a physical object called 'window'. These mental concepts gain neuronal structure in our minds. We can blend various concepts without even thinking about it, concepts like 'actor', 'identity' and 'character' (McConachie 2007: 559). We can temporarily put aside our knowledge that actors live outside their role-playing, and that the character does not live outside the performance, creating a new concept: the actor/character. Anecdotally, I have seen in young children the dawning awareness that the person before them is not really the character but an actor playing a character.

Seeing double is not the only action by the spectator substantiated in scientific research. McConachie has proposed that performance theorists should look to falsifiable theories in science to understand audience response. These would be theories 'that have undergone the rigorous evaluative procedures of good science' (McConachie 2007: 555–6), as opposed to the a-scientific work of master theorists on which theatre and performance studies have been based, such as Derrida or Foucault. Among the studies he cites is one by Niedenthal, Barsalou, Ric and Krauth-Gruber (2005) on simulation, also termed social cognition or empathy. Evidence was cited to show that:

1. individuals embody other people's emotional behaviour;
2. embodied emotions produce corresponding subjective emotional states in the individual;
3. imagining other people and events also produces embodied emotions and corresponding feelings; and
4. embodied emotions mediate cognitive responses (Niedenthal et al. 2005).

These four mental operations describe empathy, in its various modes. They were found to be true for real and for fictitious (i.e. theatrical) situations. It lends weight to the idea that the spectator can read the actor/characters' intentions and emotions and, furthermore, embody those emotions in themselves, and in doing so produce the emotions in themselves. The emotions may not be exactly the same as those of the character, but the mental processes that are simulated produce physiological changes in the spectator (Niedenthal et

al. 2005). One of the most exciting aspects for those of us in museum theatre is the point that 'embodied emotions, whether generated by a response to the environment or socially transmitted by others, shape subsequent cognitive processing and generate meanings' (McConachie 2007: 563). It is for us to figure out in what ways meanings are influenced by emotions embodied from our performances.

The study's authors (Niedenthal et al. 2005) found this embodiment highly automatic. As McConachie writes: 'Evolution has equipped us to attune our bodies to the emotions of other people; this basis of our sociality as a species is inherited and embodied' (McConachie 2007: 563). He cites the philosopher Robert Gordon's simulation theory, 'which demonstrates that humans come to know the world and themselves largely through simulation' (*ibid.*). One way of doing this is trying out behaviour through simulated play. Gordon writes that facial, postural and vocal expression of emotion is contagious: 'You can catch an emotion, just as you can catch a cold' (Gordon 1996: 169). Gordon cites Meltzoff and Gopnik (1993) to support the notion that the motor activity of moving facial muscles can induce emotions that correspond with that facial expression. So, a smile can drive a pleasant emotion in the one smiling. Replicating the facial expression of another through motor mimicry or empathy leads to a similar emotional state.

This idea that human beings are biologically equipped to know the world through empathetic connection is a powerful one for those working in the theatre. And this is further substantiated by the discovery, in an Italian laboratory, of mirror neurons. As McConachie recounts: 'Italian researchers noticed that the same group of neurons in the brain of a monkey fired when the monkey watched a male scientist bring a peanut to his mouth as when the same monkey brought a peanut to its own mouth. Doing an action and watching someone else do the same action brought the same neurological response' (McConachie 2007: 564), which was later found to be true in humans too, but in a more highly evolved way, 'allowing them to access emotions and intentions of others by watching them move' (*ibid.*). McConachie makes the jump, and it appears obvious, that spectators will often mirror, or echo, the actions of those they see in a performance, making it clear that 'cognitive imitation is a crucial part of spectatorship' (*ibid.*: 565).

In my own study I found evidence of empathic connections in several areas of response. Participants were asked whether they related to or believed in the characters and situations of the performances. I equated the word 'relate' to a state of empathy. A majority felt they could relate to and believe in the characters and situations presented in the performance they saw. In comments made to describe their experience, many participants describe an empathic connection, examples of which are provided below.

In a play about a marine's experience at Iwo Jima:

Yeah. Connecting on a emotional level. Having a mother whose son is away in the service, or even as his girlfriend Marion waiting for him to come back, or the idea of him asking her to wait for him, and you know, the whole possibility. (participant 35, focus group interview, 12 August 2006)

In a play about the union organiser in mining:

Yeah, I would be very, I don't know if I would have the bravery, but he showed the bravery that it might take. (participant 24, focus group interview, 11 August 2006)

What I found was that the participants in this study represented a broad spectrum of people who brought with them highly individualised prior experience and understanding. Their responses ranged from a limited response of taking a bit of information away, like 'Ben Franklin did a lot of things', to a deeply aesthetic transformative experience in which the participant was moved and awed by the performance of a Second World War marine's story.

What creates the difference between these two experiences? As a result of this study, I am led to believe it is partly due (of course) to the performance, the actor, the script and the director's intentions. More than anything, however, it is due to the spectator. It is about who they are, their interests, where they have been, and what they care about. All of this matters. It matters what the performance is about and how it is performed, and it matters who is watching and where they have come from. It also matters where the play is performed, and whether it is raining outside, and if there is a war on. All of these elements interact to create the quality of the experience, whether to lessen or expand the impact. As one participant confessed:

I must admit that I was a bit tired when I sat down for the performance and so was not as attentive as I should have been. I don't think I am a very good representation of the quality of the performance that was given that day. (emailed response, 6 December 2006)

Whether you find the *Titanic* an endlessly fascinating subject or could not care less about it will affect your experience of seeing a play about the *Titanic*, but it will not determine it. That is because the performance may surprise you. If you thought you knew everything about this subject, you may be surprised to learn more, as happened with several participants at the Museum of Science in this study. Or you may be surprised to find the subject interesting at all, or to see it in a new light, as another participant did (Hughes 2008). Likewise, the performance may not bring about any surprise about the *Titanic*, though the fact that one actor can play many parts well in a single performance was memorable, which was yet another participant's experience.

There were also those who did not intend to stop and watch a performance, but in the end were compelled by the performance itself. At the Kentucky

Historical Society, one participant refused the invitation to sit and watch, instead continuing to read labels in an adjacent exhibit. Once the performance began, however, this gentleman began to watch from afar. And continued to watch and step closer, to the point when, after the first scene finished, he followed the rest of the audience as they moved to the next performance area. His assumption had been: 'I never thought it'd be factual at first, but after I listened for a while that's actually the way it was. I thought it was just kind of play' (participant 66, focus group interview, 26 August 2006). Another unintentional spectator from the Kentucky Historical Society recalled being drawn into the performance: 'I just remember we were walking around and just came upon it, it was so dynamic, so much more impressive than we thought it was going to be' (participant 41, telephone interview, 11 December 2006).

So some participants were engaged, and some were not. Many factors contribute to this complex and interactive experience: many are completely individual and beyond the control of those who aspire to create experiences to which people can engage aesthetically and cognitively. While the purpose of this study was to try to understand spectator response, underlying that was a wish to narrow down the variables, to uncover what might be most important and controllable for the purposes of creating a performance that would make engagement much more likely.

At the same time, it is important to realise what cannot be controlled. Spectators cannot be controlled. They bring myriad experiences to any new experience, which then shape the new experience, producing meaning that is individual, while at the same time possibly shared. Context cannot be controlled entirely. It may be raining on a summer day in August, causing hordes of visitors to descend on a museum, which means that lines to the food and bathroom are overwhelming, causing claustrophobia and irritability in some of the visiting public, adding new elements to the loud, boisterous crowd of spectators sitting, waiting and hoping that the show, whatever it is, will be fun and educational. All of this is out of the performance creator's hands.

Nevertheless, the unique format of museum theatre seems to complement the museum experience of visitors; it is clear that museum theatre has the possibility of adding emotional meaning to the quiet artefacts in glass cases and in dioramas, of adding to the experience of learning, and of providing theatre professionals with the interesting challenge of creating an educational performance that is coloured by the aesthetic.

Perhaps this is my primary point – that understanding what happens when people watch theatre enables us to do it better. If we know that people have the ability to blend (and un-blend) characters and actors, that seeing both is not problematic, but a good thing because it encourages people's imagination, we can make sure we only do what is absolutely necessary, we can hear the echo *Less is more*.

Can we stretch spectators' capacities? I return to the Orson Welles quotation and the idea of involving the audience in the social act. If we know that spectators are hard-wired to be empathetic, and that this ability to empathise allows them the ability to mind-read, to embody another's emotions, to see into another's thinking, to 'simulate' what it's like to be the 'other' and to explore their situation, it can encourage us to produce performances that provoke empathy. Recognition of the spectator's emotional and empathic capacity assures us that our goal to invite people into an emotional conundrum is a valid practice for museum theatre. Perhaps knowing about all this merely assures us that we are on the right track. Theatre is a part of the business of the world. It is not a supplemental activity. I always believed in that idea, and it becomes very clear when you think about how much scientific effort is being focused on empathy, mirror neurons and conceptual blending which are such key parts of theatre.

Note

1 This survey was not numbered. All subsequent visitor quotations and response analyses are drawn from data collected as part of my doctoral research (Hughes 2008).

14

'The costume of openness': heritage performance as a participatory cultural practice

Jenny Kidd

> Participation is legitimate only if it influences the tone and possibly the outcomes of the performance; only if it changes the rhythms of the performance. Without this potential for change participation is just one more ornamental, illusionistic device: a treachery perpetrated on the audience while disguised as being on behalf of the audience. (Schechner, 1994 [1973]: 77)

Audience behaviours have traditionally been categorised as unified and homogenous, defined and limited by their perceived passivity and emphasis on *reception*. Recent conceptualisations, however, have problematised this notion, positing, indeed on occasion celebrating, more active, participatory and supposedly democratic relations. This chapter explores something of what this might mean in the field of heritage performance by looking at the theoretical backdrop to discussion about interactivity and performance, introducing and critiquing ways of understanding participatory perform-ance, and examining a number of models for participation demonstrated at Performance, Learning and Heritage (PLH) project case-study sites.[1] In set-ting the framework, I draw upon literature from across the field of cultural and performance studies, and introduce theory from 'new' media studies which helps us to think in more nuanced ways about the nature of dialogic practices of engagement.

The above quotation, from Richard Schechner's book *Environmental Theater*, outlines his critique of participatory performances that do little more than create the *illusion* of audience influence. The manipulation of audiences into positions of only *seeming* authority is, in Schechner's terms 'illegitimate'; even more 'maliciously' so when such activity wears the 'costume of open-ness' (Schechner 1994: 45). This phrase has been appropriated in the title for this chapter as it highlights the mostly costumed (and often scripted) nature of heritage performance which presupposes and dictates certain inequitable power relationships, but also because it serves as a useful reminder always to question the authenticity of such encounters (how far in actual fact are they ever able to be 'open'?)[2]

Schechner's model for participatory theatre is of course firmly rooted in his (and others') increased experimentation with form and content in the 1960s and 1970s.[3] Yet it provides us with a particularly vibrant locus of activity against which we might 'assess' the development of participatory endeavour. As Schechner acknowledges in his discussion, issues around participation and interaction in performance are fraught with complexity, yet remain crucial to conceptualising more equal relationships between audiences/spectators and performance events. Since his publication, a number of models for the assessment of participatory theatre (or 'commingling events', Blau 1990: 149) have been proposed, which will be outlined in this chapter.

In recent years, there has been a tendency for rhetoric surrounding the *possibility* of participation to take on a utopian glow across the spectrum of cultural encounters, and interestingly, in the discussion of heritage interpretation, to be seen as a useful counterbalance to (stereotypes of) 'traditional' interpretation techniques which reduce the role of the visitor to one of glazed passivity (Winterbotham 1994).

This chapter aims to take a realistic snapshot of the state of 'play' when it comes to participatory heritage performance and audience response. The PLH research suggests that increasingly there is an expectation amongst visitors that elements of museum encounters will be interactive; not a universally positive prospect for all, with some of our respondents making accusations of 'Disneyfication'. Visitors remain wary of such opportunity, exhibiting vastly differing degrees of demand and readiness for active involvement in performance. They (rightly) want to maintain an element of choice over how far they engage, but recognise that it is rarely they who hold the cards.

Interactivity and participation

participation means that the reader is not simply called upon to 'internalize' the positions given in the text, but he is induced to make them act upon and so transform each other, as a result of which the aesthetic object begins to emerge.
(Iser in Counsell and Wolf 2001: 183)

Engaging with the aesthetic object can, of course, take a number of forms; thus, participation can be an internalised mental practice (a process of active interpretation) or a physical intervention. For the purpose of this discussion, I will be looking principally at physical and verbal interactions between spectators and performers and/or performance spaces and the ways in which audiences articulate their responses to such instances.

Interactivity as a model for communication differs from participation in a number of quite profound ways and provides possibilities for varying forms and degrees of 'agency'. Participatory models tend to refer to texts or scripted events during which involvement means taking part or sharing

in action. Interactivity, on the other hand, indicates reciprocal relationships with texts:[4]

> This is the sort of interactivity in which content is affected not only at the 'nodal point' at which it *becomes* textual . . . but also and particularly the point at which a text leaves the hands or immediate, real-time control of an author or content creator and becomes available to alteration in some way by a reader or content-user. (Cover 2006: 140)[5]

Consequently, the 'user' has a degree of control over the nature and direction of the interaction, and can possibly even dictate the narrative outcome of that 'text'. This represents that text's ultimate use value, although, as Rob Cover asserts: 'the exercising of user choice is not . . . necessarily interactive' (Cover 2006: 142). Just because one is presented with a range of choices, it doesn't inevitably follow that one is exerting influence.

I want to suggest that although it is tempting to talk about 'interactivity' in interactions between audiences and performers in heritage contexts (and an especially tempting and familiar rhetoric for the audience members we spoke to), 'participation' more honestly and adequately captures the nature of many of these encounters. Power and authority in most instances of participation remain squarely with the institution and/or the performers who represent it, even as they are articulated as evidencing a move toward dialogue, communication and the sharing of authority. This differentiation is important not solely at a semantic level, but because it renders the premise – and the promise – that underscores much of this activity misleading at best, and cynical at worst.

Performances as examples of participatory texts have been theorised in a number of ways. It is generally acknowledged that audiences have a fluid and ever-changing relationship with performance events, and that as a result no two performances can ever be the same (Bennett 1990; Mason 1992; Delgado and Svich 2002; Wainscott and Fletcher 2004). As Martin Esslin acknowledges, there is 'a continuous process of feedback between the performers and the audience' (Esslin 1988: 93). This feedback process is of course traditionally non-verbal/physical: the theatrical context involving implied, and rarely crossed, delineations between performance space and audience space. This trend continues to dominate expectations of theatrical encounters, as Susan Bennett acknowledges:

> Contemporary audiences in theatre buildings are, therefore, most used to fixed stage–audience relationships, and the predominance of this convention has led to its necessity for a comfortable theatrical experience. (Bennett 1990: 132)

This was certainly an expectation evident in audience responses to the PLH research as the following quotation demonstrates:

You can't be prepared for anything like that. We were told by my friend that there was going to be a short play, I didn't realise we were going to be sent all over the building, which was great. I thought it was much, I thought it was going to be like a stage and we would sit. (MM_I_PP3_190)[6]

According to Bennett, the success of the theatrical experience is dependent (in part) on the maintenance of *norms*. Of course participatory performances involve usurping such norms, a variously exciting, surprising and perhaps by definition less comfortable theatrical experience (in any number of ways). Performances that involve boundary-crossing between spectator and performer (or performance space) go against the grain of the traditional theatrical event as audiences have come to understand it. As a result of such 'frame-breaking' (Bennett 1990: 153), some critics observe, it is important that rules, expectations and options for spectators are made explicit:

A crucial aspect of audience involvement then, is the degree to which a performance is accessible through the codes audiences are accustomed to utilizing, the conventions they are used to recognizing, at a theatrical event. Intelligibility and/ or success of a particular performance will undoubtedly be determined on this basis. (Bennett 1990: 104)

This is certainly not a universal wisdom for all performers or indeed audiences, however. There are of course performers who ground their practice in such 'frame-breaking', seeking to disrupt, shock and challenge audiences, working with very different notions of 'success' from that outlined above. There are also many audience members who relish opportunities to cross boundaries without any discomfort. The 'codes' being utilised are perhaps more loosely articulated in the performance of heritage than in other types of performance (especially in living history presentations), and this of course presents a number of challenges for both performers and audience members.

So, what happens within performances that frame themselves as interactive or participatory? How can we expect audience members or participants to respond? What are the implications of choosing not to frame a performance as participatory (for artistic or other reasons), but to expect unguarded co-operation none the less? Different approaches to detailing and assessing the role of 'spectactors'[7] are outlined in the following section.

Locating 'authenticity' and 'legitimacy' in participatory performance practice

Richard Schechner's notion of 'legitimate' participation is a useful start point for discussion of the implications of participatory practice (although its legal overtones and appeal to reason are perhaps misleading). For Schechner, legitimacy in participation is only possible when a level of control over a performance is exerted by an audience that is in some way meaningful. So,

in this model, illegitimate participation is that which is extraneous to the flow of a performance event, doing little more than manipulating spectators into believing they wield more power over proceedings than they actually do.

For Schechner, the ultimate in 'legitimate' participation is achieved when an entire space is given over to performance, the lines between performers and spectators are blurred, and no one is 'just watching':

> Once fixed seating and the automatic bifurcation of space are no longer present, entirely new relationships are possible. Body contact can occur between performers and spectators; voice levels and acting intensities can be varied widely; a sense of shared experience can be engendered. Most important, each scene can create its own space, either contracting to a central or a remote area or expanding to fill all available space. The action 'breathes' and the audience itself becomes a major scenic element. (Schechner 1994: xxix)

Throughout his book Schechner outlines a number of experiments in creating such shared experiences, and is candid in discussion of their resultant 'success' (in terms of 'legitimacy'). Those who choose not to become involved in such instances are described variously (and unflatteringly) as 'holdouts', 'stay-behinds' and even 'cynical whiners' (*ibid.*: 41). However, as Schechner himself explains, a problem became evident in the course of this exploration: the 'professional' performers grew variously exhausted and frustrated by the participatory elements of performances and their interference with the flow of the narrative. Thus, over time, the pieces became more scripted and 'legitimate' participation less likely an outcome. In this sense, they stopped 'breathing' in quite the way Schechner had anticipated.

The 'legitimacy' model unearths, by purposefully undermining, two considerations crucial to participatory performance and to this argument: one relating to performers, the other to audiences. Firstly, performers must be highly skilled and open to the chaos and confusion that participation may engender, its daily difference and (perhaps) occasional monotony. They must be prepared for the challenge to their authority, and the authority of the narrative, that participation necessitates. Secondly, audience members need to be aware of the possibility of a call to participation, and be offered an 'out' without being made to feel they are '*holding* out'.

For PLH respondents, participation was articulated in immensely complex and paradoxical ways, even within individual testimony: 'I wanted to speak and didn't want to speak, you know?' (MM_I_PP1_73); 'It was demanding of me something that I wasn't necessarily prepared to give and it made me feel a little bit uncomfortable at certain points' (MM_I_PP3_197). Consequently, respondents *needed* to feel they had the choice whether to participate or spectate: 'I think you have to be given the chance to stay quiet'

(MM_I_PP2_207). If an event 'breathes' for one person, it does not follow that it 'breathes' for all. An assessment of 'legitimacy' by audience member or performer of course remains fully subjective, especially for audience members who have little understanding of any impact their interventions may be having (that is, they can have no understanding of the *norm* for such a performance encounter).

Edyta Lorek-Jezinska prefers to frame the above discussion in terms of 'authenticity'. Authentic involvement, in this model, 'concerns authentic *optation*' (my emphasis), a notion used by Victor Turner (1982) in his discussion of ritual behaviours to describe real choice and influence over interactions. In contrast, inauthentic participation lacks any 'real' element of influence. To unpack 'inauthenticity', Lorek-Jezinska uses Michael Kirby's 1969 classifications for 'passive involvement': figurative involvement, where the audience is merely acknowledged; token interaction, whereby spectators are asked to perform 'certain unimportant activities'; processional passive walking; and controlled verbal reaction. These types of involvement, however they are framed, 'delude the spectators into believing that they are involved in an artistic activity' (Lorek-Jezinska 2002: 4).

It is my contention that, as useful as these differentiations are, and as important as (I will argue) 'optation' is, these categorisations are not flexible enough to guide us through the case studies that follow, or to enable detailed study of our varied audience responses. These bifurcations (legitimate/illegitimate, authentic/inauthentic) are similarly concerned with the expression and limitation of *control* in interactions between professional 'authors' and (perhaps unsuspecting) spectators. They are concerned with the distribution of power, yet they do not adequately account for the nuances of the individual participant (or indeed the actor), their desire for control (or alternatively to be led), their prior experiences and personality, or indeed the decision-making processes that occur minute by minute throughout a performance event. There are more important questions that need to be asked such as who has the right to control participatory proceedings (if anyone)? What information are performers (and spectators) privy to in advance? Who instigates the interaction? Who maintains control over the direction of the interaction (if anyone)? And, crucially, who decides when it ends?

Spectators are of course not a unified homogenous whole, and so, just as there are differing (and contested) levels of participatory possibility, there are also different responses to the call to participate. The PLH project began to explore some of these responses with rigour and with a longitudinal emphasis that is all too rare in arts research. All of the project case studies dealt with participatory performance in some way, and, perhaps unsurprisingly, the language of reflections was overwhelmingly active in response, even when encounters themselves were perceived as negative:

It was much better actually doing something than just sitting and listening. (NMM_F_PP1_116)

Nobody looked too scared or too timid to say anything. Everybody was like, yes – I want to say this; I want to say that. (MM_I_PP1_70)

We were a part of what was going on. (MM_I_PP3_192)

It wasn't just saying what happened, it was – I don't know – drawing it or something, it was interactive. (NMM_I_PP3_213)

Simultaneously however, there remains a level of ambivalence about participatory endeavour, including a stereotyping of those deemed to be 'the type' of person who enjoys the very public processes of participation; a particular set of terminology and (mostly quite negative) connotations:

I didn't [get involved], I suppose it depends on the type of person you are really. (NMM_I_PP3_20)

Perhaps it's the attention seeker in me! (TTC_observations_3)

I'm used to that 'cause I do drama, so I'm all right. (MM_S_PP2_157)

I'm not that kind of person. (MM_I_PP3_194)

I don't mind. I'm a community worker so I'm used to being gobby. (MM_I_PP3_196)

With this complex of responses in mind, the rest of this chapter will discuss how the reflections of participants and the observed performances exemplify the difficulty of providing genuinely interactive experience within heritage contexts.[8] Four categorisations for performance will be presented, with case studies exemplifying the ways in which participatory practice is currently being configured.

Controlled verbal response

Many instances of live interpretation witnessed in the research project use a form of shallow (which is not to undermine it) call and response which I am here terming 'controlled verbal response' (reminiscent of Lorek-Jezinska's 'controlled verbal reaction' but acknowledging more explicitly its prompted nature). In such instances a performer, more often than not in first person, will present a monologue whilst simultaneously acknowledging the presence of an audience. The character will rely on the audience for a certain amount of confirmation or agitation of their world view (yes and no responses to verbal prompts for example), which help give the piece momentum. Such a performance does not rely on these moments for success, however, arriving at a pre-determined point of conclusion without the audience's help. Audience

members thus have no narrative influence over the progression of the piece and the decisions that characters might make; an issue of performance design certainly, but also perhaps one of historical fact – we can have no influence over the events that actually unfolded outside of the life of the character we are coming to know, or even for that matter over that character's actions.[9]

Case study: The Gunner's Tale

The Gunner's Tale was a thirty-minute performance at the National Maritime Museum, Greenwich, focused on the experience of a Gunner aboard the *Belleisle* during the Battle of Trafalgar (1805). Able Seaman Robert Bell presented a monologue detailing and describing the battle and exploring relationships: between Nelson and Napoleon; the public and Nelson; the ship's crew and Nelson; and between the character of Robert Bell and war itself. The piece included much audience acknowledgement and short verbal response (six instances identified in the script, ten in observed actuality); Robert Bell was telling his story to an audience he knew were there to hear him speak and referenced them throughout. Audience members were not given a character or role, but remained anonymous spectators.

Robert Bell introduced us from the first instance to his seafaring identity. He was 'of his Majesty's Royal Navy' and served 'many years continuance'. His naval persona is that which was of assumed interest to those at the Maritime Museum, and it is here that the details of his life were concentrated. Audiences found out nothing about Bell outside of his life in the Navy, which is perhaps an indication also of how little can be known about a person who principally exists in the current day in ship's logs, muster rolls and pay books (sources of information for the piece). They did, however, learn something of Bell's views on the events and personalities present in his story. Robert Bell characterised himself as war-weary, craving peace. Lord Nelson was a hero, and Napoleon ('Boney'), although respected, was the enemy (Napoleon was still alive but in exile at this historical juncture). Given his life as an Able Seaman and his involvement at Trafalgar this is hardly surprising, but the presence of only one character, with no interaction or questioning, necessitated an absence of discussion and debate, and no unpacking of his assumptions. Outside the conflict of the battle, there was no room for the exploration of ideological conflict. The Gunner was thus a constant, but two-dimensional character.

Calls for verbal responses were made to any and all of the audience members throughout; however, as the 'success' of the performance was not dependent on them they had little or no impact on its narrative. None the less, where we have spoken to audience members these instances provoked very positive responses, and were seen to make the experience more 'edifying' and 'real': 'it does make it alive and it does stay in your mind' (NMM_F_PP1_117),

and 'there is something about seeing that in action than reading about it in a history book. It doesn't mean quite the same' (NMM_I_PP2_104). These moments thus helped to foster engagement, and, as is evidenced in later discussion, long-term recall of the performance as experience and as educational tool.

Scripted bodily participation

Scripted bodily participation begins to blur traditional boundaries between 'stage' and audience as not only the actor(s) but also the spectator(s) are expected to physically embody the narrative being portrayed. This might mean taking part in a promenade performance; journeying with characters through spaces and places, but also often through time as one encounters or enters a past that is being presented. It might also involve audience members being directed to physically move (or perform) within the 'set' of a static performance, as in the example below. Although these forms involve a certain amount of participatory endeavour including a level of physical commitment, what is key is that control over proceedings remains very squarely with the performer. It is the actor (or the character in most instances – the boundaries begin to blur) who will tell the audience how and when to traverse the space, and indicate to them when they are on the 'stage' or 'set' and when they are not.

Case study: The Pensioner's Tale

Greenwich Pensioner Joe Brown told the story of and re-enacted the Battle of Trafalgar using audience members to represent the positioning of the French and British fleets.[10] After an initial exposition giving name and position, and highlighting the character's relevance to the topic, the piece can be split broadly into three sections. The first detailed the building of Greenwich Hospital and the life of a Greenwich Pensioner. The second introduced life on board ship and included instances of exchange between members of the audience and the Pensioner himself (one adult and two children who enter the 'staging' area). The final section included the re-enactment. For this latter part of the piece, the spatial boundary between 'audience' and 'performer' ceased to exist, as each found themselves inhabiting the space of the other and being asked to 'embody' the historical events. The very physical nature of this piece meant that there could be no obstacles between performance space and audience space, and also necessitated a small enough audience to make people feel willing to become very public participants (usually twenty people). The Pensioner then physically manoeuvred individuals through the battle sequence, accompanying the staccato movement of the participants with a light and humorous narrative which most found absorbing and

informative. The precise unfolding of the battle was of course a familiar narrative to some, yet unfamiliar to others. The embodiment and physicality is of course intended to make the precise sequence of events both more 'real' and more memorable (which for many participants it did). Given the factual events of the battle and the interpretation strategy, however, there could be no influence over the narrative outcome of the performance (it was 'pre-scripted' in every sense).

Responses to the participatory elements of this performance were mixed in conversations after the event, with a majority of audience members feeling they had received a choice about becoming involved: 'he did make it clear that if you didn't want to be involved you just had to say so . . . I certainly didn't feel any degree of intimidation' (NMM_I_PP3_15), and a (very) vocal minority feeling distressed because they felt they had not: 'I didn't enjoy that part of it at all . . . I don't think he gave me an option. And it would have been churlish of me to refuse' (NMM_I_PP2_47). There was a concern (especially amongst some adults) that they would be made to look or feel awkward. The embodied nature of the participation (about which little warning was given to audiences) was articulated by these particular audience members afterwards as: 'picking on', 'frightening', 'not a choice', 'being trapped', 'making you vulnerable', 'embarrassing', 'dragging you up' and 'pulling people out'. For other audience members, however, it was a highlight. Such mixed responses to seemingly similar instances or calls to action highlighted very vividly the importance of the *perception* of choice and how it is built into the performance frames (see Anthony Jackson's Chapter 1 for more on frames).

The following two examples will look at instances which can more genuinely be analysed as in some way interactive.

Contextual interactivity

In this section, I borrow from Rod Sims' gradations of interactive possibility for learning in multimedia contexts, including what he terms immersive models (Sims 1997). Normally characterised as virtual environments (now we might include such an environment as Second Life), it is the specific contextual nature of the 'microworld' which is significant. It is the setting, the circumstances, the particularity of the encounters and the way in which they weave together that dictates the experience (and thus any learning outcome). Contextual forms of interactivity are especially applicable to live interpretations performed in situ (such as in a historic site) which rely not on predetermined timed narratives with a beginning, middle and end, but on more fluid and ongoing interactions between performers, audiences and the sites themselves. There is, however, no suggestion that the visitor *explicitly* takes on the role of 'performer'.

Contextual interactivity, in the vein of 'living history' re-creations, sees the user entering a microworld through which they work: a 'world which responds to individual movement and actions' (Sims 1997). The interaction is dependent on both the user and the interpreter, and the audience has at least a notional amount of influence over the path it takes. In this scenario we see interactions modelled on the ability of visitors or audiences either to 'query' or to 'browse' within an environment that one can physically enter and verbally engage with. If we think of the functionality of the Internet for 'grazing', 'hyperlinking' and creating (potentially unique) non-linear understandings, then we might be closer to grasping the peculiarities of these kinds of engagements.

Case study: Llancaiach Fawr Manor
At a living history site such as Llancaiach we see a number of different propositions for interactions between live interpreters and visitors/audiences. School groups who attend will be taken on a tour around the house over which they can have little control; however, independent visitors can choose the way in which they traverse the house, and the depth and form of their interactions with the characters they meet. The interpreters use first-person techniques, working, 'living' and performing in situ throughout the day, encountered by visitors as they tour the property. As there is no prescribed route through the Manor, and as such no specific ordering of encounters, any narrative including reference to the characters, the site, and the historical period will have to be put together by the visitor (if the visitor so wishes). There remains, however, no obligation to do this, and interactions with characters can be tangential, personal and seemingly irrelevant to their historical setting if desired. All of the characters have a back-story, outlook and political persuasion which they are happy and able to discuss (and defend) with visitors who (crucially) make enquiry.

Whilst touring the house, the characters one meets are almost invariably from 'below stairs', servants to the family of the house. This decision is made at a number of sites employing Living History approaches, seemingly giving a more familiar and accessible 'way in' for the public (these people represent the position we would have been in had we existed in the time being re-created), but also presenting something of the 'ordinary' people about whom less is traditionally known than those who owned the properties and were more regularly written into the annals of history. There is no recognition of our 'present' whilst inside the Manor, the only chronological frame being the present of 1645 and the reality of Civil War. The Manor becomes the set for the activity, and so there is no off-stage. It also follows that there is no 'out-of-character'. This is then an immersive experience of sorts.

Responses to the immersive nature of the Llancaiach Fawr Manor experi-

ence were overwhelmingly positive: 'in the room itself there were things they could look at that were seventeenth century like the floor and stuff. But in school you'd be looking at concrete' (LFM_S_PP2_101), and 'I think you take it in more easily when it's happening around you, rather than just listening to a teacher or something' (LFM_S_PP2_101). The distinction between actors, characters and the site itself is much more fluid here, and reflections on the day relate more to the experience as a whole than its constituent parts. The *context*, and the capacity for browsing, questioning and debating all make participants' encounter with the particular past on offer at the Manor a more holistic (and indeed ultimately memorable) one: 'there are no barriers and it's all hands on, you're inside it all' (LFM_S_PP2_100).

Negotiated interactivity

This form of interactivity references opportunities in which an audience (or audience member) can negotiate engagement, maintaining at least a notional level of control over proceedings, whilst on occasion taking on the role of performer also. This kind of interaction is very much about the moment of performance and what is at stake for both participants and actors. The role of the audience member becomes one of constant negotiation, decision-making and self-evaluation, necessarily then a more active mental state to be in, even if physical participation is not always required. This role might not always be presented to you as such, but thrust upon you perhaps in the moment of interaction, for you to take in whichever direction you feel appropriate, and are comfortable with. There is thus a more significant level of risk to proceedings – both for audience member and performer. These kinds of performance, playfully articulating and demonstrating challenges to the authority of grand narratives, seek to explore the interstices of truth and fiction, personal and collective memory, implicating participants in an exploration of the authentic and even identity (see also Phil Smith's Chapter 11).

This kind of participation I term interactive because it is more likely to be reciprocal in its direction of influence (depending of course on the particular participants, their desires and level of comfort). Either the end point or the route *to* that end point is, in a notional sense at least, up for grabs.

Case study: The Pollard Trail

The Pollard Trail, a performance by Triangle Theatre Company (in association with the Herbert Art Gallery and Museum) is an example of such interaction. The performance, a playful take on the notion of the 'heritage trail', invited participants to engage in proceedings, to ask questions, get involved, perform, sing and handle 'props', but always in rather peculiar and unexpected ways. The Trail itself took place out on the streets of Coventry (for the

most part) in an area of the city itself currently being re-defined by planning initiatives, and hosting a community in transience. Triangle's experimental performances – often provocative, sometimes bewildering – attempted to map the affective, cultural and historical terrain in and around Irving Pollard's former stamping ground.[11] Happenings on the Trail occur simultaneously, indicating to the audience member (or participant) that they will have a certain amount of choice, even control, in their engagements: 'I also liked the way you had total control over what you did as each person created their own experience' (TTC_observations_4).

In the differing contexts of the Trail (cafés, churches, streets, pubs, a park and a nightclub), audience members found themselves in changeable but constant negotiation with actors over how far and in which direction their participation might go next: 'at times I felt I was truly participating at others only vaguely observing' (TTC_observations_4); '[I] was starting to change into feeling like a participant rather than a spectator' (TTC_I_PP2_178). Audiences responded to this in (predictably) mixed ways, often in surprisingly (and often *un*predictably) passionate ways. They 'feel' a number of things: 'tired', 'angry', 'elated', 'duped', 'frustrated', 'joyful'. They were seen to be, and articulated themselves as being, sometimes pushing to interact with the characters and even with each other, at other times pulling away from interaction with which they were uncomfortable. Authentic participation in these encounters can only be subjectively realised for audience members, and of course for the performers also, but *optation* was at least recognised in the performance's structures and frames (even if not always respected).

One simple form of encounter between the 'audience' and the purposefully amateur performers who put on the Trail was the de-brief. Frequently throughout the day the performers (in character) would encourage comment and criticism from participants in the Trail, either in group sessions, or on a one-to-one basis. The vulnerability of the characters and their insecurities were manifested in these moments, the fractious relationships between them becoming apparent, their intensity simultaneously endearing and threatening. Participants would navigate their way through a critique that was explicitly performative and itself often a fiction. The response to this might be sensitivity, flippancy, anger, retaliation, or, indeed, a complete re-scripting of the event for all future performances (or even an impromptu encore).

The work of Triangle on *The Pollard Trail* interestingly and creatively explored the historical 'push-and-pull struggle between an audience desire to participate and an authorial desire to maintain a controlled textual coherence and inpenetrability' (Cover 2006: 149). It represented a unique exploration of the ways in which risk (with well-articulated intent and thoughtful framing) might be introduced by institutions, performers and audience members alike into each other's experiences of heritage.

Conclusions

The research has shown that the experience of being 'inside' a performance is often an integral element of an audience member's enjoyment, ability to recall, and overarching memory of a visit to a museum or heritage site. Interaction and participation are very important in this regard, as is the experience of being part of a social encounter (as in all of the examples outlined above). These experiential moments also enable respondents to get an idea of 'the past' in a more personal sense; participatory elements are often equated with 'actually seeing' or experiencing complex non-linear narratives; 'bringing it all to life' and engaging with the immediacy of the past in a way that static exhibits cannot:

> He was there, he was living it, he drew you in and he was so believable and still talking to the audience. So he wasn't sort of you know, just performing and ignoring you. (NMM_I_PP2_48)

> I like the armoury thing in the top floor because it's quite good how they let people try it on and actually show what armour they had. (LFM_S_PP2_130)

> I had my hands cut off, because I had my hands frozen to a rope and they had to be cut off, that was fun . . . even though it's not real, you remember the experience. (NMM_I_PP2_35)

However, all of the participatory opportunities outlined above are open to charges of tokenism according to the positions previously identified. Locating 'authenticity' and 'legitimacy' is relative to one's personal experience of the interaction, and to one's motivation for being involved in it in the first instance. Was I hoping to learn? To be entertained? Both? Did I want to be informed? To ask questions? Or was I just trapped in a space with no choice but to become involved? Genuine interactive possibility is no doubt difficult to achieve within sites and institutions that are used to imposing order and form, and at which controlling the outcome of the narrative might not even be a historical possibility. None the less, we saw in the research project that participatory elements, even with all of these limitations in place, *do* aid recall over time dramatically (in every sense of the word), adding to *most* individuals' enjoyment of a performance as a whole (see Jackson and Kidd 2008 for further details).

The new emphasis in museum interpretation on co-production, collaboration and democracy indicates that interactivity at all levels of museum production is increasing (at least in the rhetoric). Our research shows that it should – with reservation. Experimentation with audiences' perceptions of what constitutes participation (as we have seen in a number of our case studies) provokes various responses. Those who *choose* to engage in such a

way take away memories of experiences that remain vivid, urgent and can genuinely change their attitudes not only toward the subject matter being interpreted, but toward the form also, in pronounced ways. Those who are *forced* to participate can be turned off the idea of interpretation of heritage in this manner altogether. It is for this reason that one of the principal recommendations of the research was that the 'frames' of a performance should be considered as critical to the success or failure of participatory heritage performance. 'Induction' as a way of indicating expectations and possibilities for involvement was something the research explored in detail in the last of our case studies (see Chapter 1 for more on this).

Ultimately, the use of interactive and participatory mechanisms which provoke understanding, empathy and interest can benefit not only participants, audiences and visitors, but the institutions too. They also become a valuable resource for feedback, dialogue and re-presentation within the museum. As Taylor and Warner observed in 2006: 'Drama can both communicate experience and give the communicator a greater understanding of the participant' (Taylor and Warner 2006: 31). In this sense, to borrow again from language increasingly associated with digital media, the museum becomes more like a commons: a collaborative, open source, ongoing (and infinite) project. The 'authentic', 'legitimate', participatory museum may not be as far off as we envisage.

Notes

1 There has been only limited research into participation in heritage performance, but see Jackson et al. 2002; Bagnall 2003; Hunt 2004; and Jackson 2007. See also other chapters in this volume.

2 Umberto Eco's theorisation of 'open' and 'closed' texts is a useful pointer to the processes of active interpretation involved in everyday processes of engagement with cultural forms (Eco 1979).

3 Although experimentation with the scope of the audience's role was by no means a historically new development for theatre.

4 Here I refer to 'text' as a term for a cultural product or artefact which can become a subject for analysis, for example a book, an object, a multimedia device or, in our case, a performance.

5 This reference comes from a media and cultural studies context where the discussion around interactivity as a principle is more advanced than it is in performance studies (see in particular Manovich 2002).

6 As in Chapter 1, references of this nature refer to participant responses to the PLH research. The data, stored in the PLH archive, are available in a highly edited form, via the PLH website (the 'data trawls' for each case study).

7 As termed by Augusto Boal in his 1979 book *Theatre of the Oppressed*.

8 It is perhaps worth noting here that many museum theatre presentations offer very

limited or no opportunity for audience involvement (here the word 'audience' sits much more comfortably than 'participants'). First-person monologues, storytelling and the traditional 'play' tend to offer far less opportunity for intervention than gallery performance or living history where the visitor *may* have control over the direction and flow of the narrative (and to what extent there is a discernible narrative).

9 This of course assumes that what is being sought is a historically 'accurate' and 'authentic' presentation of the past. This is evidently not a universal aim of performance practice at heritage sites, just as it is arguably unachievable (even undesirable) in practice. Many of the chapters in this book problematise the quest for authenticity.

10 This performance was also given at the National Maritime Museum, Greenwich, in 2005.

11 Chico the Clown, or Irving Pollard (1898–1975) lost his memory and voice in a Luftwaffe bombing raid in Coventry. The Herbert Art Gallery and Museum houses a collection of objects that Triangle Theatre Company used to inspire *The Pollard Trail* in August 2006.

15

Performing human rights at two historic site museums

Joel Chalfen

Out of a generation of criticism that broke apart the singular authority of the museum exhibition has appeared a movement in exhibition-making that seeks multiple viewpoints and provokes debate. Particularly concerned with voices and communities that were previously excluded both by the representation within displays and the cultural capital required to access them, these recent initiatives deliberately aim to create a space where alternative narratives can be told and prejudices challenged. Moreover, developing the educational focus that accompanied the wave of pre-millennium ideological critique, these new museums assert themselves as agents of civic learning and social change. Pushing the very definition of the museum beyond its traditional boundaries, these institutions have adopted the idea of the forum as their model – an idea first mooted by Duncan Cameron (1971). Here, the emphasis is on the museum as a space for talking about important social issues, often in response to but at times to the exclusion of the authenticity of an object collection. Examples of these museums are the Museum of Tolerance in Los Angeles, the exhibitions at the Anne Frank House, Amsterdam and the District Six Museum in Cape Town. In each case, there is typically an explicit reference to human rights as underwriting these new approaches.

Many other museums around the world have comparable programmes, and leading the way in defining the movement is the International Coalition of Historic Site Museums of Conscience. The Coalition – which first met in 1999 as nine sites and now comprises seventeen accredited members and over a hundred affiliated members – has made it its purpose to nurture a museum practice of using the past to stimulate dialogue on 'pressing social concerns' (Sevcenko 2002, 2008).[1] Subject matter does not unify the members, only the commitment to remember an injustice (or a triumph of justice) and use it to address similar – often descendent – political issues today. Their flagship innovation is the Dialogues for Democracy – a prototype public programme in which visitors engage in a facilitated conversation with each other. The aim is that, by that involvement, the past becomes 'activated' as a perspectival

guide to the present, and that historic site museums, as Sites of Conscience, re-position themselves as 'critical tools for building a lasting culture of human rights' (Sevcenko 2004: 6).

Whilst all these initiatives raise questions about changes in how heritage is used and claimed, and about the redeployment of museum professionals as political activists, the issue that they raise for me is not about the activities of their staff but rather how they engage the participation of their publics in their mission to use the past as a resource for active citizenship. Whilst such a discussion might contribute to the debate concerning why and how heritage sites aim to radicalise their memorial practices, my focus is on the processes of learning this radicalisation defines and requires. 'Learning' is potentially very different at these places from how it is at other museums and historic sites, emphasising dialogue and active participation. From an historical narrative and setting, visitors are being asked to look critically at their own world, and to consider and express their opinion. Indeed, it is precisely that conversational space – between how a museum might *inform* public opinion and how individual members of the public might *form* their own opinion at the museum – that this chapter explores. It is in this space that a diagnosis of the performative agency of the visitor as learner–citizen can be made. The diagnosis I propose is in the differentiation of two modes of performance, named, citing the Universal Declaration of Human Rights:[2] performances of reason and performances of conscience.

Performances of reason

Going on the tour – I think of immigration, this area as a foreign area. But my family at some point was here. It humbles me. Not that opinions change but I have a different perspective. (Visitor response, The Tenement Museum, 16 January 2007)

At the forefront of the Coalition's work is the Lower East Side Tenement Museum. Established in 1988 for the purpose of honouring the nation's immigrants, the New York museum has always been clear about its political intentions. The question that preoccupied its founder, Ruth Abram, concerned the state of the American nation and in particular the moral integrity of a community fearful of difference and diversity in its immigrant populations. To overcome this barrier to democratic reconciliation, she sought a place where the historical commonality, to most Americans, of the immigrant experience could be revisited. She hoped that 'through a confrontation with ancestors who are held to be dear, Americans might be moved to a kind of national conversation about contemporary immigrants' (Abram 2001: 4). This admixture of national and civic patriotism, nostalgia, public debate and 'confrontation' with the past was the premise of her project and eventually

led her to seek international partners who were using their histories in a similar way. The museum is a private, not-for-profit organisation and now receives nearly 140,000 public visitors annually with many others coming on organised excursions.

The museum is an original tenement building, built in 1864, closed to residents in 1935 and finally re-discovered by the museum's founders after 53 years, left derelict with few traces of its 7,000 former inhabitants. Using careful research of specific families whose history can be traced to the building at 97 Orchard Street, the museum has reconstructed, in detail, six apartments in order to represent life as a new immigrant at the height of New York's expansion. These replica homes go further than restoration: though only one tour actually uses living history, theatre has always been important to the idea that the museum could re-enact the intimate world of specific, named families. It is a mimesis that intervenes in the 'still remains', inviting visitors to discover all the complexities and contradictions of the everyday life of the former residents. Whilst original features have been preserved where found, the museum barely displays the fractured artefacts found on site and has bought in most objects in order to make the reconstructions complete. The effect on the visitor is an immersion in the past. The objective is to present a history that is dynamic, multiply voiced, personal and dramatic – all the better to problematise the national story. In contrast to the more flamboyant 'repository of patriotic sentiment' (Kirshenblatt-Gimblett 1998: 177), Ellis Island, the Tenement Museum seeks to play out the motivations and crises of individuals as they sought to negotiate the hopes and dangers of their new American life. Its patriotism is in the form of a question – as the last line of the introductory video in the visitor's centre puts it, what is it to be an American?

Visiting the Tenement Museum is in guided groups only. This is ostensibly for practical reasons but it also supports the museum's pedagogy since it both relies on the power of storytelling and stimulates discussion. It can also contribute to a sense of shared experience. Visiting conditions are as restrictive as movement would have been in its original time. When you stand in one of the one-bedroom apartments in a group of fifteen, you are encouraged to feel the sense of over-crowdedness for which these tenements became infamous. On one tour, you hear the voice of Josephine Baldizzi describing the apartment she grew up in, which is now the apartment you are standing in. Through the address of their disembodied owner, the replica everyday relics are brought physically back to life and you can almost replace her absence with your presence. Such an embodied empathy with time and place serves the museum's political purpose well. It suggests that it is through a physical experience that culture can become a force of social transformation, meeting and challenging our *habitus* where our sociological codes are physically

enshrined. At this level, the Tenement Museum describes its interest to effect social change through the kinaesthetic power of place (Sevcenko 2004).

But the past is not the museum's ultimate concern. As Brecht sought in theatre, they posit a need to gain a critical distance from a total immersion in the drama. The goal of engagement has, over time and with the influence of the Coalition, become more focused on that 'conversation' about contemporary immigration – a shift toward the forum. The problem the museum sets for all its visitors is how to gain from this experience in the past a distance, or what it calls in its publicity materials (Lower East Side Tenement Museum, www. tenement.org/about.html) an 'historical perspective' on the present; that is, to look back at their everyday life from this recreated time in order to formulate an informed opinion on contemporary realities. This is the basis of the museum's Dialogues for Democracy programmes – which are several although for the independent visitor there is just one, optional one, the Kitchen Conversations. This is an additional hour at the end of the tour during which visitors can sit around a table and talk politics in a facilitated dialogue. But it has also come over time to be more the basis of the tours in general.

The advantage of the guided tour – now often given by second-generation immigrants – is to interject in the visitor's encounter with the past using narrative prompts, present examples and direct questions. Indeed, negotiating these two encounters – one in the past and one in the present – is highly dependent on the skill of the individual guides (or 'educators' as they are referred to by the museum), who by intonation, pace, register and style as much as text can draw out the innate power of the building whilst provoking some contemporary reflections. The intention is that through this facilitation dialogue opens up between visitors, performing their own 'replica', as it were, of the kind of kitchen conversations the museum imagines the new immigrants to have had at 97 Orchard Street (Russell-Ciardi 2008: 43). This is the museum's challenge to conventional practice, 'conveying to the public that they are not coming to museums to learn from experts, but rather to exchange ideas, teach one another, and decide for themselves why history matters' (ibid.: 52). But moreover, in this approach, the museum asserts that uniting the present and the past and the diversity of people inhabiting both is a fundamental belief in the powers of publicly performed reason – the principle of the forum. In claiming the universality of the forum space, the museum tries to transform the diversity of experiences to a common purpose, locating the 'human' in the ability to reason.

Much as the forum opens up a new mode of engagement for the visitor, in the neat simile – like the past so is the present – the rhetoric of the museum tries to stake its claim on how the past ought to be interpreted in and for the present. Typically, there is a discrepancy between this and visitor interpretation. For the museum, the past complicates the contemporary world as one

marked by social injustice, in need of an advanced democratic attention. For visitors, the past reveals a private need for recovery and re-incorporation, the personal re-identification with and nostalgia for a national narrative.[3] In trying to turn nostalgia on its head, there is a manipulation – often marked by threshold moments in the museum's narrative – that risks restricting the 'conversational space' between the contribution the institution makes towards shaping opinion and the visitor's own formulation through their encounter with the past. Visitors find themselves participating in a model of democracy and not making it for themselves, raising the question to what extent the museum becomes (to adapt a distinction made by Clifford Geertz) a *model of* as opposed to a *model for* social change. As the former, it is questionable how far the museum as forum does actually radicalise learning as it intends, and how far the museum's own radicalism is no more than the authority of the replica. Whilst to make the allusion of semblance – between past and present, museum and forum – might inspire new forms of curiosity and provoke a political consciousness, accepting the model necessarily requires an accession to the museum's rationality. In that sense, the museum – paradoxically given its own iconoclasm against the museum as temple – resembles the dual pos- sibilities of ritual as Victor Turner describes it: 'As a "model for" ritual can anticipate, even generate change; as a "model of," it may inscribe order in the minds, hearts, and wills of participants' (Turner 1982: 82).

Linguistic performances

It is the dialogical modes of the forum that the Coalition is seen to be pio- neering: both by practitioners and in academic review. Academic attention has incorporated the Coalition's work into other concerns such as how reconstructed historic sites with native interpreters can become venues of significant and vital social change through contact and cross-cultural negotia- tion (Peers 2007); or how museums can work within a broader 'mediascape', re-framing social conversations to overcome prejudice (Sandell 2007); or how activists and artists have contributed to the re-description of places of memory as live, embodied, political relationships (Till 2008). Each is interested in identifying the Coalition's work in the sense of a 'model for' social change, locating it within a conceptualisation of the public sphere.

Richard Sandell, for example, approaches the issue I raise at the Tenement Museum, configuring visitor participation democratically by claiming the museum as one resource amongst others from which visitors are able to draw by choice when thinking about social issues. He recognises a tension between the notion of the active visitor and the authoritative institution but argues that, where museums work to provoke debate, 're-framing public conversations', as he puts it, there is a distribution of agency that is informed both by the 'ethical

constraints' of the institution and the wealth of experience visitors bring with them to the exhibition. Between these two controls, Sandell's communicative practices 'facilitate and support the articulation of (non-prejudiced) accounts and interpretative repertoires' (2007: 102). In a similar vein, Susan Ashley (2006) re-casts museum interpreters as 'public intellectuals' in order to propose their Gramscian capacity for counter-hegemonic influence. Through their intervention, interpreters, she argues, can expose the gaps between knowledge that is assumed and 'in the service of power' and 'alternative hegemonies' based in lived experience. Whilst Ashley does not cite the Coalition, Sandell does, recommending it as an example of organisations taking on the responsibility of such facilitation.

Through theorisation of the visitor-exhibition encounter, such proposals suggest how museums encourage their public's agency, using interpretation as a means to lever their autonomous appropriation of the information the museum reliably provides. These approaches use sociological concepts of communication by which they understand that what flows through public discourse is *ideas* and that what matters is how the discursive space is managed to allow for new 'linguistic performances' (LeCouteur and Augoustinos 2001, cited in Sandell 2007) of these ideas. Such emancipatory credentials disguise, however, a paradox: given that these conversations take place within the constructed sphere of the forum, the visitor's agency is only achieved through the device of the museum. As such, the conversations do not challenge the hegemonic principle of the museum as organiser of knowledge, constructing society in its own image – even if, as Sandell (2007: 103) advocates, this can be one founded on the principles of human rights.

Though the forum establishes a space where difference is respected, it also imposes on objects and places a certain voice that orders the visitor's participation. The assumption of that order is that the right to participate is fundamentally equal, where, in fact, especially in institutional contexts, this is not the case (Billig 1999). It is not my point that, by framing social conversations, museums are setting out to authorise certain viewpoints to the exclusion of those they seek to challenge. This may or may not be the case. Rather my concern is with the way the museum promotes itself as a place of equality, and thereby inadvertently reclaims its desire to construct society according to its own rationale and in its own image.

In contrast, there is the paradigm of the 'contact zone' which is theorised precisely on the inequality of cross-cultural encounters. By means of having to negotiate this, participants move to a better understanding of each other (Clifford 1997). Clifford's particular concern was to find a responsibility in the museum's curating practices. Laura Peers effectively extends that humanitarianism to visiting practices: the responsibility of the visitor is to respond to the subject on display, to bring their understanding of it into a fluid

negotiation of contemporary political realities. Here, as Tony Bennett argues, there is a transmission of authority, where objects and words are 'constantly defined and adjusted in their relations to one another in performing their roles as dialogic bridges between different cultural worlds' (Bennett 1998: 369). But does the contact zone successfully apply to the historic site museum, to different temporal worlds?

To a degree. But I am looking for ways in which the museum–visitor relationship is not based in a rhetoric of difference, where human rights need to be recognised in others.[4] For there is something inherent in our encounter with the past that brings us into touch with human rights as a living, embodied process, something that belongs to us all, here and now – a perspective or way of being towards the world. To that end, I am interested to identify a model of participation that invites visitors to articulate their opinion as performances of conscience. This is based on their private awareness that their act of giving personal meaning to a place is in response to the discovery that the same place was meaningful to others. In such a model, as my next example suggests, it is not difference but time that constitutes the distance between participants. Time, in determining the medium of contact between them, crosses the gap between the museum's rhetoric and the visitor's response.

Immanence and experience

Laura Peers (2007) and Karen Till (2008), in different ways, remind us that performance, as a field of practice as opposed to concept, is an exchange not just of ideas but, more importantly, of experience. Whilst they too are ultimately interested in the dialogue that takes place in the space opened up by interpretation, their notion of dialogue is one that emerges out of the play of theatrical performance – double consciousness or the otherness of Self – whether as art (Till) or more subtly for Peers, native interpreters 'playing themselves'. Through this play of performance, more than 'using these spaces as local sites for conversation' (Ashley 2006: 644), interpretation reveals that *inherently* 'these sites are points of intersection for multiple and complex agendas and histories' (Peers 2007: xxiii). What these practices foreground for the visitor is that contestation is to be found within the 'really real' itself not just in the ideas that surround it.

Most importantly, such practices focus the visitor's role not as a participation in an intersubjective space but, firstly at least, as a subjective and embodied process of *place-making* (Till 2004, 2008; Peers 2007). In other words, visitors are asked to invest their sense of self, not in a debate in the present but in a dialogue with the past. This dialogue is often with representatives of the past, who may be actors or costumed interpreters. But these are interlocutors who are facilitating a relationship with place rather than with

other people. In the case of native interpreters such as at the sites in North America where Peers has researched, these are direct, face-to-face conversations; where Till describes site-specific performance, they are invoked in the multisensual contact with place transformed from its material, Cartesian co-ordinates to a multivocal, haunted or 'wounded' site (Till 2008). As Barbara Kirshenblatt-Gimblett (1998) has observed of the US living history site Plimoth Plantation, these interactions are 'environmental and improvisatory', coming out in the encounter between two presences: a past present (the actors) and a present present (the visitors). Here, theatre and learning combine as process and discovery (*ibid.*), and the visitor's participation and creation of conversation is instructed by their own imagination to respond to the provocation of performance. The avant-garde nature of these performances recalls Allan Kaprow's 'Happenings', in which an audience's participation is a choice to act upon the artwork and thereby to transform it into experience (Kelley 1993: xviii).

The immanence of dialogue and its foundation in the anticipation of response is theorised in the Bakhtinian dialogic, which itself forms an alternative to the Habermasian depiction of the rational public sphere (Hirschkop 2004). Whilst still linguistically constituted, the Bakhtinian sphere does not rely on the rational structures within ordinary language to emerge. Rather it is in a process of 'novelisation' or 're-dramatisation' that the language that we use can be represented and critiqued, and we can reconstruct our own voice, similar to the Freirean programme of 'reading the world' (Giroux 1985). 'The task', Bakhtin writes,

> consists of forcing the *thing-like* environment, acting mechanically on the personality, to speak, that is, to disclose within it a potential discourse and tone, to transform it into the semantic context of a thinking, speaking and acting (in this sense creating) personality. (Bakhtin 1986: 387, original emphasis, cited in Hirschkop 2004: 56)

Coming up face-to-face with the otherness of Time, presented though it might be by a museum, can have just such an effect. As no less than a defiance of mortality, such a confrontation exposes the precariousness of life on which the 'thing-like environment' is built.

Voices and hauntings

> I was expecting to look at the past and see what it was like. It's an issue in the back of your mind at certain times. But I wasn't expecting this one to bring it so obviously to the forefront of your mind. But it is definitely the case that going round here [i.e. the whole place] you start thinking about our current attitudes to benefits and unemployment. (Visitor response at The Workhouse, 22 October 2006)

Just such a public sphere may be realised in certain moments of interaction at the Tenement Museum but it is better described at The Workhouse in the UK, where the subjective encounter is prioritised over the intersubjective. The Workhouse at Southwell is one of few surviving buildings of its kind in England. Architecturally it is significant for its completeness but historically it is even more so, as this building was constructed to put into force a system of social welfare that was to become replicated across the country. Initially regarded as progressive, balancing the demands of local parishes to meet the needs of their poor with the rising expense through the classification of the deserving and the undeserving, the idea was later to develop into a fearful symbol of the injustice to which the poor have been subject, famously caricatured in *Oliver Twist*, and an example of a system that only served to stigmatise and undermine the freedom of those in need of social assistance. Owned now by the National Trust, it is a unique property in their portfolio, raising questions about society's treatment of the unemployed, the homeless, disabled and elderly today as much as during the Victorian period.

Though Bakhtin's notion of the public sphere may not have been in the forefront of the architect's mind, there is a remarkable resonance in the 'Spirit of Place' statement he wrote for The Workhouse when the National Trust first acquired it. This statement is standard practice for all National Trust properties where the principal concern in the interpretation is to capture the idiosyncratic character of the buildings and the people who dwelt there. For The Workhouse, the statement read:

> The key to protecting this gloomy spirit of the place rests in the sensitive handling of and low-key approach to the presentation. We have to use an invisible, non-invasive touch simply to coax out the full feel of the existing fabric with no additions to detract from the essence of the building and its ghosts, allowing them to speak, through the building, to the imagination of the visitor. (Quoted in Knox 1997)

Not only is there a symmetry with Bakhtin's public task, it is an excellent example, I think, of how this is put to work in the conservationist's implicit and often inadvertent commitment to a human rights agenda. Knox is here simply drawing on the principles applied to elite homes that seek the true expression of a place and finding by that approach, in the case of quite a different building, an interpretation that gives new respect to those who were originally given none. The 'invisible, non-invasive touch' ostensibly prepared for the display of private wealth and enterprise here redeems a tenderness of humanity that might have been overlooked and buried when the building was in use. That, in its statement, it becomes incumbent upon the visitor to complete that process of redemption is, of course, apt to my argument here. At root, and like the playful examples of Till and Peers, it is the discovery of the

visitor's imaginative relationship to the site that dictates how it might come to be used in a dialogue for social change (cf. Jackson 2005).

The role of the imagination is even greater at The Workhouse, where there is no actor or interpreter to respond to (see further discussion of The Workhouse in Chapter 3). Decisions about how to implement the 'invisible touch' meant as little reconstruction as possible: where there is no historical evidence to ascertain how the original would have been, rooms have been left empty. In some rooms, a small model is offered in which visitors are encouraged to design the room as they would imagine it. But for the most part the absence of interpreter, furniture or any pictorial representation is compensated for by an audio guide. Though not obligatory, this is the only source of information for the visitor and thus almost exclusively used. The audio guide has its own guide – a neutral voice speaking practical instructions in the moment of the visit – but it also presents a radio drama, set shortly after 1824 when the establishment opened, giving a fictionalised account of a (rather exciting) day in the workhouse. This has another 'neutral' voice, the protagonist of the drama, a landlord's agent coming to inspect the workhouse and assess its merits, with whom the contemporary visitor is likely to identify. As well as the characters of the drama, one other layer of voice is added: mod-ern-day experts, whom the neutral voice introduces intermittently, adding specific details about the conservation of the building. Thus, not only is the past multivoiced but the various voices of the present are implicated into one across-time narrative. The multiple layers of time are thus interwoven in the audio guide and that, combined with the visitor's own sense of moving through historic time in the present day, creates a virtual space at one remove from the place itself. Indeed, the very effect of the audio guide is to make the physical journeying around the site essentially private and individual – an engagement closer to reading a novel than watching a play. The text of this novel is doubled by the audio's physical independence from the place, and the visitor is consequently positioned between the two, as the 'gap' that keeps them apart. Rather than forcing a Brechtian distance between past and present, this has the effect of playing across time, much as at the living history site. Except that, by their disembodied presence, all these voices are haunt-ingly found only in the visitor's mind, and, perhaps, 'witnessed', strangely, in the bodies of other visitors who are seen, also silently and privately passing through.

In this private engagement, The Workhouse yields its governmental role, as designer and educator, to the visitor and their individual claim on the past through their imaginations. This claim is a product of the relationship the visitor establishes with the site through its interpretation of the past. But it is also one which requires an active interest on the visitor's part to be alerted to the past. As it is a 'wounded site', there are skeletons here that haunt our

everyday. For some, this is enough to prompt a search for a more socially just future, as Till hopes. For these visitors it works as a contact zone in which marginalised and unheard voices are given the capacity to speak and a new discourse must be negotiated between them and the visitor. But this is not the case for everyone. For many, the invisible and non-invasive touch compromises their capacity to summon up the Other: without seeing what life was like, it is hard to imagine life being lived there.

The site is most powerful – to most visitors – when in the last two rooms, furnishings *have* been replaced to represent later times when historical evidence can support such reconstructions. The final room is actually a bed-sit for single mothers and their families from the late 1970s. Contrary to all expectations the complete history of this early Victorian building is very recent, within the lifetime of most visitors and certainly recognisably modern, if not contemporary. The shock of this discovery provokes a critical concern amongst many visitors as to the practices of government welfare programmes. This still does not automatically alter views on the 'beneficiaries' of those programmes. Indeed, the Victorian classifications of 'deserving' and 'undeserving' remain perfectly appropriate for many visitors and many advocated to me the return of the workhouse.[5] But still, in bringing to the fore the bridgeable distance of time, this moment of discovery opens up a perspective in which visitors revisit the terms on which their opinions are formed. There is always the risk that the marginalised voices of the past remain silent in the space between institution and visitor. But, despite this important reservation, such a shock of the proximity of the past (in time and place) unsettles enough to establish not just an agenda for discussion but an urgency to respond and a consciousness of the political role visiting can perform.

Complicity and conscience

Thus, I would argue, it is in this capacity of historic sites and museums to provoke the necessity to respond that their political role can firstly be founded. It is not a matter of presenting the 'difficult history': there is something fundamentally available in the public presentation of the past that summons the precepts of human rights as 'the work of culture' (Bennett 2007). The 'novelising' techniques of The Workhouse, like the playful interventions that Till and Peers refer to, suggest that *before* the forum there is an emergent dialogue that implicates the moral responsibility of the visitor. It is in the contact with the past that speech (and hence opinion) emerge from action rather than thought, predicting the engagement of the forum. The example of The Workhouse suggests that the historic site museum potentially encourages the visitor to be their own 'public intellectual', animating their own political consciousness. More than the visitor's active participation in a formulated conversation, their

role is as co-creator of the dialogic moment. Specifically, this dialogue occurs between the visitor and the historical Other. So, whilst casting this historical Other as a marginalised Other also in the present – the immigrant, the homeless – overlays the dialogue with political connotations, it is not this identity that fundamentally constitutes the discourse of human rights. Rather it is in the discovery that the 'I' of the visitor is implicated in the 'Other' of the past. Opinion is thus formed, as Hannah Arendt describes it, 'by making present to my mind the standpoint of those who are absent' (1968: 241).

At The Workhouse, I found that visitors were typically alert to the idea that social welfare is a contemporary issue as much as an historical one even though it is only in the very last room that it is introduced as a matter of current debate. Those who, in their own words, described the historical system as, for example, 'chilling', 'authoritarian' or 'depressing', were also inclined to imagine others who, in one respondent's view, 'would quite happily have it exist' now. Whilst it was impossible, certainly in my methodology, to access the thoughts of visitors as they walked around the building, in the exit interviews it was apparent that what had been presented to visitors was not a complete and discrete past but a problem that was unresolved still today. One respondent to my interviews felt that 'as you walked in you were making a judgement about people', whilst another said that: 'Throughout the whole thing I was just thinking about what the solution was and there isn't a solution, there isn't a single solution'. For many visitors, what created the space to judge was a sense of an historical system that was and yet, equally, one which might still be enforced today.

The dynamics of the museum encounter can be understood as a competition of two performances: that of the visitors, who, in their desire for authenticity, perform their consumption of the museum experience through a process of emotional and physical mapping that places what they discover in relation to their own lives (Bagnall 2003); and that of the museum, which as 'a framed experience rooted in authenticity' (Anderson 1999: 1), seeks to perform its own system of knowledge as an appeal to something more objective. The forum, I have suggested, plays its part in this competition, supporting its own authority to frame the past and cajoling the public to interpret its meaning politically. Claiming the emancipatory credentials of reasoned communication, and in order to create a distance between personal and public meanings, the forum can overlook the capacity that a conversation in the past posits for the moral subject. As such, an alternative model for engagement might well prove useful. This would be one that encompasses the two claims on the experience of authenticity (personal and public) through a different complicity other than reason. The living history site – as a mode of engagement as opposed to a method of interpretation – offers one such alternative. Self-consciously playing with the possibility of authenticity, the living

history site suggests that complicity between museum and visitor revolves around a shared interest in the event of learning; that is, a shared interest not to experience the authentic but rather to authenticate experience. Moreover, at the living history site, the impossibility of time regulates the shared game that suspends disbelief in authenticity. Opinion, under these circumstances, is an investment in place – what makes it important to me – as opposed to an expression of a political view based on 'evidence'.

Living history interpretations do not necessarily foreground political purposes or a human rights agenda. However, in modelling a mode of engagement between visitor and museum they appeal to a definition of human rights as political process as opposed to one based in law. Whereas the forum posits human rights as constituted in difference and protected by law (hence open to rational argument), the living history model reflects Hannah Arendt's contention that human rights are in a perpetual crisis of recognition, constantly needing re-articulation where there is no normative structure to otherwise guarantee their status. Under such conditions, they must at least in part be subjectively constituted through an appeal to conscience (Parekh 2008). For Arendt, the term that we understand as human rights is better defined as civic rights, referring to rights guaranteed by a political community and not ones that exist in nature. Instead, there is 'a right to have rights', located in place, where one's being and expression can have meaning: summarising Arendt's position Serena Parekh argues that 'Without the right to *action* – to live in a world where your actions have meaning – and the right to *speech* – to be able to communicate meaningfully and formulate opinions – we are deprived of our humanity and hence are absolutely rightless' (2004: 45, original emphasis). In this light, the meeting between living history site and visitor – one that constitutes the space between them in time – can be seen as a performance of human rights.

Notes

1 See also the website www.sitesofconscience.org.

2 Article One of the Universal Declaration of Human Rights states: 'All human beings are born free and equal in dignity and rights. They are endowed with reason and conscience and should act towards one another in a spirit of brotherhood.'

3 I do not wish to oversimplify visitor responses to the museum but nor can I analyse them in any depth here. From fieldwork I carried out at the museum (as part of my doctoral research), in which I spoke with approximately thirty groups of visitors, it is reasonable to suggest that American visitors broadly tended to recognise a national identity in the personalised histories of struggle, survival and integration. Typically, they saw in the museum's examples their own family histories and personal experiences. And they were resistant to using that recognition to radicalise their view of the present.

4 This, incidentally, has been the premise on which heritage institutions have typically engaged with the discourse of human rights (see Silverman and Ruggles 2007).

5 Interviews with visitors were carried out on site on various occasions. As above, space does not allow for in-depth analysis of these here.

16

'For a little road it is not. For it is a great road; it is long': performing heritage for development in the Cape

Mark Fleishman

Introduction

Since 2002 I have been engaged in a project entitled 'Remembering in the Postcolony'. This is a remembering that is less about the need to forestall forgetting then it is about a putting back together of the fractured body (Brandstetter 2000; Seremetakis 2000) and it is a postcolony defined in the terms of Achille Mbembé: the multiple, contradictory moments of everyday life in Africa read against the persistent accretions of slavery, colonialism, apartheid and neo-liberal forms of democracy (Mbembé 2001).

In the project I have created a series of performance events that engage with key 'sites of memory' in and around the city of Cape Town. The term is taken from Pierre Nora (1989) and refers to a conglomerate of physical, material and archival sites that function to concentrate remembrance in a world in which, to quote James E. Young, the more we monumentalise, the more we seem to have 'divested ourselves of the obligation to remember' (2000: 94).

In making each of the works mentioned above my collaborators and I faced two fundamental and interconnected problems related to themes of time and silence: how to find an appropriate image in the present for something that has passed and how to make the archive speak in unspeakable ways.

The project takes place within the particular landscape of post-apartheid South Africa. Within this landscape, debates about heritage, memory and history are of great concern. The South African Truth and Reconciliation Commission (TRC) recognised in its commentary and recommendations in 1999 that 'symbolic acts . . . have a potency and significance beyond what is apparent' and argued that heritage practices and institutions should 'celebrate different aspects of the past' allowing more voices to be heard – multiple experiences and interpretations of the country's history (cited in Flynn and King 2007: 463). This was to be understood as part of an ongoing project

of nation-building based on the notion of a common citizenship rather than racial difference.

However, in 2010, South Africa remains a divided country with major disparities. Poverty and inequality persist in ever increasing dimensions, to some degree brought on by distortions that emanate from the apartheid era, or by misguided policies of the new government or a lack of adequate implementation of well-intended policies. Despite the understanding stated above of the need to use heritage as a transformative project, the heritage industry in South Africa remains largely untransformed. The conception of heritage remains conservative and based on the preservation of artefacts and in buildings, most around the major metropolitan cities. There is also a penchant for the building of new monuments coupled with a reluctance to do away with old ones.

In this chapter I will examine one of the projects conducted as part of the broader project of Remembering: the community-based, participatory Clanwilliam Arts Project. The project is different from the others in the series. All the others are professional productions performed for paying audiences in and outside of mainstream theatre spaces in metropolitan Cape Town. The Clanwilliam Arts Project, on the other hand, is an eight-day arts residency for school learners in the rural town of Clanwilliam that in its current form has operated annually since 2001.

Clanwilliam lies approximately 300 kilometres from Cape Town on the N7 highway that runs up the western side of the country. It lies inland, about 60 kilometres from the coast in the foothills of the Cedaberg mountains. It has been permanently settled since 1725. It is a small town of a few thousand inhabitants, and like all rural South African towns it is split down the middle: on one side an affluent area mostly occupied by the minority white population known as the town, and on the other side a sprawling, run-down area of newish matchbox houses, crumbling cottages and shacks occupied by the majority black population, known as the township. The town is surrounded by farmland and wilderness area. It has a fast developing tourism market growing around wild flowers in springtime and the extensive rock art in the surrounding wilderness areas.

The rock art is evidence of the fact that the area was inhabited for centuries prior to the colonial arrival by the /Xam, a group of San[1] hunter-gatherers who were the real first-peoples of what we now know as South Africa.[2] The University of Cape Town (UCT) has established a field-station in Clanwilliam to house students doing fieldwork in the area. The Clanwilliam Arts Project is located at this field-station each year.

The project involves about 500 learners from the town, almost entirely from the township. Each year about thirty-five facilitators are involved from various creative disciplines.

The objectives of the project are three-fold:

- To provide access to the arts for learners who have been denied access in the past.
- To train student facilitators to work in rural community contexts in arts development.
- To attempt to reclaim the heritage of the /Xam by re-connecting story and landscape and by putting that heritage to work in the community.

The latter objective is what makes this project distinctive in that all the work we do each year is based thematically on a story and an iconographic set selected from the Bleek & Lloyd Collection, an archive housed in the library of the university. The collection consists of over 2,000 notebooks, more than 13,000 pages, transcribed by linguist Wilhelm Bleek and his sister-in-law, Lucy Lloyd, from the words narrated to them by //Kabbo and a small number of other /Xam informants who lived with them in their house in Cape Town between 1870 and 1884.[3] Most of these informants had been brought to Cape Town as convicts to serve prison terms at the Breakwater Convict Station. Their crimes were various, ranging from stock theft to murder. Bleek recognised that the /Xam were destined to extinction. He wrote in 1875, just before his death: 'with energetic measures [we could] preserve, not merely a few "stick and stones, skulls and bone" as relics of the aboriginal races of this country, but also something of that which is most characteristic of their humanity, and therefore most valuable – their mind, their thoughts and their ideas' (cited in Skotnes 1999: 29).

For almost a hundred years after the death of Wilhelm Bleek, the stories narrated by //Kabbo and his co-informants received little attention from anyone outside the circle of the Bleek family. The entire archive was donated to the UCT library after Lucy Lloyd's death in 1914. From then, until the 1970s, it seems to disappear from view receiving little, if any, serious attention from scholars. The archive resurfaces in the 1970s in the work of the linguist Roger Hewitt (Hewitt 1976) and later in the same decade in David Lewis-Williams's groundbreaking work on the interpretation of San rock art (Lewis-Williams 1981). Both of these studies, however, reached limited academic audiences (Skotnes 1999: 48). According to Lucy Lloyd, //Kabbo had been interested in the idea that his words and stories would live on in books; that future generations would have access to them. He seemed acutely aware of the fact that his culture, language and way of life were dying out and that little would soon remain. This seemed to motivate his stay in Cape Town (even after his prison term had ended), his passing on of his knowledge, and his enduring of the separation from his family and home.

For the stories told by these /Xam informants to be written down in books and never performed again, however, is surely another kind of death. They

are after all parts of an oral tradition that ontologically is only really alive when it is changing. As Megan Biesele comments:

> Because the storytelling way of making social sense is by its nature continually creative and re-creative; it actually has its being only in its new performances. That is why variants in oral life are as uncountable as grains of sand. People who only encounter folktales in print should realise that any collection of living folktales is an accident . . . they fail to represent the single most important truth about a folktale tradition, which is its ongoing, creative life in the minds of its narrators and listeners. (1993: 65–6)

My intention in this essay is to suggest, with reference to the Clanwilliam Arts Project, that heritage, far from being a preservation of the past, a fetishization of 'authentic . . . physical relics and remains' (Harvey 2001: 336), is an event. It is an event in two senses:

1. It is something we *do* in the present with the past for our present purposes. It is an active, participatory and performative process or perhaps a set of such processes, and involves an embodied engagement with what remains from the past in order to make meaning in the present (Harvey 2001; Smith 2006). It is, therefore, never inert, and always contestable, open to engagement and constant re-working.
2. It is, in Alain Badiou's terms, something that has the capacity to change the situation; to bring something new into being, a new way of seeing the world (Badiou 2001: 41). In this sense heritage as an event is aligned to the development of subaltern communities particularly in the context of the postcolony.

Furthermore, I will suggest that heritage as an event is closely connected to place and landscape. In this sense the practice of heritage in the postcolony involves experiences *in* particular places *about* particular places that are either pregnant with particular pasts or in which particular pasts have been silenced. Such a practice of heritage exists therefore at the intersection of performance, place/landscape and social development.

What then do I mean by place and landscape and how do they relate to one another? Jeff Malpas (2008) argues that place is a complex term that has at least three possible definitions. Firstly, place is a 'simple location' with a fixed and objective set of co-ordinates on the surface of the earth. Secondly, place is a 'significant locale' with characteristics and identity specific to that place as opposed to any other. Thirdly, place is an 'existential ground', meaning that to be is always to be in place. In this sense, place is the ground of human existence (2008: 200–5).[4] He goes on to argue that place is indeed a combination of all of these, and furthermore that it is essentially dynamic and relational. It

is a matrix of interconnections and interactivity in which things happen or in which we experience the world.[5]

This latter point leads us on to the way in which the anthropologist Tim Ingold understands landscape: 'the world as it is known to those who dwell therein, who inhabit its places and journey along the paths connecting them' (2000: 193). Ingold argues that places are not small component parts of a bigger landscape; they are embodiments of the whole landscape 'at a particular nexus within it' (*ibid.*: 192). Furthermore, places in the landscape are significant because of the activities that they give rise to. In other words, it is through human engagement or dwelling that the significance of a particular place is made manifest. And this dwelling activity – or 'taskscape' to use Ingold's terminology – is embodied, meaning, 'a movement of *incorporation* rather than inscription, not a transcribing of form onto material but a movement wherein forms themselves are generated' (*ibid.*: 193).[6] What this means for Ingold is that 'the landscape is never complete . . . it is perpetually under construction' (*ibid.*: 199). Furthermore, our construction activities are not things we do to the landscape, they are part and parcel of the landscape in its perpetual becoming.

With the above in mind, let us take a journey from then until now and trace the movement of story across time and from place to place.

Then . . .

Some time in late July or early August 1873, a /Xam man called //Kabbo who had been brought to the Breakwater Convict Station in Cape Town on charges of stock theft, narrated the following to the linguist Wilhelm Bleek and his sister-in-law Lucy Lloyd in their home in Mowbray:[7]

> Thou knowest that I sit waiting for the moon to turn back for me, that I may return to my place.
>
> That I may listen to all the people's stories when I visit them; that I may listen to their stories, that which they tell; . . . because they (the stories) float out from a distance; for a story is like the wind, it comes from a far-off quarter, and we feel it.
>
> For, I do work here, at women's household work. My fellow men are those who are listening to stories from afar, which float along; they are listening to stories from other places. [. . .] they do not possess my stories.
>
> The Flat Bushmen go to each other's huts; that they may smoking sit in front of them. Therefore they obtain stories at them . . . for smoking's people they are. As regards myself, I am waiting that the moon may turn back for me; that I might set my feet forward in the path.
>
> I do merely listen watching for a story, which I want to hear; while I sit waiting for it; that it might float into my ear. [. . .]; for when one has travelled along a

road . . . one waits for a story to travel to one along the same road; [for] I feel that a story is the wind . . .

[T]he trees of the place seem to be handsome; because they have grown tall; while the man of the place (//Kabbo) has not seen them, that he might walk among them. For, he came to live at a different place; his place it is not. . . . He is the one who thinks of (his) place, that he must be the one to return.

He only awaits the return of the moon; that the moon may go round, that he may return (home), that he may examine the water pits; those at which he drank. He will work, putting the old hut in order, while he feels that he has gathered his children together, that they may work, putting the water in order for him; for, he did go away. Leaving the place, while strangers were those who walked at the place. Their place it is not; for //Kabbo's father's father's place it was.

Therefore I must sit waiting . . . that this moon . . . should return for me. For I have sat waiting for the boots, that I must put on to walk in . . . [f]or, the sun will go along, burning strongly. And then, the earth becomes hot. . . . For a little road it is not. For it is a great road; it is long. I should reach my place, when the trees are dry. For, I shall walk, letting the flowers become dry while I still follow the path.

By the time //Kabbo spoke the words quoted above he was reaching the end of his powers of endurance; his narration betrays a strong sense of unease and restlessness and a sense of being 'out-of-place'. Throughout the narrative //Kabbo differentiates between a here and a there and a coming and going. He is at pains to distinguish between the place in which he finds himself and the place to which he belongs with the road as a middle-space between the one and the other. It is important to remember that at this point //Kabbo technically had the freedom to leave. His prison term had been over for some time and he had chosen to stay on to complete the work of telling his stories. In Cape Town, //Kabbo's being is decentred; he feels out of touch; he is here but longs to be there while staying here. His physical being is in Cape Town but his existential being tends constantly toward the place called home – 'the natural abode of a certain peace or a certain joyfulness' (Merleau-Ponty 1962: 286).

The stories that he is engaged in telling Bleek and Lloyd belong to that place there. They are not of this place here. The longer he stays on in Cape Town, the more difficult it becomes for him to hear the stories he needs to tell. The stories for //Kabbo do not reside in his head but in the landscape of his place. His people, the Flat Bushmen, move around that place and visit each other and while visiting they relate stories they have gathered on their way. These stories come from the landscape and they float on the wind, coming from a distance. They drift toward those who are alert to them, those who sit waiting for them to float into their ears.

And of course it is clear from the narrative that //Kabbo desires to return;

to walk the road back to his place. He is waiting for one more moon and then he wishes to be on his way so that he can bring himself back on centre; that he can once more visit his people and listen to the stories that float on the wind.

But //Kabbo's desire to return is utopian. It is utopian, firstly, because there is little left in his place that he will recognise by this time and in his heart he must have known this. The colonial plundering of the landscape had long since begun the inevitable destruction of his people. One year after his return to his place //Kabbo was dead. By the end of the century so were most of his people. Today there is no one alive who speaks his language.

It is utopian, secondly, because, in the terms of Michel de Certeau, the road is not a bridge but a frontier (1984: 126–9). //Kabbo imagines the road is a bridge, flowing in both directions, a conduit for the free movement of people, stories and names as it has been for centuries. But in fact it has become a colonial frontier, a limit, a border between interior and exterior, legitimate and alien, and movement across and along this frontier is limited, circumscribed and controlled. It allows the alien to cross only on colonial terms and in colonial interests. //Kabbo's journey to Cape Town was not a journey of free will or free flow. He came to Cape Town as 'a guest of Her Majesty's colonial government' as they say; a prisoner convicted of stock theft. He will return, eventually, but only when he has completed his task and he no longer has anything the colony values, and then only to die.

And it is utopian, thirdly, because the colonial project has silenced the stories; sucked them out of their place, out of the landscape, out of the mouths of their speakers, and inserted them in 'scriptual tombs' (de Certeau 1988: 2). //Kabbo can no longer hear stories because he is in the wrong place but also because his place has been stripped of its stories and they can no longer be heard on the wind.

For //Kabbo and the rest of the San people, stories map a place. They perform an itinerary of living, they describe a tour that converts the potential restrictions and limitations of places into dynamic changeableness. In other words, although //Kabbo desires to return to a place – his father's father's place – his conception of place is not bounded, it is open: a nexus in a complex web of movement in and through and along-with a particular landscape. And the stories that he gathers are not representations that cover the landscape with meaning, they are in a fundamental sense *the* landscape that enfolds those who dwell within it as well as 'the lives and times of predecessors, who over the generations, have moved around in it and played their part in its formation' (Ingold 2000: 189).

The colonial cartographers were also engaged in mapping the same places, transforming the anthropological into the geographical or geometrical. In so doing they removed the performance, the life from the place, eliminated the

stories from the landscape, silencing the voices and replacing them with a text: lines on paper, spaces cut up, stakes driven into the earth proclaiming new ownership. The anthropological map and the oral tradition its existence depends upon are constantly alive and changing, growing and shifting. They are heterogeneous in their interpretative possibilities. The geographical map seems to offer itself up for interpretation in a similar way but in fact its interpretation is limited and defined, its possibilities homogeneous and circumscribed.

Now...

Today, in another century, in postcolonial/post-apartheid South Africa, the Cape colony is divided into three provinces – Western, Eastern and Northern Cape – and once more all roads lead to Cape Town. The rural interior is emptying of its stories as a steady flow of people move to the urban metropolis in search of work, education and a better life. They crowd into townships in makeshift shacks erected on any spot of empty land adding to the burden on a city already groaning under the weight of its current populace and its demands. The road is still a frontier. Resources, knowledge and information reside on the city-side; the rural country-side is depleted and dying for the impoverished majority, while the minority with access to capital create places of beauty for their counterparts in the city.

The Clanwilliam Arts Project tries to turn this frontier into a bridge by reversing the flow and channelling arts resources, skills and experiences back into the rural hinterland and by trying to free the stories from the archive, re-inserting them into the landscape from which they came. Both these objectives are, of course, as utopian as //Kabbo's desire to return to his place, to sit listening to stories, smoking with his people, but, as Greg Dening has noted in another context, this does not mean we should stop trying (Dening 1996: 57).

So at the beginning of spring each year we run workshops in storytelling, dance, music, the visual arts, lantern-making and fire performance over a week, drawing on themes and iconography from one of the stories told by //Kabbo and his fellow informants to Bleek and Lloyd all those years ago. Then, on the final evening, on the eighth day, we hold a lantern parade through the streets of the township, cutting across the rigid lines of the apartheid urban plan, infusing the place with story and the youthful energy of its inhabitants (Figure 16.1). Finally we assemble at a designated site, along with parents, grandparents and other members of the community now numbering in the thousands, to witness a performance in which the learners share what they have learnt with the community through a multi-disciplinary telling of the selected story from the /Xam tradition, not as the /Xam would have told it, but recast for our time (Figure 16.2). In this way we are not engaging with a search

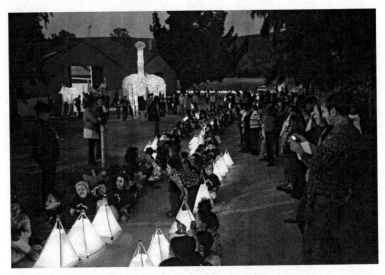

16.1 Lantern parade through the streets of the township

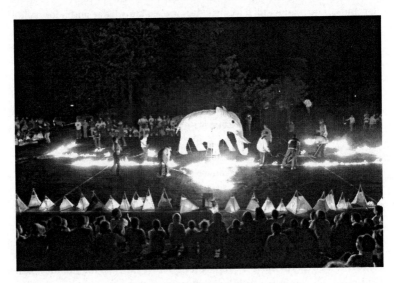

16.2 Clanwilliam Elephant performance

for authentic local roots or nostalgia for a lost paradise, we are instead using what remains from the past to imagine ways of dealing with present problems.

This is heritage as performance event, a form of remembering more appropriate to the postcolony with its volatility, its excess and its contradictions,

its fractures and differences. So as the 'state busily tries to memorialize and museumize, to build new monuments and historic landscapes that are supposed to bring together the different fragments of the nation' (Mbembé 2004: 404), transforming the past into a site of petrified signification pronouncing new rights and truths, domesticated and purged of all ambiguity, the Clanwilliam Arts Project proposes an alternative version of remembering – a remembering that is an active and embodied project, a project that recognizes, to quote Keith Jenkins, that the past 'is never over and done with but must be made tomorrow and the day after' (2003: 30), as must all performances. A remembering that must be worked at, brought into being, creatively imagined, re-invented, collectively sustained, argued over each and every time. A remembering that is never complete, never stable, never fixed once and for all.

So . . .

What is clear from the above is that in this project we are dealing not with tangible or material remains but with the intangible, a body of stories that once were integral to the landscape in which the place, Clanwilliam, is located, but now have been silenced and dislocated by the excesses of colonialism and apartheid. So how to repatriate a body of stories back into the landscape and what might it mean to do so?

I would suggest that what the Clanwilliam Arts Project does is engage in acts of remembering – a putting back together of the fractured body – that re-link the stories, the landscape and the community so as to create agency for that community. It is not about keeping things safe for all time; it is about letting things loose so that they might be used and useful right now.

My broader project of remembering proceeds from de Certeau's notion that history is not the objects in the archive; the material traces, it is what is done with them or on them, through operations or practices (de Certeau 1988: 20; Ahearne 1995: 22). The specific practice employed in the project I define as dramaturgy understood as the making of new works for or of performance.

My particular conceptual approach to dramaturgy is based on the idea of 'dwelling', a term borrowed from the anthropologist Tim Ingold. Ingold's work on dwelling proceeds from a question posed by Heidegger (1971) on the difference between building and dwelling. The answer has for a long time been that we build in order to dwell, that buildings are containers to live in. This leads to what Ingold calls the building perspective: 'worlds are made before they are lived in' (2000: 179).

This perspective depends on an essential division between the perceiver and the world, 'such that the perceiver has to reconstruct the world, in the mind, prior to any meaningful engagement with it' (Ingold 2000: 178). So, in

our world, houses are designed in the mind before they are built (by us or for us, by others).

Ingold's dwelling perspective poses an alternative:

> [T]he forms people build, whether in the imagination or on the ground, arise within the current of their involved activity, in the specific relational contexts of their practical engagements in their surroundings. . . . People do not import their ideas, plans or mental representations into the world, since that very world, to borrow a phrase from Merleau-Ponty (1962: 24), is the homeland of their thoughts. Only because they already dwell therein can they think the thoughts they do. (2000: 186)

The dwelling perspective does not, therefore, separate the perceiver from the world. Its point of departure is the body-in-the-world. We build forms, not as a consequence of having had thoughts but as a consequence of dwelling, of being in the world, of being in action. And one kind of action we take whilst dwelling, one among many, is 'taking thought' (Whitehead 1938: 217) or imagining ways of meeting our needs. 'In the process of dwelling we build' (Ingold 2000: 188).

This is a methodological approach that reverses the cognitive model. It is not a Cartesian thinking to effect being; it is an incarnated, participatory being developing thought through creative discovery and paying attention to the landscape.

In the Clanwilliam Arts Project the dramaturgy involves gathering a story from the archive and inserting it into a particular geographical landscape from which it had previously been extracted, and then allowing the occupants of that landscape to play with that story in multiple ways. The playing occurs at various levels and with various orders of participants: first, the learners, in the workshops and in the creation and performance of the final event itself; second, the broader community, who join the parade (itself a performative event) and witness the final performance.

This approach allows for a number of things to happen. First, it offers an opportunity to change the story. As Helen Nicholson comments:

> Drama provides a powerful opportunity to ask questions about whose stories have been customarily told, whose have been accepted as truth, and to redress the balance by telling alternative stories or stories from different perspectives. (2005: 63)

She connects this to Walter Benjamin's idea that storytelling is aligned to goodness; that it is a combination of aesthetics and ethics. Storying makes connections between life as it is and life as it could be. Recognising that there are different stories and that stories have multiple interpretations involves identifying the limits of one's own horizons and an interest in seeing alternative perspectives. This is what Arjun Appadurai calls building the 'capacity

to aspire'. He argues for the development of 'practices that allow poor people to exercise their imagination for participation' (2007: 33). He notes that the imagination is a means by which people are 'disciplined and controlled – by states, markets and other powerful interests' but he also sees the imagination as 'the faculty though which collective patterns of dissent and new designs for collective life emerge' (2000: 6). For Appadurai, the idea of democracy has shifted from developing the capacity to participate to participating in order to develop capacity. What this means is that through active engagement, in this case in a particular performance-based heritage process, capacity and agency is developed for participation in other aspects of life.

Second, by inserting the story into the landscape and facilitating the community's engagement with it, we are putting another identity (one historically connected to this landscape) back into circulation. Not as *the* identity but as one more possible identity, to play with and choose from. In this way the competing identities of the market-driven global story and the government-driven national story are supplemented with a third possibility, a locally driven heritage story.

It is important to note, however, that the community does not see itself originating with the /Xam in an uncomplicated and universal way. There is something of what Escobar refers to as ambivalence at work here (2001: 148). Some make direct connections between themselves and the /Xam; others refuse these connections outright; most vacillate between the one position and the other. Outsiders often question the validity of the claims, demanding compelling evidence. What is important, I would argue, is to reject demands for evidence of a biological connection between the contemporary inhabitants of the landscape and the /Xam and to pose instead a place-based and class-based connection that re-imagines or recreates new forms of identity based on the past to resist other imposed identities and to achieve present political and social transformative goals. This is a process of self-production that takes what it needs from the landscape in order to survive. The greater the range of stories available in the landscape, the more chance of survival.

To return to Nicholson again:

> This acknowledges that the aesthetics of self-production is built on the convergence and interplay of different narratives, and that constructing narratives of selfhood is both an ethical and creative process. (2005: 65)

This brings us back to heritage and our understanding that heritage is 'not given, it is made and so is unavoidably, an ethical enterprise' (Harvey 2001: 336). Here I am not so concerned with an ethics of values, with a value-based set of rules that determine how we should or should not act. I am more concerned with an ethics of engagement that draws on the ideas of Alain Badiou.[8]

For Badiou, ethics should not be driven by a desire to protect the human

rights of others less fortunate than ourselves, which involves casting oneself as the 'active determining subject of judgment – he who in identifying suffering, knows that it must be stopped by all available means' (2001: 9). Nor should ethics be motivated by an imperative to tolerate difference that Badiou argues is limited by the impossibility of ever accommodating difference, particularly radical difference or the 'altogether other' (Ingram 2005: 564). An ethics of engagement is not about protecting the weak or those who cannot protect themselves or about managing difference; it is about our capacity to act, to create, and to think affirmatively and co-operatively. It is not about preventing evil but about doing good.

In his major work, *Being and Event* (2005), Badiou divides the world in two. There is the 'situation' – the world as is, static and self-perpetuating, defined as the realm of being – and there is the 'event' – something foreign inserted into the situation that the situation cannot assimilate, that escapes from pre-established categories and frames. For Badiou, the event causes a rupture, an opening. It names the 'void', the not-known of the situation (2001: 40–4 and 67–9). These openings Badiou refers to as 'truths' not in the sense of facts but in the sense of revelations, and these 'truths' are always partial never total.

Marcel Cobussen links the concept of noise to the ethics proposed by Badiou. He describes noise as subversive, 'an aggression against all sorts of code, against all kinds of order' (2005: 30), with the potential to initiate transformation. In this sense he links noise to Badiou's idea of the 'event' that 'breaks from the status quo or ordinary situation' (*ibid.*: 30).

From this it follows that to make noise is to disrupt the situation, to initiate events that have the capacity to transform the situation, the regime of established knowledge. Noise as an event is a supplement, in Derridean terms, both an addition to what is known and a replacement or substitution. It brings something new into being, a new way of seeing the world. This resonates with Nicholas Bourriaud's concept of 'Islets of Utopia' – small islands inserted into the order of things – in which it is possible to imagine a way of functioning differently: moments of experimentation that are also moments that resist commodification, that allow a showing that does not imply a sale (2002). Bourriaud argues that we need to support and multiply these moments of 'systemic divergence' to resist the prevailing notion of no alternatives: no alternative to globalisation, no alternative to capitalism, no alternative to 'a new world disorder' (Kershaw 1999: 6–7).

And without any doubt the project is about making noise, literally and figuratively. It has a loud, unpredictable wildness about it threatening to spill over into anarchic chaos, resisting attempts to govern its excesses both in terms of the process and the performance it brings into being, despite our most valiant efforts. The danger of fire in the performance, its unpredictability, always

seemingly teetering on the edge of disaster; the otherness of the huge illuminated figures glowing in the darkness; the content of the stories themselves: full of shape-shifting, reality crossing, therianthropes and tricksters, of magic and mayhem. A salient reminder to those of us who promote performance as a political intervention that it is, by its very nature, ungovernable and that any attempt to set agendas can quickly come unstuck when performance is let loose.

The Clanwilliam Arts Project is, I would argue, an 'event' in Badiou's terms, an ethical response to 'a new world disorder'. It uses the delinquency of story to transgress limits, to turn frontiers into bridges. It allows the possibility of imagining alternative futures – ways of getting out of cycles of perpetual poverty. In the same way that //Kabbo was able to imagine another place – back home – while remaining in Cape Town, so the practice of imagination presents the possibility of developing a capacity to place the self other than where one finds oneself. In this sense it is an 'islet of utopia'. But as //Kabbo himself said: 'a little road it is not. For it is a great road; it is long'.

Notes

1 The term San is primarily a linguistic label used to describe those hunter-gatherers speaking a particular group of related languages that are similar but vary quite considerably from place to place. The San were the first peoples of Southern Africa and those few who remain are distributed across a geographical area that today includes parts of South Africa, Botswana, Namibia and Angola. The San are often referred to as bushmen or Basarwa (in Botswana). The word bushman comes from the Dutch 'bossiesman' meaning 'bandit' or 'outlaw', a term given to the San in their battle against colonial domination and extermination and apparently interpreted by them as a sign of respect for their valiant resistance against the colonial onslaught. The /Xam represent one particular San language group occurring in the southern-most parts of the area of distribution.

2 I include here some of the relevant elements of Wilhelm Bleek's phonetic system used to record the sounds of the /Xam in order to allow the reader to read the article out loud. For a more detailed description see the preface to *Specimens of Bushmen Folklore* (Bleek and Lloyd 1911) and Bleek's *A Comparative Grammar of South African Languages*, Part I, *Phonology* (Bleek 1862: 12–13), from which the former quotes extensively: '/ indicates the dental click. Sounded by pressing the "tip of the tongue against the front teeth of the upper jaw, and then suddenly and forcibly withdrawing it" (Tindall). It resembles our interjection of annoyance. // indicates the lateral click. Sounded by placing the tongue against the side teeth and then withdrawing it. "A similar sound is often made use of in urging forward a horse". X an aspirated guttural, like German ch.'

3 The full archive is now available in digital format as a CD published with Pippa Skotnes's book *Claim to the Country: The Archive of Lucy Lloyd and Wilhelm Bleek* (2007).

4 Edward Casey (1997b) argues that in Western philosophy in the modern era, the distinction between place and space has been 'hidden' so that place has been reduced to a position within extended space. Recently, partly as a result of a sense of the loss of place through the processes of globalisation, more attention has been focused on place as a concept separate from space. For a recent summary of this increased focus on place see particularly Casey 1997a, Malpas 1999 and Cresswell 2004. It is also worth noting here that in his discussion of space and place, de Certeau (1984) reverses the commonly held position that place is a location in space that people have made meaningful. For de Certeau, spaces are 'practiced places' filled with the ongoing stories of those who dwell therein (in this sense he resonates with Ingold's ideas on landscape) while places indicate a fixed and stable position or locality prior to human engagement (1984: 117). Escobar in turn sees 'the reassertion of place . . . as an important arena for rethinking and reworking eurocentric forms of analysis' (2001: 141).

5 This resonates with Doreen Massey's idea of 'the event of place' that she defines as 'the simple sense of coming together of the previously unrelated, a constellation of processes rather than a thing. This is place as open and as internally multiple' (2005: 141).

6 Here Ingold is following Paul Connerton (1989: 72–3).

7 //Kabbo was one of a number of /Xam who lived in the Bleek household in the Cape Town suburb of Mowbray over a number of years. He is, though, probably the most important because of his age (he was older than the others) and his access to a greater variety of stories. The remarkable story of the origins of the Bleek and Lloyd Collection can be found in Bank (2006) and Skotnes (1996 and 2007).

8 Badiou's ideas on ethics are set out in his major work *L'Être et l'événement* published in 1988 (translated as *Being and Event* in 2005) and the more recent *Ethics: An Essay on the Understanding of Evil* (2001).

Appendix

Performance, Learning and Heritage:
a research project funded by the Arts & Humanities Research Council (UK) July 2005–November 2008

Background information

The Performance, Learning and Heritage project (PLH) was based at the Centre for Applied Theatre Research, the University of Manchester.

The **purpose of the project** was to undertake research into the increasing and varied use being made of performance (theatre and other drama-based activity) as an interpretive tool and a medium of learning for visitors to museums and historic sites – an expanding but relatively under-researched field of performance practice. The research:

- mapped the extent, style and functions of performance as a learning medium in museums and historic sites throughout the UK and abroad;
- observed, documented and analysed a variety of performance styles in relation to their site-specific contexts, from 'first-person' interpretation to complete dramatic performances;
- encompassed the experience of independent adult visitors and families as well as organised educational groups;
- conducted longitudinal audience/visitor research to gauge effectiveness and impact over the longer term;
- initiated – and developed methods of assessing – innovative practice. In collaboration with the Manchester Museum, the research team commissioned in Year 2 a new professional performance piece to test and build on research findings as they began to emerge;
- facilitated the wider exchange of ideas and practice in museum theatre between scholars and practitioners through a dedicated website, a series of seminars and an international conference.

Outcomes

The three-and-a-half-year project (phase three of a larger research programme, from 2001) culminated in publications (including journal articles, a

detailed report available online in October 2008, an edited book (the current volume) and a DVD) as well as the international conference in Manchester in April 2008. The Full Report, and 'data trawls' from each of the case studies, are available on the PLH website, and also as part of a combined CD-Rom and DVD pack. See www.plh.manchester.ac.uk/ for further details.

Research team

Professor Anthony Jackson, Project Director
Dr Jenny Kidd, Research Associate
Ruth Daniel, Administrator (part time)
Phil Styles, Administrator (part time)

Steering group

Dr Helen Rees Leahy (Director, Centre for Museology, the University of Manchester)
Dr Bernadette Lynch (Museum consultant; previously Deputy Director, the Manchester Museum)
Pete Brown (Learning & Access Manager, the Manchester Museum)
Joel Chalfen (attached PhD student)

Museum/heritage site partners

National Maritime Museum, Greenwich (Case Study 1, October 2005) – national museum; single character performances.
Llancaiach Fawr Manor, South Wales (Case Study 2, March 2006) – seventeenth-century restored manor house; first-person interpretation.
Herbert Art Gallery & Museum, Coventry, with Triangle Theatre, Coventry (Case Study 3, May–August 2006) – major regional museum undergoing renovation and part-closed at the time; resident theatre company undertaking variety of educational outreach programmes and experimental performance events, including 'heritage trails'.
The Manchester Museum (Case Study 4, March/April 2007) – major regional university museum; experimental performance piece commissioned by research team to complement the museum's contribution to Greater Manchester's 'Revealing Histories' programme (focusing on the legacy of slave trade and empire), and to test emerging findings of the research.

Advisory board and consultants (meeting twice a year)

This included members of the steering group, with Andrew Ashmore (Andrew Ashmore and Associates); Jane Dewey (CS1); Catherine Hughes (USA); Professor Baz Kershaw (University of Warwick); Dr Sally Mackey (Central School of Speech and Drama); Rowena Riley (CS2); Verity Walker (Interpretaction); and Carran Waterfield (CS3).

Initial research questions

- How effective is the deployment of various styles of dramatic performance at museums and heritage sites in meeting – or challenging – the learning, access and 'social inclusion' objectives of the host organisations?

- If (as our 2001/02 earlier research demonstrated) museum theatre is a valuable means of supporting learning through complex cognitive and affective engagement among organised groups of schoolchildren, can it be similarly effective in supporting learning among *independent visitors* (including cross-generational groups)?

- If museum theatre may best be understood as part of a spectrum of performative learning in museums (role play, guided tours, etc.), what are its distinctive features and strengths? When does it work – and when does it not? By drawing comparisons between different styles of dramatic performance across a range of sites, is it possible to extrapolate general conclusions (e.g. in relation to performance techniques, site-specificity and actor–visitor interaction) for wider application?

- Can theatre be used to interpret collections more effectively than at present? How might the research be deployed to develop innovative approaches, and how might these be analysed and assessed?

Initial research themes

Underpinning the research as a whole were four interconnecting themes. These themes helped us to organise the key elements involved in each of our detailed case-studies, especially in the observation and the video and interview 'capturing' of both event and audience response.

1. **Understanding the site**: the museum, historic house or heritage trail;
2. **Understanding the audience**: 'casual' or independent visitors, family groups, organised school groups;
3. **Understanding the content**: e.g. subject matter of performance, relationship to collections/exhibits/setting; levels of intended meaning;
4. **Understanding the performance**: e.g. characters in role, in costume; use of artefacts during performance; single vs. multi-character events; audience interaction if any; its location within the institutional space(s).

Subsequent research themes (emerging from the data collection and interpretation)

1. **Visitors and audiences**: the transition from visitor to audience (and sometimes participant) and back again; recognising prior knowledge and

individual entry narratives; visitor contexts and visitor types; the 'eventness' of the visit, and of performative aspects of the visit; the framing of performance; the relationship between the visitor and the institution.

2. **Performance:** the performative nature of the museum/site; the site as 'stage' or 'set'; the capacity of museums to provide dialogic encounters (and of performance to do the same); performances analysed *as* 'performance'; the 'eventness' of the performance.

3. **Transaction and interactivity:** the 'rules' of interaction; different levels of interaction (e.g. promenade, controlled verbal response and 'immersion'); the language of interaction; the place of 'unsettlement' (from challenge to alienation); the role and articulation of choice.

4. **Learning in the museum through performance:** the importance (or otherwise) of factual recollection; empathetic engagement; ownership; the benefits of dialogue; the place of 'unsettlement'; how people articulate their learning; visitors' and staff expectations of and attitudes toward this kind of work.

5. **Heritage:** authenticity and a sense of 'the past'; the 'reality' of encounters with 'the past'; inspiration/curiosity and imaginative engagement.

The PLH website and the database (accessed via the website) will continue to function for the foreseeable future, courtesy of the University of Manchester, providing general information about the field and a snapshot of museum theatre and live interpretation practice across the globe for the period 2007–10.

The website for the Performing, Learning and 'Heritage' research project can be found at www.plh.manchester.ac.uk.

Contacts

Professor Anthony Jackson
 Centre for Applied Theatre Research, School of Arts, Histories & Cultures, Martin Harris Centre, The University of Manchester, Oxford Road, Manchester M13 9PL, UK.
 Tel: +44(0)161 306 1787.
 Email: a.r.jackson@manchester.ac.uk
Jenny Kidd
 Email: Jenny.Kidd.1@city.ac.uk

Bibliography

Abbott, Edwin A. 1952. *Flatland: A Romance Of Many Dimensions*. New York: Dover Publications.

Abram, Ruth. 2001. 'Using the past to shape the future: new concepts for a historic site' *Museums International*, 53(1): 4–9.

Adler, J. 1989. 'Travel as performed art' *The American Journal of Sociology*, 94(6) (May, 1989): 1,366–93.

Adorno, Theodor. 1981 [1967]. 'The Valéry Proust Museum'. In *Prisms*, trans. Samuel Weber. Cambridge; MA: MIT Press: 173–86.

Ahearne, Jeremy. 1995. *Michel de Certeau: Interpretation and its other*. Cambridge: Polity Press.

Albano, C. 2007. 'Displaying lives: the narrative of objects in biographical exhibitions' *Museum and Society*, 5(1): 15–28.

Alivizatou, M. 2006. 'Museums and intangible heritage: the dynamics of an unconventional relationship' *Papers from the Institute of Archaeology*, 17: 47–57.

—— 2007. 'The UNESCO programme for the proclamation of masterpieces of the oral and intangible heritage of humanity: a critical examination' *Journal of Museum Ethnography*, 19: 34–42.

—— 2008a. 'Contextualising intangible cultural heritage in heritage studies and museology' *International Journal of Intangible Heritage*, 3: 44–54.

—— 2008b. 'The politics of 'arts premiers': some thoughts on the Musée du Quai Branly' *Museological Review* 13: 44–56.

Allaby, Michael. 2006. *Oxford Dictionary of Ecology*, 3rd edition. Oxford: Oxford University Press.

Ames, M.A. 2005. 'Museology interrupted' *Museum International*, 57(3): 44–51.

Anderson, David. 1999. *A Common Wealth: Museums in the Learning Age*. London: The Stationery Office.

Andrew Ashmore & Associates. 2007. *This Accursed Thing*. Unpublished typescript (PLH archives, University of Manchester).

Appadurai, A. 2000. 'Grassroots globalization and the research imagination' *Public Culture*, 12(1): 1–19.

—— 2007. 'Hope and democracy' *Public Culture*, 19(1): 29–34.

Bibliography

Arendt, Hannah. 1968 [1961]. 'Truth and politics'. In *Between Past and Future*. New York: Viking Press.

Armstrong, Gordon. 1999. 'Theatre as a complex adaptive system' *New Theatre Quarterly*, 12: 57, 277–88.

Arnold, D. 2006. *What does the National Museum of Australia's Story tell us about museums as places where history is interpreted and debated?* Available online at ozhistorybytes (www.hyperhistory.org) – Issue Ten: Museums as contested history sites. Accessed in March 2008.

Ashley, Susan. 2006. 'Heritage institutions, resistance and praxis' *Canadian Journal of Communication*, 31: 639–58.

Ashworth, G.J. 2002. 'Holocaust tourism: the experience of Krakow-Kazimierz' *International Research in Geographical and Environmental Education*, 11(4): 363–7.

Atkins, Peter. 2003. *Galileo's Finger: The Ten Great Ideas of Science*. Oxford: Oxford University Press.

Auslander, Philip. 2008. 'Live and technologically mediated performance'. In Tracy C. Davis (ed.), *The Cambridge Companion to Performance Studies*. Cambridge: Cambridge University Press.

Badiou, Alain. 2001. *Ethics: An Essay on the Understanding of Evil*, trans. Peter Hallward. London and New York: Verso.

—— 2005. *Being and Event*, trans. Oliver Feltham. London: Continuum.

Bagnall, Gaynor. 2003. 'Performance and performativity at heritage sites' *Museum and Society*, 1(2): 87–103.

Bakhtin, Mikhael. 1981. 'Discourse in the novel', reprinted in *The Dialogic Imagination: Four Essays*, ed. Michael Holquist, trans. Caryl Emerson and Michael Holquist. Austin: University of Texas Press.

—— 1994. *The Bakhtin Reader*, ed. Pam Morris. London: Edward Arnold.

—— 1986. *Speech Genres and Other Late Essays*, trans. Caryl Emerson and Michael Holquist. Austin: The University of Texas Press.

Baldwin, P. 2004. *With Drama in Mind: Real Learning in Imagined Worlds*. Stafford, Network Educational Press Bank.

Ballé, C. and Poulot, D. 2004. *Musées: une mutation inachevée*. Paris: La Documentation Française.

Bank, Andrew. 2006. *Bushmen in a Victorian World: The Remarkable Story of the Bleek-Lloyd Collection of Bushmen Folklore*. Cape Town: Double Storey.

Basra, S. 2007. 'Weaving paths'. *BBC The Black Country News*. 1 June. Available online at www.bbc.co.uk/blackcountry/content/articles/2007/06/01/weaving_paths_theatre_feature.shtml (accessed 12 May 2008).

Bateson, Gregory. 2000 [1973]. *Steps to an Ecology of Mind*. Chicago: University of Chicago Press.

BCT (Black Country Touring). 2008. *Weaving Paths Evaluative Report*. Available online at www.bctouring.co.uk/resonate (accessed 12 May 2008).

Beard, C. and Wilson, J.P. 2006. *Experiential Learning: A Best Practice Handbook for Educators and Trainers*, 2nd edition. London and Philadelphia, PA: Kogan Page.

Bibliography

Benjamin, Walter 1973. *Understanding Brecht*, trans. Anna Bostock. London: New Left Books.

Bennett, Susan. 1990. *Theatre Audiences*. London: Routledge.

Bennett, Tony. 1988. 'The exhibitionary complex' *New Formations*, 4 (Spring): 73–102.

—— 1998. 'Pedagogic objects, clean eyes, and popular instruction: on sensory regimes and museum didactics' *Configurations*, 6(3): 345–71.

—— 2007. 'The work of culture' *Cultural Sociology*, 1(1): 31–47.

Bennington, Geoffrey. 2000. *Interrupting Derrida*. London: Routledge.

Biesele, Megan. 1993. *Women Like Meat: The Folklore and Foraging Ideology of the Kalahari Ju/'hoansi*. Johannesburg and Bloomington: Witwatersrand University Press/Indiana University Press.

Billig, Michael. 1999. 'Whose terms? Whose ordinariness? Rhetoric and ideology in conversation analysis' *Discourse Society*, 10: 543–58.

Bird, J. 1999. 'Minding the body: Robert Morris's 1971 Tate Gallery retrospective'. In Michael Newman and J. Bird (eds), *Rewriting Conceptual Art*. London: Reaktion: 88–106.

Blackmore, S. 2010. 'Dangerous memes: or what the Pandorans let loose'. In Steven Dick and Mark Lupisella (eds), *Cosmos and Culture: Cultural Evolution in a Cosmic Context*. Washington, DC: NASA: 297–318. Available online at www.susanblackmore.co.uk/Chapters/cosmos2008.htm (accessed 22 January 2010).

Blake, Janet. 2006. *Commentary on the 2003 UNESCO Convention on the Safeguarding of Intangible Cultural Heritage*. Leicester: Institute of Art and Law.

Blau, Herbert. 1990. *The Audience*. Baltimore, MD and London: The Johns Hopkins University Press.

Bleek, Wilhelm H.I. 1862. *A Comparative Grammar of South African Languages*. London: Trübner.

—— and Lloyd, Lucy C. 1911. *Specimens of Bushmen Folklore*. London: George Allen and Company.

Boal, Augusto. 1979. *Theatre of the Oppressed*. London: Pluto Press.

Bolton, Lissant. 2003. *Unfolding the Moon: Enacting Women's Custom in Vanuatu*. Honolulu: University of Hawaii Press.

Bourdieu, P. 1979. *Distinction: A Social Critique of the Judgment of Taste*. Cambridge, MA: Harvard University Press.

—— and Darbel, A. 1989. *The Love of Art. European Art Museums and their Public*, trans. C. Beattie and N. Merriman. Cambridge: Polity Press.

Bourriaud, N. 2002. '*Islets*' *and Utopia*, trans. Timothy Corneau. Available online at www.goodreads.ca/bourriaud.html (accessed 21 June 2010).

Boyd, A. n.d. *Exoticism*. In The Imperial Archive: Key Concepts in Postcolonial Studies. Available online at www.qub.ac.uk (accessed August 2008).

Boylan, P. 2006. 'The intangible heritage: a challenge for museums and museum professional training' *International Journal of Intangible Heritage* 1: 54–65.

Brandstetter, Gabriele. 2000. 'Choreography as a cenotaph: the memory of movement'. In G. Brandstetter and H. Völckers (eds), *Remembering the Body*. Ostfildern-Ruit: Hatje Cantz Publishers: 102–34.

Bibliography

Brecht, B. 1965. *The Messingkauf Dialogues*, trans. J. Willet. London: Methuen & Co.

Bressey, C. 2005. 'Victorian photographs and the mapping of the black presence in Britain'. In J. Marsh (ed.), *Black Victorians. Black People in British Art 1800–1900*. Aldershot, Lund Humphries: 68–77.

Brett, D. 1996. *The Construction of Heritage*. Cork: Cork University Press.

Bridal, Tessa. 2004. *Exploring Museum Theatre*. Walnut Creek, CA: AltaMira Press.

Brown, Bruce. 2000. Memory Maps and the Nazca. In Roy Ascott (ed.), *Reframing Consciousness*. Bristol: Intellect: 47–51.

Brown, I. 1993. 'The New England cemetery as a cultural landscape'. In S. Lubar and D. Kingery (eds), *History From Things: Essays on Material Culture*. Washington, DC: Smithsonian Institution Press: 140–59.

Brown, M.F. 2005. 'Heritage trouble: recent work on the protection of intangible cultural property' *International Journal of Cultural Property*, 12: 40–61.

Burke, Peter. 2005. 'Performing history: the importance of occasions' *Rethinking History*, 9(1): 35–52.

Burkitt, I. 1999. *Bodies of Thought: Embodiment, Identity & Modernity*. London: Sage Publications.

Butler, Beverley. 2006. 'Heritage and the present past'. In Chris Tilley, Webb Keane, Susan Kuechler-Fogden, and Michael Rowlands (eds), *Handbook of Material Culture*. London: Sage: 463–79.

—— 2007. *Return to Alexandria: An Ethnography of Cultural Heritage Revivalism and Museum Memory*. Walnut Creek, CA: Left Coast Press.

Butler, Judith. 1993. *Bodies that Matter*. London and New York: Routledge.

Cameron, Duncan. 1971. 'The museum: a temple or the forum?' *Curator*, 14(1): 11–24.

Carlson, M. 1989. 'Theatre audiences and the reading of performance'. in T. Postlewait and B. McConachie (eds), *Interpreting the Theatrical Past*. Iowa City: University of Iowa Press.

—— 1996. *Performance: A Critical Introduction*. London: Routledge.

—— 2003. *The Haunted Stage: The Theatre as Memory Machine*. Ann Arbor: University of Michigan Press.

Carr-Griffin, Salli (Assistant Property Manager, National Trust). 2008. Email to Phil Smith, 21 August 2008.

Casey, Edward S. 1997a. *The Fate of Place*. Berkeley: University of California Press.

——1997b. 'Smooth spaces and rough-edge places: the hidden history of place' *Review of Metaphysics*, 51: 267–96.

Chakravorty, P. 2007. *Bells of Change: Kathak Dance, Women and Modernity in India*. Calcutta: Seagull Books.

Chatterjea, A. 2004. *Butting Out: Reading Resistive Choreographies through Works by Jawole Willa Jo Zollar and Chandralekha*. Middletown, CT: Wesleyan University Press.

Cleere, H. 2001. 'Uneasy bedfellows: universality and cultural heritage'. In Robert Layton, Peter Stone and Julian Thomas (eds), *Destruction and Conservation of Cultural Property*. London: Routledge: 22–9.

Bibliography

Clifford, James. 1997. *Routes: Travel and Translation in the Late Twentieth Century.* Cambridge, MA: Harvard University Press.

—— 2004. 'Looking several ways: anthropology and native heritage in Alaska'. *Current Anthropology* 45(1): 5–30.

—— 2007. 'Quai Branly in process' *October*, 120: 2–23.

Cobussen, M. 2005. 'Noise and ethics: on Evan Parker and Alain Badiou' *Culture, Theory & Critique*, 46(1): 29–42.

Collins English Dictionary. 2003. 6th revised edition. Glasgow: HarperCollins.

Combrink, X. and Kyle, S. 2007. *The Greater St Lucia Wetlands Park: Rare, Threatened and Endemic Species Project: Biodiversity and Scientific Survey.* Wildlife and Ecological Investments. Available online at www.wei.org.za (accessed March 2008).

Conil-Lacoste, Michel. 1994. *The Story of a Grand Design: UNESCO 1946–1993.* Paris: UNESCO Publishing.

Connerton, Paul. 1989. *How Societies Remember.* Cambridge: Cambridge University Press.

Conquergood, Dwight. 2002. 'Lethal theatre: performance, punishment, and the death penalty' *Theatre Journal*, 54: 339–67.

Corlett, Ewan. 1990/1975. *The Iron Ship: the Story of Brunel's SS Great Britain.* London: Conway Maritime Press.

Cormack, P. 1976. *Heritage in Danger.* London: New English Library.

Corsane, Gerard (ed.) 2005. *Heritage, Museums and Galleries: An Introductory Reader.* London: Routledge.

Counsell, C. and L. Wolf (eds). 2001. *Performance Analysis: An Introductory Course Book.* London: Routledge.

Cover, Rob. 2006. 'Audience inter/active: interactive media, narrative control and reconceiving audience history' *New Media and Society*, 8(1): 139–58.

Craft, W. 1860. *Running a Thousand Miles for Freedom or, The Escape of William and Ellen Craft from Slavery.* London: W. Tweedie. Available online at http://docsouth.unc.edu/neh/craft/menu.html (accessed 22 June 2010).

Cremona, V.A., Eversmann, P., van Maanen, H., Sauter, W. and Tulloch, J. (eds). 2004. *Theatrical Events: Borders, Dynamics, Frames.* Amsterdam and New York: Rodopi.

Cresswell, Tim. 2004. *Place: A Short Introduction.* Oxford: Blackwell Publishing.

Crimp, D. 1980. 'On the museum's ruins' *October*, 13 (Summer): 41–57.

Custer, Paul A. 2007. 'Refiguring Jemima: gender, work, and politics in Lancashire, 1770–1820' *Past and Present*, 195: 127–58.

Dabydeen, D. 1987. *Hogarth's Blacks. Images of Blacks in Eighteenth Century English Art.* Manchester: Manchester University Press.

Davis, Peter. 1999. *Ecomuseums: A Sense of Place.* Leicester: Leicester University Press.

Dawkins, R. 1996. *Climbing Mount Improbable.* London: Viking.

DCMS (Department for Culture, Media and Sport). 2005. *Guidance for the Care of Human Remains in Museums.* London: Department for Culture, Media and Sport.

Bibliography

Dean, D. 1994. *Museum Exhibition: Theory and Practice*. London and New York: Routledge.

Debord, Guy. 1995. *The Society of the Spectacle*, trans. Donald Nicholson-Smith. New York: Zone Books.

de Certeau, Michel. 1984. *The Practice of Everyday Life*. Berkeley and London: University of California Press.

—— 1988. *The Writing of History*, trans. Tom Conley. New York: Columbia University Press.

——, Giard, Luce and Mayol, Pierre. 1988. *The Practice of Everyday Life*, 2nd edn, trans. Steven Rendall. Berkley and Los Angeles, University of California Press.

De Jong, F. 2007. 'A masterpiece of masquerading: contradictions of conservation in intangible heritage', in F. De Jong and M. Rowlands (eds), *Reclaiming Heritage: Alternative Imaginaries of Memory in West Africa*. Walnut Creek, CA: Left Coast Press : 161–84.

De l'Etoile, B. 2007. *Le Goût des autres: de l'Exposition Coloniale aux arts premiers*. Paris: Flammarion.

Deleuze, Gilles and Guattari, Félix. 2004. *A Thousand Plateaus*, trans. Brian Massumi. London and New York: Continuum.

Delgado, Maria M. and Svich, Caridad. 2002. *Theatre in Crisis? Performance Manifestos for a New Century*. Manchester and New York: Manchester University Press.

Demastes, William W. 1994. 'Re-inspecting the crack in the chimney' *New Theatre Quarterly*, 10(39): 242–54.

—— 1998. *Theatre of Chaos*. Cambridge: Cambridge University Press.

Dening, Greg. 1996. *Performances*. Melbourne: University of Melbourne Press.

Department of Arts and Culture (South Africa): Strategy documents available at www. dac.gov.za (accessed March 2008).

Drake, A. 2008. 'The use of community heritage in pursuit of social inclusion: a case study of Castleford, West Yorkshire', unpublished Masters dissertation, University of York.

Duncan, Carol. 1995. *Civilizing Rituals: Inside Public Art Museums*. London: Routledge.

——and Wallach, A. 1980. 'The Universal Survey Museum' *Art History*, 3(4): 448–69.

Dupaigne, Bernard. 2006. *Le Scandale des arts premiers: la véritable histoire du Musée du Quai Branly*. Paris: Mille et Une Nuits.

Durie, Mason. 1998. *Te Mana Te Kawanatanga: The Politics of Maori Self-Determination*. Auckland and Oxford: Oxford University Press.

Dresser, M. and Fleming, P. 2007. *Bristol: Ethnic Minorities and the City 1000–2001*. London: Phillimore and the Institute of Historical Research.

Eco, Umberto. 1979. *The Limits of Interpretation*. Bloomington: Indiana University Press.

Edensor, Tim. 2005. *Industrial Ruins*. Oxford and New York: Berg.

Edson, G. and Dean, D. 1994. *The Handbook for Museums*. London: Routledge.

Eldridge, Lizzie. 2005. 'Genet's *The Maids*: performativity in performance' *Studies in Theatre and Performance*, 25(2): 99–113.

Epstein, James and Karr, David. 2007. 'Playing at revolution: British 'Jacobin' performance' *Journal of Modern History*, 79: 495–530.

Escobar, A. 2001. 'Culture sits in places: reflections on globalism and subaltern strategies of localization', *Political Geography* 20: 139–74.

Esslin, Martin. 1988. *The Field of Drama: How the Signs of Drama Create Meaning on Stage and Screen*. London: Methuen Drama.

Fairfax-Lucy, Alice. 1958. *Charlecote and the Lucys: The Chronicle of an English Family*. Oxford: Oxford University Press.

Falk, J. 2006. 'An identity-centered approach to understanding museum learning' *Curator* 49(2): 151–66.

——and Dierking, D.L. 2000. *Learning from Museums: Visitor Experiences and the Making of Meaning*. Walnut Creek, CA: AltaMira Press.

Farr, James R. 2003. 'The death of a judge: performance, honor, and legitimacy in seventeenth-century France' *Journal of Modern History*, 75: 1–22.

Farthing, A. 2007. *Destination Freedom*. Bristol. Unpublished playscript.

Fauconnier, G. and Turner, M. 2002. *The Way We Think: Conceptual Blending and the Mind's Hidden Complexities*. New York: Basic Books.

Fava, A. 2007. *The Comic Mask in the Commedia dell'Arte. Actor training, Improvisation and the The Politics of Survival*. Evanston, IL: Northwestern University Press.

Fisch, A.A. 2000. *American Slaves in Victorian England. Abolitionist Politics in Popular Literature and Culture*. Cambridge: Cambridge University Press.

Fleming, D. 2007. Transcript of speech given by David Fleming, director of National Museums Liverpool, at the gala dinner to celebrate the opening of the International Slavery Museum on 22 August 2007.

Flynn, M.K. and King, T. 2007. 'Symbolic reparation, heritage and political transition in South Africa's Eastern Cape' *International Journal of Heritage Studies*, 13(6): 462–77.

Fortier, M. 2002. *Theory/Theatre*. London: Routledge.

Foster, Hal (ed.) 1985. *Postmodern Culture*. London: Pluto Press.

Frantz Parsons, Elaine. 2005. 'Midnight rangers: costume and performance in the reconstruction-era Ku Klux Klan' *Journal of American History*, 92(3): 811–36.

Friedland, Paul. 2002. *Political Actors: Representative Bodies and Theatricality in the Age of the French Revolution*. New York: Cornell University Press.

Gadamer, H.-G. 1989. *Truth and Method*. London: Sheed and Ward.

Gargano, Cara. 1998. 'Complex theatre: science and myth in three contemporary plays' *New Theatre Quarterly*, 14(54): 151–8.

George, David E.R. 1989. 'Quantum theatre – potential theatre: a new paradigm' *New Theatre Quarterly* 5(18): 171–9.

Gielen, P. 2004. 'Museumchronotopics: on the representation of the past in museums' *Museum and Society*, 2(3): 147–60.

Giroux, Henry. 1985. 'Introduction'. In P. Freire, *The Politics of Education: Culture, Power and Liberation*, trans. D. Macedo. London: Macmillan.

Bibliography

Glancey, J. 2002. 'War and peace and quiet' *The Guardian* 22 April 2002: 10.

Goffman, Erving. 1974. *Frame Analysis*. New York: Harper & Row.

Gordon, R.M. 1996. Sympathy, simulation, and the impartial spectator. In L. May, M. Friedman and A. Clark (eds), *Mind and Morals: Essays on Cognitive Science and Ethics*. Cambridge, MA: The MIT Press: 165–80.

Gray Buck, E. 1997. 'Museum bodies: the performance of the Musee Gustave Moreau' *Museum Anthropology*, 20(2): 15–24.

Greater St Lucia Wetlands Park Authority. 2003. *Wetlands Wire*, 1(1) (June/July). Available online at www.lubombomapping.org.za, (accessed 10 March 2008).

Greenhalgh, Paul. 1988. *Ephemeral Vistas: The Expositions Universelles, Great Exhibitions and World's Fairs 1851–1939*. Manchester: Manchester University Press.

Groenewald, H.C. 2003. 'Zulu oral art' *Oral Tradition*, 18(1): 87–90.

Gröppel-Wegener, A. 2004. 'Communicating thoughts' *Working Papers in Art and Design* 3. Available online at www.herts.ac.uk/artdes/research/papers/wpades/vol3/agsfull.html (accessed 11 October 2008).

Gumbrecht, H.U. 2004. *Production of Presence: What Meaning Cannot Convey*. Stanford, CA: Stanford University Press.

Haigh, K. (n.d.). www.saidwhat.co.uk/quotes/favourite/kenneth_haigh (accessed 21 April 2008).

Hakiwai, Arapata. 2005. 'The search for legitimacy: museums in Aotearoa, New Zealand – a Maori viewpoint'. In Gerard Corsane (ed.), *Heritage, Museums and Galleries: An Introductory Reader*. London: Routledge: 154–62.

Hanson, R. 1989. 'The making of the Maori: culture invention and its logic' *American Anthropologist*, 91: 890–902.

Hart, L. 2007. 'Authentic recreation: living history and leisure' *Museum and Society* 5(2): 103–24.

Harvey, David. 1990. *The Condition of Postmodernity*. London: Blackwell.

—— 2001. 'Heritage pasts and heritage presents: temporality, meaning and the scope of heritage studies' *International Journal of Heritage Studies*, 7(4): 319–38.

Hawking, Stephen and Penrose, Roger. 1996. *The Nature of Space and Time*. Princeton, NJ: Princeton University Press.

Hawthorne, N. 1898. *Passages from the English Note-books*, Cambridge, MA.

Heathcote, Dorothy. 1980. 'Signs and portents'. In L. Johnson and C. O'Neill (eds), *Collected Writings on Education and Drama*. Cheltenham: Stanley Thornes: 160–9.

Heddon, Deirdre. 2008. *Autobiography and Performance*. Basingstoke: Palgrave Macmillan.

Heidegger, Martin. 1971. *Poetry, Language, Thought*, trans. Albert Hofstadter. New York: Harper and Row.

Hein, G.E. 2001. *Learning in the Museum*. London: Routledge.

Hein, Hilde S. 1998. 'Museums: from object to experience'. In C. Korsmeyer (ed.), *Aesthetics: The Big Questions*. Oxford: Blackwell: 103–15.

Hemingway, A. 1995. 'Art exhibitions as leisure-class rituals in early nineteenth-century London'. In B. Allen (ed.), *Towards a Modern Art World*. New Haven, CT and London: Yale University Press.

Bibliography

Heuvel, Michael Vanden. 1993. *Performing Drama/Dramatizing Performance: Alternative Theatre and the Dramatic Text.* Ann Arbor: University of Michigan Press.

Hewison, R. 1987. *The Heritage Industry.* London: Methuen.

Hewitt, R.L. 1976. 'An examination of the Bleek and Lloyd collection of /Xam bushman narratives, with special reference to the trickster, /Kaggen'. PhD dissertation, University of London.

Hirschkop, Ken. 2004. 'Justice and drama: on Bakhtin as a complement to Habermas'. in N. Crossley and J.M. Roberts *After Habermas: New Perspectives on the Public Sphere.* Oxford: Blackwell.

Historical Association. 2007. *T.E.A.C.H. Teaching Emotive and Controversial History 3-19.* Available online at www.history.org.uk (accessed 22 June 2010).

Hitchcock, Michael, Stanley, Nick and Siu, King Chung. 2005. 'The South-east Asian 'living museum' and its antecedents'. In Gerard Corsane (ed.), *Heritage, Museums and Galleries: An Introductory Reader.* London: Routledge: 291-307.

Hochschild, A. 2005. *Bury the Chains: The British Struggle to Abolish Slavery.* London: Pan Macmillan.

Holtorf, C. 2006. 'Can less be more? Heritage in the age of terrorism' *Public Archaeology* 5(2): 101-9.

Holub, Robert. 1984. *Reception Theory: A Critical Introduction.* London: Methuen.

Hooper-Greenhill, E. 1992. *Museums and the Shaping of Knowledge.* London: Routledge.

—— 1994. *Museums and their Visitors.* London and New York: Routledge.

—— (ed.) 1995. *Museum, Media, Message.* London and New York: Routledge

—— 2000. *Museums and the Interpretation of Visual Culture.* London: Routledge.

—— 2004. *Inspiration, Identity, Learning: The Value of Museums: The Evaluation of the Impact of DCMS/DfES Strategic Commissioning 2003-2004: National/ Regional Museum Education Partnerships.* Leicester: Research Centre for Museums and Galleries.

Hoyle, B. 2009. 'Tate Modern to restage 1971 show that sent art-lovers into a frenzy', *The Times,* 6 April 2009. Available online at: http://entertainment.timesonline. co.uk/tol/arts_and_entertainment/visual_arts/article6041348.ece (accessed 15 May 2009).

Hudson, Kenneth. 1991. 'How misleading does an ethnographic exhibition have to be?' In Ivan Karp and Steven Lavine (eds), *Exhibiting Culture: The Poetics and Politics of Museum Display.* Washington, DC: Smithsonian Institution Press: 457-64.

Hughes, C. 2008. 'Performance for learning: How emotions play a part'. Unpublished doctoral dissertation, Ohio State University.

Hultsman, J. 1995 'Just tourism: an ethical framework' *Annals of Tourism Research,* 22(3): 553-67.

Hunt, Stephen J. 2004. 'Acting the Part: "living history" as a serious leisure pursuit' *Leisure Studies,* 23(4): 387-403.

Illeris, H. 2006. 'Museums and galleries as performative sites for lifelong learning:

constructions, deconstructions and reconstructions of audience positions in museum and gallery education', *Museum and Society* 4(1): 15–26.

Ingold, Tim. 2000. *The Perception of the Environment: Essays in Livelihood, Dwelling and Skill.* London and New York: Routledge.

Ingram, J.D. 2005. 'Can universalism still be radical? Alain Badiou's politics of truth' *Constellations*, 12(4): 561–73.

Ionesco, Eugène. 1960. *Plays. Vol.3: The Killer; Improvisation, or The Shepherd's Chameleon; Maid to Marry*, trans. Donald Watson. London: J. Calder.

Ironbridge Gorge Museum Trust. 2001. *Blists Hill A Victorian Town.* Norwich: Jarrold Publishing.

Iser, W. 1978. *The Act of Reading: A Theory of Aesthetic Response.* Baltimore, MA and London: The Johns Hopkins Press.

iSimangaliso Wetland Park Authority. 2007. *About iSimangaliso Wetland Park.* Eastern Shores Study Guide (pilot). St Lucia, South Africa.

Jackson, A. 2000. 'Inter-acting with the past: the use of participatory theatre at museums and heritage sites' *Research in Drama Education*, 5(2): 199–215.

—— 2005. 'The dialogic and the aesthetic: some reflections on theatre as a learning medium' *Journal of Aesthetic Education*, 39(4) (Winter): 104–18.

—— 2007. *Theatre, Education and the Making of Meanings: Art or Instrument?* Manchester: Manchester University Press.

—— 2010. 'Visitors Becoming Audiences: Negotiating Spectatorship in Museum Performance', *About Performance*, 10: 169–92.

—— and Kidd, J. 2008. *Performance, Learning & Heritage Report.* Manchester: Centre for Applied Theatre Research, University of Manchester. Also available online at www.plh.manchester.ac.uk (accessed on 10 October 2009).

—— and Rees Leahy, H. 2005. 'Seeing it for real?': authenticity, theatre and learning in museums' *Research in Drama Education*, 10(3) (Winter 2005).

——, Johnson, P., Rees Leahy, H. and Walker, V. 2002. *Seeing it for Real: An Investigation into the Effectiveness of Theatre and Theatre Techniques in Museums.* CATR (report on the Phase two research). Manchester: University of Manchester. Available online www.plh.manchester.ac.uk/research/resources/Seeing_It_For_Real.pdf (accessed 1 August 2008).

James, Portia. 2005. 'Building a community-based identity at Anacostia Museum'. In Gerard Corsane, (ed.), *Heritage, Museums and Galleries: An Introductory Reader.* London: Routledge: 339–56.

Jameson, Fredric. 1985. 'Postmodernism and consumer society'. In Hal Foster (ed.), *Postmodern Culture.* London: Pluto Press.

—— 1997. 'Postmodernism and consumer society'. In Ann Gray and Jim McGuigan (eds), *Studies in Culture: An Introductory Reader* London: Arnold: 192–205.

Jenkins, Keith. 2003. *Refiguring History: New Thoughts on an Old Discipline.* London: Routledge.

Jolly, Margaret. 1994. 'Kastom as commodity: The land-dive as indigenous rite and tourist spectacle'. In Lamont Lindstrom and Geoffrey White (eds), *Kastom-Culture-Tradition: Developing Cultural Policy in Melanesia.* Suva: Institute of Pacific Studies, University of South Pacific: 131–44.

Jones, E., Curator, Charlecote Park, private conversation 4th August 2007; and MA Heritage Conservation, University of Leicester, unpublished MA coursework: 45.

Jones, Jonathan. 2006. 'To Timbuktu, and beyond', *The Guardian*, 1 November. Available online at http://arts.guardian.co.uk/features/story/0,,1936350,00.html (accessed 15 October 2006).

Joshi, Pankaj S. 2009. 'Do naked singularities break the rules of physics', *Scientific American* (February). Available at www.scientificamerican.com/article. cfm?id=naked-singularities (accessed 23 June 2010).

Kachur, L. 2001. *Displaying the Marvelous: Marcel Duchamp, Salvador Dali and Surrealist Exhibition Installations*. London: The MIT Press.

Kaplan, F.E.S. 1995. 'Exhibitions as communicative media'. In Eilean Hooper-Greenhill (ed.), *Museum, Media, Message*. London and New York: Routledge: 37–58.

Karp, I. and Lavine, S.D. 1991. *Exhibiting Cultures: The Poetics and Politics of Museum Display*. London: Smithsonian Institution Press.

Kelley, Jeff. 1993. 'Introduction'. In Allan Kaprow, *Essays on the Blurring of Art and Life*. Los Angeles: University of California Press: xi–xxvi.

Kernodle, G., Kernodle, P. and Pixley, E. 1985. *Invitation to the Theatre*. San Diego, CA: Harcourt Brace Jovanovich Publishers.

Kershaw, Baz. 1992. *The Politics of Performance: Radical Theatre as Cultural Intervention*. London: Routledge.

—— 1996. 'The politics of performance in a postmodern age'. In P. Campbell (ed.), *Analysing Performance: A Critical Reader*. Manchester: Manchester University Press: 133–52.

—— 1999. *The Radical in Performance: Between Brecht and Baudrillard*. London: Routledge.

—— 2002. 'Performance, memory, heritage, history, spectacle: *The Iron Ship*' *Studies in Theatre and Performance*, 22(3): 132–49.

—— 2006. 'Performance studies and Po-chang's Ox: steps to a paradoxology of performance' *New Theatre Quarterly*, 22(1): 30–53.

—— 2007a. 'Pathologies of hope', *Performance Paradigm: A Journal of Performance and Contemporary Culture 3*. Available online at www.performanceparadigm.net (accessed 23 June 2010).

—— 2007b. *Theatre Ecology: Environments and Performance Events*. Cambridge: Cambridge University Press.

—— 2008. 'Performance as research: live events and documents'. In Tracy C. Davis (ed.), *The Cambridge Companion to Performance Studies*. Cambridge: Cambridge University Press: 23–45.

—— 2009a. 'Performance practice as research: perspectives from a small island' and 'Environment'. In Shanon Rose Riley and Lynette Hunter (eds), *Mapping Landscapes for Performance as Research: Scholarly Acts and Creative Cartographies*. Basingstoke: Palgrave Macmillan: 3–13.

—— 2009b. 'Practice-as-research: an introduction'. In Ludivine Allegue, Simon Jones, Angela Picinni and Baz Kershaw (eds), *Practice-as-Research: In Performance and Screen*. Basingstoke: Palgrave Macmillan: 1–16.

Bibliography

—— 2009c. 'Practice as research through performance' in Hazel Smith and Roger T. Dean (eds), *Practice-led Research, Practice-led Practice in the Creative Arts*. Edinburgh: Edinburgh University Press: 104–25.

Khan, N. 1997. 'South Asian dance in Britain 1960–1995' *Choreography and Dance*, 4(2): 25–30.

Kidd, J. 2007. 'Filling the gaps: interpreting museum collections through performance' *The Journal of Museum Ethnography*, 19: 57–69.

Kimmelman, Michael. 2006. 'A heart of darkness in the city of light' *New York Times*, 2 July. Available online at www.nytimes.com/2006/07/02/arts/design/02kimm.html?partner=rssnyt&emc=rss (accessed 15 October 2006).

Kirby, M. 1995. 'On acting and not-acting'. In Phillip Zarrilli (ed.), *Acting (Re) Considered. Theories and Practices*. London: Routledge: 40–52.

Kirshenblatt-Gimblett, Barbara. 1998. *Destination Culture: Tourism, Museums, and Heritage*. Berkeley: University of California Press.

—— 1999. 'Performance studies' *Rockefeller Foundation, Culture and Creativity* (September). Available online at www.nyu.edu/classes/bkg/issues/rock2.htm (accessed 7 July 2009).

—— 2004. 'Intangible heritage as a metacultural production' *Museum International*, 221–2: 52–65.

Knowles, Ric. 2004. *Reading the Material Theatre*. Cambridge: Cambridge University Press.

Knox, Tim. 1997. Spirit of the Place statement, attached to memo dated 8 September 1997 from Leigh Rix. Curator Files, Pre-Opening March 2002, The Workhouse archives.

Kolb, D. 2007. *Sprawling Places*. Available online at www.dkolb.org/sprawlingplaces (accessed 15 July 2009).

Kreps, Christina. 2003. *Liberating Culture: Cross-cultural Perspectives on Museums, Curation and Heritage Preservation*. London: Routledge.

—— 2005. 'Indigenous curation as intangible heritage: thoughts on the relevance of the 2003 UNESCO Convention' *Theorizing Cultural Heritage* 1(2): 3–8.

Kuechler, S. 2002. *Malanggan: Art, Memory and Sacrifice*. Oxford: Berg.

Kurin, R. 2004a. 'Museums and intangible heritage: culture dead or alive?' *ICOM News*, 57(4): 7–9.

—— 2004b. 'Safeguarding intangible cultural heritage in the 2003 UNESCO Convention: A critical appraisal' *Museum International*, 56(1–2): 66–76.

Lapp, A. 2002. 'The Jewish experience in Germany' *Museums Journal* (January): 12–13.

Laqueur, Thomas W. 1989. 'Crowds, carnival, and the state in English executions, 1604–1868'. In A.L. Beier, David Cannadine and James M. Rosenheim (eds), *The First Modern Society*. Cambridge: Cambridge University Press.

Lash, Scott and Urry, John. 1994. *Economies of Signs and Space*. London: Sage.

LeCouteur, A. and Augoustinos, M. 2001. 'The language of prejudice and racism'. In Augoustinos, M. and Reynolds, K. (eds), *Understanding Prejudice, Racism and Social Conflict*. London: Thousand Oaks: 215–30.

Lévi-Strauss, C. 1966. *The Savage Mind*. Chicago: University of Chicago Press.

Bibliography

Lewis-Williams, David. 1981. *Believing and Seeing: Symbolic Meanings in Southern San Rock Paintings*. London: Academic Press.

Libeskind, D. 2001. *The Space of Encounter*. London: Thames & Hudson.

Lo, J. and Gilbert, H. 2002. 'Towards a topography of cross-cultural theatre praxis' *The Drama Review*, 46(3): 31–53.

Lopez y Royo, A. 2002. 'South Asian dances in museums: culture, education and patronage in the diaspora'. Roehampton University Public Repository. Available online at: http://rrp.roehampton.ac.uk/artspapers/2 (accessed 12 May 2008).

Lorek-Jezinska, Edyta. 2002. 'Audience activating techniques and their educational efficacy' *Applied Theatre Researcher 3*, Article 6. Available online at www.griffith. edu.au/__data/assets/pdf_file/0008/54962/audience-activating.pdf (accessed 15 July 2009).

Lowenthal, D. 1985. *The Past is a Foreign Country*. Cambridge: Cambridge University Press.

—— 1998a. 'Fabricating heritage', *History and Memory*, 10(1) (Spring): 5–24.

—— 1998b. *The Heritage Crusade and the Spoils of History*. 2nd edn. Cambridge: Cambridge University Press.

Lucy, Mary Elizabeth. 1983. *Mistress of Charlecote*, ed. Elise Birch Donald. London: Orion.

Luke, Timothy. 2002. *Museum Politics: Power Plays at the Exhibition*. Minneapolis and London: University of Minnesota Press.

Lumley, R. 2006. 'The debate on heritage reviewed'. In Gerard Corsane, (ed.), *Heritage, Museums and Galleries: An Introductory Reader*. London: Routledge: 15–25.

Luttwak, Edward N. 1998. *Turbo-Capitalism: Winners and Losers in the Global Economy*. London: Weidenfeld & Nicolson.

Lyotard, Jean François. 1976. 'The tooth, the palm', trans. Anne Knap and Michel Benamou, *SubStance* 15: 105–10.

Mabweazara, H. n.d. 'Present day African theatre forms have filtered through from the past'. Available online at www.usp.nus.edu.sg/post/africa/mabweazara1.html (accessed 10 August 2008).

MacDonald, G. and Alsford, S. 1989. *A Museum for the Global Village: The Canadian Museum of Civilization*. Quebec: Canadian Museum of Civilization.

Macdonald, Sharon. 2003. 'Museums, national, postnational and transcultural identities' *Museum and Society*, 1(1): 1–16.

—— and Basu, Paul (eds). 2007. *Exhibition Experiments*. Oxford: Blackwell.

McAuley, G. 2000. *Space in Performance: Making Meaning in the Theatre*. Ann Arbor: The University of Michigan Press.

McBryde, I. 1997. 'The ambiguities of authenticity: rock of faith or shifting sands?' *Conservation and Management of Archaeological Sites*, 2: 93–100.

McCarron, Kevin. 2008. 'These two French theorists walk into a bar: stand-up comedy, writing and speech'. Paper given at Playing for Laughs Conference, De Montford University, Leicester. February, 2008.

McConachie, B. 2007. 'Falsifiable theories for theatre and performance studies' *Theatre Journal*, 59(4): 553–77.

Bibliography

—— and Hart, H.E. (eds). 2006. *Performance and Cognition: Theatre Studies After the Cognitive Turn*. London: Routledge.

McFarlane, B. 1996. *Novel to Film*. Oxford: Clarendon.

McNaughton, Marie Jeanne. 2006. 'Learning from participants' responses in educational drama in the teaching of Education for Sustainable Development' *Research in Drama Education*, 11(1): 19–41.

McNeil, J.R. 2001. *Something New Under the Sun: An Environmental History of the Twentieth-Century World*. London: Penguin.

Magelssen, S. 2007. *Living History Museums: Undoing History through Performance*. Plymouth, MA: Scarecrow Press.

Malpas, Jeff. 1999. *Place and Experience: A Philosophical Topography*. Cambridge: Cambridge University Press.

—— 2008. 'New media, cultural heritage and the sense of place: mapping the conceptual ground' *International Journal of Heritage Studies*, 14(3): 197–209.

Manovich, Lev. 2002. *The Language of New Media*. Cambridge, MA: The MIT Press.

Markwell, S., Bennett, M. and Ravenscroft, N. 1997. 'The changing market for heritage tourism: a case study of visitors to historic houses in England' *International Journal of Heritage Studies*, 3(2): 95–108.

Marling, K.A. (ed.) *Designing Disney's Theme Parks: The Architecture of Reassurance*. Paris and New York: Flammarion.

Mason, Bim. 1992. *Street Theatre and Other Outdoor Performance*. London: Routledge: 200–14.

Mason, R. 2005. 'Museums, galleries and heritage: sites of meaning-making and communication' in Gerard Corsane, (ed.), *Heritage, Museums and Galleries: An Introductory Reader*. London: Routledge.

Massey, Doreen. 1994. *Space, Place and Gender*. London: Polity Press.

—— 2005. *For Space*. London: Sage Publications.

Massey, R. 1999. *India's Kathak Dance: Past, Present and Future*. New Delhi: Abhinava Publications.

Mbembé, Achille. 2001. *On the Postcolony*. Berkeley: University of California Press.

—— 2004. 'Aesthetics of superfluity' *Public Culture*, 16(3): 373–405.

Meduri, A. 1988. 'Bharatha Natyam: where are you?' *Asian Theatre Journal* 5(1): 1–22.

—— 2008. 'The transfiguration of Indian/Asian dance in the United Kingdom: contemporary Bharatanatyam in global contexts' *Asian Theatre Journal*, 25(2): 298–328.

Meer, S. 2005. *Uncle Tom Mania: Slavery, Minstrelsy, and Transatlantic Culture in the 1850s*. Athens: University of Georgia Press.

Meltzoff, A. and Gopnik, A. 1993. 'The role of imitation in understanding persons and developing a theory of mind'. In S. Baron-Cohen, H. Tager-Flusberg and D.J. Cohen (eds), *Understanding Other Minds*. Oxford: Oxford University Press.

Merleau-Ponty, M. 1962. *Phenomenology of Perception*, trans. Colin Smith. London: Routledge & Kegan Paul.

Bibliography

Message, Kylie. 2006. *New Museums and the Making of Culture*. Oxford and New York: Berg.

Mitchell, Timothy. 2004. 'Orientalism and the exhibitionary order'. In Donald Preziosi and Claire Farago (eds), *Grasping the World*. Aldershot: Ashgate: 442–61.

Moore, K. 1997. *Museums and Popular Culture*. London and Washington, DC: Cassell.

Moscardo, G. 1996. 'Mindful visitors: heritage and tourism' *Annals of Tourism Research*, 23(2): 376–97.

Munjeri, D. 2004. 'Tangible and intangible heritage: from difference to convergence' *Museum International* 221–2: 12–19.

Murray, Warwick G. 2006. *Geographies of Globalisation*. Abingdon and New York: Routledge.

Nas, P. 2002. 'Masterpieces of oral and intangible culture: reflections on the UNESCO World Heritage List' *Current Anthropology* 43(1): 139–43.

The National Trust. 2004. *Interpretation and the National Trust* (internal document).

Neelands, J. 1992. *Learning through Imagined Experience: The Role of Drama in the National Curriculum*. London: Hodder & Stoughton Educational.

Nicholson, Helen. 2005. *Applied Drama: The Gift of Theatre*. Basingstoke: Palgrave Macmillan.

Niedenthal, P., Barsalou, L., Ric, F. and Krauth-Gruber, S. 2005. 'Embodiment in the acquisition and use of emotion knowledge'. In L. Feldman, P. Niedenthal and P. Winkielman (eds), *Emotion and Consciousness*. New York: Guilford: 21–50.

Nora, P. 1989. 'Between memory and history: les lieux de mémoire' *Representations*, 26 (Spring): 7–24.

Oddey, A. 1996. *Devising Theatre: A Practical and Theoretical Handbook*. London: Routledge.

O'Gorman, Frank. 2006. 'The Paine Burnings of 1792–1793' *Past and Present*, 193: 111–55.

Orlin, Doris. 2003. *Paradox*. Chesham: Acumen.

O'Shea, J. 2007. *At Home in the World: Bharata Natyam on the Global Stage*. Middletown, CT: Wesleyan University Press.

O'Toole, J. 1992. *The Process of Drama: Negotiating Art and Meaning*. London: Routledge.

Papastergiadis, N. 2005. 'Hybridity and ambivalence: places and flows in contemporary art and culture' *Theory Culture Society*, 22(4): 39–64.

Parekh, Serena. 2004. 'A meaningful place in the world: Hannah Arendt on the nature of human rights' *Journal of Human Rights*, 3(1): 41–53.

—— 2008. 'Conscience, morality and judgement: an inquiry into the subjective basis of human rights' *Philosophy and Social Criticism* 34(1/2): 177–95.

Parrington, Alan J. 1997. 'Mutually assured destruction revisited', *Air and Space Power Journal*, 11(4): 5–19. Available online at www.airpower.maxwell.af.mil/airchronicles/apj/apj97/win97.html (accessed 28 June 2010)

Parsons, Julien. 2008. Collections and Interpretation Officer, RAMM. Email to Phil Smith, 20 August 2008.

Patraka, V.M. 2002. 'Spectacular suffering: performing presence, absence and witness

at the US Holocaust Memorial Museum'. In E. Striff (ed.), *Performance Studies*. London: Palgrave.

Pearson, Jeremy. 2008. Curator (Devon) and Historic Properties Advisor (Devon & Cornwall) National Trust. Interview with Phil Smith, 12 September 2008.

Pearson, M. 1997. 'Special worlds, secret maps: A poetics of performance', in Anna Marie Taylor (ed.), *Staging Wales (Welsh Theatre 1979–1997)* (Cardiff: University of Wales Press): 95–6.

Pearson, M. and Shanks, M. 2001. *Theatre/Archaeology*. London: Routledge.

Peel, C.V.A. 1928. *The Ideal Island*. London: Old Royalty Book Publishers.

Peers, L. 2007. *Playing Ourselves: Interpreting Native Histories at Historic Reconstructions*. Lanham, MD and New York: AltaMira Press.

Pettie, A. 2008. 'The Mona Lisa curse' *The Daily Telegraph*, 17 September 2008. Available online at www.telegraph.co.uk/culture/tvandradio/3560841/The-Mona-Lisa-Curse.html (accessed 17 January 2010).

Pfister, M. 1977. *The Theory and Analysis of Drama*. Cambridge: Cambridge University Press.

Phelan, Peggy. 1993. *Unmarked: The Politics of Performance*. London: Routledge.

Phillips, R. 2005. 'Replacing objects: historical practices for the second museum age' *The Canadian Historical Review*, 86(1): 83–110.

Pitches, Jonathan. 2000. 'Theatre, science and the spirit of the time: towards a physics of performance'. In Anthony Frost (ed.), *Theatre Theories: From Plato to Virtual Reality*. Norwich: Pen and Inc.

Poignant, Roslyn. 2004. *Professional Savages: Captive Life and Western Spectacle*. New Haven, CT and London: University of New South Wales Press.

Pollock, D. 1998. 'Making history go', In D. Pollock (ed.), *Exceptional Spaces: Essays in Performance and History*. Chapel Hill: University of North Carolina Press.

Price, Sally. 2007. *Paris Primitive*. Chicago: University of Chicago Press.

Rajchman, John. 1999. Time Out. In Cynthia C. Davidson (ed.), *Anytime*. Cambridge, MA: The MIT Press: 153–4.

Reason, Matthew. 2006. 'Young audiences and live theatre, part 2: Perceptions of liveness in performance' *Studies in Theatre and Performance*, 26(3): 221–41.

Rees Leahy, H. 2007. 'Walking for pleasure? Bodies of display at the Manchester Art-Treasures exhibition' *Art History*, 30(4): 543–63.

——2008. 'The context for the research: museums and heritage sites'. *Performance, Learning and Heritage: Final Report*, pp. 11–13. Manchester: PLH Archive. Also at www.plh.manchester.ac.uk/documents/Performance,%20Learning%20&%20 Heritage%20-%20Report.pdf (accessed 6 June 2008).

——2009. 'Watch your step: Embodiment and encounter at Tate Modern'. In Sandra Dudley (ed.), *Museum Materialities*. London: Routledge: 162–74.

Ricoeur, Paul. 2004. *Memory, History, Forgetting*, trans. Kathleen Blamey and David Pellauer. Chicago: University of Chicago Press.

——and Antohi, S. 2005. 'Memory, history, forgiveness: a dialogue between Paul Ricoeur and Sorin Antohi' *Janus Head*, 8(1): 14–25.

Ridout, Nicholas. 2006. *Stage Fright, Animals and other Theatrical Problems*. Cambridge: Cambridge University Press.

Roach, Joseph. 1996. *Cities of the Dead: Circum-Atlantic Performance*. New York: Columbia University Press.

—— 1998. 'History, Memory, Necrophilia'. In Peggy Phelan and Jill Lane (eds), *The Ends of Performance*. New York: New York University Press.

Rogoff, I. 2002. 'Hit and run: museums and cultural difference' *Art Journal*, 61(3): 63–73.

—— 2005. 'Looking away'. In G. Butt (ed.), *After Criticism. New Responses to Art and Performance*. Oxford: Blackwell Publishing: 117–34.

Rojek, C. and Urry, J. (eds). 1997. *Touring Cultures: Transformations of Travel and Theory*. London: Routledge.

Rosenblatt, L. 1938. *Literature as Exploration*. New York: Appleton-Century.

—— 1978. *The Reader, the Text, the Poem*. Carbondale, IL: Southern Illinois University Press.

Ross, M. 2004. 'Interpreting the new museology' *Museum and Society*, 2(2): 84–103.

Roth, Michael S. and Charles G. Salas (eds). 2001. *Disturbing Remains: Memory, History and Crisis in the Twentieth Century*. Los Angeles: The Getty Research Institute.

Rowe, N. 1823. *The Complete Dramatic Works, and Miscellaneous Poems of William Shakspeare*. London: Bohte.

Royal Armouries Museum, Leeds, UK (n.d.) *Souvenir Guide*. No publication details.

Rubidge, S. 1996. 'Does authenticity matter?' In P. Campbell (ed.), *Analysing Performance: A Critical Reader*. Manchester: Manchester University Press: 219–33.

Ruggles, J. 2003. *The Unboxing of Henry Brown*. Richmond: The Library of Virginia.

Rumble, P. 1989. 'Interpreting the built and historic environment'. In David Uzzell (ed.), *Heritage Interpretation Vol. 1*. London: Bellhaven: 24–32.

Russell-Ciardi, Maggie. 2008. 'The museum as a democracy building institution: reflections on the shared journeys program at the Lower East Side Tenement Museum' *The Public Historian*, 30(1): 39–52.

Sabri, S. 2009. Email to R. Mitra, 20 March 2009.

Salih, S. (ed.) 2004. *The History of Mary Prince, A West Indian Slave*. London: Penguin Books.

Samuel, R. 1994. *Theatres of Memory. Volume 1: Past and Present in Contemporary Culture*. London: Verso.

Sandell, Richard. 2007. *Museums, Prejudice and The Reframing of Difference*. London: Routledge.

Sanjit B. 2007. 'Weaving Paths'. *BBC The Black Country News* (1 June). Available online at: www.bbc.co.uk/blackcountry/content/articles/2007/06/01/weaving_paths_theatre_feature.shtml (accessed 12 May 2008).

Schechner, R. 1994 [1973]. *Environmental Theatre*. London and New York: Applause Theatre Book Publishers.

—— 2003. *Performance Theory*. London: Routledge.

—— 2005 [2002] *Performance Studies: An Introduction*. London: Routledge.

Schmitt, Natalie Crohn. 1990. *Actors and Onlookers*. Evanston, IL: Northwestern University Press.

Schneider, Rebecca. 2009. 'A small history (of) still passing', in Bernd Hüppauf and Christoph Wulf (eds), *Dynamics and Performativity of Imagination: The Image Between the Visible and the Invisible*. New York: Routledge.

Sedgwick, Eve Kosofsky. 2003. *Touching Feeling: Affect, Pedagogy, Performativity*. Durham, NC and London: Duke University Press.

Seremetakis, C. Nadia. 2000. 'The other city of silence: disaster and the petrified bodies of history'. In G. Brandstetter and H. Völckers (eds), *Remembering the Body*. Ostfildern-Ruit: Hatje Cantz Publishers: 302–30.

Serrell, B. 1996. *Exhibit Labels: An Interpretive Approach*. Walnut Creek, CA: Altamira Press.

Sevcenko, Liz. 2002. 'Activating the past for civic action: the International Coalition of Historic Site Museums of Conscience' *George Wright Forum*, 19(4): 55–64.

—— 2004. *The Power of Place: How Historic Sites Can Engage Citizens in Human Rights Issues*. Minneapolis, MN: New Tactics.

—— and M. Russell-Ciardi. 2008. 'Sites of conscience: opening historic sites for civic dialogue' *The Public Historian*, 30(1): 9–15.

Shakespeare, William. 1963 [1623] *Hamlet*. New York: New American Library.

—— 1998 [1598–99]. *Much Ado About Nothing*. New York: Signet Classics.

Sheldon, Eric. 2002. 'Relativistic twins or sextuplets' *European Journal of Physics* 24: 91–9.

Shelton, Anthony. 2006. 'Museums and museum displays'. In Chris Tilley, Webb Keane, Susan Kuechler-Fogden and Michael Rowlands (eds), *Handbook of Material Culture*. London: Sage: 480–99.

Shorter Oxford English Dictionary. 2003. Fifth ed. Oxford: Oxford University Press.

Silverman, Helaine and Ruggles, D. Fairchild. 2007. *Cultural Heritage and Human Rights*. New York: Springer.

Simmons, I. 2003. 'The house of the spirits' *Fortean Times*, 166: 50.

Simpson, M. 1996. *Making Representations: Museums in the Post-Colonial Era*. London and New York: Routledge.

Sims, Rod. 1997. 'Interactivity: a forgotten art?' *Instructional Technology Research Online* www2.gsu.edu/~wwwitr/docs/interact (accessed 25 January 2007).

Sitas, A., Mthethwa, D. and Williams, W. 2000. *Draft Proposal for a Cultural Development Centre in the Greater St Lucia Wetlands Park World Heritage Site*. Report prepared for iSimangaliso Wetland Park Authority.

Skotnes, Pippa. (ed.) 1996. *Miscast: Negotiating the Presence of the Bushmen*. Cape Town: University of Cape Town Press.

—— 1999. *Heaven's Things*. Cape Town: Llarec – The Museum Workshop at UCT.

—— 2007. *Claim to the Country: The Archive of Wilhelm Bleek and Lucy Lloyd*. Cape Town and Athens: Jacana and Ohio University Press.

Smith, J.D. (ed.) 2003. *My Bondage and my Freedom by Frederick Douglass*. New York: Penguin Books.

Smith, L. 2006. *The Uses of Heritage*. London: Routledge.

—— 2009. 'Deference and humility: the social values of the Country House'. In L. Gibson and J.R. Pendlebury (eds), *Valuing Historic Environments*. Aldershot: Ashgate: 33–50.

Bibliography

——and Akagawa, N. 2009. *Intangible Heritage*. London and New York: Routledge.

——and Waterton, E. 2009. '"The envy of the world?"': Intangible heritage in England'. In L. Smith and N. Akagawa (eds), *Intangible Heritage*. London: Routledge: 289–302.

——and Waterton, E. 2010 (in press). 'Constrained by common sense: the authorised heritage discourse in contemporary debates'. In John Carman, R. Skeats and C. McDavid (eds), *The Oxford Handbook of Public Archaeology*. Oxford: Oxford University Press.

Smithson, R. 1996a [1966]. 'Entropy and the new monuments'. In Jack Flam (ed.), *Robert Smithson: The Collected Writings*. Berkeley: University of California Press: 10–23.

——1996b [1967]. 'What is a museum?' In *Robert Smithson: The Collected Writings*. Berkeley: University of California Press: 43–51.

——1996c [1968]. 'A museum of language in the vicinity of art'. In Jack Flam (ed.), *Robert Smithson: The Collected Writings*. Berkeley: University of California Press.

Smorodinskii, Ya A. and Ugarov, V.A. 1972. 'Two paradoxes of the special theory of relativity', *Soviet Physics Uspekhi* 15(3): 340.

Sonia Sabri Dance Company. 2008. 'Introduction to the company'. Available online at www.ssco.org.uk/index.html (accessed 12 May 2008).

Stam, D.C. 2005. 'The informed muse: the implications of 'The New Museology' for museum practice'. In Gerard Corsane, (ed.), *Heritage, Museums and Galleries: An Introductory Reader*. London: Routledge: 54–70.

Stanley, Nick. 1998. *Being Ourselves for You*. London: Middlesex University Press.

——(ed.) 2007. *The Future of Indigenous Museums: Perspectives from the South Pacific*. New York and Oxford: Berghan Books.

Stead, N. 2008. 'Performing objecthood: museums, architecture and the play of arte-factuality' *Performance Research*, 12(4): 37–46.

Stephenson, Jenn. 2006. 'etatheatre and authentication through metonymic compression in John Mighton's *Possible Worlds*' *Theatre Journal*, 58: 73–93.

Storrie, Calum. 2006. *The Delirious Museum: A Journey from the Louvre to Las Vegas*. London: I.B.Tauris.

Taylor, Charles. 1974. *British and American Abolitionists. An Episode in Transatlantic Understanding*. Edinburgh: Edinburgh University Press.

——1992. *Multiculturalism and 'The Politics of Recognition'*. Princeton, NJ: Princeton University Press.

Taylor, Diana. 2003. *The Archive and the Repertoire: Performing Cultural Memory in the Americas*. London: Duke University Press.

Taylor, P. 2000. *The Drama Classroom: Action, Reflection, Transformation*. London and New York: Routledge.

——and Warner, Christine (eds). 2006. *Structure and Spontaneity: The Process Drama of Cecily O'Neill*. Stoke on Trent and Sterling, VA: Trentham Books.

Thomas, Nicholas. 1994. *Colonialism's Culture: Anthropology, Travel and Government*. Cambridge: Polity Press.

Thomson, Keith S. 2002. *Treasures On Earth: Museums, Collections and Paradoxes*. London: Faber & Faber.

Bibliography

Thrift, Nigel. 2005. *Knowing Capitalism*. London: Sage.

Tilden, F. 1977. *Interpreting Our Heritage*, 3rd edn. Chapel Hill: The University of North Carolina Press.

——2007. *Interpreting Our Heritage*, 4th edn. Chapel Hill, University of North Carolina Press.

Till, Karen. 2004. 'Emplacing memory through the city: the new Berlin', *GHI Bulletin*, 35 (Fall): 73–83.

——2008. 'Artistic and activist memory work: approaching place-based practice' *Memory Studies*, 1(1): 99–113.

Tinniswood, A. 1998. *The Polite Tourist: A History of Country House Visiting*. London: The National Trust.

Triangle Theatre. n.d. *A House Full of Character* and *A Servant's Christmas* www.triangletheatre.co.uk (accessed 27 July 2009).

Tulloch, J. 2005. *Shakespeare and Chekhov in Production and Reception: Theatrical Events and their Audiences*. Iowa City: University of Iowa Press.

Tunbridge, J. and Ashworth, G. 1996. *Dissonant Heritage: The Management of the Past as a Resource in Conflict*. Chichester: J. Wiley.

Turner, Victor. 1982. *From Ritual to Theatre: The Human Seriousness of Play*. New York: Performing Arts Journals.

Unamuno, Miguel de. 1954 [1913]. *The Tragic Sense of Life*. New York: Dover.

UNESCO. 2003. *Convention for the Safeguarding of the Intangible Cultural Heritage*. Paris: UNESCO.

Vergo, Peter (ed.) 1989. *The New Museology*. London: Reaktion Books.

Vom Lehm, D., Heath, C. and Hidmarsh, J. 2001. 'Exhibiting interaction: conduct and collaborations in museums and galleries' *Symbolic Interaction*, 24(2): 189–216.

Wainscott, Ronald and Fletcher, Kathy. 2004. *Theatre: Collaborative Acts*. Boston, MA and New York: Pearson Education.

Wainwright, Clive. 1989. *The Romantic Interior: The British Collector at Home, 1750–1850*. New Haven, CT: Yale University Press.

Wakkary, R. and Hatala, M. 2007. 'Situated play in a tangible interface and adaptive audio museum guide' *Personal and Ubiquitous Computing*, 11:3 (March 2007): 171–91.

Walker, C. 2005. 'Land of dreams: land restitution on the eastern shores of Lake St Lucia' *Transformation: Critical Perspectives on Southern Africa*, 59: 1–25.

Walsh, Kevin. 1992. *The Representation of the Past: Museums and Heritage in the Post-Modern World*. London: Routledge.

Waterfield, Carran, Andrews, Norwood and curators of The Herbert Museum. 2009. Exhibition: *The Hour of Death*. Exhibited at The Herbert Art Gallery & Museum, Coventry, 4–18 March 2009.

Watkinson, D., Tanner, M., Turner, R. and Lewis M. 2006. 'SS Great Britain: teamwork as a platform for innovative conservation' *The Conservator*, 29: 73–86. Available online at www.ssgreatbritain.org/ArticlesandResearch.aspx (accessed 20 August 2009).

Watson, S. 2007. 'Museums and their communities'. In S. Watson (ed.), *Museums and their Communities*. London: Routledge: 1–23.

Weil, Stephen E. 1990. 'Rethinking the museum: an emerging new paradigm'. In *Rethinking the Museum and other Meditations*. Washington, DC: Smithsonian Institution Press: 57–72.

Welles, Orson (n.d.). http://quotationsbook.com/quote/38690 (accessed 19 April 2008).

Welsford, E. 1935. *The Fool. His Social and Literary History*. London: Faber & Faber.

Welton, M. 2007. 'Feeling like a tourist' *Performance Research* 12(2): 47–52.

Wertsch, J.V. 2002. *Voices of Collective Remembering*. Cambridge: Cambridge University Press.

White, H. 1978. 'The fictions of factual representation'. In *Tropics of Discourse: Essays in Cultural Criticism*. Baltimore, MD: The Johns Hopkins University Press: 121–34.

Whitehead, Alfred N. 1938. *Science and the Modern World*. Harmondsworth, Penguin.

Wilkie, F. 2001. Email to Phil Smith, 3 September 2001.

—— 2002a. 'Kinds of place at Bore Place: site-specific performance and the rules of spatial behaviour' *New Theatre Quarterly* 18(71): 243–60.

—— 2002b. 'Mapping the terrain: a survey of site-specific performance in Britain' *New Theatre Quarterly*, 18(70): 140–60.

—— 2007. ' "It's a poor sort of memory that only works backwards": performance, site and remembering' *About Performance*, 7: 25–44.

Winterbotham, Nick. 1994. 'Happy hands-on'. In Eilean Hooper-Greenhill (ed.), *The Educational Role of the Museum*. London and New York: Routledge.

Witcomb, Andrea. 2003. *Re-imagining the Museum: Beyond the Mausoleum*. London: Routledge.

Wood, M. 2000. *Blind Memory. Visual Representations of Slavery in England and America 1780–1865*. Manchester: Manchester University Press.

Woolf, Janet. 2008. *The Aesthetics of Uncertainty*. New York: Columbia University Press.

Wright, P. 1985. *On Living in an Old Country: The National Past in Contemporary Britain*. London: Verso.

Yim, D. 2004. 'Living human treasures and the protection of intangible cultural heritage: experiences and challenges' *ICOM News*, 57(4): 10–12.

Young, J.E. 1993. *The Texture of Memory: Holocaust Memorials and Meaning*. New Haven, CT: Yale University Press.

—— 2000. *At Memory's Edge: After-images of the Holocaust in Contemporary Art and Architecture*. New Haven, CT and London: Yale University Press.

Zola, E. 1970 [1876]. *L'Assommoir*, trans. Leonard Tancock. Harmondsworth: Penguin.

Websites

Allaby, Michael. *A Dictionary of Ecology* – 'diversity': www.encyclopedia.com/doc/1O14–diversity.html (accessed 15 June 2010).

Bibliography

Encarta Dictionary – 'singularity': http://encarta.msn.com/dictionary_1861734961/singularity.html (accessed 15 June 2010).

Imperial War Museum North: http://north.iwm.org.uk (accessed 28 June 2010).

The Lower East Side Tenement Museum, New York: www.tenement.org/about.html (accessed 15 August 2009).

Mitai Cultural Village: www.mitai.co.nz (accessed 20 August 2008)

Musée du Quai Branly: www.quaibranly.fr (accessed 20 August 2008)

National Museum of New Zealand Te Papa Tongarewa: www.tepapa.govt.nz (accessed 20 August 2008)

The National Trust, 'Charlecote Park – What to See and Do': www.nationaltrust.org.uk/main/w-vh/w-visits/w-findaplace/w-charlecotepark/w-charlecotepark-seeanddo.htm (accessed 20 July 2009).

Schiller, Christoph – *Motion Mountain: The Free Physics Textbook*: www.motionmountain.net/index.html (accessed 15 June 2010).

Shakaland 2008 'The Greatest Zulu Experience in Africa': www.shakaland.com (accessed 10 August 2008)

SS Great Britain: www.ssgreatbritain.org (accessed 15 June 2010).

Stanford Encyclopedia of Philosophy 2008 – 'Dialetheism': http://plato.stanford.edu/entries/dialetheism (accessed 15 June 2010).

Stanford Encyclopedia of Philosophy 2008 – 'Thought experiments': http://plato.stanford.edu/entries/thought-experiment/#SomRecVieThoExp (accessed 15 June 2010).

Tourism KwaZulu Natal – 'Some statistics of our tourism industry': www.kzn.org.za (accessed 1 February 2008).

Tourism KwaZulu Natal – 'Zulu history and culture': www.kzn.org.za (accessed 1 February 2008).

UNESCO: www.unesco.org (accessed 20 August 2008).

Vanuatu Cultural Centre: www.vanuatuculture.org (accessed 20 August 2008)

Warwick Castle: www.warwick-castle.com (accessed 10 May 2008)

Wikipedia – 'gravitational singularity': http://en.wikipedia.org/wiki/Gravitational_singularity (accessed 15 June 2010).

Wikipedia – 'free radicals': http://en.wikipedia.org/wiki/Free_radical (accessed 15 June 2010).

York Castle Museum – 'The History of Kirkgate': www.kirkgatevictorianstreet.org.uk/pages/history.htm (accessed 10 October 2008)

Index

Note: 'n.' after a page reference indicates the number of a note on that page

Index